about the author

ROBERT GREENFIELD is an award-winning novelist, screenwriter, and playwright, and is the author of *Bill Graham Presents: My Life Inside Rock and Out*, *Exile on Main St.: A Season in Hell with the Rolling Stones*, and *Timothy Leary: A Biography*. He lives in California.

dark star

also by robert greenfield

Exile on Main St.: A Season in Hell with the Rolling Stones
Timothy Leary: A Biography
Bill Graham Presents: My Life Inside Rock And Out
S.T.P.: A Journey Through America with the Rolling Stones
The Spiritual Supermarket: An Account of Gurus Gone Public in America

dark star

an
oral
biography
of
jerry
garcia

Robert Greenfield

DEY ST.
AN IMPRINT OF
WILLIAM MORROW *PUBLISHERS*

DEY ST.
AN IMPRINT OF
WILLIAM MORROW *PUBLISHERS*

A hardcover edition of this book was published in 1996 by William Morrow and Company, Inc.

HarperCollins books may be purchased for educational, business, or sales promotional use. For information, please e-mail the Special Markets Department at SPsales@harpercollins.com.

FIRST HARPER PAPERBACK PUBLISHED 2009.

Designed by Linda Kocur

The Library of Congress has catalogued the previous paperback edition as follows:

Greenfield, Robert
 Dark Star : an oral biography of Jerry Garcia / Robert Greenfield.
 p. cm.
 Includes index.
 ISBN 0-7679-0035-9 (pbk.)
 1. Garcia, Jerry 1942–1995. 2. Rock musicians—United States—Biography.
3. Grateful Dead (Musical group) I. Title
ML419.G36G65 1997
782.42166'092—dc21
[B] 97-5061
 CIP
 MN

ISBN 978-0-06-171572-3 (reissue)

HB 03.13.2023

at long last, donna

contents

preface to the
new edition of dark star

this book was put together during the months after Jerry Garcia died on August 9, 1995, and then published the following summer on the first anniversary of his death. Although I did not realize it at the time, many of those who spoke to me about Jerry did so in order to make it plain that they had played a significant role in his life and so deserved serious consideration when it came time came to parcel out what he had left behind. Others did so simply because they loved the man and wanted him to be remembered as he really was.

The fact that nearly all the speakers in this book were still grieving for Jerry and the music he had made on stages all over the world lent immediacy to their recollections, which were as yet undiminished by time. Although Jerry has now been dead for thirteen years, Bob Weir, who was kind enough to provide the new introduction to this book, had to fight to keep from breaking down in tears as he spoke about his old friend and former bandmate. No man could have asked for a more eloquent tribute.

For all their help, I would like to thank Dennis McNally, Bob Weir, John Gulliver, Bev Doucette, and Will Hinton. In memory of Jerry's spirit, I'd like to dedicate this edition of *Dark Star* to Deadheads everywhere, both old and young, with the hope they will all soon get to live in the world they deserve.

Robert Greenfield
August, 2008

remembering jerry

the first time I ever met him was backstage at the Tangent, a coffeehouse in Palo Alto, in October, 1963. It was hoot night and he was somewhat of a local banjo hero, so I didn't have that much interaction with him because he was warming up with his outfit, The Black Mountain Boys. At that point, he had bigger fish to fry.

The second time I met him was New Year's Eve of 1964, and that was a whole different story. I was walking the back alleys of Palo Alto with a couple of friends, and we heard banjo music coming from the back room of Dana Morgan's music store. We just knocked on the door and he invited us in. It was seven-thirty at night and I asked him, "What's up?" and he said, "Well, I'm waiting for my students."

I looked at my friend's watch (I don't think I had one at the time) and I said, "Well, Jerry, it's seven-thirty on New Year's Eve so I don't know if any of them are going to be here." That raised his eyebrows.

He asked us if we played instruments and we said yeah and he said, "Well, I got the keys to the front of the shop. You guys wanna kick some stuff around?" He clearly felt like playing so I said, "Hell, yeah." There were three of us, all young folkies, and we went and got some instruments and had all kinds of fun for a few hours. As we broke it up, maybe because somebody had to get to a New Year's Eve party, Jerry, who knew how to get gigs, said, "That was a lot of fun. Maybe we ought to get together and start a jug band, make a little money on the weekends."

With Jim Kweskin and the Jug Band, Dave Van Ronk, and what became The Lovin' Spoonful, jug bands were the fad in the folk craze and real popular back then. Jug band music was early blues. These musicians were the same guys who played minstrel music on the riverboats and the blues in the night spots and street corners all along the chitlin' circuit. I was sixteen, still a kid, and needless to say, the idea was impossibly attractive to me. I hitchhiked to rehearsals for what immediately became

Mother McCree's Uptown Jug Champions, though The Black Mountain Boys also continued to exist for a while.

In Mother McCree's I played the jug, the washtub bass, and maybe a little guitar. Does it get any lower than that? Well, when I was working on a ranch, I shoveled a lot of stalls, and playing music was better than that. These are the jobs a kid gets.

Eventually, that band coalesced into The Warlocks. We went for about a year as Mother McCree's and got popular enough that the gig money was better than what Jerry had been getting with The Black Mountain Boys. We became sort of the toast of the town on the folk circuit.

That summer, 1964, Jerry wanted to take a sabbatical and go catch some fiddler conventions. At this point, he was with Sara and they had a newborn kid, but he traveled all over the South and saw Bill Monroe and a bunch of those guys. While he was gone, he had me teach his beginning and intermediate guitar and banjo students. Did I know enough to teach? I knew enough to bullshit. By then I was making headway playing guitar, and I spent a lot of time dodging school so I could play, which got me kicked out of the California public school system. Because I am dyslexic in the extreme, I couldn't read music, but since Jerry wasn't teaching his students how to read either, I was okay as his replacement. What we were teaching was folk music, and we were bringing our students into the folk process. They learned it eagerly.

In early 1965, The Warlocks got started. With Mother McCree's, it had been just the music. With The Warlocks, Pigpen was kind of the showman. He was singing half the leads, and Jerry and I took the other ones. I was the kid in the band—and I still am—and there were often times when Jerry had to come to my defense. He was protective of me because I was basically his little brother. As in any family, a raft of horseshit gets dished out to the younger brother. I was used to this. My musical skills were not as advanced as the older guys', but I knew I had some sort of talent, and Jerry gently horsewhipped me with that. That said, the band was my mentor, as it was to the other guys.

Then came Mickey. One of the pleasing things about Mick back then was that he was so not California. As Mickey today is so not this planet. He managed much better than most New Yorkers to assimilate to the California lifestyle. California chews up and spits out New Yorkers just like New York does Californians. Jerry himself was way more California

than you would think. He did have that cynical beatnik thing in the beginning, but that was California. He was certainly not Mr. Mellow.

Was Jerry the sun around which we all revolved in the Dead? No. Not to any of our minds. He wasn't regarded that way by the other band members. We were all brothers and he was the biggest brother. We all listened to him when he had something to say, but if we disagreed, we disagreed. It was a free-for-all. When he did have something to say, it was not that he was persuasive, it was his clarity that was persuasive. Everybody saw the picture. And sometimes we didn't. And sometimes he was wrong. We were all wrong about a lot of stuff. He was outspoken about pretty much everything, even the stuff he wasn't clear on, but he was always the first to admit, "You know, we can't make this decision now." Or at least that he couldn't.

Jerry was only fifty-three when he died. I am older than that now, but he looked a lot older then. Was it the drugs that killed him? I think it was the burgers and pizza. The drugs enabled him, but it was the whole lifestyle. The drugs didn't stop his heart. It was the fat. And the sleep apnea. I'm quite certain he died of sleep apnea. If you'd ever been around him when he was sleeping, you'd see him snore and wake up suddenly. Flying out on a tour, we would have most of the first-class section, Jerry would be sawing away, I'd be sitting next to him, and the stewardess would come up in a panic because the people around us were freaking and she would say, "You've got to get your friend to shut down that goddamn chainsaw." I would gently twist his head the other way, and usually he would keep sleeping. In his case, the sleep apnea was a component of being overweight. And with apnea, your heart stops when you're asleep.

I heard he was dead while I was on tour with the early version of Rat-Dog. I'd woken up early that morning from a dream that I still remember quite clearly. In the dream, I was backstage at some club, and on a shelf I had discovered a can of invisible paint. Dressed in Castilian splendor, Jerry came in through the back door. His hair was black again and he was wearing a blue-black velvet cape. I couldn't get him interested in the inviso-paint, something he would normally have reveled in. He seemed completely preoccupied. He just looked me deeply in the eye, and then he was gone. I think he was already dead. He had just checked out. I went back to sleep, and then a couple of hours later, my sound man knocked on my door, came in, and said, "I want you to sit down. I've got some bad news for you." And I went blank. My reaction was nothing. I went home

for the funeral proceedings and then hit the road and stayed out there for as long as I could.

Jerry died in August, and I went to India with his widow in April to scatter his ashes. When I was over there, I became enthralled by one of the Hindu deities, Lord Ganesh. I had a couple of letters from people who had traveled in India, and one of them said Jerry was a manifestation of Lord Ganesh, whose major attribute is intelligence. Piercing intelligence. He has all these arms and one holds a little axe, which symbolizes intelligence and enables him to cleave to the truth. The gods all live within us. Jerry just had a heaping helping of that one.

The story about scattering the ashes was that Jerry had this river that he would talk about whenever he was waxing whimsical. It was a mythical place for him. And one morning between dreams and waking, I saw the river. And I knew it was the river he had always been talking about. I don't know where it came from. But when we went to India to scatter his ashes, that was the river. The Ganges.

Is he gone from our culture? He's not gone! Because when I'm onstage, I can hear him. I can hear his guitar. I can hear the overtone series. I can feel him saying, "Nah, don't go there. Yeah, go there." It's the same thing that always used to go on telepathically between us when we were on stage. Or, it could be abnormal psychology. But after spending thirty years living in each other's hearts and souls, not to mention brains and minds, he is immortal to me.

Was he an American original? He was a world original. One of a kind. Although I distrust pride and take a dim view of it, America can be proud of him. He had such an American childhood. And he was self-created. He created the culture as he was a part of it. Because the man was an artist, and nothing but. Jerry was my dearest friend. He was also my big brother.

Bob Weir
July, 2008

It's the same story the crow told me
It's the only one he know—
Like the morning sun you come
And like the wind you go. . . .

—*Robert Hunter, "Uncle John's Band"*

History had kicked him between the eyes. You could see it all the way back there.

—*Ken Kesey, interview with author, 1989*

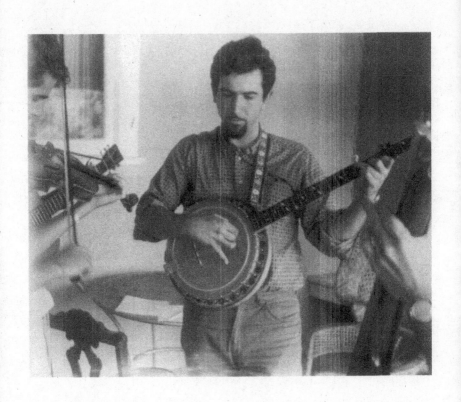

first
days

Well, the first days are the hardest days
don't you worry anymore
When life looks like Easy Street
There's danger at your door. . . .

—Robert Hunter, "Uncle John's Band"

I personally feel my heart is in San
Francisco. I left my heart in San Francisco.
I'm from there. I still feel like a city
person. . . . I don't really relate to Marin
County consciousness. I'm locked
in my old world.

—Jerry Garcia, interview with author, 1988

1

clifford "tiff" garcia: Our mom was a registered nurse. She wasn't a practicing nurse. Maybe she practiced for one year and then she got married. In the thirties, she was a housewife. Her family was working-class Irish. Her mother, Tillie Clifford, organized the laundry workers union. She was elected secretary-treasurer and she kept the post for like twenty-five years. I was named after her. Which I guess was traditional. It might have been at my father's insistence. I don't know. My father used to play in speakeasies. He also had big bands that used to play out in the park and various places. A big orchestra. Twenty-piece, at least. I've seen pictures of them in their formal stuff. He had these pictures taken for promotion and in one of them, he was all spruced up. Really looking sharp. Tux, tie, everything. He had kind of fair skin and he worked under his own name. Jose Garcia. Or Joe Garcia. Depending on the particular gathering he was with.

When they got married, he went into the bar business because he got blackballed from the union and his band had a breakup. It was a job he had to take to survive. Back then, you had to take any damn thing. You couldn't be really picky. So he got into the bar business with a partner. He took a day job because he couldn't make money being a musician. He was lucky to even have a job back then. This was right after the Depression. Things were pretty slim. Usually, he was at home at night because he worked in the daytime. He was perfect for the bar scene. Maybe a little bit too suave. Shirt open. Sleeves rolled up. Apron. It was his place but he served.

The first of his bars was located on First Street and Harrison in San Francisco right where the Sailors Union of the Pacific is now. It's an industrial neighborhood about two blocks from the waterfront with a lot of seamen. In fact, a seamen's hotel was on top of the corner businesses. There was a bar on one corner, a Curtis Baby Ruth candy factory on the

other corner, and right behind that was Union Oil. Running bars, my mom went from one corner to the next. She was on three or four corners.

Two blocks away was the poorest area in town. Third and Howard. Down there was really scumbag city. Skid row, totally. Jerry and I used to go down there. We'd take the bus from my grandmother's house or the streetcar down to First Street and then all the way to Mission from the Excelsior District where we lived. Then we'd wait for the bus at First where the terminal is and then ride it up. We could see the transients and sailors. A lot of drunken sailors and it was rowdy. That was the worst part of town we could go to. We were street kids but in our neighborhood. We knew when we got in another neighborhood, we didn't know who anybody was. We were living on the other side of town in the Excelsior or the Crocker-Amazon District. My grandmother lived three blocks away. Within a five-mile radius lived all the family members that I was aware of. All in different neighborhoods but we'd see each other weekly.

The Cliffords and the Garcias bought a summer house in Santa Cruz. In Lompico near Felton. In the wintertime, you could never get out of there. In the summertime, they had a nice dam, a lodge, a bar, and a little grocery store. Sometimes we'd go there all summer. We'd ride down there with my grandfather and my grandmother would stop at the store and load up on groceries and we'd go into the canyon. The first stuff they brought down there was tools. Between the half-dozen adults down there at the time, my father and my uncle and my grandfather Clifford put all the kids to work, raking leaves or unloading the car so they could fix up this cabin. The different family members would go down there and have a picnic and they started gradually staying longer because the place was fixed up. But there was no electricity or nothing.

A year before my father died, I chopped off Jerry's finger. That was where it happened. I'm not sure how long we'd had the place by then but we'd been there for a while. Long enough to put what I thought was my name across the driveway. CLIFFORD GARCIA. Actually, we'd been given a chore to do but we were fucking around. Jerry had the ax for a while, too. I wasn't the only one that had the ax. We both had axes. He would hold the wood and I'd chop it and we were chopping these branches. My dad was constantly cutting parts of this redwood tree down and Jerry just kept fucking around. He was putting his finger there and pulling it away.

He was fucking around and I was just constantly chopping. I was going

to tease him. But I would stop the hatchet before getting to the wood. He'd put the wood there and I'd go "SWEEEEE" and stop. And he'd pull it away thinking it was chopped. I'd say, "Hey, I forgot to chop," and I'd pick it up again and I'd do that. We were playing little games like that and then I nailed him. He screamed. I screamed. We both screamed. It was an accident. I didn't do it maliciously. I was a kid. I was eight and Jerry was four. We were little guys.

They took him to the hospital in Santa Cruz. Back then it could have taken two hours. I remember I was in the car. It was traumatizing. Jerry was home that night but they couldn't get him to the right surgeon to save the finger. They could have saved it. I didn't cut it off. It was just a wound.

All of a sudden, my aunt came down from the city and I ended up going up there. They took me away. I was always the first one to get moved away because I was more portable. I was older and I could walk on my own and I knew directions.

No one hard-timed me about it. I think they all realized it was an accident. But there are these things you feel. I felt guilty. I can still feel it. My mom would bring it up now and then. When she was on my case for something else. She would bring up the incident. Like, "Remember what you did."

2

clifford "tiff" garcia: I was not there when my dad drowned. I was in Santa Cruz, near Lompico. The drowning was in Arcata. They were up there fishing. My dad didn't want to take me along because he knew he'd have to take me out there with him and that was probably why I didn't go. That was the only reason. I was ten but I had fished with my dad before. Whereas Jerry was too small to go out there with him. Not that I could have saved him. We probably both would have gone.

Jerry and my mom were sitting on the beach and my dad was out in waders in the ocean. He was a good to very good swimmer. I guess he got pulled down by an undertow and cracked his head. The body was lost for like six hours. Jerry didn't witness his father's death. When it happened, he was five years old. All he knew was what the adults were telling him. It was not as though he sat and watched. That would have been a horrible thing to watch. But that was not what happened.

For the whole family, this was the first death in this particular generation. So there was a lot of grief and I felt that hard. I got dragged to the funeral parlor and it was my first real encounter with death. It was very intense. All of a sudden, as a little kid, I saw all these adults I'd never seen before. Besides all the aunts and uncles who were in one place at one time. Everybody was there. It was traumatizing. I remember that. The thing that I think had the biggest effect on me and that probably got me into nine-to-five-type jobs for the rest of my life was that all of a sudden my mom said, "You're the man in the family." I hated that. Soon as she said that, I said, "Why me? What am I supposed to do? Can I drive a car? Can I have a job?" I was ten years old. And I'd had absolutely no responsibilities up until that point. I didn't even know how to comb my own hair till I was eleven. My childhood ended right there. Definitely. But not Jerry. Jerry was coddled totally and he got everything he wanted from my mom until he left home and went into the Army.

After my dad drowned, my mom started trying to be mom and dad. That was laid on her. She wasn't trying to do it but it was automatically laid on her. But I had an aunt and uncle that lived up the street. I had two aunts and uncles who lived within half a mile of our house. My grandmother was half a mile away in the other direction. So we went from one aunt and uncle to the other. Then we went back to my grandmother's house to live while my mother maintained the bar business. After my dad died, things all happened.

laird grant: Where Grandma lived was Eighty-seven Harrington Street. Where Jerry had lived was First and Harrison. It was not the same neighborhood. One of them was way down on the docks and the other one was in the middle of the Mission District. In the Excelsior District was where his grandmother was. Between Mission and Alemany. Jerry lived with his grandmom for a lot of the time. Later on, I actually ended up moving into the house and I lived there for a while as well. A bunch of us did. Tillie was great. Tillie really liked Jerry a whole bunch. She was a typical grandmother. A very stern kind of a lady but with a twinkle in her eye. God, she must have been a mischievous woman when she was younger. She was really a character. She helped organize the laundry workers union and she was kind of a radical for her time. For a woman back then, this was not a heard-of thing. Harrington Street was kind of Jerry's psychic home and his stomping grounds, too. Balboa High was just across the way and all of his old running partners were over in that area.

clifford "tiff" garcia: My mom wanted to move a lot so we moved a lot. Four or five times in three or four years. One of the reasons was the bar business. She kept wanting to get another house in the country. She wanted to go to the Russian River. Most of the time, she would get home in time to make us dinner. When we were living with my grandmother, my mom didn't cook at all. My mom went down and she worked from six in the morning to one at night. Late, long hours. At night when we were staying at my grandmother's before we got the TV, we'd sit around the kitchen table and listen to the radio. My grandfather would sit there with the paper and listen to fights with his beer and we'd draw on these laundry sheets that had all this stuff written on them. On the other side, there was nothing and they were pretty thick. We'd both draw. Sometimes, Jerry would take mine and start drawing on it and I'd

take his and start drawing on it. He had more of a knack for it than I did or he was at least as good as me even though he was four years younger. He did come out with some good stuff. He was creative. He always had that creative passion.

He was pretty social. If there were kids to play with, he'd be out playing rather than sit at home. If there was activity in the street, he was in it. He wouldn't sit around or get into his own stuff. He wasn't like that. He never got into fights. He had a pretty normal childhood. Definitely middle-class. Definitely normal. The Little Rascals were no different than us except they looked a little more tattered than we did. Any of those pictures I have of us from the fifties compare with the Little Rascals.

When we moved down to Menlo Park, my mom had to work until six P.M. At first she stayed home to be a housewife and didn't work at all. My stepfather, Wally Matusiewicz, took care of the bar business, and my mom did nothing but be a homemaker. She even made her own clothes. Everything new. She went down to Montgomery Ward and bought everything new for the brand new house and brand new neighborhood. Everything brand new. We almost went down there naked. We didn't bring anything from my grandmother's house. She just wanted to start over. A new life. Her dream then was the housewife dream. And she did it.

marshall leicester: Jerry and I first met and discovered that we liked each other in grade school in Menlo Park. We were kids and I can remember us riding bikes together. I remember him as being a distinctive and sort of shaped individual from when we were nine and ten. There weren't many kids around like that. I was a young intellectual and uncomfortable with it. I was going to Catholic school at the time and there was definitely no room for that kind of thing. Garcia was a guy who liked to talk that way too even then. He'd picked it up. I don't know where.

clifford "tiff" garcia: When I was sixteen, I was dragged out of the city to go to Menlo Park. I had nobody down there. I knew nobody except for my next-door neighbor. In the city, I was going to go to Balboa High. Now I had to start high school down there. Then it got to the point where my mom was working again. They needed the money. They had to drive Cadillacs and all this shit. Plus, Wally was a merchant marine. He'd be gone for two months at a time.

I finally got a driver's license so Jerry and I would hop in the car and go to the city and see our friends. My stepfather was working in the bar, my mom was working with him, and Jerry and I would take whatever car was there. We'd hot wire a car and I'd take him to the city and drop him off at his friend's house and I'd run around and show off whatever car I was driving to my friends and party for a while and then I'd haul him back down there. Then I went into the Marines. I enlisted because I had to get out of the house. I was seventeen and my stepfather and my mom used to argue a lot.

laird grant: Jerry's dad had died. His mother was with a man by the name of Wally Matusiewicz. Wally was kind of a stevedore. A seaman. He was a real rough-and-tumble guy but she really loved him. Because even though she was a nurse, she was kind of rough-and-tumble herself. That was why she liked running that bar for seamen down at First and Harrison. She was always very nice to me. She and I got along wonderful. I was one of the kids that she really liked having around because if there was a leaky faucet or something that needed to be done, I could do that stuff. In that way, I took up Jerry's slack. It never seemed like there was a closeness there like I had with my mom. But I saw a bond. It wasn't like she was abusing him or beating him or anything like that. It was almost kind of a loving indifference. It was like, "Go ahead and do your thing. Just don't get into trouble and don't bother me." I guess there was some conflict with the new husband. I was a kid so I didn't really look at that aspect, although I saw a certain amount of tension between Wally and Jer. But I had the same things with my stepdad so I figured that was just family stuff. The old man saying, "Oh you lazy bum, why don't you do something?" "I'm busy doing nothing right now. Thank you very much. I don't want to be busy doing something else that you want me to do."

clifford "tiff" garcia: Jerry was fourteen, fifteen. He could do what he wanted in the city with all people he knew before we moved. I think the kids I associated with were more on the hoodlum level. Partying dudes in Hagars, peg pants, and one-button rolls. At that time, Jerry was like a Richie and I was a Fonzie. Everyone I knew was a Fonzie. Everyone he knew was a Richie. Once he got to know Laird? Fonzie.

9

3

laird grant: When I was in the seventh grade, he was in the eighth. He stayed back a whole year. This was at Menlo Oaks School in Menlo Park, California. It was a semi-middle-class neighborhood. He'd moved down from San Francisco. His mom had decided to get him out of the city and they found this place. He'd already been in the seventh grade and to the eighth and he had failed to do anything for a whole year. In a way, I guess he just shut down. It was so different from the city. Jerry was a very intelligent and precocious kind of a person even at that age and the teachers knew it and he could get their goat. Because they knew that he was so damned intelligent yet he refused to do anything. So they had to fail him.

I also came from San Francisco. I grew up in the Mission District. I left when I was ten. The change from the city, the difference in the interaction ... after coming from the streets of San Francisco, Menlo Park was like country bumpkins. Basically, Jerry ignored them and in doing so of course isolated himself. I met him during hazing. All of a sudden, a couple of other guys and Jerry grabbed me. I wasn't that big a kid. He was bigger than I was and here was Jerry sitting on my chest smearing me with lipstick and shaving cream while another guy was trying to get my pants off. That was how I first met Jerry. Looking up at this fat kid. He was always chubby. He had his hair in a burr cut so he was kind of pinheaded.

He and I just started hanging out together. As kids, we were always throwing spiders, frogs, and worms on each other. We'd get into a little mischief because I was kind of an outsider too. I didn't go along with the straight crowd. We knew about the beatniks and we knew about the Hell's Angels and were fascinated by both of these cultures. We'd see the bikers around, the Hell's Angels coming up from San Jose, or read about the runs that would happen in Monterey. The movie *The Wild One* with

Brando came out in '53, I think, and that was incredible. At that point, all of us wanted to wear leather jackets and ride Harleys.

Even though we were in the seventh grade, Jerry and I realized that we were surrounded by straight geeks. We knew we were different. Jerry was a prankster and so was I. We both saw that sparkle in each other's eyes and said, "Ah! Kindred souls." If we were back-to-back, better not try and fuck with us. We were bad boys. We were. We wouldn't look for trouble. But when we walked down the street a lot of times, people would just move.

At the time, he was playing saxophone. Nine-and-a-half-fingered saxophone. He was also playing piano and he was taking guitar lessons. I remember going by his place sometimes on this cul-de-sac where he lived maybe half a mile from my place. I'd go, "Hey man, let's go out and screw around," and he'd go, "I can't. I'm taking guitar lessons, man." I told him back then. I said, "Hey man, you know what? You're going to be a fucking rich famous rock 'n' roll star someday." And he was going, "No, man. You're the guy who's going to be rich and famous. You're always working, you always have money. You always got these little hustles going." When I was in high school, I had three different gigs.

I didn't see Tiff very often. I think he was in the service at the time. Tiff would show up occasionally. He had a bedroom there at the place.

clifford "tiff" garcia: I went to San Diego for boot camp and at that time it was brutal because all the drill instructors, the DIs, were Korean War vets. Bitter. Cream of the crop bitter. And they ran us through all kinds of shit. But their job was to do that. I never wore my uniform at home except once when my mom had to take some damn pictures.

laird grant: I got Jerry a job one time. We worked picking apricots in the fields down in Santa Clara. We didn't do too good at that so the guy put us on the cutting trays and of course we sliced ourselves up pretty good trying to cut apricots and put them on the trays. We also picked beans. We worked for about a week in the fields there. I liked it because I had learned a little bit of Spanish and I was somewhat interested in the Spanish culture. After a week of doing that, Jerry went back and said, "Bullshit. Enough of this stuff, man. This is too weird."

clifford "tiff" garcia: When I was in the service, I'd been smoking some pot down in San Diego. I'd gone into Mexico and I had pot. I came home and Jerry was wondering if I'd ever smoked any pot. I didn't have the heart to tell him that the last time I was up there, I was in jail because I had brought some pot in my car. I'd gotten in an accident and they towed away my car and I was afraid to go into it because I had this stash under the seat. They found it and they called up the bar where Wally was working at the time and they said, "We've got your son's car. You want to come down to the station and talk about this?" He paid a thousand dollars and they let it go. It was funny because he said, "Yeah, I used to smoke pot years ago and it's better than alcohol any day." Wally was an ex-alcoholic. "But they'll never legalize it." He was afraid I'd get court-martialed. And he was sheltering it from my mom. If my mom found out, she would have been in total hysterics. Definitely. She would have fucking blown it. But he was real cool. If something like this happened now, I'd be in jail for like ten, fifteen years. For just possessing that big an amount.

When Jerry asked me if I'd smoked pot, I told him I did. And he said, "That's cool. Let's have some." I remember my grandmother had this matchbook collection. She'd travel around and every time she was at a conference or something, she'd bring home these matchbooks as souvenirs. She kept them in a little place and they were steadily going down. Jerry was using the matches. I knew he'd been smoking pot all along because all these matches had gone. He was also smoking cigarettes. But you don't use too many matches with cigarettes.

laird grant: Jerry and I started smoking pot in ninth grade. It was really hard to get a hold of. It was rolled in two Zig-Zag brown wheatstraw papers with a very thin liner. In those days, we bought joints. That was all we could get. We couldn't even get a matchbox. Nobody would trust us enough to sell us a matchbox. A matchbox was a lot of dope back then. If you cleaned it up, you'd probably get fifteen joints out of a matchbox. Skinny pinners. We'd pay fifty cents apiece for them. Three for a dollar.

Then Jerry went back to San Francisco. He started going to Balboa High and I continued on in Menlo Park at Menlo-Atherton High School. He and I were always going to the Russian River together up to some place his mom had. Later on when I had wheels, we'd take off for the

weekend and go up there and bring girls up there to the cabin. Actually, moving back to San Francisco was a great change for him because he was able to get back into the city beat. He spent a lot more time at the California School of Fine Arts with Wally Hedrick doing his art stuff and music stuff. We'd see each other maybe a couple of times a month. He wasn't into any kind of criminal activities other than just being a general rowdy to a certain degree but not a violent guy. He and I would practice with our switchblades and our choke chains up on the roof.

We would also get pills from various street gangs and people that Jerry knew in the city. I'd show up for a weekend trip and he'd open a bag and go, "Well, man, we've got a bunch of candy." And he'd have about fifteen different kinds of colored pills. If there were two of each kind, we'd separate them out. We didn't even know what they were. We'd just separate them out to get equal piles and then we'd drop five or six pills each. These were unknown substances. Ups and downs and sideways and tranks. We'd drop all of that and then go out and go tripping around San Francisco. We'd go out and get silly and do weird little pranks.

I remember one great Halloween Night at the California School of Fine Arts. I'd made this weird costume out of bedsheets that had been cut into strips and sewn on to a shirt collar. It went all the way to my feet. I had a weird rag thing over my head and full eyes like a bug. Jerry dressed up as Dracula in a completely immaculate suit with the black and red cape. He had on facial paint and the spike teeth. We dropped a whole bunch of different kinds of pills we'd been saving.

Jerry used to clean the bar for his mom. That was one of his gigs. He'd bus up the bar on Harrison Street during the morning before she opened. So we'd managed to save like half a bottle of vodka but there were all these other drainage things in it. Whenever there was a little bit left in the bottom of a bottle, we'd just drain it all into one bottle. There was rye and whiskey and vodka and rum and God knows what else. I was drinking on that and Jerry took a few swigs but he didn't really ever like to drink.

In those days, they still had the streetcars. We walked down to Market Street and took the streetcar and went up to Powell and then got on the cable car and rode over into North Beach to go to this party and we were goofing on people the whole time. Freaking out, jumping off the cable car, running around, acting silly. Doing kid stuff on Halloween. We were sixteen. Then this big limo pulled up in front of the California School of Fine Arts. This chick got out in this fur coat and left it there. She was

totally stark naked with a raisin in her navel. She came as a cookie. She was one of the art student models who modeled in the nude all the time. To her, it was nothing at all. But in '56 or '57, it was quite unusual.

clifford "tiff" garcia: When I came out of the Marines, I remember I spent a month trying to talk Jerry out of going into the Army. I was home to visit him and he was staying at my grandmother's, getting high with his buddies and going to Balboa High. Next time I went home, I was out of the service. All of a sudden, he was living up in Cazadero and going to another school. He was in his last year of high school. He would have graduated. He was only seventeen. I said, "Jerry, think about it. You shouldn't do it. Finish school." I told him, "Shit, you don't have too much more school. Finish it. Just get it out of the fuckin' way." I hated to see him that close to being out of school and not finishing. He listened to some things I said. With my mom, he wasn't totally disobedient or anything like that. But after my dad died, she was the authority figure. Definitely. She cracked down. She was heavy.

laird grant: A bunch of weird stuff went down between Jerry and his family. He was seventeen going on eighteen but not really all that interested in going to school. So he moved to Redwood City to live with his girlfriend and her parents. That worked for a while. At that point, he decided to join the Army. He was down at Fort Ord so I was going down on the weekends and picking him up. I thought his joining the Army was pretty radical. He said, "Hey man, it got me out to where I could legally be away from home." In those days, you couldn't just leave. I'd also left home when I was seventeen. I had my own apartment and was working and going to high school. I'd pick him up at the Army base and we'd cruise around. I had a '47 Cadillac convertible we partied in. In terms of playing music, he was just kind of plinking around. When he was in the Army, he met the Kingston Trio. They were in the Army at the same time and they were playing at the Officers Club so he hung out with them a little bit and got into playing with them. A little taste, I guess. This was probably before they were the Kingston Trio. They were all just in the service together.

clifford "tiff" garcia: While he was in the Army, I'd see him now and then when he'd come by and ask for some money or when

he came by my grandmother's house. He wasn't really AWOL for long. He was just AWOL so frequently that they said to him, "Enough." He told me he apologized. Every time he'd screw up in the Army, he'd say, "Oh, I'm sorry. I didn't mean that." And he just kept screwing up. I don't think his record was all that severe. Not enough for us to know about it. It was like a hardship discharge. I was surprised he stayed in as long as he did. I really was.

alan trist: What he told me in '61 was that he was down in Monterey at Fort Ord and that his job was driving the missile trucks. There he was, driving around the means of destruction on his back. It wasn't so much that which upset him about the Army. It was the authoritarianism of it all. He said, "I couldn't handle that for very long." It was typical Jerry that he was able to get himself out of the Army by just being really smart. He'd go AWOL and come up to San Francisco and hang out with Laird. When I first met Jerry in '60, he may have still been on the tail end of that. I saw him for so many days in a row sometimes that his AWOLs must have been quite extensive.

suzy wood: Jerry told us stories about being in the Army. He said, "I didn't do anything in the Army. I didn't do anything at all. But I was very nice about it." He told us about leaving his tank out in the middle of a field. They'd say, "You left this tank out in the middle of a field." And he'd say, "Oh, did I? Oh, I'm sorry." He'd be off on leave for the weekend and wouldn't come back and he'd say, "Oh, I'm sorry." Finally they said, "Maybe you'd like to leave?" And he said, "Oh, okay."

alan trist: That sounds about right. He always did everything with a big grin and he always put people off the defensive by being that way. It was, "What are we gonna do with this guy?" and they realized he was not the type to be in the Army and that was what Jerry's strategy was. He knew that he and the Army were not suited to each other. From his perspective, it was just a question of making a cool exit.

laird grant: He got busted out of the Army because they could not deal with him. He was like the prodigal son gone awry. It was just one thing going on after another.

15

4

laird grant: The whole thing in Palo Alto was happening. He was out of the Army, he was hanging out at Kepler's Bookstore, and he was staying with me in this apartment over in East Palo Alto while I was trying to go to Ravenswood High School which no longer exists because they burned it down. And there were all these parties going on up on Perry Lane and Homer Lane and at the Chateau. This was all before our eighteenth birthday. He was eighteen by now but I wasn't yet.

alan trist: Roy Kepler had created one of the first paperback bookstores. They would let us sit there all day and read the books off the shelves and even take them home and bring them back. So we had literature and we had a place to hang out and there was coffee and they didn't mind if Jerry played the guitar all day. Which was what he did. We were Bohemians.

david nelson: The atmosphere was beatnik. It was a literary crowd based on books and writers. Music was just starting to happen. It was a coffeehouse scene. You sat around and discussed things.

barbara meier: I was a sophomore in high school in Menlo Park and my friend Sue Wade and I were going for a hike after school and she said, "Oh, I just met this guy and I want to stop and pick him up. Is that okay with you?" I said, "Sure." We went to the Skylight Art Supply store and he was waiting on the porch and she went up and said, "I brought a friend with me. Is that okay with you?" He looked in the car and said, "Oh yes. Tell her I love her." Those were his first words to me. I was fifteen at the time and he was three years older.

So he got in the car and we drove up to the Mill Pond in Los Trancos Woods, a very beautiful, magical place. We walked around and on the

way back, he sat in the backseat and sang Joan Baez songs to me and it was the most exotic, seductive, dangerous—I mean he was the archetypal beatnik with his goatee and black hair—singing these songs and looking up from under those eyebrows. When I was fourteen, right before I went to high school, I had read *On the Road*. I'd read it and fallen in love with that world and somehow connected on a very deep level with the whole Kerouac/Buddhist vision and beat poetry. I got it and then when I met Jerry, he embodied and manifested that world for me and apparently I did the same for him.

That was the spring of 1960. We met in April or May so it was really just a question of weeks since he had gotten out of the Army. He was living in his car in East Palo Alto and Robert Hunter was living in his car. What then ensued was this whole long period where we all sort of functioned as a tribe. There were all these different people with different roles but we were this wonderful collection of poets, musicians, painters, writers, socialists, and pacifists, with a smattering of out-and-out lunatics.

alan trist: It was art that interested us. A large part of our conversation was based upon what we had been reading. Or it was Jerry learning those folk songs. Or it was Hunter writing in this journal. Or it was John the Poet who had an incredible collection of classical music. We would go over and spend whole evenings listening to Bach. Endless Bach. In early 1961, the then organist at the Vatican came to Grace Cathedral in San Francisco for a series of fourteen concerts where he played the complete organ works of Bach. I remember going with Jerry to three or four of those. It was incredible. It was in the middle of a period when we were doing that young person's thing of seeing how many nights we could stay awake for and I remember having a very psychedelic experience. Grace Cathedral is made of concrete. Looking up at the vaulted roof, I saw all the different patches of dark and light concrete turn into faces. The faces were very clear. D. H. Lawrence was the one that stays in my mind. In the middle of Bach, I was having this conversation with D. H. Lawrence.

barbara meier: I spent a lot of time hanging out with Bob Hunter, Jerry, and Alan Trist. I was going to this affluent suburban high school and they would pick me up after school and we'd just go rave, the four of us. We'd drive up into the mountains or go over to the beach or

go to St. Michael's Alley or to Kepler's Bookstore and hang out or go to somebody's house or over to East Palo Alto where there was a big jazz scene with black jazz musicians. We were all smoking cigarettes and drinking wine and Hunter was into Dylan Thomas. The scene was always extremely literary. Jerry was already an incredible intellect, very well read, and he had lots of literary references. He'd tuned in to James Joyce's *Finnegans Wake* at a very early age and that was a powerful reference point for him. The book is fundamentally a psychedelic vision of reality and he got it. He got that long before he took psychedelics. We'd all just scratched the surface with that book but he and Hunter would riff on it and there were always running gags about it between them. Very early on, Jerry got the essential random nature of the art that James Joyce and John Cage represented. Before I met him, he had connected with the scene at the San Francisco Art Institute. He had connected with action painting, abstract expressionism, and the jazz underpinnings of it all. The whole mix of Kerouac, Joyce, painting, poetry, and jazz. That vision was really surfacing strongly in the late fifties and the early sixties and was a formative and perennial reference point for him.

Jerry could have easily passed himself off as an intellectual but because he was a high school dropout, he had no self-esteem. He didn't have what he considered to be the required academic foundation, but he always got the essential meaning of whatever he encountered and he could hold his own. The thing I loved about being with him was being considered an equal on that level and being able to riff back and forth with the puns and literary references. I loved to play in that world. It was very heady and it was also fucking hilarious. I have never laughed so hard in my life.

clifford "tiff" garcia: All his friends were now in Palo Alto. That was his group. I tried to find him a couple of times. Finally, a friend of mine who owned a gas station down there said that he'd seen him. So I went and I found his old car. While he was in the service, he had to go buy this car and I had to sign for it. So I went down and that was the last time I actually saw him for about a year and a half.

barbara meier: Because I was much younger, the three of them treated me with kid gloves and protected me. I was their darling on some level. I was their muse on some other level. They put me in a role which was incomprehensible sometimes. I was like their kid. At the age of fif-

teen, I wrote my first poem and it was about the three of them. The first part is about Jerry and then Alan Trist and then Bob Hunter. The blind man is Bob because he wore glasses.

> *He speaks of angels and snowy hillsides*
> *But I am in rapture of the thing*
> *where we are all in love*
> *with life and each other*

> *Never before and perhaps again*
> *will it be so*
> *with such youthful vigor*
> *and wild eyes*

> *He who creates such magical music*
> *radiates it upon us*
> *The one of poetic words*
> *encourages*
> *and overwhelms us with faith*

> *The blind man in the corner sees all*
> *even though he believes not in himself today*
> *and I, follower of each,*
> *cry beautiful tears of joy*

"He speaks of angels and snowy hillsides"; that's the poet, Kenneth Patchen. We were reading Patchen. Patchen was there in Menlo Park and we would go and visit him. We were such a motley group of people, but we were all there for each other in a way that now feels like the seed of what eventually became the Dead scene. It was a beautiful little green shoot coming up through the concrete of fifties consciousness and we were taking our cues from the beat culture and from the pacifist culture.

laird grant: These people were the upper crust Bohemians of Stanford University. Their parents were professors or something like that.

Frank Seratone was a San Francisco artist who'd happened to make it fairly good and moved to Palo Alto and he had the Chateau. He rented out some rooms and we soon took it over. It was groovy and he didn't mind the parties. It was a rambling house with a porch. Built probably turn of the century. Maybe in the twenties. And it had all kinds of weird little alcoves and stairs that went upstairs and downstairs and gardening rooms and a pump house. Because there was no water in those days except what you got from your own well. Jerry moved into the pump house.

tom constanten: There was one rather large party type of house called the Chateau at 838 Santa Cruz Avenue. Jerry's place there was a pleasant one-room shack with a big thick Persian carpet on the floor and hippie-type lighting. I remember one party when I was out there with him and about twelve other friends and I counted eleven joints in a row that were trotted out by one person or another. It was just mind surfing.

laird grant: Alan Trist was living right around the corner. He was halfway between the Chateau and Kesey's. Right on the corner in this Spanish-style house that his dad had gotten when they came from England.

alan trist: Kesey may have finished the writing program at Stanford, but he was still hanging out in that area and he had a lot of parties in his little cabin back there on Perry Lane, which backed on to my house. We knew this was going on but we hadn't met any of these people. One night, Jerry and Hunter and maybe Laird and I decided to crash one of these parties and I remember we were thrown out on our ear. It was so funny, man. Because we were kids. The real connection didn't happen until many years later in La Honda. Still, we managed to make some sort of rebellious reputation for ourselves at an early age. Sometimes, we were walking around stoned. I remember at one point, we managed to buy a lid of grass for five or ten bucks which actually came in a matchbox in those days. Because my parents were away, we all went out to my house to smoke this lid. Jerry, Bobby Petersen, Laird, Hunter, Phil Lesh, Willie Legate. I forget who else but we smoked up this lid and we got very stoned because we were young people whose systems were quite open. And we designed this fantasy of how we would like to be, where we

would like to take all this beat stuff and the art, and where we would like to go with it. We designed an ideal habitation which was very influenced by the Chateau. We took the Chateau as a model and expanded it. We said, "What we need is a large central house with a kitchen with a refrigerator full of beer." Which is what old Frank had there. It was his beer. We weren't allowed to touch it, actually. We all would have our individual cabins spread around these large grounds. We imagined acreage. Then we would have the ability to get on with our own things because we were aware that this one was a musician and he was a writer and someone else was a painter. We wanted to come together but we wanted to have our privacy, too. I've never forgotten that particular session because it was a model. The dream of the hippie commune. But right then we had already taken care of the problems which communes would have. Which was the lack of ability to get away from it. We designed it right from the beginning so that wouldn't happen.

barbara meier: My parents were alcoholics. I had a lot of trouble with them. I was really bummed about this and Jerry once went and got one of those little books of Buddhist sayings and came back and read it aloud to me and I got it. I'd previously read in Kerouac about Buddhism but Jerry brought it home to me and made it more alive for me. Even now I have the sense of him as being an incorrigible Buddha. Because I was having a difficult time living with my parents, I moved to San Francisco at the age of sixteen to live with my aunt for the summer. I went to the Art Institute and that was also Jerry's trip. He was the one who said, "You have to go there. This is what you need to do. Go there." He pointed me in that direction. Jerry used to say that he and I invented each other. In the sense that I gave him his first acoustic guitar and he steered me toward Buddhism and painting, it's true.

laird grant: Me and this kid got drunk and decided to take a car from Monterey to the highway so that we could hitchhike to Mexico, but we never managed to get out of town. They'd busted me before I was eighteen so I went into Juvie. When I was in Juvie, Jerry got into that horrible automobile accident. I was in the Salinas Boys Home when that happened. Some people at Juvie got in touch with me because Paul Speegle was a friend of mine. He'd been in school with me and Jerry both at Menlo Oaks.

alan trist: There was Jerry and I and Paul Speegle and Lee, the driver, in the car. Paul was somebody that I had just met and he was tremendously important in our scene. Talk about living theater or street theater. This was a guy with long hair who wore amazing clothes. He made jewelry and incredible paintings, one of which, "The Blind Prophet," used to hang in the Dead's studio in the eighties. He was our age and he did all this stuff and he was a theatrical person and he was really living out what we were raving about verbally. He was more extreme than us.

laird grant: They were coming back from a party and Lee, who was driving, was saying, "Oh well, we got to get to such and such at a certain time." More than likely, it was to another bottle shop.

alan trist: That evening, we'd played a game of charades at the Chateau. I remember Jerry opposed Paul and me. Paul was dressed up in a big cloak and so was I. We were putting on costumes now. We had never done this sort of stuff until Paul turned up. Paul and I and Jerry were playing a game of death. And then we took off to take Paul home. It was Paul and me in the back and Jerry was in the front seat. Lee, as always, had drunk a little too much, as we all had, and the car went off the road. It was a Studebaker Hawk, a car way ahead of its time with two doors, but it didn't have seat belts in there.

laird grant: Lee had this Studebaker Golden Hawk and he brought it on up to— They were doing well over a hundred. The last words that anybody can remember was Paul saying, "Wow, this is really beautiful," and over she went.

alan trist: Before it happened, we were going a hundred. Easy. I felt the car fishtail. Then we rolled and cartwheeled into a field. All four of us were thrown out of the car. Those in the back seats went through the front doors. Paul was unlucky. Unfortunately, the car got Paul and not the rest of us. Jerry broke his collarbone. All his life he had problems with it. It was interesting how he held that guitar. I had a compressed fracture of the back, which has always troubled me but not too extremely. The way we talked about it wasn't so much like "I got away with it" or "I was spared." It was more, "Look what happened to Paul." This gem

of a person. Why was he gone from our lives? That was the significance of this. Hunter was right in on this, too. He'd left the party about the same time in his old car, the ambulance passed him on the road, and he sensed it was to do with us. There was a psychic concentration that evening. This was when we were all coming into adult life. It had a profound effect on Jerry. It made him aware of life's fragility. Of how things could be taken away.

laird grant: Paul was the only one killed. But they all got thrown out. Alan got his back crunched. Jerry broke his shoulder, I think. Lee got his gut sliced open on the door when he went out of it. The car landed on top of Paul. Broke every bone in his body except his hands. Prophetic stuff here, you know?

5

barbara meier: That summer, John the Cool and Jerry and someone else lived in a hotel room on McAllister Street in San Francisco. I was working as a model for Joseph Magnin so I used to go hang out with them and give them money. Rent money, food money, cigarette money. That was a crazy scene. A lot of raving around San Francisco. I moved back to Menlo Park to do my junior year in high school and they moved back too. Sometime in October of that year, I was at a party at the Chateau and there were these girls in the kitchen where Jerry was playing and they were dancing around and saying, "We love Jerry Garcia!" I went up to Hunter and just burst into tears. I said, "I can't stand that. I'm in love with him." He said, "You are? He's in love with you and he's been afraid to tell you all this time because he didn't want to spoil everything." He went up and he said, "Jerry, come here. I've got to talk to you." Jerry said, "Are you kidding me? Are you telling me the truth?" Jerry came up to me and said, "I've been in love with you from the minute I met you." That was it. That was it. *That was it!* I can't remember anything after that. That was the end of my virginity.

peter albin: My older brother Rodney and I went down to Kepler's Bookstore in Palo Alto to get Jerry. We had heard about the scene down there. Kepler's was a much larger, college-oriented bookstore. It had a lot of textbooks, but it also had all sorts of Marxist magazines. It was definitely a leftist bookstore. There were a lot of radicals like Ira Sandperl in Palo Alto. There weren't any radicals in Belmont and San Carlos, where we had gone to Carlmont High School with David Nelson. Kepler's had a back room. If I remember correctly, the room was divided. One half had books about halfway up the wall. Then it had this area that had tables, chairs, and a coffee machine. It wasn't a coffeehouse. It was

just a reading area but some people like Garcia had taken it over and started bringing their instruments and playing.

david nelson: There he was. This hairy guy in the summer playing a Stella twelve-string.

peter albin: I remember sitting around listening to Garcia play. He was playing Appalachian ballads and "Sitting on Top of the World." Not too many blues things. Mostly old American folk songs. He was real good and we got the definite impression that he knew that he was real good. When we asked him to come up to play the Boar's Head in San Carlos, it was like, "Why should I?" I don't know if he said those exact words but the attitude was like, "What's in it for me?"

tom constanten: He looked like Cesar Romero and he sounded like the Limelighters. It was before the Prince Valiant look. And he sang songs like "Long Black Veil" and "Fennario." At one of those wild party scenes, he did a version of "Mattie Groves" that silenced the party in awestruck wonder. He played songs like you would have found on the first couple of Joan Baez albums.

marshall leicester: In the summer of 1960, I came back from college and I walked into Kepler's and saw this guy playing a twelve-string guitar. What I remember hearing is that song "Everybody Loves Saturday Night." In general, the picking in those days was sort of somewhere between Pete Seeger and the Kingston Trio. I asked to see his guitar and struck up a conversation and we discovered that we remembered each other from grade school in Menlo Park. I knew how to do a kind of Elizabeth Cotton pick that was a technical challenge to him. Once I showed him how to do it, he picked it up in nothing flat. We weren't much in touch when we were three thousand miles apart but each summer, we'd immediately sort of take up where we'd left off.

peter albin: The Boar's Head was no bigger than fifteen by twenty. People would gather on Friday and Saturday nights. We had a little stage with maybe a foot-high riser tucked in the corner. The place could hold no more than twenty-five people, but it was packed. It had

chairs and tables and sometimes people would sit on the floor. It was an open-mike scene: two, three songs, pass the hat. Wasn't hardly any money. I don't think that Garcia was making any money at Kepler's Bookstore either. We said to him, "You can have a lot of fun and there's lots of young girls there. It's a neat place. It's small but there's a dedicated audience."

suzy wood: It seems to me there were a lot of women who would have liked very much to sleep with Jerry. I remember him looking into their eyes and saying, "Ho ho, I have a feeling I'll see you again sometime." Of course, people were having sex before marriage back then. It was just that nobody ever admitted it. That was the whole point. One of Jerry's earlier girlfriends had this straight merchant father. Her parents were terribly respectable and she had to be terribly respectable and it would have been horrible bringing Jerry over to meet her mother because her mother would have just died.

peter albin: If I remember correctly, there weren't a lot of people sitting around watching Garcia at Kepler's. So he came up. He would come up every once in a while. It wasn't like he was up there every weekend.

suzy wood: I remember the first time I played in public. I got through doing this sappy little set and Jerry said, "You're going to be great. You've got that old fuck-you attitude." When I play that one back, that was what Jerry had at the Boar's Head. It wasn't quite fuck-you. It was really being scared inside but also real confident at the same time. He had an air of intensity and professionalism, dedication, and concentration that was just more focused and intense than the other people who played there.

marshall leicester: He lived at my house for two or three weeks and we spent all our time together until my mother got upset. "Who is this freeloader?" she asked and I had to pass this on to Garcia. He was no problem at all but it was just too unconventional for them.

barbara meier: We had this exquisite time together until my father found out that I had in fact lost my virginity. I was living at home

26

and things were just crazy. You couldn't run off with the Grateful Dead in those years. Girls who got pregnant in the early sixties ended up in homes for unwed mothers. My father wore me down with his disapproval and made it absolutely impossible for me. For over a year, I had to have goofy guys from high school pick me up on "dates" and drop me off to see Jerry. We'd go to bed and then I'd have to go home at midnight. Ultimately, everything got way too crazy and Jerry and I broke up.

We had planned to get married when I turned eighteen and he turned twenty-one. All I ever wanted in my life was to paint and be a happy beatnik with Jerry Garcia. I would have been ecstatic if he had been playing in bars in San Jose and we had been living in a trailer court. It was about the fabulous way our minds interacted. I finally left him and he drank himself silly for three months. I guess I totally broke his heart. I was just a kid. It wasn't as if he'd said, "Come live with me, baby. I'll take care of you." I was taking care of him financially.

It was horrible. By the time I realized, "Fuck it. Fuck my father. Fuck all of it. Fuck college. I want to be with this man," it was too late. He'd already gotten Sara pregnant. So that was the end of that. I left town and went to the Art Institute, got my degree, and became a student of Suzuki Roshi's at the Zen Center in San Francisco.

sara ruppenthal garcia: It was funny. He was there all the time and I was there all the time but we didn't meet for a long time. Our paths were crossing. Ira Sandperl was my mentor. I was a pacifist and a folk singer and a student at Stanford, hanging around with Ira a lot. I first saw Jerry at Kepler's. I remember it very well. It was evening. He was there with Hunter and Nelson. I met the three of them all together. They were playing music. There were some tables and a little coffee bar. I would help Ira run the coffee bar sometimes and sit around with Joan Baez when she was in town—a lot of sitting around and drawing on napkins with our Rapidographs, a drawing pen you had to hold absolutely straight up to get the ink to come out. One night, these guys were there. After they played, Jer came to the coffee bar for coffee. I was eating a tangerine and I gave him some. We looked into each other's eyes and smiled and I picked him. He was clearly the leader.

They were hanging out there and we all started hanging out together. They cracked me up. They were just so terribly clever. Witty, zany, and

smart. A lot of the people I knew in college didn't seem nearly so smart. I had also never known people my own age who were disconnected from their families. But Hunter and Jer lived up at the Chateau with this strange crew of what seemed to me like the Lost Boys. I'd heard about them before. When I was in high school, I'd heard there was something going on up in La Honda and something going on at this place called the Chateau. Whatever it was, my mother wouldn't let me go. Instead, I would go up to San Francisco on the bus or on a train and hang out in North Beach, looking for the beatnik scene. We were all looking for it, wanting to be part of that.

laird grant: He was doing stuff with Sara and Hunter and Nelson at the Boar's Head but also at the Palo Alto Peace Center. That was when we all got our names on the attorney general's list for belonging to a subversive organization. The Peace Center. Obviously, if you were for peace, you were a Red in those days. I could never understand that. I still chuckle at it.

sara ruppenthal garcia: I think Jerry and I started singing together right away. We knew a couple of songs in common. They were playing bluegrass in Kepler's and they were so good. They were so incredibly good. Then I learned from him about old-timey music. I'd been studying the Childe Ballads and the Folkways collections and wishing I had gone to a different school and studied folk art. I was living on campus and hating it. So this was exactly what I was looking for. I think I went home with them that first night. I had my roommate's car, her little Mercury convertible, so I drove them home. Which was pretty classy. None of them had cars. In those days, it was dormitory sign-outs and strict rules as to when you had to be back in at night. One of those early nights together, I called my roommate on the hall phone and got her to sign me in. But somebody overheard it happening and the school sent out an all-points bulletin. The California Highway Patrol found me by morning. They actually came to the Chateau to get me and escorted me home. They said, "We know you haven't done anything wrong but your parents are worried."

As a pacifist and a folk singer, I guess I had been a little weird at Palo Alto High School. Joan Baez had gone there but she had graduated the year before I started. I hadn't known her there but some of my friends

knew her and her family from the Peninsula School. Jerry didn't like her. He was jealous of her because her record had just come out. She was about to go on her first European tour and had asked me to come with her and be her companion because I'd been to Europe a lot and I knew how to travel there. She didn't know her way around. This was right when I met Jerry. So I had to make a choice between them. He didn't like her because she wasn't a musical purist and he didn't think she played very well. It just didn't seem right that she should be on the cover of *Time* magazine and getting all this publicity. She had a record that was becoming successful and it just didn't seem right. He said, "Ah, she picks her nose." Like you had to be perfect in order to be successful?

suzy wood: No matter who was there in the daytime or the nighttime when Jerry was living in the Chateau, he would walk around the house with a guitar on. He would be so intent on what he was doing that he would come and stand in front of people the way you stand in front of somebody you're going to have a conversation with. But he would be absolutely completely inside himself. He would make no response at all to the person he was standing in front of. He was inside himself playing. That used to be frustrating and odd for me. He would be standing this close to me. This person I knew. "How are you doing today?" And he wouldn't say a word. His fingers would never stop moving. He was really inside himself with stuff going on inside his head and coming out of his fingers. My very clearest picture of Jerry is standing in front of him sitting in a chair at the Chateau playing guitar. Completely encased in himself.

sara ruppenthal garcia: The scene at the Chateau was totally male. It was definitely a guys' scene. Guys and music. That was why it felt like the Lost Boys. It never got cleaned. Maybe somebody like Hunter would take care of things now and then and do the dishes. Once a week.

suzy wood: Bob Hunter was such a crack-up. He was so anal that it just cracked me up. He and I were boyfriend and girlfriend or whatever the hell that was for a little while. His parents were going to come out from Connecticut. His father was a publisher. Bob was going

to be a writer and Jerry just used to rag on Bob all the time saying, "We're going to have this big pile of joints right here in the middle of the table and when your dad comes out, we're going to offer him one." He was waving his arms around and pointing at this imaginary pile of joints that was going to be on the table. Bob would be seething and all ticked off.

sara ruppenthal garcia: In honor of our relationship, Jerry bought himself new underwear which was kind of thoughtful, I thought. Because these boys didn't do much laundry either. He made the mistake of leaving this package of underwear in the living room. Of course, it disappeared. One of his buddies helped himself to it. Jerry was a lot bigger than any of them but that didn't matter. New underwear was new underwear. He was very forgiving and tolerant of such behavior. He would have done the same thing.

suzy wood: I had a paper to write for San Francisco State and it was late. My school career was rapidly crumbling around me. I went down to the Chateau. Bob Hunter wanted to be a writer, so who better to go to when I was trying to figure out how to write a term paper? He said, "Here, take these," and he gave me some Dexedrine. So I stayed up for three days and three nights on a couple of Dexedrines. Meanwhile, Jerry and I don't know who else were in the kitchen divvying up some Romilar cough drops. I remember people calling drugstores and having these terribly ill grandparents and could they please deliver these Romilar cough tablets? I don't know what it did for them because I didn't take it. They also ate the little folded-up papers in the Vicks inhalers. I don't know what that did for them, either. I was professional. I would only take Dexedrine for a purpose. I was writing a paper and those people were just getting fucked up. I remember them trying to figure out how to make a peanut butter sandwich. They had a loaf of French bread and a brand new jar of peanut butter. Figuring out how to cut the bread, figuring out where to insert the knife in a brand new jar of peanut butter, and how to get it on the bread in order to get it in their mouths must have taken forty-five minutes. I don't know if they even ever got to that part. They were pretty loaded.

sara ruppenthal garcia: We had kind of a whirlwind courtship. I was still at the dorm but I got kicked out of the college really quickly because of the all-points bulletin. I was a restless, rebellious kid. I remember that night I met Jerry, I had this sense of putting on some new piece of clothing and it just felt really—what would be the word? I was feeling wild and ready for action. And I got it.

david nelson: Jerry said that he'd gotten a gig offer if we could get a band together. Pete Albin was getting together this College of San Mateo Folk Music Festival. So we put together the band for that. Me, Bob Hunter, and Jerry. Hunter was playing mandolin or bass. Doubling. At first, we didn't even have a mandolin. The very first gig, it was bass, guitar, and banjo. We had all taught ourselves how to play. We used to slow records down or play with the same track on a record over and over again to learn things. We drilled a lot because we were paralyzed with stage fright. The first few times he played, Jerry had to have it on automatic.

sara ruppenthal garcia: He lived for music. He'd be in a bad mood if he couldn't practice for several hours a day. At this point, he was very ambitious. He wanted to do something big. But there wasn't any show business niche for him.

peter albin: Jerry was always witty. Wry humor. "Hey man, hey, hey. What're you doing, eh, eh, eh." But I didn't find him to be one of the friendlier guys in the world. He wasn't, "Hey, Pete. How are you doing?" He was always, "Hey, hey man, hey." He was cool. He was watching everybody but he was not quiet. He was very vocal. Jerry talks on that series done by the BBC and PBS, *History of Rock 'n' Roll*. That was the way he talked then, too. Pretty much the same. I don't think he really changed.

suzy wood: Jerry did seem older. He was separate to himself. You know how a lot of times people are kind of formless but what makes them who they are is the group they're a part of? You pull any little piece out of it and they're essentially a representative of the group. Jerry wasn't

like that. Jerry was the thing that groups formed around and a certain group formed around him when he and Marshall Leicester were together. Marsh was very very bright, and Jerry was very very bright and they had incredible amounts of fun aside from music.

sara ruppenthal garcia: Those guys had such keenly wry senses of humor. Those three. David Nelson, Hunter, and Jerry. The sidekicks. They loved each other a lot and played wonderful music together and shared a kind of an off-the-wall, quirky sensibility. I wasn't good enough to play with the three of them. But we started doing old-timey music. I met Marshall and Suzy [Wood] Leicester. The four of us did some performances in places in the city like the Coffee Gallery or Coffee Cantata and we were quite well received. I threw myself into the study of these old tunes and just loved it. Jerry and I played at the Tangent in Palo Alto. We had a little duo.

suzy wood: Jerry took up with Sara. She was straight and darling and impressive as hell. She was a Stanford student and her dad was a pilot and my sense was that they were a cut or two above the general riffraff.

sara ruppenthal garcia: We sang together and I played a little autoharp and my little rosewood Martin guitar. He played most of the instruments. We sang well together. We took turns. One of us would sing the verses and we'd join each other on the chorus. The surviving tape is really awful. It sounds like the Chipmunks. But we liked singing together, we were good at it, and people seemed to enjoy it. Remember that song, "Walk Right In" by the Rooftop Singers? That was popular then. We figured we could do something better than that. So that was our plan.

john "marmaduke" dawson: I was just another folk guitar player when they had the hootenannies at the Tangent on Wednesday evenings. There was a back room there and people would get together and put a little bit of a trio or a duet together. "Hey, you want to play some stuff with me tonight?" "Sure. What are we going to play?" "Okay, let's do this one." "You want me to capo up and play it in a different key so we get two different guitar sounds?" "Yeah, okay, let's go." There was

a lot of that going on. Just instant groups coming together and falling back apart again. At that point, Jerry was the best picker in town. Along with Jorma and a guy named Eric Thompson. Jerry was one of the hot pickers and David Nelson was one of the hot pickers.

jorma kaukonen: I think we all taught each other a lot. One of the really neat things about that period and I don't know if this was a function of the period or just that we were younger and more open-minded but there was a lot of jamming and that doesn't happen that much anymore. In those days, it happened almost all the time. In terms of who was the best player, keep in mind that as youngsters, we were all bad boys. I'm sure all of us thought we were the coolest thing in our external persona. Internally of course, it was, "God. I don't know what I'm doing here."

john "marmaduke" dawson: Even then, I think Jerry had that beatnik cutting edge. Because of his history. He never did like cops and he never did like the Army even though he was in it for a while. He was a good maze rat. It only took him one try to find that out. He learned that course real quickly. It didn't take two tries for him.

david nelson: At the College of San Mateo Folk Music Festival, Jerry did a three-part thing where he started out doing solo stuff from the old ballads. Then he got into the twenties and thirties with string band music. We'd be an old-time string band and play old stuff. Then, modern age. We played bluegrass in the third section. That was really a nice little display.

peter albin: We were all local folkies but he was a little bit higher on himself than the other people because he had more talent. He did and he knew it. When he first started playing banjo, he'd come up to you and say, "Hey, dig this," and he'd play "Nola" on the five-string banjo. And he'd go faster like Roger Sprung. It was something you could never play. He was excellent but he put it in your face. He knew who did everything. He did his research. He did his homework. I don't want to make him sound as if he was unfriendly and not willing to share things because he was. As a matter of fact, when I put on a folk music festival during this time at the College of San Mateo through the auspices of the

Art Club, Jerry and his group played there. We also did a guitar workshop where he did finger picking and I did flat picking.

david nelson: The thing about Jerry was that you could come up to him and ask him how to do something and he would show you, which was an incredible thing when you think back about those times. There wasn't this free atmosphere of exchange. I remember asking him a few questions and he came and showed me in detail how to do certain finger-style things.

peter albin: The musicians respected him and the audience at the College of San Mateo show thought he was good. But God, he took so long to tune. It was like he went for like some sort of philosophical tuning. I remember my father who always came to these gigs said, "When is that guy going to stop tuning?" That was his major complaint after the gig. He said, "God, that guy Garcia. When is he going to learn how to tune that damn thing? He spent about like a half hour on that goddamn banjo tuning that fucking thing." The audience would be getting restless and Jerry would be going, "Just a second, folks. You want me to play good here, I got to be in tune, blah, blah, blah." He'd make some more clever remarks. "And now a Chinese song. 'Too-Ning.'" That was the classic line during the sixties. Named after a city in China.

7

sara ruppenthal garcia: There was a folk music festival in Monterey in the summer of '63. Chris Strachwitz, who still owns Arhoolie Records, brought in old-timey people, the original guys who were still alive. I don't know if Doc Watson was there but I think he brought Clarence Ashley. Clarence White may have come. I don't know how we afforded the gas to get down there. I know that we didn't have any food. We didn't have any place to stay. We slept in the car. I was pregnant. It was just peanut butter and bread if we were lucky. Bob Dylan played there. Lots of things had been going on. Small performances and workshops. Connecting with some of the real seminal American folk music. Dylan did more of a performance in a big space. He came out by himself on stage and brought a little amplifier and plugged in his guitar. We were so outraged by the amp that we got up, walked down the center aisle to the stage, and marched off. It was like, "We are not going to be a part of this." Amplified guitar? This wasn't pure. For money, Jerry had played in a rock 'n' roll band with Troy Weidenheimer. They played fraternity parties. What they had to put up with was awful. And in high school, Jerry had played on Bobby Freeman's "Do You Wanna Dance?" But he didn't consider that exactly worthy. What he really wanted was to play with Bill Monroe. That would be the pinnacle of success.

david nelson: Hunter wasn't really as dedicated as we were. He wasn't ready to die for it like we were. We were insane. We were nuts for bluegrass. Back then, you couldn't get this music in record stores. You had to know some real big-time collector. One lived up at Stanford. I think his father was a professor. We would go over there and pester him to play tapes for us because he had a collection like the Dead tape system now. People would give us copies and we'd trade tapes of different bluegrass gigs. So we'd actually get to hear the real thing. Not a studio slicked-

up version. I remember going over there lots of times, sitting on that couch and listening to stuff. I would just never get tired of it. All these other guys were older than me. So when they decided that was enough, we had to go. I'd always be saying, "Oh, can we hear some more?" Jerry would say, "No. Don't make him mad. Don't piss him off, Nelson. Don't wear out our welcome." Because we wanted to be able to do that most any time. That was where I first heard the Stanley Brothers live and Flatt and Scruggs live and Clarence White, the guitar player. It was amazing.

peter albin: Garcia and Nelson and Hunter concentrated on heavy-duty bluegrass. Bob Hunter played well but he wasn't your real ethnic type like you find at the music colleges. He wasn't going to delve into exactly how those bass lines were played. He was a trumpet player. So he played simply.

david nelson: We were the Wildwood Boys and that lasted about only a year at the most. Garcia had a disagreement with Hunter about were we going to get serious about bluegrass. I remember one practice when they were going back and forth and I was just stepping out of it. I think Garcia put it to him and said, "You're really going to have to get serious or I'm going to have to get another mandolin player." Bluegrass is a staunch kind of music. It's not easy and if you don't really dedicate yourself to it, you'll never make it. They had sort of a falling out and Hunter just quit. So we went and found Sandy Rothman. There were these Berkeley people who played bluegrass. We went over to Sandy's house one night and Sandy said he'd like to play with us but he played guitar and he didn't want to make me not play guitar or anything. Garcia just talked me into it. He got an F12 and said, "You can do it. You can do it." He put a mandolin in my hand and the next thing I knew, we were doing gigs and I was playing mandolin. I had a few weeks to get it together and then we were the Black Mountain Boys.

sandy rothman: These two guys came to Campbell Coe's Campus Music Shop just off Telegraph Avenue in Berkeley. I seem to recall that Garcia pointed his finger at me and said, "Are you Sandy Rothman? We want you to be our new guitar player." Really bold and confident and no question about it. Like it was going to happen. I started going down to Palo Alto by Greyhound bus with my guitar every weekend.

clifford "tiff" garcia: The next time I saw Jerry was actually just before he got married. A couple of months before the wedding, he came up to the city with Sara. She was pregnant. So it was like, "We're going to get married. We have to get married quick. Because it'll start to show and people will talk and blah blah blah."

sara ruppenthal garcia: It was Jerry's idea that we get married. When I found out I was pregnant, he said, "I always wanted to be married!" Poor guy. We had no idea. No idea. We were babies.

clifford "tiff" garcia: He went to my grandmother Tillie first. Because there was always somebody there at Tillie's house. My grandmother called my mom. My mom went over and then I went over and we all met Sara at the same time.

sara ruppenthal garcia: When we decided to get married, he told me his mother and his grandmother both lived in the city and I said, "We've got to go meet them. We've got to bring them to the wedding. We have to do that." He had run away from home when he was sixteen or seventeen. Before that, he'd been pretty much raised by his grandmother, Tillie. Tillie was something else.

By the time I met her in the spring of '63, she was starting to get senile and it really really upset him. But we went and found her and she was so happy to see him. And so thankful to me for bringing him. Coming out of there, he was shaking his head, saying, "Oh, she's losing it." It was so sad for him because he'd had a tough childhood. Can you imagine how terrifying it would be to watch your father drown? Think about yourself at five. Your father is out fishing in his wading boots in the ocean and he gets swept away? You're really conscious at five and full of fears. What a terrible loss.

Jerry talked to me about losing his finger. He talked about losing his father. Later on, when his mother and stepfather moved to Menlo Park, Jerry was miserable in suburbia. He didn't fit in there. I think these were formative events. We don't have a lot of memories from our childhood. The things that we remember, we do for a reason. They're so full of meaning. The accident in which Paul Speegle was killed was another absolutely formative event. All these formative events in his life were difficult, tragic. Loss. Utter loss.

Jerry's mother, Ruth, had really wanted Jerry to be a girl. She'd had a boy and she doted on him. Tiff was the favorite kid. Tiff was the star. When Jerry took me that same night to meet her in her little place in Diamond Heights, there was a photo on top of the TV. Tiff in his Marine suit with the gun. On top of the TV. She watched TV all the time. I loved that woman a lot but she and Jerry didn't have a very good relationship.

His whole family came to the wedding. I was making an honest man out of him. We got married real quick. At the Unitarian Church in Palo Alto. By the Reverend Danforth K. Lyon. Or maybe it was K. Danforth Lyon. Jerry's friends came to the party at Rickey's on El Camino. He and Hunter and Nelson played bluegrass. They called it a shivaree.

clifford "tiff" garcia: Jerry had a goatee. In fact, Jerry had a goatee in the ninth or tenth grade for Halloween. He had his goatee, he was all dapper, he played banjo, and he had his little band and they played for the wedding. He hadn't come to my wedding. But I had a totally different kind of wedding. Quick, low-key, *fffshp*. He didn't know. I'd already been married a year or two before I went to his. I knew a few people there. I knew Laird and Hunter. I was the working-class blue-collar guy. Sara was kind of the elite of the upper middle class. But I understood the scene. Because the same kind of scene was happening around some of the people I knew in the city. It was just in a different area and I didn't know all the faces.

suzy wood: My father gave them an electric frying pan for a wedding present. And I remember thinking, "Oh God, this is too weird."

8

sara ruppenthal garcia: We found this little hovel in Mountain View. A one-room cottage in back of a house. We had no car. Jerry was teaching at Dana Morgan's Music but that depended on him getting from Mountain View to Palo Alto. We weren't that far out of the fifties. He had this little goatee and greasy black hair. Carrying his guitars or with a guitar in one hand and a banjo in the other, he would hitchhike to Palo Alto. Oftentimes, he didn't make it in time for his lessons. His students would show up for lessons and he wasn't there.

dexter johnson: Jerry was my first guitar teacher. My mom got him for me by going to Dana Morgan's, which was just blocks away. The teaching rooms were borderline tiny. A dumpy little place in the back with a phonograph and it was like, "Hey, Jerry teaches on Monday nights at seven or seven-thirty." I went for my first lesson and I didn't know what to expect. He said, "What do you want to learn? Bring whatever you want to learn." He showed me a chord or two and the next week I brought a Kingston Trio and a Highwaymen record. That strumming thing. "Tom Dooley." I was into that. His music at that time was more Lester Flatt and Earl Scruggs and Bill Monroe. He actually threw aside the albums I brought. I was a little shocked when he did that. He didn't do it in a way that made me feel bad. It was a little bit confusing but then again from my straight world, he was a confusing guy. I was in junior high school trying to be cool and he looked like a beatnik. His socks might not have matched or he might have been wearing high-top black tennis shoes which were completely uncool with no socks. I noticed his finger missing. This guy was definitely not trying to be in with the in-crowd. And that was interesting to me. He told me to listen to Bill Monroe, Flatt and Scruggs, and in blues, Lightnin' Hopkins. So I went to this record store at Town & Country Shopping Center and they had

booths where I could listen to these records. As soon as I heard that stuff, that was what I wanted to do. I wanted to make the guitar sound like that.

sara ruppenthal garcia: He was a good teacher. A very good teacher. But making very little money at it. The person who'd lived in our room before us was one of those people who would take the change from their pocket and throw it on the floor. That was pretty much what we counted on for bridge money and cigarette money. Until it ran out, we were scrounging around under the furniture for pennies.

dexter johnson: He started teaching me "Wildwood Flower" and various forms of thumb picking. For six months, that was all we did. Then he started me finger picking. "Freight Train," Elizabeth Cotton. He turned me on to Mike Seeger and the New Lost City Ramblers. I remember once coming to a lesson and he wasn't there and on the music stand was a note: "Gone to New Lost City Ramblers concert in San Jose. See you next week." Psychologically, he was interesting to me. Like, "God, I could just do what he's doing." It had never occurred to me that I didn't have to grow up and get a job somewhere. He didn't seem to have a job. He taught but he certainly didn't go to the office. This was a novel plan for me. Maybe you could grow up and not go to the office. He never said, "Gee, I'm a Bohemian." There was nothing but the music. But it was still in my kid's mind. "How does this guy get away with not going to the office and looking the way he does?"

sandy rothman: Someone who grew up in Palo Alto told me about walking into Dana Morgan's when Garcia was teaching there. Jerry was in between students when this young kid picked a guitar up off the wall. Like people always do in music stores, he started playing fast and furiously. Quickly, he then put the guitar back up on the wall. Garcia said, "What's the matter? Run out of talent?"

sara ruppenthal garcia: We married in April and our daughter Heather was born in December. By then we lived in Palo Alto. We'd found a nice little studio apartment behind another house. We went to Stanford Hospital for the birth. Jerry came with me and was with me during the labor. They would make him leave for the procedures but he

was there all day. I remember it was a Sunday. We read the Sunday paper. It was a long labor and when Heather was finally born, Jer was so cute. I remember they wheeled us out into the hall where he was waiting anxiously. He'd been pacing and smoking cigarettes and doing all the things he thought he needed to do as the expectant father. Either the nurse or I told him, "It's a girl." He jumped for joy. It was so sweet. He went leaping down the hall to his friends in the waiting room, saying, "It's a broad! It's a broad!" And then he went off to hear and play with Clarence White in L.A. The next week.

suzy wood: They had wedding present-y things around and it was attractive and nice. That was all Sara's stuff and Jerry looked lost. He was teaching at Dana Morgan's to make money. He was being the supportive husband and father and Sara was a Stanford student and being a mother and it was just all impressive as hell. Sara was impressive to me because she was holding all that together. And they were going to marriage counseling. He was trying real hard to do whatever it was that he was supposed to be doing.

david nelson: As far as doing things, the marriage didn't really change him because he went on that trip with Sandy. At the time, he was married. That just occurred to me now. I didn't even think of it then or haven't thought of it since. How did he get the wife to let him do that? The reason it didn't occur to me was because I'd never been married. I didn't know what it was like when the wife put the chain on you.

sara ruppenthal garcia: Heather was about four months old when Jerry left with Sandy on their trip. They were gone for a couple of months. It was a musician's life. They were up late at night and out a lot and I'd lost interest in going to the gigs because of Heather. Jerry wouldn't hold her when she was little. He was afraid he would drop her or hurt her. I have a photo of him taking off on the trip to go with Sandy. I forced him to hold her so I could take a picture and he has this scowl on his face. He never did handle emotional difficulties well. Me neither. But Heather heard music nonstop in those years. The first time she ever stood was by pulling herself up on a guitar case. That kind of says it all. Valiantly, Jer also tried to learn the fiddle when she was a baby. That was painful to be around. But she's a violinist now.

peter rowan: A lot of cats from the West would go on this pilgrimage east. They'd drive for three days. We were all influenced by *On the Road* by Kerouac. It was like, "That's what you do." You get in the car and you drive and you go to Pennsylvania and then you have a meeting there of Jerry Garcia from California and David Grisman from New York who'd come to hear bluegrass in the only place where you could hear it.

david grisman: This was before bluegrass festivals. There were what you would call country music parks. Little outdoor deals with a stage and some wooden plank bench seats and every Sunday, they would have shows there. Sometimes it would be Kitty Wells and Johnny and Jack and many Sundays, it would be bluegrass. Usually a double bill with somebody like Bill Monroe or Jim and Jesse or the Stanley Brothers. There were two such places near the Maryland-Pennsylvania border. One was Sunset Park, which is in West Grove, Pennsylvania, and the other was New River Ranch in Rising Sun, Maryland, and they were probably less than thirty miles from each other. There were a lot of Amish people there in black vests and regular people from that area and then there'd be us. These people from the cities who had discovered this music. The parking lot was where the pickers hung out.

sandy rothman: How did it escape my attention that Jerry was leaving his wife with a four-month-old daughter without any notion of how long he was going to be gone? We went in Jerry's white '61 Corvair. The magic Corvair. What I called "the intrepid little beast." I remember leaving from Sara and Jerry's apartment in the afternoon. We went to this Payless store and bought boxes of seven-inch reel tapes to take with us and Jerry had his little Wollensak with him. We had our instruments and the car was full. I don't think we had any clothes or food or anything like that but we had lots of tapes. Gas was cheap, like twenty-three cents a gallon. It was really a pilgrimage for the music because we went around and heard a lot of music and we filled up all those tapes with live shows that we collected from people taping back there and we taped a bunch ourselves. Later, Jerry said many times, "We were just like Deadheads are today."

sara ruppenthal garcia: They'd gone off with the great hope of playing with Bill Monroe and it didn't work out. I don't know

what we were going to do if he got a gig in Nashville. We didn't do much anticipating. I was twenty and he was twenty-one. We were babies. Our plan was I would come out and meet him. Actually, we had planned on my going with him but that became unrealistic, partly because it would have meant leaving the house. We couldn't pay the rent and leave. My dad was financing us. If I went to school, he would give us a hundred dollars a month. Jerry needed me to go to school because we needed the money. We thought maybe I should go out to Bloomington, Indiana, and transfer into ethnomusicology. That was another plan.

sandy rothman: We had this dream that was never verbalized: We could get a job playing with Bill Monroe. We went out to the Brown County Jamboree at Bean Blossom, just outside Bloomington, Indiana, on the first weekend of the season to watch Bill Monroe play. Before the show, Monroe was signing autographs and talking to people out in front of this barn door. We positioned ourselves right in his line of vision, about eight or ten feet away. We had our instrument cases standing upright and we were sort of leaning on them. We were too scared to say anything. We thought he was going to just take pity on us and come over and talk to us. But he never did.

sara ruppenthal garcia: They came back. Around that time, jug band music started coming in. The Lovin' Spoonful became a national phenomenon. We went to see them. Some of those people knew some of our people. They'd heard of each other and they were like rival gangs checking each other out. Zal Yanovksy looking Jerry over, Jerry acting cool.

sandy rothman: Jerry decided he wanted to get back to Sara. Recently, I asked Sara whether he ever called her in that approximately two-month period. She said, "Are you kidding?" But when he got ready to go back, I remember him talking about Sara all the time. "I gotta get back. I want to see Sara." He told me later that he drove back without stopping except for gas. He didn't sleep at all.

sara ruppenthal garcia: They started getting interested in jug band music. Jug band music was wonderful. A major step towards rock 'n' roll. Bluegrass is very heady. It's very mathematical in its virtu-

osity. Jug band music is gutsy. Earthy. Jerry started playing it with David Nelson and Pigpen.

sandy rothman: After Jerry went back, I was at Bean Blossom again and Bill Monroe did come over and talk to me. He asked me what I was doing around there and he said he remembered me from California. A couple of weeks later, I ended up playing with him for the rest of that summer. Jerry and I never really talked about it. By the time I got back to the West Coast and checked in with Jerry, the jug band was reactivated.

bnun, ing band music's either. Finally Jerry started playing a with David Nelson and Parker.

us a s a be a a a After Jerry went back, I was at Bean Blossom again and Bill Monroe did come over and talk to me. He asked me what I was doing around there and he may be remembered me from California. A couple of weeks later, I ended up playing a with him the rest of Indiana. Jerry and I were really talked about it. By the time I got back to the West Coast and checked in with Jerry, the jug band was reactivated

peter albin: I can't remember all the names of the various bands they had. In '63 or '64, there was some change when he went into the jug band music. I know that they played in what they called the Gallery Lounge at S.F. State as Mother McCree's Uptown Jug Band.

david nelson: We went over and saw the Jim Kweskin Jug Band live and then Dave Parker learned the real pattern stroke on the washboard. It was like the first time you learn three-finger picking. Where you're picking up the beat with your thumb and you play the syncopated notes with your fingers. It's something you have to walk through the first few times. You can't know and understand it and just do it. He learned that and that turned the trick. We sounded like a jug band then.

sara ruppenthal garcia: Jerry loved to get up there on stage and play but it was a challenge. Can you pull this one off? He'd get an idea and pick up something. He'd want to give it a try. Would they be able to follow? But it was really a shared virtuosity. He was the king in some way. He couldn't help it. He was a triple Leo. But really modest and self-effacing. Willing to share always but getting so pissed if he couldn't get something right. That winter, he got hold of a record of Scott Joplin rags, which weren't known in those days. They'd been lost but they were found and he listened to one. I think it was "Maple Leaf Rag." He picked it out on the banjo. Can you imagine? Listening to it phrase by phrase and going over it and over it and over it again. What I'm aware of now is his incredible single-minded drive. My goal then was to just make him his coffee and see that he had his cigarettes and not bother him because he had this work he had to do. He would work on a single phrase for two days. Three days. Until he got it exactly right. I would love it when he got it right because he'd be pleased and happy for a

moment and then he would go into the next one. He set high standards for himself and he would get in an absolute funk if he couldn't get something just absolutely right. Or if somebody else messed up.

marshall leicester: The way he talked about Mother McCree was that it was nice to play for people. It was nice to be listened to and it was nice to be paid. Of course, that was not all that was going on. I'd say it was a coalition out of all the kinds of musicians that were available. Integrating all the various worlds that had built up around the Chateau and around the Peninsula in the course of those four or five years was also part of it. Even though the band wasn't together very long, Mother McCree was really an important intermediary step and sort of a bridge between that old-time music and blues. Because it was so much looser than the rest of it. And I think that live energy was always important to him.

sara ruppenthal garcia: I talked about the Lost Boys. My fantasy was that my role was Wendy. Sewing on the buttons. It was an auxiliary role. Being a mom. I got into "the domestic arts" and tried to make a home. I learned how to cook cheaply and hand-sewed a quilt for the baby. Ever since he'd been a child, Jerry'd had asthma pretty bad. He told me once about his mom coming to visit him when he was sick. He must have been living at Tillie's and he didn't get to see his mom very often. And when she left, he remembered looking out the window and seeing her leave and then having this really scary asthma attack. He thought he was going to die. To me, there was a real connection in that. But he got over his asthma when we got together. In those early years, I always felt I was good for him, that he was destined for greatness, and that I had a role to play. To help him. I often got really anxious and really bitchy about him smoking grass because I did not want him spending our money on it. We had so little money. If I didn't get over to Dana Morgan's on the day when he got his paycheck, he would go off and spend it on grass. No doubt. And I didn't like him getting silly. I was really a bitch about it until I took acid. I was the mother and I was the guardian of the family and anything that threatened that, which was most everything, I was against. I really went from being one of the guys and having fun with them to this other role a lot of the time. Being the cop and the caretaker. Kind of tapping my finger and waiting and telling him

he was supposed to be home and that kind of stuff. Which fit his expectations of "the old lady."

david nelson: Bob Weir and a couple other young kids came over to Hamilton Street where I was living. They knew Pigpen because Pigpen was younger too. They showed up and started hanging around. I think we asked them, "Hey, you want to play jug? Here, *you*." Weir was the most unabashed to give it a try. He was up there making fart noises. To play jug? What an offer. In a band? To go, "Uhh phoooo. Booooo." And that was your instrument? Next thing you know, we had gigs and everything. Because of Pigpen being in it, that changed everything. Pigpen was remarkable. Jerry had introduced Pigpen to us about a year or two earlier at one of those Boar's Head's things at the Jewish Community Center in Palo Alto. Pigpen was still Ron McKernan then and we were coming out of there and everybody was milling around. The usual thing was to decide where we'd go to party. Suzy Wood's house was not available that night and people were arguing about where they were going to go. Ron McKernan made some remark and Sherry Huddleston turned around and said, "Oh, Pigpen!" It just clicked. Everybody howled and turned around and went, "Pigpen!" Referring to Pigpen in Charles Schultz's *Peanuts* cartoon strip, which was a very very popular thing in the early sixties. Pigpen the comic strip character had long hair and he was a mess. It was just a momentary gag. But I remember Pete Albin saying to me, "That'd be a great name for a performer, man. Pigpen, man. Like Blind Lemon Jefferson. *Pigpen*, you know?" And we all went, "Yes!" Him being in the jug band made it really legitimate beyond belief. In that respect, we had something more than the Kweskin Jug Band. We were able to do those blues and Pigpen did those harmonica parts exactly perfect. He didn't copy it note for note. He had perfect feeling. We were playing jug band music and doing those rags and I thought of the name. Me and Hunter came up with Mother McCree's Uptown Jug Champions.

carolyn "mountain girl" garcia: In Palo Alto, there was a club; actually it was a pizza parlor, called the Tangent. I had just moved to Palo Alto from upstate New York where I grew up. I was probably seventeen and a half, driving around Palo Alto on my bicycle when I heard this banjo music coming out of the top floor of the Tangent. I slammed on the brakes, pulled over, parked the bike, went inside, and

there was this old bald guy making pizzas there. It was a scary kind of place, really funky, the windows had never been washed. It was hot in there and they had a little stage on the upstairs floor and I was listening to this banjo music floating down the stairs. This was the best banjo music I had ever heard. It was like nothing I'd ever heard before. My ear was just going right up the stairs. I asked the guy behind the counter, "Who the heck is playing the banjo up there?" And he said, "Oh, that's Garcia. He plays over here. He plays with the jug band and they're going to be playing here in a couple of days and he's just using the room to rehearse in." I said, "Do you think he'd mind if I went up and had a look around?" And he said, "No, go ahead." So I trotted up the really crusty old stairs and there was Jerry sitting on a stool in the middle of this dusty dark place, practicing the shit out of the banjo and just tearing through these unbelievable long runs, and what he was practicing was a song called "Nola." He would rip through these long complex runs and then hit a bad note and stop, go back to the beginning, and start over. Then he looked up. He looked at me and I looked at him and I said, "Oh, just looking around." There was no contact because he was rehearsing. I thought, "Pretty cute. Not bad." I went back downstairs and the guy behind the counter leaned over and said, "What'd you think?" I said, "Gee, really interesting. When are they going to play here?" And he said, "Now, listen, honey. He's married." He could read the interest. I went back out and got on my bicycle and went away. I did come back for a show a few days later and absolutely loved it. That was Mother McCree's Uptown Jug Champions or one of the pretty early versions of it and it was my first look at the people who were to become my friends. But it was several years before I met any of them.

sara ruppenthal garcia: Jerry had very few role models for what it was to be a father or a husband. His grandmother Tillie had a husband at home. But she also had her boyfriends coming in and out and he thought that was normal. Tillie was the matriarch. She was the strong adult in his life. I didn't find out until months after we split up that he had been running around. Had I known then, I would have killed him. I would have killed him! I still could kill him! We had no skills. No way to handle relational difficulties. There was no arguing. Jerry did not do emotional honesty or confrontation. I could make him mad and he'd be pissed but there wasn't any exchange then.

david nelson: The jug band became a regular working band. A known band that would do parties. We got more gigs because people could dance to it. If you were playing bluegrass, it was this scholarly atmosphere where people were studying it. You were in a vacuum because you were a city person playing another kind of music. That was not your ethnic background. Even though jug band wasn't either, it was related more to rock 'n' roll. There'd been a conversation in Hamilton Street years before about, "Let's do rock 'n' roll. That would be a goof." And everybody was like, "Yeah." At a lot of parties, especially Pete Albin-related things, there'd be these howling doo-wop groups, impromptu stuff. But that idea got into our heads then and it came back out a couple years later with the jug band. The idea of, "Let's just flat out go electric. Do rock 'n' roll. Do the thing, you know?"

sara ruppenthal garcia: I loved the jug band music. I really did. It was such fun. The Beatles' first record in this country was in '63. Or their first hit. At that time, we were dismissing them as a pop phenomenon. Lightweight.

david nelson: Garcia was working at Dana Morgan's and he called me up and said, "We've got to go down to St. Mike's Alley now. They're playing this group, the Beatles. They've got the album and I want you to check it out." So we went and got coffee and sat there looking at each other listening on the sound system to the Beatles' first album. The "I Wanna Hold Your Hand" album. After every song, we'd look at each other. I was going, "This is going to make me puke, man." He said, "Oh no, give it a chance. Let's listen with an open mind." I said, "Okay, okay. I like rock 'n' roll but I don't think those British punks can play it, man. Do they know who Jimmy Reed is? Come on, man." Garcia would say, "Calm down, man. They probably do, you know." I'd say, "You can't put it past me, man. I don't hear no Jimmy Reed in that. I don't hear no Hank Ballard and the Midnighters or Fats Domino." Because I loved those people so much. I was angry that these British guys had come and now people were going to think that was it. Now people were going to think that that was where rhythm and blues was at. This pissed me off. He wanted a good perspective on it because I think he could sense that it was going to be big. The British invasion was coming.

After each song, it was like, "Pretty good. Good harmony. Like in the

bluegrass band. Yeah, they do sing good harmony." We finished the album and we both looked at each other and said, "Okay, what's the verdict? What do you think?" And we both gave it the iffy sign. Not the okay sign. It was iffy. And we got up and left. I was thinking, "So that's the story on the Beatles."

A year later, the movie *A Hard Day's Night* came out. A friend called me up and said, "You gotta see it, man. I think they smoke pot." So I went to see it and I went, "Oh, my God! I think they do. They're smoking it." It hadn't come above ground then and so anything about pot was like the cat that ate the canary. Any time you laughed, you'd cover your mouth because nobody knew what you were laughing about. Only we knew.

sara ruppenthal garcia: When *A Hard Day's Night* came out, we started changing our mind about the Beatles. They were a trip and there was something inspiring about these smart adorable talented guys our own age getting to make a movie about themselves being very silly. We could identify with that kind of irreverent off-the-wall zaniness. By the end of 1964 or in early 1965, we got turned on to acid. That changed everything. By the time *Help* came out, the Beatles and their music were part of big changes going up for a whole group of us. Sue Swanson and I saw *Help* about twelve times and memorized every line. Things were still very innocent in Palo Alto then. Taking acid and tripping out, we felt like we owned the sidewalks downtown. It was a sweet time.

Mountain Girl and Jerry

Splintered Sunlight

Walk into splintered sunlight
Inch your way through dead dreams
to another land.

—*Robert Hunter, "Box of Rain"*

We had enough acid to blow the world
apart. We were just musicians in
this house and we were guinea pigging
more or less continuously. Tripping
frequently if not constantly. That got
good and weird.

—*Jerry Garcia, interview with author, 1988*

10

sara ruppenthal garcia: I had always wanted to do psychedelics. I'd read Aldous Huxley's *Doors of Perception* when I was a teenager and really wanted to expand my consciousness. As far as I knew, it was different than grass. I'd smoked some grass with Hunter and gotten kind of silly and it was okay. But grass made Jerry irresponsible and that was why I didn't like it.

david nelson: We all took acid together the first time. Me and Jerry and Sara. We were moving into this place on Gilman Street in Palo Alto. I believe it was probably in the spring of '65. We'd always been talking about if we could get some LSD. LSD was something in the Sunday supplement of the newspaper in some weird psycho article. The drug that made you go psychotic. People would see lions and tigers and stuff. We all said, "Yeah. I want that! I want that!" I thought, "If I hallucinate, I want to see a full life-size cartoon of Mickey Mouse. I want to see Mickey Mouse and Bugs Bunny. Only as life-size cartoons actually walking up to me." Then somebody said, "I want to see myself. I want to hallucinate and see myself walk in the room!" The only one with personal experience with it was Hunter because he did that Veterans Administration program where you were a guinea pig and they tried you out on mescaline, psilocybin, and LSD. When Hunter told us that in the Wildwood Boys, me and Garcia went, "We're going for coffee. Come on!" We went down to this coffee shop and sat there and just pumped him. "Tell us all about it. Every detail. Every gory detail." I remember him telling us about the deificoition plane. He was allowed to have his typewriter so he did some writing on psilocybin or something and came up with this plane of writing or thought that was called the deificoition plane. As far as hallucinations, he said he didn't see too much except on one

occasion he looked around and the seat of this chair that was in the room looked like a mouth and lips and it went "Whoaff!" at him. Another time, he said that he was really getting deep into a nightmare trip where he was being chased by this demon with a dagger. A crystalline dagger that was this long and he was running and couldn't get away. Finally there was nothing else to do but turn and face the demon. He turned and he grabbed the dagger out of the demon's hand and stabbed himself in the heart and licked the blood. Me and Garcia went, "Ahhhh, yeah. That's my man!"

Rick Shubb from Berkeley, a Sandy Rothman friend, a bluegrass guy, who now makes those Shubb capos, had found a place in Palo Alto where we could share the rent. On the first day we were moving into Gilman Street, he said, "I can get LSD." We went "Okay" and everybody coughed up their money. It was twelve dollars or something that he had to have from each guy. It was Jerry and Sara, me, and eight or nine others. We all dropped acid at the same time for the first time. It was everybody's first time.

It was white powder in a capsule and it was just amazing. Everybody walked off into their own thing for a while and then came back and we were looking at each other in the mirror and going, "That's incredible!" It was you but only different. It was like the archetype of you. The basic you coming through. I was saying, "Everybody looks like animals. Like the human version of their animal." We were saying, "Jerry, you look like a bear, man." And he did. He looked like a big brown bear. Sara looked like a swan or a goose. At some point, I suddenly thought, "Does anybody know if there's something we ought to know about this? Some of the dangers? Does anybody know anybody who's experienced?" I said, "Hunter's experienced. Let's go see him. And find out if we should be tipped off to anything." So we ran over to Hunter's house. I told him about it and he went, "Oh, are you always in the habit of jumping out of planes without parachutes?" We all looked at one another. "Oh, my God!" He said, "No, no. Relax. Sit down." So we sat down and he was talking and I remember when he was talking, I stopped listening to what he was saying because he was gesturing with his hands. He went, "And then you get to that point and then it's *peeeuuuuuu!*" And he made this gesture. But I saw it in stop motion. He made this fanning motion with his fingers and I saw it *click click click click click click click click*. Like that photography thing. It was amazing.

sara ruppenthal garcia: Taking acid was wonderful for me. It was like coming home. I just loved it. That first time we took it, I remember Jer and I jointly freaked out in the middle of the night when we were off by ourselves. Big-time freaked out. We drove to Hunter's and woke him up because he had the *Tibetan Book of the Dead*. So we figured he would be able to help us. We woke him up and said, "We're freaking out, man, you gotta help us." Hunter looked at the book for a while and then he said, "It's okay." "It's okay? It's okay. *It's okay!* Oh, *yeah!* It's *okay!*" What a relief. Everything was okay. That revelation saved our lives.

david nelson: In the evening, we went and played basketball. We were just fooling around, throwing the ball to one another, not really playing hard or anything. The thing about the basketball and the light was that the ball had a jet trail about six feet long. It made it easier to hit a basket and definitely easier to catch. Because it had this trail you could see like a big pointer. It was like Disneyland. It was the first-time realization that we could go to Disneyland any time, man. It was great. We were all remarking about how there was no hangover. There was this feeling of great energy to stay up and do things without being speeded. Without being like raped. It was really great.

sara ruppenthal garcia: We had such wonderful times on these early group trips. We just had wonderful wonderful times. They were so magical. This was large amounts of pure pharmaceutical acid. We were having very profound and deep contact, not with spirits but with the basic energetic components of life on earth. I do remember that after the Muir Beach Acid Test, Bob Weir and Jerry and I and maybe Sue Swanson went up on top of Mount Tam and we all had a joint hallucination that scared the shit out of us. Somebody else who was there actually took off and ran across the countryside. We had all seen something in the path. It was probably a gnarled tree branch. But to us, it was a dark malevolent being in the predawn light. We all had the same scare. But usually it was pretty positive. Considering we were taking acid, we did quite well. We had wonderful times. Just so high and delightful.

suzy wood: Sara would write to me about acid. "Hitch your scrotum to a star," she'd say. That was what acid did to you. It was an interesting thought. Considering it was coming from a woman.

sara ruppenthal garcia: But I don't have a scrotum. How would I know?

clifford "tiff" garcia: Jerry had finally taken acid. That was my attitude. Because I'd already been taking it for a year or so before he was taking it.

11

laird grant: There were parties all the time and then the whole Kesey thing started happening in La Honda. It had been happening down on Homer Lane and Perry Lane in Palo Alto. Sometimes there would be parties in all three places. You'd spend half an hour or an hour here. Then you'd go over to another party. Tripping openly at parties was still six months to a year away. Then it was really secretive. People were feeling, "Should we let other people know about this?" Then the thing was, "Yeah. Everybody should do it." Which again changed everybody's life into a whole different larger, stranger circle.

david nelson: We all actually came in contact with the Kesey bunch there at Gilman Street when Page Browning who also used to hang out at the Chateau but now was living at Perry Lane came by one afternoon and told us about the first bus trip. Garcia was there. He had a ringside seat. Page was actually there to score some pot. Phil Lesh had moved into Gilman Street and Page was a friend of Phil's from the Chateau days. We used to smoke pot and go to drive-in movies. We started talking and Page said, "Have you heard about the bus?" And I said, "No." He said, "They painted this bus just like a Jackson Pollock painting and then they got Neal Cassady to drive it." We were going, "Yeah?" They'd gone east with the goal in mind to meet Kerouac and to get in contact with Timothy Leary and those people at Millbrook and they'd encountered complete stuffiness and snobbiness from the Timothy Leary people. Leary himself wasn't even there. Jerry was sitting there listening to this and then I remember Page saying, "So what we did was, we went to a nearby Army and Navy store in town and got some surplus smoke bombs, red and green smoke dye marker canisters, and we went and lobbed it over the wall at them." We were laughing and he told us great stories about this bus trip. About Neal Cassady with headphones on being

stopped by cops and the cops just being completely nonplussed and straight people across the nation being totally nonplussed by this outrageous bus and this guy with headphones on driving. "God," we said. "You mean Neal was taking acid and driving, too?" We were going, "Wow! How do you drive when you're hallucinating?" And Page said, "We asked him about that too and Neal said, 'You just pick out the hallucinations from the real stuff. Then you drive right through the hallucinations!'"

sara ruppenthal garcia: Neal Cassady was a figure who'd sort of appear now and then, take whatever he could find in the medicine cabinet, bend everybody's minds, and disappear. The Martian policeman.

john "marmaduke" dawson: I loved Neal, man. He was fabulous. He was always willing to have a toke. He'd say, "I been smoking this shit for fifty years. Still gets me high."

jerry garcia (1988): *We loved Cassady. He was the guy, you know? The real thing. The Pranksters were learning from him and we were also learning from him. We were just that much younger. Neal was great. He was just unbelievable. There really has never been anything like him since. He was a true inspiration.*

laird grant: Kesey moved to La Honda. At that point, everything really kicked into gear. When I look back now at the chronology and the time space that it happened in, there was so much stuff going on at some points, it seems like it had to have taken five years. But it was only a matter of eight to twelve months. Because of the madness. All of a sudden it just exploded. I still say it was the Stanford Research Institute's fault. They let something out the smokestack. All of us in Palo Alto got contaminated. You look at all the weird and talented people who came out of Palo Alto in comparison to any other town in the U.S., you go, "Wait a second. This is rather strange."

sara ruppenthal garcia: I wasn't involved in the early Kesey stuff. Jerry went up to La Honda and from what I could tell, there was this kind of uneasy alliance. What we'd been doing before was very organic and elemental. Although we might not have spoken of it that

way, there was this deeply spiritual aspect to it for us. When we took acid, we started listening to the Beatles. Dylan's first electric album came out right about then, too. We had been putting him down. But taking acid and listening to that album was incredible. So the resistance to amplified music waned. And there wasn't a huge market for jug bands.

By this time, we had a little house of our own on Bryant Court in downtown Palo Alto with a white picket fence and a garage out back. Jerry and I had a family scene with him going off to work at Dana Morgan's and practicing at home. Heather was walking and as she got older, she and Jerry enjoyed playing together, singing, and talking. I was a film major at Stanford by then and I had a social life of my own. I was hanging out with other filmmakers, making little movies. The jug band practiced out in the garage, Mother McCree's Uptown Jug Champions.

When did we start going our separate ways? There was a theme running through our relationship from the start. Early on, I got preoccupied with pregnancy, motherhood, the family, making ends meet, that sense of responsibility. We didn't talk about what was bothering us. His real relationships were in the music, not his family. He had this drive to succeed.

sue swanson: I went to Menlo-Atherton High School and in my junior year, Bob Weir walked into my world history class. I knew Wendy, his sister, forever and I'd always heard about her weird brother, Bob. But I'd never met him and then this guy walked into the classroom. This was after the first Beatles' summer and so I was totally into anybody who was into music or long hair and of course Bob was so cute. He overheard me and my friend Sue Ashcroft talking about the Beatles' concert and how my friend Connie and I had gotten in the garage of their hotel. Weir went, "Are you talking about the Beatles?" That was the first thing he ever said to me. We started talking and he told me that he had this band he was in. At that point, it was Mother McCree's.

justin kreutzmann: My dad told me he didn't even see the Mother McCree's Uptown Jug Band. He was just into rock 'n' roll. He played in bands that wore red jackets and did "At the Hop" and the first time he ever played in public was at a party and they did "Johnny B. Goode." He realized that everybody at the party was dancing and that was when he decided that this would probably be a good thing to do. He was the rock 'n' roll element and Jerry had the bluegrass and Phil had

the orchestrated stuff and Weir had probably a little of everything strange mixed into it. I think Weir's probably a folkie more than anything else.

dexter johnson: Weir came and subbed for Jerry during a lesson once. He didn't seem like a man to me. He didn't have a beard, he was clean cut, and he was younger than Jerry. I was probably fifteen and he was seventeen. He wanted to show me some electric stuff. That was not what I wanted to learn. I said, "Well, that's not what we were working on, you know." He said, "Well, what are you doing?" If I'm not mistaken, I played "Spike Driver Blues" by Mississippi John Hurt. He just flipped. It was like, "Wow, man. How do you do that?" He wanted me to show it to him. He said, "So what else is Jerry showing you?" Of course I was disappointed. I'd come to learn, not to show. But I showed him how to play it. Then I stopped taking lessons for a month until Jerry came back.

clifford "tiff" garcia: I'd be out for a couple of months in the Merchant Marine. I'd come back and I'd hear, "Jerry's doing this. They're playing this place with these guys." Sometimes I'd go down and help him *schlep* their equipment around. They would go try these different coffeehouses in the city. They'd go around and audition and I'd end up talking to the manager or the bartender and they'd be saying, "These guys dress any better?" And I'd say, "Shit, I don't know. Maybe they have sweatshirts that match. They don't have any money. They're all real poor." Starving artists, you know? They were slovenly. That was the trend at the time. This was pre-Warlocks. After the Warlocks, I seen them once or twice. Then I didn't see them again for a long time.

david grisman: I got them their first piece of national press in *Sing Out* magazine. I was living in Greenwich Village and going to NYU and I worked part-time for a guy named Israel G. Young who had a place called the Folklore Center. Izzy wrote a column called, I believe, "Frets and Frails" for *Sing Out* magazine, which was sort of a newsy, chatty thing. I came back from California and I told him about this band. I think I even mentioned Jerry. I was taken with the fact that it was like a rock band. It was becoming cool for folk people to get into rock 'n' roll because of the Beatles and the Rolling Stones. We all dug on that and Bob Dylan.

tom constanten: I saw one of the Warlocks' shows at the Inn Room in Redwood City. I think it was a bar in a hotel and I was one of about twelve people in the audience. Let me say charitably that the room could have held more. Jerry was no longer Cesar Romero but Prince Valiant doing "Roly-Poly," "Do You Believe in Magic?," and other songs like that. Did people listen? When there are twelve people, you can't tell. It seemed everybody was listening. It was like one of those Danish film festival theaters. When you're there and there are six or seven other people in the whole theater, you don't want to profess too much curiosity about everybody else.

david grisman: Jerry and those guys were beyond the music even then. They were a bunch of very hip guys. They were all reading *The Hobbit* and they were doing this communal living that opened my eyes. I dug the music because they were doing bluegrass songs. They were doing Bob Dylan. They were putting this roots music in the context of rock 'n' roll.

dexter johnson: Now the Warlocks were happening. I remember seeing them at some dive over by the railroad tracks playing rhythm and blues. I also remember coming to Dana Morgan's one afternoon, not for a lesson, but to buy picks or strings and they were practicing and they were doing "Money." "The best things in life are free. . . ." I didn't think it was as good as the hit on the radio. I still listened to teenage radio and I was thinking, "Why would he do this?" Jerry could play that banjo so good and he played in those bluegrass bands and I'd gotten to love that. It just seemed bizarre to me that anybody would want to play that electric music if he could play the banjo and guitar and mandolin. I remember being really disappointed that he had any interest at all in playing the electric guitar.

david nelson: We all knew that he'd played electric guitar on Bobby Freeman's "Do You Wanna Dance?" Before any of this. Before the folk thing. Before anything. When he was in high school. In a real funky studio. If you listen to that recording, there are no drums. There are cardboard boxes. He was a kid from Balboa High. It was what he used to refer to as his "teenage hoodlum period." When he got that first electric guitar from his mom in exchange for the accordion. He got that guitar and he was really happy with it and he told me that he just tuned

it to one tuning. The solo actually sounds like it could be in that tuning because he said it wasn't until a couple months later when he found out how to really tune it. It's very primitive and it's very much that style of plunging out and jumping in with both feet first. The solo itself is basically two licks used very modestly. Very modestly.

sara ruppenthal garcia: I first met Phil Lesh back at the Chateau when he was a music student. He was this madman coming in with these musical scores where there were great slashes of music going down the paper and all over. He was just so wildly excited about avant garde music, which didn't seem to have anything to do with what Jerry was doing. Jerry could share his enthusiasm for some of it but it wasn't his thing.

peter albin: Lesh lived down the street with a friend of my brother. I'd go over there and I'd see these charts that Lesh had written. I couldn't believe this weird shit. Like a symphony for fifty guitars. They were all circular. It was a circular chart. A bizarre-looking thing. How do you read this?

john "marmaduke" dawson: I remember going to a couple rehearsals of Mother McCree's Uptown Jug Champions. Various publications have listed me as a member of that band but I never was. I was at the Warlocks' first gig at the pizza parlor at Magoo's. This was when they finally got all their shit together. I think they rehearsed in Dana's for the first one and then they got this gig at Magoo's. The thing about Dana was that he had all the stuff to play on so they let him be the bass player. He couldn't play bass for shit, man. They gave him the best break possible and he just couldn't do it.

sue swanson: I drove Jerry up to the city the day that he went to find Phil to get him to play in the band. We went up in my car. It just wasn't working with Dana Morgan playing bass. When they fired Dana from the band, it was tough. Jerry's guitar was from Dana Morgan's Music. So all of a sudden, he didn't have an ax. I remember him and his wife Sara sitting there trying to figure it out. "We've got two hundred dollars in the bank. How much is this ax? Maybe I can borrow money from my mom...." I'm not sure how but Jerry got the guitar. It was a

lousy place to rehearse anyway. The whole room was instruments. There were cymbals all over the place. When they played there, everything played right back at them.

marshall leicester: In terms of forming the Warlocks, I especially remember Lesh as being the decisive force in that. It was not so much Lesh himself, although Phil was obviously extremely important, but the moves that got Dana Morgan out of the band. That was the moment at which something which was partly being done as a concession to grown-up bourgeois life and the need to make money and all the rest of it turned into the possibility of making something greater. Dana was their original bass player. And when Lesh came along, it was a great deal more than a question of just replacing one musician with a better musician. Because Jerry took a real leap there. I remember some of us chicken bourgeois types being afraid he'd lose his job at Morgan's by firing his boss's son. But Lesh was adamant about that. I think some of us went to Phil at one point and said, "Would you back off a little? We're worried about whether Jerry's going to be able to survive." And Lesh said, "No way. I've waited too long for this." Phil was really ambitious and could be really hard-nosed in a way that was always difficult for Jerry. Yet what often looked like a kind of narcissism on Jerry's part was in fact him being more intense and in a certain way much more ruthless than others. I heard people say that you hadn't been dropped until you'd been dropped by Garcia. When you became no longer of interest to him because he was moving in a different direction.

john "marmaduke" dawson: So Phil came down and now the scene shifted to Guitars Unlimited in Menlo Park. Dana Morgan's was no longer part of the scene. Now Jerry was teaching at Guitars Unlimited. Phil came down one day and I got to meet Phil. They were in the back room at Dana's and they said, "Here, Phil, here's a bass." And Phil said, "What do I do with it?" And I said, "This is the A string, this is the E string and you get to make the E string be the same as the A string by pushing on the fifth fret and then the same tone. The basic beat is boom boom, boom boom and then you need to go up to here, boom boom, boom boom." I just showed him which string was which and where an E was on the A string. He picked up on that right away.

jerry garcia (1988): *We were stoned on acid the first time we walked into one of the Family Dog's first shows at Longshoreman's Hall when they had the Lovin' Spoonful. We went in there and looked around and Phil went up to Luria Castel and said, "Lady, what this little séance needs is us." We thought, "Yeah. We should be here. Hell, yeah. You kiddin'?" It was obvious.*

sue swanson: The first time I ever got high was when the Lovin' Spoonful played Longshoreman's Hall. Garcia put the sugar cube under my tongue and said, "In half an hour, you won't believe your eyes." We went somewhere in Larkspur, a place I'll never find again, and then we ended up going back to Longshoreman's Hall to see the Lovin' Spoonful.

dexter johnson: Bill Kreutzmann was a drummer in a group called the Legends at Palo Alto High School and they were the best band at the school. I was Social Commissioner at Palo Alto High and I hired them for the opening dance. They were great. All my friends were like, "All, right, man!" Then when I came to school on Monday, there was a note for me to go to the office and I was screwed. Kreutzmann's band had made the kids dance like they weren't supposed to. There were no fights or anything but it was some moral issue because they were doing the "Swim." They were pumping and doing bumps and grinds. It was a white upper middle class thing. We were right next to Stanford University.

justin kreutzmann: My dad met Jerry in '63 before the band started because Jerry answered an ad in the paper put there by my grandfather, Big Bill. He was selling a banjo that we had and my dad answered the door and there was this guy named Jerry Garcia asking to buy this banjo and he bought the banjo and then they both ended up working in Dana Morgan's music store.

sue swanson: Then they started the rock band and they didn't want to let me watch them. Bobby wouldn't let me come to the first rehearsal. No one could go. But then he let me go to the second rehearsal and I was the first person that ever got to go to their rehearsal besides them and I never went away. That was it. I've always been there. That was why Jerry called me his first fan. This was 1965. I was a junior in high school.

sara ruppenthal garcia: I remember spending some time up at John Dawson's parents' house in the hills when they were just getting the band together, playing "Gloria" and some Rolling Stones' songs. It took some persuasion but Phil was definitely the bass player by then. They also practiced at Sue Swanson's parents' place. By now, we had moved to that big old house on Waverly with Hunter and Nelson and Rick Shubb and some other folks. Things were changing.

john "marmaduke" dawson: Pigpen really did have the beatnik edge. Pigpen was the real beatnik. Everybody else was imitation beatniks. Pigpen got brought up on R and B. That was why he was able to play harmonica like a black guy. He'd go hang out in East Palo Alto with black hookers. One time Garcia said, "If you're going to hang out with Pigpen, you're taking your life in your hands." He was hanging some with Pigpen just to see but he was not going to go on Pigpen's trip because that was a little bit too weird. Pigpen was drinking Ripple. Pigpen was able to buy when he was sixteen because he looked that old. That was what ruined his liver by the time he was twenty-five.

clifford "tiff" garcia: I was surprised when Jerry first told me he was playing with this electric band. It was like he had really gotten down on the ladder after he got married. They had a baby and he was saying, "I have to make gigs. So this is what I have to do." And I thought, "Jeez, this banjo player all of a sudden is lowering himself to play in a rock 'n' roll band?" I was thinking, "Jerry, what's happened to you?" And he said, "I gotta make a buck. You know?" I could understand it. They were hurting. You do what you have to do to survive.

david nelson: That place on Gilman Street only lasted about six months and then we had to move out. Rick Shubb scored another house that was just amazing. Right around the corner, there was this place called Waverly on Forest and Waverly. None of us checked it out because we thought, "Oh, we'd never get a place like that. That'd be just too good." It was this old big Victorian that had round turrets on the corners and this porch with actual pillars and lots and lots of rooms. Jerry and Sara were living there. Me, Hunter, Dave Parker, an occasional ne'er-do-well in the other room or somebody in the attic. But that was the main hard core. I really loved that place. It had a big garden area in back with a

huge avocado tree and it had an elevator but the elevator wasn't working. The place was that big. That was where Jerry was living and where the band was centered.

peter albin: I knew that they had gotten together a rock band in the ensuing months and were playing some pizza parlor down at Menlo Park but I never saw them at that point. I saw them at Pierre's on Broadway in San Francisco. They played behind a stripteaser. It was the funniest fucking show I ever saw. Here were my old friends playing rock 'n' roll music and "In The Midnight Hour." Pigpen was playing behind this girl with these tassels. This was an old-fashioned type of stripteaser. It was before totally nude dancing. I was sitting behind three sailors and they were going, "Hey, take it off!" This girl was down to these little things and there were these air holes in the floor. That was real entertaining. The tassels would go up whenever someone pressed a button. Air would shoot up, the tassels would flap, and you'd see the boobies. Can you imagine the Grateful Dead playing behind a stripteaser? But after a while, the sailors' eyes turned away from the girl and began watching Garcia and the band. The girl was boring. She was just dancing. Her tits were flopping. So what? The band was playing some interesting music. This guy with the one finger missing was doing some incredible shit. Even the sailors appreciated it. Of course, the people I was with, my brother and his friends, they thought it was fantastic.

justin kreutzmann: In the '65 to '66 period, they just basically wanted to be the Rolling Stones. That was what my dad said. They just wanted to make blues records like the Rolling Stones. He said they used to back up strippers and there was one bar where they had this little drainage ditch in front of the bar. A little dip right there. If the set was really good, the bartender would pour alcohol into it and he'd light it on fire. This whole ring of fire would burn down the bar. What if you were reaching for your glass and you didn't notice that? *Aaahh!*

david nelson: I went up to their Tuesday night audition at the Fillmore. The other bands that were auditioning that same night were the Great Society and the Loading Zone. I remember I took acid that night, too. I walked in real early and nobody was even there. Bill Graham used to put a barrel of apples out. I saw the apples. I thought, "Hmm!

Probably for somebody private or something." I said, "I'm hungry. I'll steal one anyway." So I took an apple and I was just biting into it when Bill Graham walked in. I didn't know who he was. I thought, "I hope he's a janitor." I just started cooling it and then he walked by and I looked at him and nodded. He looked and nodded and then he did one of those Bill things. He stopped, did a slow double take, and went, "Uh, who are you? Who are you with?" I said, "Warlocks." I knew this would make him know I really was with them. Because this was the first night they were auditioning as the Grateful Dead.

12

sara ruppenthal garcia: So the acid and the Beatles
and Dylan all together and then the Acid Test. The idea of the Acid Test
started to really capture our imagination in a big way. There were those
Acid Tests in the Palo Alto area. After I plugged into that, I really
loved it.

ken kesey: When we started doing the Acid Tests out in La
Honda, the thing that made them exciting was the fact that they were
entertaining but it wasn't a closed circle. We hadn't planned our enter-
tainment to the point that everybody knew for sure how it was going to
end up. The most bizarre one was when we invited Kenneth Anger and
the San Francisco diabolists out for Mother's Day. We had all taken a lot
of acid and were wearing long robes and playing dolorous music up to
the trees and we walked them all up to this little amphitheater we'd made
in the redwoods where the thunder machine was. We banged and clanged
on the thunder machine with the sound system set up so we were getting
a nice echo with about three hundred yards between the echo. In the
middle was a little spotlight hung about a hundred and fifty or two hun-
dred feet up in a redwood tree so you had no sense of there being any
light. It just looked like a glowing stump. The stump was painted gold
and sitting on the stump was a golden ax. After banging and clanging,
we lowered a bird cage from the redwoods. In the bird cage was a big
hen. We got everybody out and spun this little pointer on what was called
the "toke board." We spun it around and whoever it pointed at, it was
obvious they were going to take that hen out and chop its head off. The
thing pointed at Page Browning. Page went in there and picked the
chicken out and the chicken had laid an egg. On the tape we've got, you
can hear that Herman's Hermits song, "Stomp That Egg." *"Stomp that
egg!"* So he got the hen out of there and put its head on the stump and

chopped the head off. Page threw the chicken still alive and flopping right into the audience. Feathers and blood and squawking and people jumping and screaming and all these diabolists and Kenneth Anger got up and left. They didn't think it was funny at all. We thought we were paying them the sort of honor they would expect. We out-eviled them. It all had that acid edge to it of, "This is something that might count." We might conjure up some eighty-foot demon that roared around. As Stewart Brand said, "There was always a whiff of danger to it." Those Saturday nights got bigger and bigger till finally La Honda couldn't hold them and we started branching out with the Dead who had just become the Dead. They'd been the Warlocks till then.

clifford "tiff" garcia: Actually, Jerry didn't love that scene up there at Kesey's right away. It took him a while to fit into it. He was always telling me, "These people are up in the woods getting ripped and doing this...." Like it was beneath him to do that. I said, "Jerry, people do that all over. What's the big deal? If you want to play with these guys, that's what you have to do." I'd lay that kind of trip on him whenever I talked to him about it. I said, "Don't feel bad about doing that shit." He didn't think they were too stable a group and he knew they were party animals. He wasn't into it. It was a wild scene.

carolyn "mountain girl" garcia: Page Browning was the liaison guy. He said, "I can get you this band. I can get you this band." We didn't know who it was. We'd never heard of the Warlocks. It sort of happened while we were concentrating on our weirdness up in the woods. And when we did meet up with the Warlocks, then I realized who it was and I recognized them from the Tangent. By then, they had started to change their haircuts. They were starting to get into these really lame bad haircuts. Bad moustaches and bad haircuts. But they were pretty cute.

sara ruppenthal garcia: They did that first Acid Test at Kesey's house probably before it was even named the Acid Test. I didn't understand what it was about and I was threatened by it. Jerry tried to describe this event to me. It meant a lot to him and it was hard for him to figure out. He was amazed by it. As it turned out, the Hell's Angels came to that party and I was really glad I hadn't gone because I was afraid

of those guys. The idea of dealing with motorcycle gang members while stoned on acid was not my idea of fun. The new thing was, "Can you pass the Acid Test?" Do you have the resources to open up your nervous system to anything? I wasn't sure I could. The idea of somebody directing or evaluating people's trips was pretty scary. Then came the Palo Alto Acid Test and I got to be part of it and see Cassady do his hammer routine which was so amazing that I began to get a sense of this new possibility. Once I started to catch on, I was divided between being the mom and the student and tending the home fires and going off to participate in something extraordinary that had never happened before. There really was a sense of history to it all that was quite exhilarating. I couldn't stay at home while this was going on.

carolyn "mountain girl" garcia: Ken's parties were getting bigger and harder to handle and we got busted and the Hell's Angels were coming and it was just unwieldy and it was getting unruly. But Ken's dedication to making a place where people could get together to get high was unshakable and I fell right into that and became part and parcel of it and spent all my time splicing film, repairing microphones, plugging stuff in, packing and unpacking, and making little films.

sara ruppenthal garcia: And there was Carolyn. I was so impressed with her. Patching together the electrical systems. An Amazon. I didn't know if she liked me but I really admired her. She was gutsy. She said what was on her mind. Like a big kid, a big beautiful girl who had somehow escaped being squelched as a teenager.

carolyn "mountain girl" garcia: I was pretty young and I hadn't been to college. Ken was a generation older than me. Was there a big initial flash between Jerry and Ken? At that point, I think there was more of a professional rivalry. Jerry was always interested in what Ken was doing but at that time, I think, they all felt kind of overpowered by the Prankster scene. Because it was so well developed and so loony and unpredictable. The Warlocks sort of treated us as the loonies in the band. They thought they could drive through our scene. They were almost voyeuristic. They would come through, perform, and take off again. They didn't really want us to stick to them. The straight guy was Kreutzmann. He was the guy that organized the gigs and he was kind

of the manager. The guy that would get all upset if there wasn't any money. Still, there was room there to form some friendships. But it was so wacky. Plus, we were going to court all the time.

jerry garcia (1988): *We were younger than the Pranksters. We were wilder. We weren't serious college people. We were on the street. It was kind of a more intellectual bent than street kids in the present-day sense. It was street kids in Palo Alto. More Bohemian than anything else. We were definitely Dionysian as opposed to Apollonian. It was like we were celebrating life. And so for us, psychedelics was what we'd always been looking for. Drugs were part of that continuous search for that explosion. The realization of something. When the Pranksters took acid, they fucked with each other really. In a big way. We just got high and went crazy. It was unstructured. But they liked us. Because we were so out there. Our music scared them. It scared them at first but then as soon as they realized it was not going to hurt them, they liked it. Like a scary roller coaster.*

ken kesey: I never thought of the Dead as kids. From the very first time I met Garcia, I thought of him as a peer. Same way with Phil Lesh. Bob Weir was a kid. But Phil had gone to Juilliard and studied under John Cage and Jerry was just—history had kicked him between the eyes and you could see it all the way back there.

ken babbs: We always thought of the Grateful Dead as being the engine that was driving the spaceship that we were traveling on. We talked about being astronauts of inner space. We had to be as well trained, in as good a shape, and as mentally powerful as an astronaut in outer space so as not to be thrown by any of the accidents or the unexpected we'd run into. Once the Grateful Dead got the engine cooked up and running, that became the motor driving the thing. It provided something that kept everything going and then they would do their unexpected things too. They would play what was going on and what was going on was going along with what they were playing. It was really give-and-take. Back-and-forth.

sara ruppenthal garcia: Who's in charge here? That was the question. Who's in charge here? And basically the answer was, "You gotta be. Or you're in big trouble." So we got in trouble and some-

times learned. The people in Kesey's scene were all good at something practical and they put it together in amazing ways. That all caught my imagination. Once I got the idea, I liked that a lot.

owsley stanley: In December '65, I really heard the Grateful Dead for the first time. It was at the Fillmore the night before the Muir Beach Acid Test. I was standing in the hall and they were playing and they scared me to death. Garcia's guitar terrified me. I had never before heard that much power. That much thought. That much emotion. I thought to myself, "These guys could be bigger than the Beatles." To be perfectly frank, I never thought of Jerry as the center of the band ever in my whole life. He was just another member. All the bands then were tribal and tribal meant you agreed amongst yourselves as to who was momentarily the leader of the team. Musically speaking, they all wound up together because they all liked playing with Jerry. But he never stood up and said, "I'm the band leader and you're all sidemen." He was not that way. The thing was, they said they needed a manager. I knew Rock Scully had been involved in the Family Dog. He was the only person I knew who knew anything about business. Later on, he brought in Danny Rifkin. This was a matter of nobody knowing how to do anything. But I had a very strong feeling that musicians were exploited by most managers and record companies to an extent I considered absolutely unbelievable.

rock scully: The first time I saw Garcia was at the Fillmore Auditorium. It was kind of an acid test. Danny Rifkin and I were running a show for the Family Dog on the same night at California Hall. We were aghast that the Grateful Dead were playing the same night, but at this point they were just sort of the Acid Test house band. Forsaking our gig, we ran over to the Fillmore to see what the hell was going on. We'd never seen anybody play like that before. Jerry was lifting the roof. Of course, we were slightly stoned. To be frank about it, we were tripping. So it seemed like there was no roof on the house. I'm absolutely sure Jerry was tripping, too. Every now and then, he'd look down at his guitar and I thought he was seeing some kind of monster. He was all surprised. Looking over his hand down the neck of his guitar like "Wait a minute. Where is the end of this thing?"

Actually, Pigpen was the driving force. He had the songs together. He

was doing blues like "Little Red Rooster." Basically, the Dead were a blues band in those days but I could already hear that from his bluegrass and gospel and folksy background, Jerry had come to understand that there was more to add to it than just John Lee Hooker kind of stuff. Having gone from banjo to electric guitar, Jerry was on a new instrument. Suddenly he had all this fluidity. He was reaching into the roots of music we had heard before. He was calling forth Americana.

After the show, I went up to them and said, "Man, you guys were *great*!" They said, "The sound system sucked. We weren't that good. We never played that song before." They'd been a bar band. They'd been playing in pizza pubs. Owsley said to me, "Look. These guys need a manager and I told them I want you to do it. Come on down and see them, they're playing Saturday night at the Big Beat Club in Palo Alto. I'll take you."

The next weekend, Owsley picked me up and drove me down in his little Morris Minor. Here I was with this madman and I decided, "Maybe I'll just take a half a hit tonight. Instead of a whole one." Stewart Brand was there and he'd set up a tepee inside the place and it projected light so you could see it from the inside out. The first guy I ran into was Neal Cassady, who took me over to the bar. I was with Owsley so he immediately hit on us. I think he was already dosed but he wanted some more. He could just gobble gobble pills. Immediately, I was getting introduced. Owsley was going, "This is Jerry Garcia." I said, "I saw you last weekend and I loved it." He was doing that same thing. "We were shitty and . . ." This was the first time I really sat down with him and we talked for a while before he was supposed to get up and play. Meanwhile, Kesey had his Prankster band on this other stage at the other end of the A-frame. Playing creative noise.

carolyn "mountain girl" garcia: Somebody played. I'm not sure who it was but it may have been this sort of ragged little punk band that Ken had. He was trying to record a hit record with Neal Cassady and I was the recording tech for this record, and for an isolation booth we had this old Chevy out in the yard. Neal would sit in the Chevy and I'd sit in there with him and it was just absurd. We were doing a bunch of absurd crazy stuff.

rock scully: On the other end was all the equipment that Owsley had managed to fashion and piece and string together in some way or

another. Pigpen was playing on this spindly old box organ with an aluminum frame. It looked like a TV stand and he didn't sit down at it. He stood up at it. Up close, this guy was really gnarly. This was before Garcia had his beard. So he was a little frightening looking also. As a child, I think he'd had something and he was a little pockmarked. Plus his hair was starting to grow out and he was having a real bad hair day. He looked like somebody you'd run into in the garment district or the diamond district in Manhattan. Truly. He looked very Jewish. Half of them were underage. Bill Kreutzmann, he was called Bill Summers at the time, he was underage. Weir was definitely underage. But we were all sitting there at this pizza pub bar having beers. I was twenty-two and a graduate student at San Francisco State but we were all kids compared to Kesey. He'd come out of dropping acid in laboratories. He'd already written *Cuckoo's Nest* and *Sometimes a Great Notion*. To me and Garcia, he was famous. We were in awe of the man.

ken kesey: With Garcia, it was not a one-way thing. Garcia was as well read as anybody I'd ever met. He understood Martin Buber's *I and Thou* and that he was in a relationship with his audience. He was not playing at them. He was playing with them. Anybody who's been on acid and has felt Garcia reach in there and touch them, all of a sudden they realize, "He's not only moving my mind. My mind is moving him!" You'd look up there and see Garcia's face light up as he felt that come back from somebody. It was a rare and marvelous thing. Whereas the Doors were playing at you. John Fogerty was singing at you. When the Dead had a real good audience and the audience began to know it, they were playing the Dead. Which meant the Dead didn't have to be the leaders. They could let the audience play them.

rock scully: The band went on and this fierce-looking biker guy dude, Pigpen, got up there and started belting out these blues. Garcia was also high. His eyes were all dilated. He started to swoop around the room with his picking. He had a good grasp of all this old American music and he wasn't doing the blues comping thing. He was running all over the place. Pig was trying to be the leader and bring them back. He'd be looking at them like, "*Boys*..." They were looking at Pig like, "This is our anchor over here!" Pig was their control but everybody followed Jerry. They had to because Jerry was rushing. Especially because he was high

on acid. Bill Kreutzmann was trying to keep up with him and Phil had only been on the bass for a couple of weeks so he was doing his best to keep up and make it sound presentable, but in the middle of an Acid Test, it didn't much matter. It was a lot different than Winterland or the Fillmore. You know how you can sometimes see what people are thinking? Garcia was either thinking that there were insects on his guitar or that it had done a Salvador Dali drip over his wrist and now was melting over his hand. It was a very spacey show and it was really hard to tell if it was over or not. Garcia sort of put down his guitar and everybody kind of ambled off the stage and came back to the beer bar. And that was the end of the set.

Then we talked. I was astounded at what he was doing. I said, "You're cramming in more notes than I've heard anybody jump on before in my life and I've been listening to a lot of music." Working backstage at the Monterey Jazz Festival, I'd listened to Thelonius Monk and Charlie Mingus. Here was this guy who three months ago was playing a banjo. Now he was playing this electric guitar like it was on fire. I also thought, "Man, the guy is ugly. This isn't going to wash in the Dick Clark world of rock 'n' roll as we know it." At this point, we'd had only one example of an ugly rock 'n' roll band and that was the Rolling Stones. I signed on that night. The next day, I signed out of Family Dog. I sold my share to Chet Helms and said, "I'm not going to be a promoter anymore." This was after I'd done four shows. Four shows was all I'd done. According to Owsley, I was supposed to be an expert on the business of rock 'n' roll. Jerry Garcia said to me, "Good luck."

ron rakow: I was in the land loan business. Because the band was playing through home hi-fi gear supplied by this guy named Owsley, Danny Rifkin and Rock Scully came to my office to borrow twelve thousand dollars for new equipment. I'd never seen anything like them. I breathed hard like my father did a year later when he saw me. Danny looked like a lion. His hair was brushed out like an Afro with fourteen-inch hair that went down over his shoulders on the side and in the back. Rock was like Cochise. We started to talk and it turned out Danny had a degree in cultural anthropology. Rock had his master's and was going toward his Ph.D. in German Renaissance literature. These were brilliant guys. Rock said, "I been studying this music business. There's going to be a scene in San Francisco around music that's so big that in five years,

there won't be a physical plant on planet Earth big enough to contain it." While they were there, my banker showed up. He was my lifeline and I had these two apparitions in my office. I had to ask them to climb out the window to leave. So they climbed out the window.

ken kesey: We did a really good Acid Test in Portland, Oregon, that is not well-known but by this time, we were becoming like a really crack terrorist group. We could hit a place, get in there, mess it up, and be gone before people knew what happened. In that one, a guy off the street, a businessman, came in and paid his dollar and got his hit of acid. He had a suit on and an umbrella. At that time, it was still small enough that one person could become the center of attention. He was out there dancing and somebody hit him with a spotlight and he said, "The king walks!" And he began to walk with this umbrella and play with his shadow. "The king dances!" He'd open the umbrella and say, "The king casts a long shadow!" The Dead were watching this and playing to every moment so he became the music that people were playing to. After it was over, we packed up into the Hertz rent-a-van. Because it was so miserable on that floor, we decided to put the equipment on the floor and sleep in the cargo net. Everyone was still wired and that was the most miserable ride in anybody's history because everybody kept rolling to the bottom like to the toe of a sock. It was the most miserable strange bizarre night. Everybody was so tired. We were laughing to the point where you just didn't want to laugh anymore. You were sick. You just wanted to cut it off. But you couldn't. Somebody would be lying there about to get to sleep and somebody would start rolling. Somebody would fart and it would all swell up again. It was just awful. That was when the Dead resolved to get their own vehicle. They split off with us and from then on, they were their own group. They were no longer on the bus. They decided, "We're going to get our own bus to be on." Just theirs.

ron rakow: Rock said, "Come to a gig." So I went to the second Mime Troupe Benefit at the Fillmore. I was there because they wanted twelve thousand dollars from me. Behind my back, they called me "Moneybags." In that scene then, it took like eighty bucks to be "Moneybags." I was with this beautiful light-colored black girl. We went backstage and got something to drink. All of a sudden, I noticed that every time I talked to her, gray fur grew on her face. And that was just a

deposit. I kept getting weirder. I took my coat off and I went in front of the band and laid right down at the feet of Jerry Garcia, who I had met two hours before when I was still cogent. I just laid there, closed my eyes, and he took me out.

They played "Viola Lee Blues" and it had a chaos section in it. My metaphor for the universe was that life was a dance between order and chaos. I thought, "Oh, this is it. Chaos is going to win out. It's over." I was lying there waiting for the end. And then bingo, out of the chaos came the blues. When I went into the Fillmore that night, I was Sammy Glick. When I came out, I was "Cadillac Ron." I went backstage to the dressing room and Garcia was sitting there like Buddha smoking Pall Malls. I grabbed a cigarette and told Jerry I wasn't taking it to smoke but only for a pause in the conversation. He said to me, "You're heavy. What do you do beside make money in the real world?"

After the weekend was over, I told Danny and Rock, "As nice as you guys are, as honorable as you are, you'll never never be able to pay any of this money back. It just won't happen. But what I can do is give you the twelve thousand dollars. I'll become a patron and be entitled to respect." So that was what I did. I gave them the twelve grand.

laird grant: I was hustling their equipment in my minivan. A Metromite walk-in van. It had a little teeny four-cylinder Austin engine and it was just like an eight-by-eight. A little bit bigger than a postal truck. We'd stack our PA and everything else into it and a lot of the time the band went along. Usually, Pigpen rode with me anyway. I set their stuff up on some of those Acid Tests and then they went off to L.A. and did the Watts Acid Test.

13

sara ruppenthal garcia: Kesey and Carolyn had gotten busted. We went to a meeting in Bernal Heights where Kesey asked the Ouija board what he should do and the Ouija board told him to go to Mexico. At that point, Jerry was messing around with somebody else. I was picking up the vibes from that one and I was really pissed. I didn't like that at all. Except when I was on acid, I was miserable. I wanted something different in the relationship and he was really not available to me. After having been in that primary maternal preoccupation with the baby, I was starting to feel my oats. So I fell in love with a Prankster and left Jerry.

rock scully: We decided to get out of town because we didn't really have enough material. We'd waste ourselves playing around San Francisco with the same songs because they really only had one set together. They could do blues forever but already Garcia was the driving force to get new material together. It was his idea and Owsley's, out of considerations about his nefarious businesses, that we bail out of town. Jerry was the one who'd clued me to it. I was supposed to get them to a place where they could get more songs together rather than work them to death in pizza pubs. That was when we went to L.A. We got a house big enough for all of us that we could rehearse in off Western Avenue in the middle class section of Watts. Not a stick of furniture in there.

owsley stanley: I'll tell you what living with them was like. If people were on one floor and you were on another and they decided to go somewhere, the next thing you knew the house was empty. There was very little concern for others' possible interests. We were just sort of all there. It had something to do with the Kesey bunch. There didn't seem to be much of a family thing in the Kesey scene. It was everybody for

themselves. The camaraderie there was kind of gritty. Almost like the Hell's Angels who'd punch each other out and that made them the best of friends. I never understood that.

carolyn "mountain girl" garcia: Owsley had rented this huge house that had no furniture. So everybody had like little mats on the floor that they slept on. And he had them on a diet of milk and acid and Kentucky Fried Chicken, which was the grossest. There was also a lot of DMT around.

owsley stanley: It might have been Chicken Delight. Chicken Delight and steak. But it was never my idea to go to L.A. I was against it. The Dead were following the Acid Tests and it seemed to me not such a good idea to do that and it was inconvenient for me but they decided they had to go there. They decided the Acid Test was more important than anything else they were doing. Now, when they worked a regular show in the Bay Area, they only got a hundred and twenty-five dollars. That was twenty-five dollars for each musician. They got paid nothing to do an Acid Test. They had no roadie, they had no manager, they had no sound man, they had nobody because they could barely make enough to cover their expenses. Most of them had day jobs. So then I started thinking, "Maybe this *is* a good idea."

rock scully: The idea was that I would put together gigs down there for the new material. Jerry had this thing about playing new material in front of live audiences. Which would change how the song developed. This was the only band I know of that has ever done that. The Jefferson Airplane certainly never went out there with anything that they didn't have down cold. The Dead would play stuff that they didn't even remember having written that day. They'd go out there and try to remember it. All of them staring at each other bad, saying, "No, wait a minute. We did *this*." They would rehearse all week long and I was booking these weekend gigs at Trooper's Hall on Fairfax. We'd go to Cantor's Deli every night we could get out of Owsley's sight because all he wanted us to eat was meat and milk and eggs.

owsley stanley: I tried to get people to eat meat because it was cheaper. That was not a good idea. It was okay for me but not for

others. Those guys taught me as much as I taught them about getting along with others. I didn't want to smoke pot. But they kept saying they couldn't get along with me unless I did.

rock scully: We'd rehearse all day long and into the night and there was this black card parlor, not a crooked game but an underground game, next door. So they made noise all night, which was perfect. There were always cars pulling up and people fighting and arguing about hands that they had been dealt. I think this had something to do with how a lot of our songs ended up as gambling songs.

owsley stanley: It was a whorehouse. And the whores would complain that our music would drive their johns off. They used to throw pot seeds out the window and we found pot plants growing between the two houses and they weren't ours. We thought the whorehouse was going to get us busted but we brought the cops on ourselves. Because of the loud music we were playing, they would call them.

jerry garcia (1988): *We'd met Owsley at the Acid Test and he got fixated on us. "With this rock band, I can rule the world!" So we ended up living with Owsley while he was tabbing up the acid in the place we lived. We had enough acid to blow the world apart. And we were just musicians in this house and we were guinea pigging more or less continuously. Tripping frequently if not constantly. That got good and weird.*

owsley stanley: It doesn't take a lot of acid to keep a lot of people high for a long time. One gram is three or four thousand doses. In modern terms, it's ten thousand doses. Which is a lifetime supply for a band fifty times the size of the Dead. Saying we had a lot doesn't mean much.

rock scully: We were even selling the stuff. It was illegal but we were selling it over at the deli at night. That was where everybody went. Zappa was there and Captain Beefheart and Jim Morrison. We were turning on all these L.A. people in the parking lot.

owsley stanley: Number one, Cantor's Deli doesn't have a parking lot. There was no parking lot at Cantor's, there is no parking lot,

there never will be. We never met any other musicians when we were down there. This is absolutely false. Just total bullshit. Number two, we never sold acid to anybody anywhere in Los Angeles. Ever. As far as I was concerned, it was a religious thing for me. I never cared about the money. I wasn't doing it for the money. Money was an embarrassment.

rock scully: At that point, Garcia's thing was actually very down-to-earth. "Let's get some songs together. Let's work. Let's work." He was very curious as to what I was doing. Did I get the hall? Are the people there? How are we going to get people in the hall? He cared about there being an audience. He didn't want to play to an empty house and right-fully so.

owsley stanley: In L.A., I saw sound coming out of the speakers. One dose of acid, some DMT, and something else, and I thought, "This is important. I've got to remember what this is about." I studied it very intently, which was difficult to do when you were that high. I thought, "This is not what I expected sound to look like." I never assumed it was some hallucination caused by the drug. The circuits were open full-on. It was real.

sara ruppenthal garcia: Owsley was trying to manage them, making them live on nothing but acid and steak. I was in L.A. too but with the Pranksters. Kesey had already gone on the lam so Babbs was in charge and none of the wives and kids were along. I was the only mother there with a child. I'd bring Heather along to the Acid Tests and make her a little nest someplace off quiet and safe and read her her books and put her to sleep in her little sleeping bag so I could go off and dance in the light show. Poor kid.

carolyn "mountain girl" garcia: Jerry adored Sara. And Heather was such a precious child. They had bought her a bag of junk jewelry at a thrift store or something, a great big box of wonderful rhinestones and pearls and all sorts of cool junk jewelry, and she would just laden herself with it. She would cover herself with this stuff and then walk around and give pieces to people and she gave me this really beautiful rhinestone cross that I used to wear on my Acid Test outfit. I wore

it up on my forehead a lot on my swami hat. I had a big froufrou hat that I wore on my head and that was right in the middle of it. I remember being very stoned over at their house and spending quite a bit of time with Heather going through the jewelry piece by piece, commenting on all of them. Sara was there but I was not paying too much attention to Sara because she was in a state of real frustration over Jerry being unable to quit doing what was he was doing. At this point, he and I weren't talking on any kind of intimate level. He was one of the boys and I loved to go hang out with the boys. Mostly we just bullshitted each other and giggled and talked. It wasn't personal.

sara ruppenthal garcia: At one of the Acid Tests in L.A., Jerry and I sort of reconciled a little bit. But it had been clear that our paths were separating and we were going in different directions. When he started the band, he didn't want me coming to where he was playing. Because then he'd have to worry about me. I would get out there and dance and he wanted me to stay home. He probably didn't want me knowing what was going on. It probably felt terribly constraining having the old lady there. And I wanted a life of my own. I'd always said I played second fiddle to a banjo. I said that jokingly but there was a lot of pain in it. By the time we started doing the Acid Tests in L.A., I had left him. I gave away all of our stuff. It was a real separation. I even threw away his letters.

carolyn "mountain girl" garcia: It wasn't until after the Watts Acid Test that Jerry and I first made contact. The Watts Acid Test was just a hell of a scene. Two separate parties dosed the punch independently so it was stronger than it should have been. There were many overdoses. After it was over, we were in the process of cleaning up the building. We were sweeping the floor. I'd gone back in the janitor closet and found these great big wide brooms and I was wearing my pink-and-yellow-striped tent dress that I'd made for myself during my pregnancy. It was very gaudy and hilarious and I had some funny hat on my head and I was sweeping away.

We were talking and loading stuff on the bus and wrapping up the wires and the sunlight was coming in and Jerry came over and grabbed a broom and helped me sweep. Together, we swept the place out and talked while we were sweeping. We were mostly just bullshitting each

other and goofing off and saying funny stuff and commenting on what had been going on. I was eight months pregnant and I didn't feel really attractive. I felt like one of the guys. I was just there working. So we spent about an hour and a half sweeping together and made friends. And then they drove off in their big car. They had a big car and we had a bus and I didn't see those guys again for six months. That was April. We came back to see them at San Francisco State in October.

owsley stanley: We were having a good time. We'd go to the beach and run around and do our own shows and we did several Acid Tests there. Every so often, we'd get a phone call with a job offer. First, it was the hundred and twenty-five dollars. Then it was one fifty. Then it was one seventy-five. Then it was two hundred. Just at the time when we had absolutely totally run out of money and there was nothing left, Rock went up to San Francisco and hammered out a deal for three hundred and fifty dollars for a show in April '66 with the Loading Zone at the Longshoreman's Hall. By being out of town, we got to rehearse and know each other better but we also created a mystique where fans of the band were agitating and calling up the promoters and club owners and saying, "Where the hell is the Grateful Dead?" So they thought, "Maybe they have a better audience than we thought." That was the start. It was a way of proving that the band could be in control.

rock scully: The L.A. thing lasted about six or eight weeks. Then we came back up to San Francisco. Because now we had a couple of sets.

sue swanson: I met Bob Dylan at the airport late one night and told him about the Grateful Dead. They were living down in L.A. in that big house. I was with Danny Rifkin. Three o'clock in the morning, we were both coming through the airport and there was Bob Dylan standing there with that manager of his who looked like Ben Franklin. I shouldn't have done it. You know how friendly he is. He's *so* friendly, right? But I walked over to him, waited until he finally looked at me, and said, "Look. I gotta tell you about this incredible band called the Grateful Dead." He looked at me and said, "Oh, aren't they the ones that play with the one-handed drummer in the front of the picture of the Taj Mahal?"

jerry garcia (1988): *We met Danny Rifkin and Rock Scully, who became our early managers. They said, "We have these people in San Francisco who are dying to hear you guys." So we decided to move back up. Having been out of town, we'd created a little legend for ourselves. When we got back into town, there was already a crowd waiting to see us. After that, we played really regularly in the Bay Area.*

14

rock scully: By the time we came back, Chet Helms was taking over the Family Dog. Bill Graham had formalized his Fillmore deal. With the advent of the Fillmore and the Avalon, things started changing in terms of the size of our audience. The scene had fired up just the way we thought it would. Because we had bigger places to play, we had to be more professional. Since Bill Graham and Chet Helms were charging money and people were paying to come and see us, Garcia's full thrust on this thing was, "This isn't an Acid Test anymore, boys and girls. They're paying money to come and see us. We have to put on a show." He was very professional about it. He was really diligent and he got Phil on the case. Phil was such a perfectionist. But Jerry was the guy who instructed the band that we were now getting into show business and the people were paying money to come and see us so we had to be good. We had to do our best and we had to be on time. He was very specific about that. "Scully. Just get us there on time." Personally, I was late a lot. As far as the band went, I got them there on time every time. Because of Jerry.

suzy wood: In the summer of '66, we went to Avalon Ballroom to see the Grateful Dead and the Jefferson Airplane. It was an awful experience. It was a huge crowd. There were too many people and light shows and people smoking joints in the middle of a public place, which was just horrid and weird. San Francisco had become something real *real* different. We were wending our way through this crowd and we heard this voice say, "Want coffee?" We turned and there was Jerry. His hair was in braids and I was so relieved to see the person we had come to see. He took us to the backstage area. Ron McKernan was back there and I was so glad to see them both in this little back room where we could sit

around and talk and joke, and Jerry was just like he always was. When I left, Jerry was leaning against a post.

laird grant: When they came back to the Bay Area, they got this place up in Novato, Rancho Olompali. That was when I split from my wife and said, "I've got other things to do, dear. I'm joining the band." I went back as the van master.

rock scully: It was the height of our folly. This was a time when girls were taking off their clothes. It was wonderful. It was idyllic and a very happy time.

eileen law: Olompali was just a wonderful place to go to hang out. The parties were outrageous. There was this big all-night party when the Hell's Angels raffled off a motorcycle with Chocolate George. The Angels and their ladies ended up running the place. I grabbed all the kids and put them in a room and we just hung out in there. Danny Rifkin and different people stayed up all night and made sure the house stayed okay.

jorma kaukonen: It was a really fun place. To get out of town, go up there, and take a guitar, hang out for a day, two days, whatever. Play, socialize. It didn't get much better than that. I really didn't know much about Marin County then because it was like another world, and this was an era when we all had cars that couldn't be relied upon to go very far. Our world was really proscribed in a lot of ways but they moved out there and they had an *empire*. When I was living in an apartment in the Western Addition on Divisadero Street, they had a fucking empire and to go visit them was great. I didn't have to hear the rats in the kitchen. Before we knew what rock star heaven was, they were defining rock star heaven.

eileen law: I remember being at an Olompali party when a musician in another band went a little nuts and he had a gun. I guess he thought Garcia was coming on to his girlfriend or something. I'd had an accident a few weeks before where I'd burned my legs so I had to stay in one position out there on the lawn. Garcia was near me and here was this guy with the gun. I kept saying, "Will you please move? Will you *move*!" Under my breath, I kept going, "Garcia, just move, please. Get

out of the way." I was right in back of him and I couldn't move because of my legs. Everybody was so high, I don't think anyone realized how serious the guy was.

rock scully: Jerry freaked out there on an overdose of LSD. He blamed it on ghosts of the Tamal Indians. That was the site of the Bear Flag Republic War, which lasted about twelve hours. An uprising that was put down immediately by the cavalry. It was a very quick war. But that land was sacred to the Tamal Indians. One day, I caught Jerry in the old adobe that the house was built around. There was a little trapdoor with a window in it where you could see the original adobe and he was in there feeling around. Feeling the adobe. His hands were all down inside the hole.

He was high and then the next time I saw him, he was out by this giant oak tree that had partially died and it was ancient. The Indians had baked bread in it. They had put clay on the inside of this dead tree. You know how dead trees sort of get hollowed out? They'd used it like a chimney and it was their baking oven. Jerry was out there communicating with that tree. I was looking for him all over the place because I thought something was a little bizarre about his behavior and the next time I saw him, he was under the dining room table all huddled up and shivering. It had been a tough day. Some kid had almost drowned in the pool and things had gone a little haywire. There were about two hundred people there and they had played and David Freiberg had played.

LSD can be a razor-edged kind of deal sometimes. It's a very chemical psychedelic. It really is. You feel it in your back and your jaws. When you do mescaline or peyote or mushrooms, it's like you're sore from smiling. Everything's got rounded edges. You look at an old Buick and it's got a friendly face on it instead of being cold steel and iron. But LSD is sort of two-faced. It takes away your defenses and then leaves you vulnerable. At the same time when you start coming off it, everything looks pretty sharp. For instance, if somebody's lying to you, it's apparent. Then the world starts looking harsh and cold. The color goes out of it and everything becomes black-and-white. It's not all that friendly anymore.

I couldn't get Jerry out from under the table. So I just tried to keep people out of the room to give him space. After everybody left and it had gotten dark, I made a fire in the fireplace. It got to be more organic and the vibes went down. Once the fire got going and most of the people had

left and it was back more to a familial thing, he came out. He'd just hidden there. It wasn't like he was invisible or anything. You could see him. But he felt with this low roof over his head, which was the tabletop, he was okay down there. That was where he'd gone to gain his solace. He came out and sat by the fire. He didn't say anything for maybe an hour or two. I played some Otis Redding. Music always helped. Then he started to talk about it. I said, "You know, Jerry, I saw you in the wall there and out by the tree." He said, "I started having feelings about the Spanish coming to California and what happened to the natives that were here and I just felt their ghosts. I felt a ghost and it scared me."

I got him to talk about it and he started talking about how the Spanish had come into California and kicked the Native Americans' butts and then how gold had brought in all these other people and he was Spanish so he felt this sort of *mea culpa*. He felt some guilt and dealt with it and came out of it. Then the color came back into his face. He'd been really pale. Ghostly pale. Scary. That day, this kid had nearly died in the swimming pool and there had been some shockers but it was shocking for me to find Jerry in this state because I'd always leaned on his good vibes which were always there. I could always rely on him to find the positive track. Always.

Without a doubt, he'd always go for the most positive thing. When we'd be walking down these hallways in our minds with all sorts of dark decisions everywhere, I'd run into Garcia and he'd say, "Hey, try this door. Check it out." I was sure that was why Kesey loved him so much. Jerry never had a bad thought in his head about anybody. I never heard him ever say he hated anyone. He'd get pissed off at people. He was pissed off at Albert Grossman for the way he treated Big Brother. But never hate. Never disgust or hate. He always looked for the positive. That was his major forte, I thought.

That was the only time I ever saw him like that. There was one other time in L.A. when we all dosed and went up around the observatory. Way up on the top of Griffith Park. It was kind of desertlike. Especially in the summertime. It got kind of otherworldly and Jerry felt that an alien ship had landed. Several of us felt an electrical presence. Being that close to some of the power lines across the hills might have had something to do with it but we all got spooked out. That wasn't real scary because we all shared that. This was something that he went through by himself.

carolyn "mountain girl" garcia: Sunshine was born in Mexico. She was an absolutely precious little blond child. We drove from Texas back to California because someone had put together a scene at San Francisco State. In our absence, San Francisco had changed. We came back and somehow San Francisco felt a little stale. When the band came off stage there, they said, "Oh, we're so glad to see you guys!" Big hugs all around and it was just a really important moment of contact for Jerry and I. We actually walked off and spent some time together that day. Actually, quite a bit of time. To the point where I left Sunshine on the bus and they had to come looking for me because she was crying and hungry. I just walked off with Jerry and we talked for a long time. I didn't pursue it at all at that point because we had a lot more stuff ahead of us as the whole Prankster scene began to come apart.

Then I was invited to a party in Lagunitas out in Marin at the boys' camp. I remember going out there looking for the band but just missing them. I missed them like at four or five different scenes. I never did quite find them. During all that looking for them, I began to realize that it didn't really have that much to do with the band. I was really looking for Jerry. So then I was having this moment of truth over that. I was thinking, "Oh, man, do I really want to be involved in another group living scene?" And the answer was "Yes. Yes, I do." It was ever so much more fun than struggling along alone. Soon as I could, I contacted him at 710 Ashbury. I went over there and we got together. It was a wonderful relationship from the very beginning.

rock scully: I'd convinced Danny Rifkin to try to remove the lodgers from 710 Ashbury so we'd have a place to move back to from L.A. I'd lived there before with Danny and Danny was the actual official landlord. It was a boarding house. Jerry was a bachelor for the first part of our 710 stay but somewhere along the way, Mountain Girl started coming around to our gigs and just fell for Garcia. She came to 710 and at about that time, my girlfriend Tangerine did this deal on me. "It's me or them, Rock. I can't handle this." She was the only girl in the house and we wouldn't do the dishes so she had to clean up after us and there were beer cans and dirty towels.

carolyn "mountain girl" garcia: Tangerine was there for a while but she quickly split because she was tired of cooking

and cleaning for those guys. But she had whipped them into shape. When I stepped in, they were already pretty domesticated. The house was full of wild crazy people living in chairs and basements and closets. The plaster was falling from the roof and the door was never locked and it was just a wonderful scene. None of them cooked or cleaned. They didn't know where the grocery store was. I had already lived through the Pranksters and I loved these guys. They were so sweet. You have no idea. Danny Rifkin, Laird Grant, the sweetest people on earth. And they weren't nearly as cranky as those old Pranksters. They were darling. I came in right when Phil and Billy had both moved out. They had gotten their own place up on Diamond Heights with their girlfriends and they actually had dinner on the table and clean laundry and all that stuff. They had a really solid living scene. Which meant that the scene down at Ashbury Street needed some tending and there was room for me there. It was a great big house and I felt that I was needed. I felt that I was called to do this. I also felt they would let me get away with shit there. In there, I knew I could rule.

sue swanson: It was a gathering of a tribe. Palo Alto was a faction. There were people in Berkeley. There were people in L.A. And then slowly but surely, everybody ended up together in the city and it became something else.

carolyn ''mountain girl'' garcia: Quickly, I got busy and made Jerry a whole bunch of little bit wilder clothes than he'd been wearing. I felt my role there was to keep it together and that felt good to me because I had to keep it together for Sunshine as well as for myself. I did a lot of laundry and I did an awful lot of cooking. There was a stove in that kitchen that if you took your eye off it for ten minutes, something bad would happen. I remember one time I was turning on the gas oven and it burned off all my eyebrows and eyelashes and ruined dinner completely. We spent a lot of time sitting on the steps out in front looking up at the old nunnery up the street. Over on Haight Street, there was a drugstore and a Chinese grocery store where we shopped and the little St. Vincent de Paul store where I bought all my stuff. We had such a beautiful spot to watch the fog come in.

sara ruppenthal garcia: Jerry and I got together another time around Heather's birthday. She was a little more than two when we

split up. He came to her third birthday party at my parents' house, and we talked then about getting back together. By that time, he was living on Ashbury Street with the band, and he said, "Come back."

rock scully: We weren't the kind of a band that had this following of groupies or anything like that. With Pigpen in charge of the kitchen and Garcia at the top of the stairs, we were a pretty frightening bunch. It was not like we were mobbed there. It did start up, though. First of all with druggies. Pot dealers. People who wanted to get high. People who wanted to finance it. Six months earlier, we were having dances in these Victorian houses on Page Street. We'd have the band in the kitchen banging on pots. Red Mountain burgundy. That was about it.

sara ruppenthal garcia: I went to visit him there. On some level, we both really wanted to bring the family back together. But there was no privacy at 710 and people were coming in at all hours of the night. There was noise and who knew what was going on. It wasn't a family. It wasn't a place where I could do family. Although we both felt the pull to get back together, it just didn't seem like it would work. By this time, I was singing with the Anonymous Artists of America. We were living up at Rancho Diablo off Skyline Boulevard. There were couples and there were children and there were dogs. We lived in the redwoods and we ate meals together. It was family.

ken kesey: We were planning to do this Acid Test Graduation. It happened in a place called the Warehouse. The Dead were supposed to play but because it all got too tacky, they didn't play and we got a group called the Anonymous Artists to play for the Acid Test Graduation. Which in its way was appropriate because it was the dénouement of something.

sara ruppenthal garcia: When they let Kesey out of jail, the band I was in, the Triple A, played for the Acid Test Graduation. The Dead was supposed to play but they were worried about jeopardizing their record contract. Because it might be bad for their reputation to be associated with the drug scene. "Cleanliness is next"—that was Kesey's new motto to impress his parole officer. But in case it didn't turn out to

be too clean, the Dead couldn't afford to be associated with it. They dropped out at the last moment.

joe smith: I was doing some A and R stuff and promotion at Warner's and Tom Donahue tipped me about the Grateful Dead, who had this very offputting name. I didn't know much about them. I went up to San Francisco and they were playing the Avalon Ballroom. My wife and I were having dinner at Ernie's and I was in my Bank of America blue suit with the striped tie. My wife was in her basic black with the pearls and Donahue called. He said, "The band would like to see you now." I said, "I'm all dressed up." He said, "It won't matter. Nobody will notice." We went over to the Avalon Ballroom and went upstairs. This was something so removed from anything I had ever known or seen in my life before. It was Fellini on stage. People lying on the floor. Body painting. Light shows. Incense. And this droning set from the Dead. One of their eleven-hour shows. With a twenty-nine-minute space guitar solo from Jerry Garcia. As soon as I started talking to them, I got calls from people around the country. "Wow. You're going to have the Dead? Okay!"

carolyn "mountain girl" garcia: The focus became the performances and how to get them there. Where to play and how to get some freedom in the system. How to close the street so we could do the gigs in the Panhandle and in the park. The scene was based around the music, which was powerful. They were playing amazing, compelling music. Very compelling.

sue swanson: I think we all got twenty-five dollars a week. Jerry got twenty-five dollars a week. I got twenty-five dollars a week. That was the way it was. But there was nothing more fun than just going out, getting in the flatbed truck, getting the generator, and going down to the Panhandle to play. It was the greatest.

rock scully: No one was supposed to be in charge. That was one of our rules in those days. That way, they could never put the finger on anybody. When the Grateful Dead started doing free concerts in the park, we never went and got permits or anything. We didn't get permission to play in the middle of the street on Haight Street. We just did it. One of the ways that we got away with another hour's worth of music before

they finally shut us down was that they could never find out who was in charge.

mickey hart: Every time we looked around, somebody was into something. Nobody was saying no. Every day, we were exploring. We'd get up in the morning and say, "What are we going to do? Let's play free in the park. Rock! Benny! Get the trucks and get the generator! Call Sweet William! Call Badger! Let's get it on!" We'd get a couple of flatbed trucks and the Hell's Angels to run the lines to make sure that the cops didn't pull the plugs. That was the way it worked in those days. We were spontaneous and looked forward to it. The Grateful Dead would play on Haight Street. And when we played, we closed the street down.

15

rock scully: Jerry was such a curious intellect that he always questioned everything. He was reading all the time and asking questions and meeting people and very outgoing that way. The crew wanted to protect him because he'd always say yes to everything. Which was why we did so many benefits for so many years. Garcia would say yes to almost everyone. The Zenefit. HALO, the Haight-Ashbury Legal Organization, and on and on and on and on. Somebody died, we'd do a concert. The Zen Buddhists wanted to take over this piece of property? We'd do that. The creamery was failing in Eugene or Springfield? Let's go fix that. We got to the place where we were going, "There is really no such thing as a free gig." We had to drive there, buy the gas, and rent the generator.

owsley stanley: On numerous occasions at 710, I would come across this little notebook that Jerry had which was full of doodles. They were just doodles that he would sit down and draw. These intricately drawn beautiful pen-and-ink figures of all the things you would see when you got high on acid. Beautifully detailed interlocking motifs that faded in and out of each other on different levels and mutated and all beautifully done and exquisite. The finest artwork you've ever seen. The stuff you could never do once you came down. But he could draw them perfectly.

ron rakow: Garcia wanted to go into business with me. I said, "How can I go into business with somebody I can't even talk to about the business?" He said, "You can talk to me about anything." I said, "No. The language of business is accounting." He said, "How hard could it be?" So I brought up a bunch of financial statements and went over them with him and he said, "Oh, this isn't going to be hard. I'll get this." I bought an elementary accounting textbook from the NYU bookstore and sat down with him. Over the course of some months, I taught him about

debits, credits, non-cash charges. Assets, liabilities, and net worth. I taught him formal accounting. When we were done, he could analyze a financial statement.

sue swanson: Those were glory days, man. Did you ever hear about the Thanksgiving dinner at 710? It was Quicksilver, the Dead, and the Airplane and I'm sure there were other people there as well. At 710, there was a front room, a middle room and then Pig's room, all with sliding doors. We opened all the sliding doors, even Pig's room, pushed all his stuff out of the way, got the TV over to the side, and put a table that snaked all the way through. Everybody cooked something. That was the first time I ever baked bread. Jack Casady rolled a joint for each place. Every plate had a joint. What a great night. That was sort of what the place was all about.

jon mcintire: My take on what I think was really important about the hippies was not the political stuff but the avowedly apolitical stuff, the more authentic experiments with the new. There was an avowed duty to experience joy and Garcia personified that. The flip side of that was also there because just like when you get close to any family, the surface seems all neat and together, but there are a lot of snakes underneath. You got too close to Garcia and all these positive things that he personified, he was. But there was also a lot of stuff totally contradictory to that. Which he also was.

carolyn "mountain girl" garcia: We were taking psychedelics and smoking great weed. When I moved into that house, they had a kilo of Acapulco Gold in the kitchen and I had never smoked anything like that in my whole life. It was just fabulous.

sue swanson: They were the first couple I had ever been around who were so magically together. He was very affectionate. Very touchy touchy touchy. And Sunshine was this beautiful child. She was the reason I had children. She was blond-haired and blue-eyed. I carried her around and I thought she was mine. I thought, "Gotta have one of these."

carolyn "mountain girl" garcia: At the time, Pigpen was very much an enigma to me. I didn't understand him at all. Jerry

seemed really wide open and completely accessible. Pigpen was very mysterious and stayed up all night a lot and drank cheap wine. I didn't understand that. I don't think any of us understood how much he was drinking except for the people who drank with him. None of us drank. Are you kidding? It was totally the antithesis to what we were doing.

jon mcintire: The most recent musical turn-on for me before the Grateful Dead was *Moses and Aaron* by Schoenberg. I couldn't quite get the Dead and then all of a sudden, I was hearing this incredible voice, this amazing sweet voice, and I was trying to figure out where was it coming from and it was Pigpen. He was the only one back then who could sing well. And he was the only one who could really play. Jerry wasn't that good on the guitar as I remember and as he remembered it, too. We talked about that. And Pigpen really played the organ well and he really sang well because Pigpen came from a blues background from his dad.

carolyn "mountain girl" garcia: The worst stuff that happened was Pigpen keeping us up all night singing. We'd be stomping on the floor. "*Pig!* For crying out loud, *shut up!*" I had a little baby. I was on baby time and we had regular bedtimes. We were down by eleven. Jerry would be out of bed chipper at six-thirty in the morning, practicing. The first thing I'd hear when I woke up would be Jerry plinking away. *Plink, plink, plink, plink, plink.* Going a mile a minute and he'd already been up for two hours. Apparently, he didn't need a lot of sleep. He practiced religiously every day until nearly noon. He had started with the banjo. My feeling about his banjo thing was that he was such a gifted musician that he'd taken his banjo, which was a really clanky, clunky, basically rhythm instrument on which you play these weird patterns, as far as he could go. It had been his mission to excel at the banjo to a point where he was better than everybody else and he was there. He'd nailed that one.

jon mcintire: Back when Jerry had really been into the banjo, he told me that he'd considered himself one of the best banjo players in America. In terms of the guitar at that time, which was about 1968 or '69, he didn't consider himself to be that good yet. Back then, his playing

didn't stand out for me the way it did later on. It was like they were all learning, and of course Phil really had just barely taken up the bass.

carolyn "mountain girl" garcia: When he moved on to the electric guitar, that was a whole new instrument. It took him a good deal of time to get proficient with it. He was busy learning in the midst of the Jefferson Airplane and Big Brother and the Holding Company and Quicksilver Messenger Service, all of them claiming to have some musicianship. Jorma Kaukonen was a really strong influence because he was such a good musician as well. There was some rivalry there and Jerry felt the need to really push himself.

jorma kaukonen: Jerry was a leader. When I look back on it, I realize that Jerry was always the leader. When he worked with us on *Surrealistic Pillow,* he really helped discipline us. Because he had come from a band and as a band leader and an arranger, he just really knew what was important. He was really important in the formation of that record and I know that personally he taught me a lot about playing in a band. I remember one evening he said to us, "It's not what you play. It's what you don't play that's important." In terms of dynamics and just plain letting the music speak for itself. As a band leader, he was really ahead of the rest of us.

jon mcintire: I remember Phil Lesh's story about the first time he met Garcia. He hated him. "Really?" I said. "Why?" He said, "This guy has too much power." There was this thing about Garcia that had been there from the get-go. An aura of personal power that could not be explained by any single thing. Although he was extraordinarily lucid when speaking, he didn't play on that very much. But he just emanated an authority. What was also going on was a redefinition of what cool was. An expansion of what cool was. And Garcia personified that.

bill thompson: The Jefferson Airplane were playing the Matrix and two guys came in wearing leather who I thought were Hell's Angels. Marty Balin started laughing. He said, "Bill, you're not going to believe it. Those guys have got a band." It was Pigpen and Jerry Garcia.

grace slick: The Grateful Dead looked like they were almost dead. They were only just twenty years old. But a bizarre-looking group of people.

david freiberg: He sure did help the Airplane with *Surrealistic Pillow*. I don't know what that would have been without him. He was on every track, pretty near. I can hear him playing on "Today." I always thought the sweetness thing that got put on that whole album never would have been there if it wasn't for him. Because it wasn't on any other album they ever did.

jorma kaukonen: It is Jerry. Absolutely. You bet. It's Jerry and Marty. I think he might have played rhythm guitar on another track. He's definitely in the mix and an important part of the band on those tracks. When I got into the Airplane, I didn't have a clue about what an electric guitar was except that you plugged it in and it was louder. Jerry was way ahead of all of us in that. Jerry was his own electric guitar player from the jump. He was never played like B. B. King, or Freddy King or Chuck Berry. Jerry always had his own thing on the electric guitar.

sue swanson: It was never easy. Every day you'd wake up and there was always some kind of psychodrama going on at some level or other. One person was disagreeing with another or they were going to fire Weir. Pig was not playing right or somebody was being a motherfucker or Billy was pulling some maneuver with the money. It was always something. For many years, I lived and breathed by what was happening with them. Those kind of habits die hard.

jon mcintire: Neal Cassady was around a lot. Really a lot. He would kind of live up in the attic. There wasn't really a floor in the attic. There were just boards that were laid down. I remember at one point, Cassady's foot came through the ceiling. He slipped and his foot came down into Pigpen's room. I think Neal Cassady just went where the juice was and this was where he felt it. This was the moment of the shift from the beatniks to the hippie movement. The baton was passed on by Neal Cassady directly to the Grateful Dead. You can draw that literal connection because of Neal Cassady.

jorma kaukonen: They had a house and they all lived in it. The Airplane lived together later in our career but never in the embryonic state where you were working together, living together, dealing with each other's day-to-day shit. We did not do that in the beginning. But they did and I think that formed a really important bond in their emerging character. Strictly looking at it as an outsider, their band family almost superseded their personal lives. To really live in a real honest-to-God, no bullshit commune? That's hard.

ron rakow: We were poor for a lot of that time. It wasn't poor. Poor is when your spirit is beaten down. We were broke. But we were having a great time. One time Garcia said, "I found my guitar. It's at Dana Morgan's Music. I can't buy it, though. I need nine hundred bucks." I said, "Oh, I got nine hundred bucks. Let's go get it." We jumped in my Cadillac and we drove down there with Mountain Girl who was wearing these white Keds tied with thick round wool instead of shoelaces. One was red and one was green. She pushed down the armrest between the seats and put her feet up on it. We got him a black Les Paul Gibson with flat frets. The guitar that's in the Irving Penn photograph.

jon mcintire: The reason they lived in 710 was because it made economic sense to do so. There wasn't any money. And so yes, there was a commitment to community, to family, to the living situation as a commune, but it wasn't some sort of political ideal that was being lived out and realized as in, "Ah, yes, we will become a commune." It was economic necessity and the fact was they were all buddies. Music was always the driving force. As soon as there was the financial wherewithal, their living situation changed.

carolyn "mountain girl" garcia: The bust really put an end to 710. The bust and that we were busted by a Prankster. We had just gotten some weed and this guy came to the front door and asked me for a joint. He was somebody I was on the bus with. Now this guy was not your up-and-coming Jaycee or anything like that. He was quite a gnarly, weird little guy who'd been in and out of Napa State Hospital, the mental institution. He came in and asked me for a joint. I rolled a joint right out of the strainer on the kitchen sink there and he said, "Oh, wow, thanks a lot. See, I have to leave right now but are you going to be

home later on?" I said, "Jerry and I are going over to Sausalito." We had a car and we were going over to Sausalito to buy stuff at the ribbon store because I was making Jerry a ribbon shirt. So he said, "I guess I won't see you later then," and he went outside. He waited for us to leave and then he handed the joint to the narcotics officers who were with him. I think he busted eight houses that day. He had been busted. They had him and they turned him. Because they were going to send him back to Napa if he didn't do it.

We came back from having our nice day in Sausalito but we didn't get busted. Because Marilyn, who was Brian Rohan's girlfriend, lived right across the street from us. She saw us pull up in the car, raced downstairs, and said, "Oh, *hi*! Come up to my apartment. Come *on*!" Suddenly, she was so friendly. We said, "Oh, okay." She got us up to her house and she said, "Look out the window," and I was going, "Uh-oh." There were these strange guys coming out of the house carrying stuff. We hung out in her living room watching all this in relative safety as they were taking Pigpen and Weir away in handcuffs. Poor Pigpen, who didn't smoke weed, got arrested repeatedly for other people's sins.

After they cleared out of the house, we slipped back over there after dark and looked around. Everybody was gone. That damn kilo of weed was still sitting in the kitchen. They had not found it. It was in the pantry. It was sitting there in its cellophane wrapper dribbling weed on the floor and they had not found it. How this is possible, I don't know. But they got that colander full of seeds and stems that I had rolled a joint for that guy out of.

Jerry and I were pretty cheerful about not being swept up and it didn't really turn into anything anyway. But it made us not want to go back to the house. It made it very edgy over there. There was another trip to Los Angeles right after the bust. While we were down in L.A., I was saying things like, "I don't ever want to move back into that house. I feel really uneasy and unsafe there." So while we were gone, Rock moved all of our stuff out of our room and moved himself into our room. At that point, we had the big room. When we came back from L.A., we weren't living there anymore. All our stuff was over in the little room.

jon mcintire: The first time I met Mountain Girl was when she and Jerry had moved out of 710 and gone somewhere else but not for very long. Wherever they went didn't work out. So they were coming to

move back into their room. Of course someone else was already in the room and they were kind of storming around, especially MG was kind of storming around, trying to figure out what the fuck to do here. Rock was following after her. Poor guy, he didn't know they were coming back and so he was saying, "MG, please. Please don't be mad at me." And she turned around and said, "No. It's okay, Rock. I just forgot how quickly things change around here." Because there was a lot of that in-and-out and back-and-forth with things happening very quickly. But also there was a definite family feeling.

carolyn "mountain girl" garcia: Jerry and I moved into an old motel somewhere down by the beach along the Great Highway. We stayed there for a couple of weeks. I was madly searching for an apartment and I finally found one out in the Richmond District out by the Palace of the Legion of Honor on Thirty-third and Geary. We moved in there with baby Sunshine, who by now could run.

rock scully: Jerry didn't even get busted. He stayed across the street. Marilyn was at 715 and warned him off. He was over there with Richard Brautigan, who wrote that wonderful poem, "The Day They Busted the Grateful Dead." They were determined to clean up the street but they were dirty about it. They took our money. We had a cashbox, which was what we would use to send Tangerine or Mountain Girl or Bobby Weir or whoever was available to go down to the market to get food. It was like our food drawer and in there was the lease on the place out at Novato and my name was on that lease so they assumed that I was leasing 710 Ashbury as well. After we got through the bust and Owsley got us all bailed out, we went for our arraignment and all the TV crews were down there and they busted me a second time for "running a place where marijuana is smoked." Like it was some sort of a bordello for marijuana smokers. Like an opium den or something.

jon mcintire: They weren't famous and they didn't have a lot of money but they were certainly famous in San Francisco. There were giant headlines in the *San Francisco Chronicle*: GRATEFUL DEAD BUSTED. It was as though the Grateful Dead somehow personified what was going on in San Francisco and that they were San Francisco, and here was this other thing that was also San Francisco personified by the police. A lot

of people back then were getting busted. But this was the Grateful Dead and they had that name. That name that, for whatever reason, was absolutely brilliantly chosen.

sat santokh singh khalsa: Every time someone mentioned the name to me, they told me a different thing. At 710, I clearly remember Jerry telling me that the name, the Grateful Dead, came from the *Egyptian Book of the Dead*. There was a line in the book, which he had with him at the time and that he showed me, which said, "Osiris, we the grateful dead salute you." That was definitely what Jerry told me and that was probably in '67.

jon mcintire: They were originally called the Warlocks. It was a goofy sixties kind of name but then another group named the Warlocks came out with an album. The band was at Phil's house and Garcia was sitting at a table. On the table was the *Oxford Companion to Classical Music*. Garcia told me he opened up the book at random and there, looking to him like it was written in red, was the term "grateful dead" and it went on to define it as kind of an English folk song about people who were grateful to be released into death. Among the Grateful Dead, no one ever ever talked about the name coming from the Egyptian Book of the Dead.

jerry garcia (1988): *Our background was the sort of deeply cynical beatnik space. Which evolved into something nicer with the advent of psychedelics and the good-time mentality of the Haight-Ashbury. There really was a good year in there. Maybe a little more than that. And it was special and exceptional and magical. The fun part was before acid was actually made illegal. Because then you could go out there fearlessly and you weren't breaking any laws. It was just crazy as hell. And what were they going to do? That was fun. That was like pure fun.*

ron rakow: When we played at the O'Keefe Center in Toronto in the summer of 1967, the review in the big-time Toronto newspaper was "The Grateful Dead—hirsute simian horrors." We read the review out loud in a room with everyone there and people started saying, "What does that mean?" Jerry said, "It means we have a lot of hair and we walk on our hind legs." When I was interviewed in *Billboard* magazine, I was quoted using the word "exacerbated." When the Grateful Dead read that

article, everybody said, "What the fuck is he talking about?" Garcia just said, "Makes worse." He had a fabulous vocabulary. He also trained his cat to eat cantaloupe and I have a photograph to prove it. He was a tripster.

suzy wood: It wasn't odd that Jerry was part of it. It was odd that the whole thing was going on. That there was this Haight-Ashbury, hippie, summer of love, flower children huge phenomenon boiling out of Vietnam protests and freedom riders and this whole boiling seething thing was going on all over. That was what was odd to me. Because that was not what had been happening in Palo Alto. But it got huge. The dope-smoking, Diggers, communal living, Avalon Ballroom, acid rock blah blah blah taking LSD. The whole thing was just so enormous and frightening to me. Which was my own personal trip. I was terrified of psychedelics. I thought I would go crazy if I took them. I thought I would never come back.

eileen law: In '67, the Haight started changing. I started seeing bars being put up on windows. Then they advertised it as the place to go and all those songs came out. "If you're going to San Francisco, be sure to wear some flowers in your hair," and all. When the tour buses started coming around, I believe the people came out of 710 and put mirrors up so that the people on the buses could see themselves.

sue swanson: The next thing we knew, there were tour buses coming down Haight Street. Then we were out of there.

(left to right): *Phil Lesh, Mickey Hart, Bob Weir, Jerry Garcia*

One Way
or Another

Please don't dominate the rap, Jack
If you got nothing new to say
If you please, don't back up the track
This train got to run today. . . .

One way or another
One way or another
One way or another
This darkness has got to give.

—*Robert Hunter, "New Speedway Boogie"*

It wasn't surprising to get busted. It
was surprising if you *didn't* get busted.

—*Jerry Garcia, interview with author, 1988*

16

carolyn "mountain girl" garcia: We bought a little TV and settled into some sort of domestic life. We had a big Plymouth station wagon with a back window that didn't roll up, and that was what we got around in. Right about this time, we took our one and only camping trip. Jerry and I went camping in the Sierras. They'd played a show at a bowling alley in Lake Tahoe. We just hated the motel. Jerry said, "Let's camp out." I said, "Camp out?" I loved camping but I had never tried anything like this with him. I figured, "I'll have to do it all." So I made my checklist and got some food and made sure we had sleeping bags and something to sleep on. He drove up to some little logging trail and on out into the woods. Bumpety bumpety bumpety down into this really beautiful spot that was there off the road. He slammed the station wagon down there and I was going, "Oh, hell. We're going to be stuck here forever." The sun immediately set and the mosquitoes came out. Jerry really surprised me. He bustled all around and built a little fire and he cooked some steak and potatoes in tin foil and we made ourselves peanut butter and jelly sandwiches and sat out there. We spent the night looking at the stars and it was as sweet as it could possibly be. That is one of my most treasured memories because it was the only time we ever did anything like that and it was completely on his whim. In the morning, he threw everything back in the car and packed us all in there. I was so sure we'd never get that car out of there because it was so damp and we were way down in. He just hauled ass. Spinning mud all over, just *booow-wow,* he came up out of the woods and heaved this station wagon back up on to the logging road and we were out of there. It was really a lot of fun. When we got back, everybody said, "Where were you guys? You missed a great party."

There was a very very strong cohesive addiction that we all had to each other and to getting high together. It was hard to break off from the

group and get high separately. It felt lonely. When you were used to that connection being made for you all the time, you were being reflected back in a circular group. You were aware that it was limiting on a certain level. But you're also aware of the nurturing, and the comfort level was much higher. I'm talking about taking psychedelics. I don't think any of us were ready for the spiritual development that it would have required for us to go off and get high by ourselves and sit in a dark room and trip our brains out. That wasn't what we were doing at all. We were forming a social nucleus. It was very nuclear and it was very centered on the band members. Phil was a very strong-minded member. Phil never seemed to lose his consciousness of the situation or of the players or of the humor that was inherent in any of the silly stuff we did. I remember Phil as being one of the funniest people I'd ever heard in my whole life. Just a needle wit and he could keep you giggling when you really didn't want to laugh anymore because your face hurt.

bill thompson: The Grateful Dead and the Airplane started the Carousel Ballroom. This was in '68. The Airplane and the Grateful Dead got together and we were both going to be given ten percent of this club. We played there for free and we had lots of jamming shows. In return for that, we got ten percent. Ten percent of nothing. A guy named Ron Rakow ran the Carousel. Later, he would start Round Records for the Grateful Dead. He was our first mistake. He had cut a very bad deal. A hundred and some thousand dollars a year for rent. At that time, it was a lot of money.

ron rakow: I didn't want to do the Carousel. I made a deal for the ballroom which later was written up as the worst lease in show business. The deal I made was seven thousand dollars a month against fifteen percent of the gross. The deal my lawyer, who was incompetent, wrote up was seven thousand dollars a month *plus* fifteen percent of the gross. I had to sign it. By the time the papers were drawn up, we already had guys in the building with sledgehammers, chopping the building up.

sat santokh singh khalsa: There were two major critical errors made. The first one was that the previous owner of the Carousel had convinced Ron Rakow that the capacity of the place was greater than it was. In most places like that, the fire capacity is generally no more than

two thirds of the actual amount of people it can hold. It turned out that the previous owner had bribed the fire department and the fire capacity of the place was the physical capacity of the place. Ron always believed the true capacity was another fifteen hundred higher than that. That was one thing, and the other one was that he based his projection on carrying that place on the shows of the Grateful Dead, who could not play every night.

ron rakow: The fire capacity was not accurate. We knew we could get more people in there. But it was not a democracy. I ran that place. It was my mistake and I paid for it. It wasn't a communal thing.

owsley stanley: Rakow was charging too little and he was paying too much and he wasn't paying attention to what was going on. The band had nothing to do with it. They just contributed a certain amount of money to it in the beginning. Bill Graham offered people more money and told them that if they ever played for the Carousel Ballroom, they would never play for him. He wanted the hall for himself. It was a better location than the Fillmore.

ron rakow: The night Bill Graham and I were sitting in Zim's making the deal for him to take over the Carousel, Bobby Kennedy got assassinated. Prior to that, Martin Luther King, Jr., had been killed. For eleven weeks in a row, no dance halls made money. It was a bad business time. Also, I overpaid for every act because I had this bear barring people from playing for me. That was Bill.

bill thompson: It lasted less than a year. Then it became the Fillmore West.

jerry garcia (1988): *We thought we'd give it a try. It was terrible! But we did have some crazy times. We had a lot of fun. It was one of those things that we just couldn't make work. We weren't ruthless enough.*

carolyn "mountain girl" garcia: In that group situation, we all had a tendency to generalize and not be specifically one-on-one with people and just let the energy move around the room. It was not soul searching. It was soul involvement. It was admitting that you were part of this group and that you were involved with this group energy.

And it wasn't necessarily good for you as an individual during your individual growth. Jerry floated in it like nectar. He loved it because it allowed him lots of freedom. In it, he was pretty golden. He definitely had the gift of charming people and it almost seemed like the bigger the job, the harder he worked at it. Everyone sort of waited for his say-so. I know that Rock and Danny Rifkin wanted to run things a little bit more their way but Phil and Bill Kreutzmann both had strong leadership impulses. Jerry was really good at undermining them by changing the plans at the last minute.

owsley stanley: I got busted in December 1967 and while I was locked up, it changed. It became partitioned. The guys on stage had little black curtains between their little cubbies. It all got divided up. It became, "This is my territory and this is your territory and this is my job and that is your job." People started going off into their own dressing rooms and their own little cubicles on stage. To me, that was absolutely alien. It was more of a star trip. Somebody told me, "Things aren't the way they were in the old days. We're much more professional now." Weren't we always professional? We were writing the book on rock 'n' roll.

carolyn "mountain girl" garcia: Through the years, I mistrusted women less than I mistrusted a lot of men that came through our scene. I felt there were men who came through that were far more dangerous than any of the women. I felt equal to the men in the group. But I also felt the possessiveness of the situation. That in a certain way, I belonged to the group. I also felt it from Jerry. He was definitely a possessive person when it came to me. As far as I was concerned, it was a monogamous relationship. The playing around that went on, I tolerated it. The part I didn't like was women coming through the scene who were too messed up to look after themselves. I really frowned on that. They were never the ones who were after Jerry. His were more clever than that. They didn't come and stand in front of me. They knew better. But the ones who were interested in Bobby or Laird or Pigpen, they'd trail through the house. Basically, they were just looking for a place to lie down. I could feel that they were searching for something they could get their hooks into and that always really upset me.

17

carolyn "mountain girl" garcia: We moved out of the Haight into that little apartment. After that, the rush was on to Marin. Jerry and I found a little cottage which is gone now over in Larkspur. It was rented to us through Gino Cippolina, who was John's father and a sweet old man. Jerry and baby Sunshine and I moved over there and it was pretty bare bones. It was a really funky old place and we had to do a lot of cleanup. We lived there for about six months. While we were gone one time, we actually had everything stolen out of that house. We had no furniture left. Nothing but the bed. They left the mattress on the bed and I think one chair but everything else had been moved out. They even stole Jerry's banjo.

Jerry had gone to rehearsal and I was sitting on the porch just feeling really sad and this guy walked up and he was this really weird-looking guy. He had another guy with him that was skulking around and looking around the corners really weird. He said, "If Jerry wants his banjo back, it's going to cost you about a hundred dollars." And I went, "Hah, okay. Got the message. Check back with us tomorrow. Same time, same station." When Jerry got home, I told him the story and he was like, "Oh, wow."

So we got together ninety bucks for this guy and bought Jerry's banjo back. But we didn't get anything else back. The baby bed and the baby clothes were gone. They even took my diapers. These guys were a bunch of junkies and it turned out they were guys that Jerry knew a little bit. We were really lucky that he did because I don't think we'd ever have gotten any of those things back. For a lot of this time, I knew nothing about nothing. I didn't understand that there were junkies out there that would steal stuff from you. They'd steal stuff from their mother.

We were really broke during those days. We had no extra anything. It was hard to stay honest when you were that broke all the time. I was not

above boosting a pint of strawberries from the grocery store. Luxuries were out of reach. But life was a lot less expensive in those days. I think we paid a hundred and twenty-five dollars a month for that cottage.

bob weir: Needless to say, for the first many years of our existence, we didn't run a very tight ship businesswise. God knows how much money got away from us. More often than not, we'd be going through pretty lean times. After a fair bit of that, we started to try to streamline things so that our managers wouldn't take our money and run. So we would be able to function fairly comfortably without having to be constantly scrounging. Bill Graham came and made a presentation to us. Basically, he was too organized for us. We weren't ready for even that much structure. We were a complete democracy. The band and the crew and the family would all come to our meetings. With Bill, there would be shouting. In rapid order, we sort of drifted apart.

jon mcintire: We were at Mickey Hart's barn in Novato and Mickey said something like, "Okay, so we've got a problem here. We've got a crisis. We don't have anybody managing us. We have a problem with keeping track of stuff. We're hippies and we need something more, and enter Lenny Hart, my father. . . ." On cue, Lenny entered from behind this door. There was this concrete runway through the middle of the room and Lenny started rapping like a charismatic minister and he was a self-appointed Pentecostal minister. "Okay. We're talking about the spirit. We're talking about the spirit of God. We're talking about the spirit of the devil. We're talking about the same thing. It's the spirit. We want to bring out the spirit. We're the spirit of music, we're the spirit of . . ." He was going on and on and on and walking the whole time, throwing out this charismatic rap and they hired him. The same way I became their manager was the way Lenny became their manager. He was there. At that moment.

At the really big junctures, Garcia called the shots. He was always the goose that laid the golden egg. But Garcia didn't believe in being very consciously selective about these kind of things. Especially the stuff that he didn't take very seriously. Such as management. In terms of Lenny Hart, he wanted to believe. Absolutely. Anybody that Garcia chose, he was going to give full belief to. You had to fuck up bad before he would cut you loose. You had to be a jerk. You could make any number of

mistakes and Garcia would say, "Of course, mistakes are made. It seemed like a good idea at the time. It just didn't work out." That was the way they did it on stage with music. They would go down different musical lines and try it and then say, "Well, that one didn't work out."

bob weir: Then Mickey's father came in and that was a fiasco. Mickey's father didn't argue with us. He didn't have the time. He was too busy pocketing money.

owsley stanley: They wanted to play the bigger shows and they had to keep renting sound systems that didn't coordinate very well with the gear that was there. They turned to me and said, "Do something."

carolyn "mountain girl" garcia: After we lost that cottage, we had a second house on Madrone Avenue. Hunter lived with us and that was where *American Beauty* came together. John Dawson lived right across the street. Our house was 271 Madrone and we lived there for almost two years. It was during that time that Annabelle was born. It was also the period of time during which Altamont took place. The band had just done Woodstock so they were still high on that Woodstock vibe. The Woodstock thing had been so incredible. It really set the stage for Altamont because it raised everybody's expectations about how everybody would come together and how this thing would be so great. In other words, the audience would lend their participatory energy to making this a wonderful event. That didn't happen.

nicki scully: I went by myself to Woodstock and discovered coincidentally that I was on the same plane with the band so I sat with Jerry and he took me under his wing. I ran with Jerry for a day or two until I found Rock. It was a fun trip. Everyone was up for it. I remember we wound up at some motel. The first time we went into the site, I went with Jerry and it was pretty easy to get in. We checked things out. And then when I tried to get back in with Rock at four in the morning, it took hours and hours.

owsley stanley: Woodstock was a disaster because the wrong sort of people tried to control it instead of just flowing with it. The

helicopters and all those guys with their weird announcements about things that could have easily been avoided.

nicki scully: I had been carrying around this bag with brown acid. I hadn't been giving it out because I'd already been told it was bad. I had it and nobody was going to get any more. Then I looked and there was a hole in the bottom. I had been trickling brown acid wherever I walked.

owsley stanley: On stage, they had four of these large plywood cookies with two-by-four structure and casters underneath. They would set up two bands back-to-back on the cookies, roll them into place, and that was their way of getting rid of the time lag between sets. Ramrod and I looked at this and we said, "This is not going to work. Our equipment is too heavy. We're gonna have to set up on stage." They told us, "Absolutely not. You have to do it this way." The time came for our set. The guys hooked up the ropes. The plywood moved approximately one foot and all the casters broke. *Wham.* Down the thing came on the floor. We had to take everything down and set it up again. Everyone was bitching and saying it was our fault. We hooked it all up again on the stage. Phil turned on his bass amp. Out came the helicopter. We were getting the helicopter radio on Phil Lesh's bass. It was not a great show.

nicki scully: I was standing on stage as they played. It was night. The wind was blowing, nearly tipping over the stage. It was an ominous moment. I was so high that I knew it was my fault. I knew if I weren't there, everything would have improved instantly. Looking out over that sea of people in every direction, there was obviously no place to go. No way out. I tried to dance. I couldn't dance. I really struggled to help them by trying to get myself out of the funk I was in. It was like a bad acid trip. It was a bad acid trip.

jon mcintire: I was their manager at Woodstock. They got off stage and they'd sucked the hairy root. They were just horrible. I'd never heard them play so badly. I was feeling it personally and I was crestfallen. I was so embarrassed. But I would never have talked to Jerry about it. Later on, when I felt more at ease talking with each of them about musical things, I would have said, "God, that was awful!" But at that point, I

didn't feel it was my place to make any musical comments. I just happened to be standing there when Garcia was walking off stage. He walked up and looked at me and said, "Well, it's nice to know you can blow the most important gig in your career and it doesn't really matter." There it was. The epitome of cool.

sat santokh singh khalsa: Jerry and MG and Sunshine lived in Larkspur. I was still recuperating from Woodstock and I was living in Mountain Girl's bus. At nine o'clock in the morning every day, Jerry and I would watch *Sesame Street,* essentially with Sunshine. But if Sunshine wasn't there, we watched it anyway. We liked the psychedelic images of the show.

carolyn "mountain girl" garcia: I didn't go to Woodstock. I was pregnant with Annabelle and decided not to make the trek. I regretted not being there. I watched it on TV and I heard all the stories. But it set the stage for Altamont, which was a series of errors. It has been exhaustively autopsied but each of us had a different path through that thing and it was all scary.

owsley stanley: Altamont was an example of greed, the inability and unwillingness of the Rolling Stones to take care of one of their problems, which was with the company that owned the Sears Point Raceway, and the energy of the event. It was December 6, the day before Pearl Harbor Day, which is a very low energy moment in the yearly cycle anyway.

jerry garcia (1988): *Originally, the Rolling Stones were just going to come out and play in Golden Gate Park. They made the stupid mistake of announcing that they were going to play. That was it. That was the end of it right there. They should have just called it off from then on. But the Stones were traveling in a bubble. They couldn't be contacted. You couldn't explain. Somebody, I think it was Emmet Grogan, wrote on the bulletin board up at Alembic Sound up by Hamilton Field where we were rehearsing and a lot of planning was going on—"First Annual Charlie Manson Death Festival." Before it happened. It was in the air that it was not a good time to do something. There were too many divisive elements. It was too weird.*

owsley stanley: We were driving to Altamont in a sports car that I had. All of a sudden, we looked up and there was this rocket blowing up in the sky. I said, "That's got to be some kind of strange sign." We couldn't figure out where to get off the freeway. Most people drove along until they saw the site and then drove right onto the grounds. We took a turnoff somewhere and the road kept getting weirder and weirder and the trees kept getting closer and closer and eventually we were going through a tunnel. We came out of this tunnel into this moonscape of crushed auto bodies. Crushed and crunched. As we drove along, we looked over to the left and we saw this place that looked like a skull. It was the actual arena in which they had these demolition derbies. And I thought, "Oh, my God. This place smells of death. And of the energy of people who come here to watch other people crashing these cars and hoping they die." I thought, "This is the *worst* possible place to hold something like this." I realized that if you took acid at this show, you were going to have a trip you didn't really want to do.

jon mcintire: Lenny Hart, Mickey's father, was the co-manager with me during Altamont. Before we went there, we were on the helicopter pad with the Rolling Stones. Lenny ran over to Mick Jagger and said, "*Mick! Mick!* You remember Jerry?" and he dragged him over. They'd never met. Of course, they put the Rolling Stones on the helicopter first. They were more famous.

jerry garcia (1988): *And that place. God. It was like hell. It was like one of those things you could watch happening. You could see it coming and you couldn't do anything about it. Like watching trains. I ended up acting like a security person. Trying to keep people off the stage and off stuff. I never was threatened. But it was horrible. We went there expecting to play but we didn't play. It was so horrible for one thing. For another thing, Pigpen got lost in the traffic flying in and out and he didn't show up. We had another gig that night but we blew it out. We said, "Fuck it." We were too depressed.*

laird grant: Straight people used to say to Jerry, "Oh God, man. The Hell's Angels, you ought to take their jackets away from them." But he would say, "No, man. It's a good thing they have the jackets on. At least you know where they are and who they are. All those straight people

wearing the same colored suit walking down the street are the sons of bitches you got to look out for because they're all wolves in sheep's clothing. At least here you can see the wolves. You can know who they are when they growl at you." That was the basic thing of the Dead. We got out there and growled. Sometimes we bit. Sometimes we got bit back.

carolyn "mountain girl" garcia: Altamont was a terrible blow. It was organized originally in my living room and it seemed like such a good idea at the time. And to have it turn into such a nightmare was frightening for us. We were still pretty addicted to the peace and love generation. To have it turn into such a nightmare was a serious wake-up call. After it all went down, we all felt guilty and really concerned about the people who had gone out there and gotten hurt. Every single one of us saw different terrible things that happened there. I think it made the band aware of the danger of calling attention to yourself and calling for mass attendance at these kind of events.

18

john "marmaduke" dawson: The Dead had just gotten back from a road trip and they were at their place in Hamilton Field. They had a big barnlike building with an office that they used as a studio and a rehearsal hall. I was hanging out up there and Garcia said, "I got this brand-new pedal steel guitar." I said, "Can I come over and hear it?" And he said, "Sure." So I brought my guitar and a few of my songs and he just jumped right into it. Like not even sticking his toe in the water to see what the water temperature was. He just jumped in and started playing pedal steel.

I played him some of my songs and he said, "Oh yeah, this is cool. That's nice. I like that. When are we going to do this again?" And I said, "I've got this gig down in Menlo Park." On Wednesday evenings, I was the entertainment in a Hofbrau House not far down the street from Guitars Unlimited. I'd play for a couple hours for the people eating their roast beef sandwiches. Garcia invited himself along. He had this little foreshortened school bus, just as big around as a regular school bus but squashed, only four rows of seats in it. They had converted that to a hippie van slightly bigger than a Volkswagen. He put his pedal steel together and he would drive all the way from Larkspur down to Menlo Park every Wednesday and unload the stuff and set it up.

I'd sit there and do my songs and he'd accompany me on the steel. There wasn't any money involved and there was no importance to the thing. But it got to be pretty good. On Wednesday evenings at about seven o'clock, you could see all the kids emptying out of the Round Table Pizza Parlor which was their normal hangout up the street. They'd come marching down the street and pay their fifty cents or a dollar at the door of the Underground, which was the name of this Hofbrau House.

david nelson: I was staying at Jerry's house. Hunter came downstairs one day and said, "I've got a name for you. The Riders of the Purple Sage." We'd called ourselves the Murdering Punks and we'd also had some other names. I said, "There already *is* a Riders of the Purple Sage. Foy Willing and the Riders of the Purple Sage. How about New Riders of the Purple Sage?" And he said, "You just like names with new in 'em." Because I had just been in the New Delhi River Band. And we'd all always liked the New Lost City Ramblers.

john "marmaduke" dawson: After the Underground, we said, "Let's make a little bar band out of this." Like the country and western guys who played in bars and had a good time. So we got Nelson and we rehearsed a bunch of stuff.

david nelson: When we were starting the New Riders, I was staying at Jerry's house in Larkspur. That was where I first heard all the Grateful Dead's new songs because the band would come in and do vocal rehearsals in Jerry's house. I got to hear "Attics of My Life" and "Candyman" and "Cumberland Blues." God, it was great. On *Workingman's Dead,* I play acoustic guitar on "Cumberland Blues." It's pretty apparent that song is about Cumberland, the mines, and the southern Appalachians. After the big chorus and singing, it comes back into a rest on G and gets more country. Jerry was going to play banjo there and I was going to play guitar. Just like we did in the Wildwood Boys. But the banjo playing didn't mesh with the drums. It had never been done and it was too much trouble so Jerry stuck with the little banjo-y sound on the electric guitar and he had me play the acoustic part. I know he did do a banjo track on that. Maybe they just mixed it down. But it was him and me playing some bluegrass on there.

john "marmaduke" dawson: This was when Hunter came up with the idea for "Friend of the Devil." Hunter was living in Garcia's house. He came over to my house and said, "I've got this brand new song." He had the melody. "Okay," I said. "So you can do that twice. Then you gotta go somewhere else." I came up with the other place to go to. "A friend of the devil is a friend of mine." I came up with the chorus. The hook part. Together, we evolved that song.

david nelson: I ran the tape recorder and strummed along while they worked out this tune, "Friend of the Devil." Actually, Hunter had it pretty much worked out. It was just me and John playing along as far as I was concerned but Hunter swears that John really helped write it. I have the piece of paper that Hunter wrote the lyrics on and it has lyrics on it that aren't in there. Before Hunter thought of, "Set out runnin' but I take my time," it was "Looks like water, tastes like wine. Run like the demon from the thousand swine." That was crossed out. Then in place of it is "Set out runnin' but I take my time, a friend of the Devil is a friend of mine." They changed "Got a girl in Boston, babe and one in O-hi-o" to "Got a wife in Chino, babe, and one in Cherokee. First one says she's got my child but it don't look like me." It's in his handwriting and the chords are A minor, E minor, F, E minor. F, C, F, C.

john "marmaduke" dawson: Garcia listened to it and said, "Fine, fine. That's very nice. But it needs a bridge." So Hunter said, "Okay," and he scribbled out some more words. No problem for Hunter. He could do it. He could write 'em out. Just turn him on. "Got two reasons why I cry..." That was the bridge. Hunter wrote the words and Garcia came up with the tune for that and that was how the three of us got that song together. Garcia would make Hunter agonize over a single turn of phrase. Over a single word. Hunter would have to sit there and come up with it because it wasn't good enough for Garcia. Garcia couldn't do that himself but he was a judge of it and he appreciated where Hunter was coming from. Hunter was the only guy that he ever wrote with. Except for that one occasion.

david grisman: If Jerry came to the East Coast, we'd hang out. If I came to the West Coast, we hung out. I was in a band called Earth Opera and our last gig was somewhere south of L.A. I came up to visit a friend in San Francisco for a weekend right after that. Somehow we ended up in Fairfax at a baseball game between the Grateful Dead and the Jefferson Airplane. I ran into Jerry and that was where he asked me to play on *American Beauty*. If I hadn't gone to the baseball game, I would not have gotten asked. He saw me and said, "I got some tunes that you'd sound great on." Which turned out to be "Friend of the Devil" and "Ripple." I played two mandolin parts on "Ripple." It was just an overdub session. No interaction other than a couple of the guys had suggestions. I

certainly didn't realize then that these tracks would become landmarks in the Grateful Dead repertoire.

david nelson: During the two-year period before all this when I hadn't seen Jerry, he'd gone through a transformation. He had the full beard and he was wearing the Levi shirt and that poncho all the time. He looked beatified. I thought he looked like an angel. Like an angel with a bad streak.

john "marmaduke" dawson: We played a gig at a benefit for the Hell's Angels. That was at Longshoreman's Hall and the Bear [Owsley Stanley] was our soundman. This night at Longshoreman's Hall, something fucked up with the PA. I don't know what it was. I don't think the Bear knew what it was. But the Bear started whipping out all this shit. Here was the soldering gun coming out. And here were these six-foot Hell's Angels coming up and saying, "Uh, you think you could play some music?" And I was saying, "We need the PA, man. We sing and we have to have the PA." "Hey, man. Couldn't you just *play?* You don't need the PA. Just play some stuff." We were saying, "Bear, come *on.* Get this goddamn thing *fixed.*" Eventually he got it on and we actually played a couple of songs for the people. We played for the Angels on a couple of occasions when the Grateful Dead had nothing to do with it. We played for Sonny Barger's birthday party in Folsom Prison.

sonny barger: The Grateful Dead actually had always been our friends. They'd been friends of the Hell's Angels since the sixties. I guess Jerry was the main reason. Jerry liked us and we liked Jerry. Other people in the band sort of came and went but Jerry was always there. Jerry said he was scared of us but I don't believe it.

john "marmaduke" dawson: In the New Riders, we got Mickey Hart to play the drums and Phil to play the bass. In order for us to go on the Grateful Dead's tour, Jerry needed only two more tickets. He only needed to add my name and Nelson's name to the itinerary. Because everybody else was already in the band. We gave them an opening act for cheap. For the price of two tickets, he got a new five-piece band to open for the Dead.

david nelson: Those nights were great. The New Riders would do a forty-five-minute set. Jerry could sit down and play pedal steel. There was no pressure on him because it was not his band and he wasn't singing anything. Then he'd do the acoustic thing in between. That was the Dead actually but me and John would come up and do a couple songs. Then they did the full electric set. It was called "An Evening with the Grateful Dead." Jerry would be on stage all night long. In those days, the show wasn't over at two in the morning. Sometimes, it was over at like six in the morning. Not every gig. But sometimes.

john "marmaduke" dawson: The first time we played Fillmore East was "An Evening with the Grateful Dead Featuring the New Riders of the Purple Sage." Jerry was in heaven. Because he was a picking junkie. If he was ever going to be accused of being a junkie, accuse him of being a picking junkie first. Before he got to be uncomfortable without some heroin in his blood, he got to be uncomfortable without a guitar in his hand. That was his first draw.

jerry garcia (1988): *We did our great shows at Fillmore East. We worked for 'em. The crowd was sitting down and they got it out of us. They pulled it out of us. In the Bay Area, it was almost too easy.*

joshua white: The Dead started coming to Fillmore East. When it started, the Dead were just this band with Pigpen. Then the Deadhead concept began to develop. So the concerts went longer and longer and later and later and Owsley was around.

john "marmaduke" dawson: We always stayed around after our set was over to watch the Dead. The real magic was in the days when there were still people allowed on stage. When they still allowed their friends to have backstage passes. It was almost like a church hierarchy. After a while, they evolved it so that nobody got on stage except a band member or a member of the crew like Steve Parish or Kid or Dan Healy or Harry Popick. Only those people. Nobody else. In the days when it was really cool was when everybody was hanging out there. When it got truly apocalyptic at the end, there was this feeling that "Okay, this is a model of how the world could be." Everybody having a good time and

everybody getting off. Everybody going "Ohhhhh *woww!*" during one of those churning ongoing jams.

joshua white: It wasn't just the band coming to play. It was the band with their whole environment that they brought with them. People were hanging around to score Owsley acid and then they wanted to do the show on Owsley acid. I remember visiting the light show backstage during the winter of 1970. By then, I had already moved into large-screen video projection. All my former colleagues were still performing the light show for the Grateful Dead at Fillmore East. Sparks were coming out of their heads. They were not people I knew anymore. To me, they were aliens who were so deeply involved in this Dead concert that nothing could distract them. The concerts themselves began to go on until five in the morning.

john "marmaduke" dawson: In the first days, the length of the sets was due to the LSD because that gave you that unlimited amount of energy. You didn't even know when you were tired and you couldn't go to sleep. There was no fucking reason to even try to go to sleep. Because it was brighter with your eyes closed than it was with them open. There was more noise that way. That was how they evolved into playing these three and four and five hour long sets. In terms of how tired Jerry would get on stage, Garcia was not known for his James Brown imitations. He just stood there and sang. Still, the Dead would try for that magic each time. Sometimes they would get it. The magic of all of them seeming to think together, possibly because of all the times they had played together. Garcia was the one who was the blind leading the blind. None of them knew where they were going. Especially in those spaces. They were just looking around. Garcia would be there playing around with something and Weir would be playing around with something and everybody would be doing five things together on the stage and people would still be listening and saying, "What the hell is going on here?"

dexter johnson: I saw Jerry with the Grateful Dead and Jefferson Airplane do a duet show at the Fillmore. Jorma and Jerry just traded licks and it was unbelievable. I remember the light show flashing the words "The Grateful Airplane." In "Dark Star," it was like he was

finding new notes. They weren't new notes of course but a new way of doing it.

tom constanten: If you listen to, say, "Dark Star," the reason you won't hear as much black blues is because Jerry's using more penta-tonic-type scales. He was not using your flat fives, your flat threes, the little signals that say "blues." But that was a minor technical adjustment in his own playing. It wasn't like he was saying, "I'm going to adopt this entire style of playing or go with this style of playing." The trappings or components of a style make more difference to a reviewer or listener. Whereas when you're playing, you're just dealing with mechanical things. You get into the inner kernel that way and there's a lot of stuff that doesn't make any difference. During "Dark Star," I don't think Jerry would be thinking, "I'm affecting this or that style." He was merely adapt-ing the mode to the mode of the subtext of the piece. Except to the degree that he might want to make some implication or some sort of reference like "First there is no mountain, then there is. . . ." Throwing in that sort of thing. There were a lot of pieces that sounded real good but they were very hard to fly like one of those World War I biplanes. You had to have a crew of six, each minding these gauges to make sure that it came out okay. "Dark Star" was the opposite of that. It was sublimely easy to fly and it worked wonderfully well and you could go any number of places. Rhythmically, you could superimpose triplet patterns. You could do two-plet patterns. You could take them either direction you wanted to go. For that reason, I don't know if it was even rehearsable. It was only ever a showcase for Jerry's playing to the same degree that ninety-five percent of all the tunes they played were showcases for his playing. In terms of the lyrics, like a lot of the words, they were words that if you were on the psychedelic mountain, you could just let them reflect and refract and do what they do. They would reflect the moment as it was and as you perceived it at that time. "Dark Star" is going on all the time. It's going right now. You don't begin it so much as enter it. You don't end it so much as leave it. Any Fillmore East "Dark Star," I would recommend.

john "marmaduke" dawson: After a couple of tours back there, the New Riders got their own record deal. Clive Davis had his eye on Garcia the whole time. I think he recognized that Garcia was the true talent in that mob. He wanted him and the only way that he

was going to get him was by getting the New Riders. Like Garcia used to say, man. "Sell out? Sell out! Where do I sign?"

joshua white: They had this thing with dosing people. "Whhheeee. Wicked. Awful stuff." Trying to dose Bill Graham and dose this person and dose that person. Basically, they were all taking cocaine or speed. That's what it really all was. It was a very hypocritical time.

peter rowan: One thing I didn't really like about the Dead was this kind of obligatory dosing that went on. It was a mind-control thing. Being backstage with them, you'd often find yourself high on acid. The rule was, "Go with the flow." So it was like, "Oh no, the flowers are talking at me again. Not that bass solo now. Oh, no." I would be trying to go to the men's room and Phil Lesh would decide it was time to kick in some new invention he had that dropped the octave to the center of the earth. The walls would be caving in and all I wanted to do was take a piss.

joe smith: They always said they would get me. They would nail me. They would dose me. Because I couldn't understand their music unless I did. I never did. But I wouldn't eat around them or drink around them. One time in New York, they were playing the Electric Circus in the Village. I was having dinner four blocks away at the Coach House. It was a cold night. One of those wind chill specials and I had on a light raincoat but I wanted to see them. I went running down the street and I was really freezing. I got up the stairs of the Electric Circus and they were on a break. Bill Kreutzmann and Pigpen were there. They were so surprised to see me and they were hugging me and saying, "Jesus, it's cold. You want some coffee?" I said, "Yeah. God, get me some coffee." As they started to get the cup, I said, "Wait. I'll get my own coffee." They said, "What's the matter?" I said, "No. I'll get my own coffee. I'll get it. Don't get it for me. Don't do me any favors." I once inhaled the gas with them. I did that. The laughing gas. I thought, "I've now broken eight of the Ten Commandments." The Top Ten Commandments.

john "marmaduke" dawson: Jerry used to be doing up acid behind the stage. Back in the magic days when everybody was

able to be on stage, everybody would be stoned on acid and then you'd smoke some DMT. Bear swore to me, and I've heard other people say this, too, that when they were smoking the DMT, the meters on the amplifiers would actually crank up about ten or twenty percent. You could actually see the meter going up when the DMT was being smoked back there.

joe smith: With the Grateful Dead, the use of drugs was so pervasive and innocent at that time. Crack makes you crazy and speed gets you nuts but acid really turned the world upside down so you didn't know where reality let off and fantasy began. My adventures with the Grateful Dead were dumbfounding. They never fired a manager. They never got rid of anybody. When we'd have a meeting, sixty people would show up. Mothers nursing babies. Owsley mixing up God knows what on the side. Everything. It was a phalanx that moved in.

david nelson: Jerry was not yet doing coke. Not that I knew about it. I wasn't familiar with that until the New Riders started hobnobbing with some of the high rollers around the country. I wondered, "What's everybody doing?" Garcia told me, "Oh, it's coke, man. Here. Try it." I remember thinking, "I don't like this. Oh, no. This is going to be another one of those speed things." I had written when I was on speed, on methedrine. I was so gung ho when I was doing it and then I'd read it later and it was just drivel. The most self-indulgent self-satisfying kind of drivel you could imagine. Really trivial and it had no substance whatsoever and it was not soulful. And pushy to boot. I hated that. Musically, I thought, "Okay, here go the ideas out the window. Nothing's going to be valid for the time. . . . How long does this stuff last?" I cautioned myself about it. Nevertheless, I got bit by the same thing that everybody did. It was such a wonderful thing to have that frontal brain activity out there. To have all those thoughts. If you didn't get too self-indulgent with that, it could be useful. Otherwise, I just thought it was nowhere.

john "marmaduke" dawson: As to joints, Garcia usually had his own. Mountain Girl was a fabulous farmer. He'd be sitting there at the beginning of a session twisting up a couple of doobs and then he'd have them ready for when he wanted them. I don't remember him

having done particularly more or less than anybody. I do remember the evening that everybody was passing around the Acapulco Gold and the joint was just about finished or a couple of joints were just about finished. Everybody was sitting there and Garcia said, "I want to make enough money to stay high like this forever."

19

clifford "tiff" garcia: As far as the drugs went, my
mom was not worried about Jerry. She figured it was trendy. She was a
nurse so she had gone back to nursing. She worked the night shift and
she would go to work at four in the afternoon. She had a dog that I had
given her and she'd take the dog up to Twin Peaks and let him run
before she went to work. Then she'd drop him off at the house and go
to San Francisco General, the hospital she worked at. She had stopped
the car. Before she put it in park and set the hand brake, the dog got
really excited and got between the brake and the gas. She put her foot on
the gas and her Oldsmobile Cutlass went off a cliff into a tree. You
wouldn't believe it could happen. From the windshield and the dash-
board back, everything was totally intact. Everything in front of that was
shredded. The engine included. It couldn't have stuck out more than a
foot or two.

This was in 1970. She was sixty and in excellent health. Jerry was the
one that told me about it. My wife and I were living back in the city at
Harrington Street so he knew where to find me. He came by there and
left a message. "Mom's in the hospital." He was hanging out there until
I got home from work and then we both went to the hospital. Jerry
was working at Wally Heider's and I was working in the Post Office.
He'd pick me up at the Rincon Annex and we'd go to the hospital. Every
night for a month. We both lost twenty pounds. It was that stressful. She
had multiple injuries. Slowly, she was fading. There were other things
where you couldn't count on Jerry. You couldn't count on his being reg-
ular to show up for events. Just like me. But he showed up for this. We
both did.

jon mcintire: When I would ask, Jerry would tell me about the members of his family. I asked him once, "How come you don't ever see them?" And he said, "That's just not the kind of family we are."

carolyn "mountain girl" garcia: Jerry's mom died while they were working on *American Beauty* at Wally Heider's. Jerry had never wanted me to meet his mother. All I can say is that we were not family oriented at that time. We were still into the rebellious stage. My parents were not particularly welcome at all. Even my brothers weren't particularly welcome. One of the problems of the group scene was it took over from your blood family. It became your true family. I didn't meet his mom until we got to the hospital. She was lying there just miserable. Fully conscious and in pain and on a breathing tube with casts everywhere. It was very sad. I took Annabelle in there to see her so she did get to see her granddaughter. After she died, I felt pretty bad that I hadn't insisted on developing a relationship with her.

sara ruppenthal garcia: Although Jerry and I had been split up for some years, his mother and I were very close. During the two weeks she took to die after her car accident in 1970, I was teaching nursery school at a Quaker school in Palo Alto in the mornings. Then I'd drive up to the city and be with her in the afternoons. Jerry and I were in the elevator there together once before she died. I remember trying to talk to him about seeing each other and his mother being in such bad shape and I remember him saying, "God! You even wear the same perfume that my mother wears." He couldn't stand it. It reminded him too much of his mother and he couldn't deal with it.

clifford "tiff" garcia: I don't think either Jerry or I cried because to tell you the truth, I think we were all cried out when my father died. Sometimes, you expel all your emotions only once in a lifetime. The rest of it tenses up and it's hard for people to release it. Instead, you keep stuff built up inside.

carolyn "mountain girl" garcia: Jerry took her death really hard. He was so saddened by it. I could tell there were issues with his mom that had not been resolved. Then he came to that moment

when he knew they could never be resolved. When Jerry came to that, he was spending quite a bit of time with Tiff.

clifford "tiff" garcia: We were warm with one another. That was the thing. We were pretty warm. But the other thing was that I was standoffish. I never got involved in his shit because a lot of the drug dealers used to hang around and it was just a little sleazy. Basically, I was not a night person. I hated the bar atmosphere or anybody that got drunk. I generally never bothered him at shows because everybody was trying to bother him and I figured he needed the space and I didn't have a hell of a lot to say to him anyway. The time wasn't right.

carolyn "mountain girl" garcia: After his mom died, Jerry sank into a rather serious depression for a while. It was hard for him to finish that record. He had no joy for a long time. It lasted for months. He got very close to the children at that time and he told me lots of stories about his upbringing and his mom I'd never heard before. As far as he was concerned, what she had done wrong was that she had remarried. Think about it from the kid's point of view. His father drowned. This was all terribly sad. Then she married a stranger who expected to be able to discipline these little boys. Apparently, he was real hard on them. He was somebody with quite a temper. Jerry just hated this guy and that is so typical. Think of women who have lost their husband or been divorced and then the boyfriend comes in and the kids are growling at him from the corners. That was why Jerry wound up at Grandma's house. Ruth couldn't deal with Jerry's passion about her new husband. Tiff was older. He wasn't a little kid. I have a feeling this guy was pretty hard on Tiff, too. I know Jerry was furious when they buried his mother next to this guy. Oh, Jerry was mad about that. He didn't like her being buried next to this guy. But that was where her plot was.

clifford "tiff" garcia: After the funeral, Jerry and I rode around the cemetery smoking a joint. It was nice. My cousin gave us a joint and it was sweet.

carolyn "mountain girl" garcia: Jerry never blamed Ruth for what happened to his father. It was just that he had witnessed it and it was terrible. He said to me that his childhood had

been so painful that for him to seek any kind of therapy or go back over that stuff would be so dreadful that he couldn't even conceive of doing it. To bring all that stuff up again would be so painful that he couldn't make himself do it. That was really all the information I had to go on but of course it broke my heart. I felt so bad about it and was terribly sympathetic. Somehow, his mom passing away brought us closer together. He remembered that he really loved his brother and it was a sweet time for us. We had lots of time together without anybody else hanging around in the living room and it made for a very close family scene there for quite some time.

20

carolyn "mountain girl" garcia: We moved to Stinson Beach. I wanted to get away from those people who would come over to our house, take up space, and drive me crazy. They would sit around the living room and talk to Jerry. Our circle of acquaintances had expanded considerably and some folks had come to work for the band that I couldn't stand and there was an element around that was the hustler kind of element. What I never understood before was just how much of the power went with us. When we went out there, a lot of people moved out there with us. I thought, "Oh, you guys are moving out to Stinson too? How cool." Ron Rakow was our neighbor. Big Steve Parish moved out there. The Rowan brothers were out there. It changed our social set.

richard loren: Gino Cippolina got us this house in Stinson Beach. David Grisman and I and the Rowan brothers all moved in. David was at Ed's Superette and Jerry was in there buying cigarettes. David came back and said, "You know who lives in Stinson Beach? Jerry Garcia. He lives on the hill." I said, "No shit. Isn't that a pisser?" David and I started visiting Jerry mornings up at the house on the hill. MG was there. Jerry would wake up, have his coffee, and we'd sit around and bullshit for a couple of hours about the music business. We'd smoke big joints and listen to everything from the Swan Silvertones to Stockhausen. We'd listen to whatever was turning Jerry on at the time and it was never necessarily some new rock band. We had a lot of questions about the music business. Granted, I'd been an agent for years but Jerry told me inside stuff about his dealings with Warner Brothers and Joe Smith. The things to avoid and the pitfalls of the industry.

joe smith: The Grateful Dead could go to New York and sell out any place but the first two albums didn't sell that well. Somehow, they

never captured what they were on stage. We decided to do a live album and record it in different places. In terms of making an album back then, thirty to forty thousand dollars was a major investment. I figured, "Okay. We'll give them thirty grand." With their great indecisiveness, with the drugs, and with their running around, three would be straight and two would be stoned, and two would be straight and three would be stoned, and four would—and then they'd all be stoned. They ended up spending ninety grand. Which at the time was unheard of. Then they wanted to call the album *Skull Fuck*. I remember we were all sitting around and talking and Phil Lesh, the bass player, said, "I've got a great idea. We'll go to L.A. and we'll record thirty minutes of very heavy air on a smoggy day and then we'll go to the desert where it's clear and record thirty minutes of clear air and we'll mix it and we'll use that as a pad and we'll record over it." I was waiting for people to laugh. But nobody laughed. He was serious and they all agreed it was a great idea. I had to tell them the American Federation of Musicians wouldn't allow it. So they couldn't do it.

carolyn "mountain girl" garcia: Everybody was sick of Warner Brothers Records and their little routines and trying to stay on the edge rather than just lay back and not sell records very much. Because the Dead's records just didn't sell worth beans compared to the Airplane, who had really hot record sales. We didn't and it was tough.

joe smith: At one of our interminable meetings, the Dead convinced me that we didn't know how to promote their records. They hated everybody. They just hated me a little less. I was the guy they would talk to. They said, "You guys just don't know how to do this. Let us promote the record. Set up these cities. We'll send out members of the family and members of the band. We'll go out." In excruciating detail, we set up sixteen cities they were going to. Our promotion people were going to pick them up at the airports. We had lined up all the alternative radio stations, the FM people, and so forth. All the members of the group failed to make the planes they were going on. They were not going on the same plane. Different times. Different planes. Different cities. Every one of them blew it. I had sixteen people standing out there at the airports in Baltimore, in Seattle, in Boston, in Miami. Nobody showed. Because nobody made the plane.

richard loren: I don't think Jerry had anything bad to say about Warner Brothers at the time. He had just gotten a record deal from Joe Smith to do a solo album. The one where he played all the instruments with "Sugaree" on it. That was the album that was coming together in his little studio which he had built outside of his home on the hill at Stinson Beach. I think it was the first record project that he'd done outside of the Grateful Dead and it paid for the house. He would talk with us and then he'd go up and record.

carolyn "mountain girl" garcia: Basically, I just wanted a place where I could grow a garden and have some privacy. We had a beautiful yard. It was so private and pleasant up there. God really smiled on us. The cosmos really looked out for us because it was a gorgeous spot and we got it at a good time for us. The kids were small and it was safe. It was secure and a place where if you wanted to sit in the sun and do nothing, you could. Jerry built a studio there. Old and In the Way rehearsed in the living room, which was just great. Bob Dylan even came over and visited us. Trixie was born. Theresa was nicknamed Trixie as soon as she was born. It was all very idyllic. That place was paradise.

peter rowan: David Grisman, with whom I'd been in Earth Opera, was living in California and producing my two younger brothers, Chris and Lorin, for Clive Davis on Columbia. I'd heard some of Garcia's playing on their demos and I thought, "Cool. This is going to be interesting." After Sea Train broke up, I moved out there as well and we all ended living in Stinson Beach. I remember there was a sign outside Garcia's house. It said SANS SOUCI, which means "without care." The word "serendipitous" became this big word. Synchronistic happenings. We were out there on the San Andreas fault line smoking dope and going, "Man, I don't know what it is. But man, this is, this is, this is . . ."

The guy of course that we all gravitated toward was Jerry. For me as a musician, the reason for hanging out with Garcia was to play music with him. For other people, it might have been an intellectual thing. Because Jerry was a tremendous conversationalist as well. As a musician, it was so rare for me to see another musician who loved to let the discursive thought net subside. Between musicians, there's always a lot of eye contact and nodding of the head. With Jerry, it was, "Yeaaahhh." Once it was yeah, it was *yeah*.

david grisman: Jerry's daughter, Annabelle, used to play with my daughter, Gillian. They were the same age. This was an idyllic period. I thought, "Wow, this is it. This guy's got it made." He lived in the highest house in Stinson Beach. He had a great old lady and a family. He had his studio. He was making his own album. He could do this. He could do that. It was just a great time.

peter rowan: We started going up to Garcia's house. David would say, "Garcia's home and he wants to play some banjo," and I'd say, "Cool." We were living in each other's living rooms most of the time. We'd go up there and hang out at Jerry's house and Jerry would often greet us at the front gate with his banjo on. That was the real Garcia to me. Then I saw how he had to be a businessman in some way because the Dead kept getting twirled around by business deals.

carolyn "mountain girl" garcia: That was where I lost track of Jerry. Our life in Stinson Beach was isolated because we were a long way from the Grateful Dead office in San Rafael. Once I moved our domestic scene over the hill to Stinson and I had kids in school and I was running them back and forth and doing all those things, I took my eye off the ball. Jerry came and went when he wanted to. It wasn't easy for me to let go of him but I had to. At that point, I felt like I had to let go and not concern myself with where and what he was doing every day. We were watching the Watergate trials on TV, which was just a fascination for us. Remember how long that went on for? We sat there for months and watched that stuff. Jerry would get up in the morning and turn on the Watergate hearings and we'd have breakfast and get the kids off to school. He'd hang till one and then he'd go over the hill and rehearse or go to the office and then he'd come back later.

richard loren: Jerry did the *Rolling Stone* interview and they asked him, "Are there any other groups in San Francisco that you've seen that you like?" He said, "The Rowan Brothers. They're great. They're like the Beatles." Very reluctantly, we went out with the Grateful Dead. It was the worst mistake that could have been made. We put them in front of a Dead audience, who were looking for a band that jammed like the Dead. They wanted to like them because Jerry had said they were great. They weren't booed like a lot of other bands that were put on out

of respect for Jerry but it wasn't the right chemistry. They opened maybe five or six gigs but it just wasn't right. It just wasn't right and then boom, it went downhill from there.

merl saunders: A girl singer told me to come by a place where she'd been hanging out and I met Michael Bloomfield. He was producing an album with Nick Gravenites. I went to a session and I met this guitar player called Jerry. We hit it off very good because we had this chemistry. We just had this warmness. This thing. Gravenites picked up on it and he passed the word. Pretty soon, people started booking us together. We did a whole lot of sessions together and that was how we became friends. For about five or six months, I didn't know who he was. I had no idea. I had listened to the Grateful Dead but I never put the two together. All I knew was that he was Jerry with the smiling face. Then I began to know.

Jerry would say, "Hey man, I'm working down at the Matrix. Come on down, man." I'd go, "Okay." We'd sit there at the Matrix and play open jazz, free. Very few people showed up. We were totally out there. We were getting paid about ten dollars a night and we'd split the money up. Then people began to get into it. Fifty people. A hundred people. Pretty soon, the place was jam-packed, lines outside. People were flying in from Baltimore and New York to see us. I had an album to do over at Fantasy Records. I said to Jerry, "You helped me develop these tunes, you might as well come and do them." So that was where it started.

richard loren: Merl and Jerry were doing their thing together and Jerry was starting to play the Keystone. I said, "You need some help?" He said, "Yeah. Let's do it." I became Jerry's personal manager and his tour manager. I set up the gigs and I started handling everything. I handled his money as well as all the business that didn't really have to do with the Grateful Dead. I didn't even go to their office. I'd known Jon McIntire a little bit but I was really not plugged into their scene at all. I was just this guy that Jerry met who was living with David Grisman in Stinson Beach. Miles away from San Rafael and the hub of what was going on. At the time, Sam Cutler was managing them. This was the era of Bear building the big sound system. Jerry's thing was to go and play on Friday and Saturday nights. It didn't get in the way of the Grateful Dead. Jerry started to like that a lot. He wanted to play a few more gigs.

Even though no one would come out and say it, the Merl and Jerry Band became a little bit of a threat. I'd have to go to Cutler and McIntire and say, "This is what Jerry wants to do. Is it all right? Is this getting in the way of your tour?" "Oh no. Yes it is. No it isn't." I'd have to work with them. On the surface, it was cool. But I think there was a little uneasiness amongst a lot of the band members to accept it. They wanted Jerry all to themselves.

merl saunders: Jerry would always ask me about different runs I would do and I would teach them to him. The first tune I taught him wasn't a standard. It was "Imagine" by the Beatles, which he could have probably figured out himself. One of the standard tunes that he did learn from me was "My Funny Valentine." I taught him classics like "The Man I Love" and "Georgia." We hung out a lot. One night, he called me. "Merl, you know Kenny Burrell?" I said, "Yeah, I know Kenny Burrell, he's at the El Matador. Why don't we go see him?" After the show was over, Jerry wanted to meet Kenny Burrell. He asked him questions and Kenny didn't know who in the hell Jerry was till after I talked to Kenny the next day.

donna godchaux mckay: Jerry and his band were playing at the Keystone Corner in San Francisco with Merl Saunders and John Kahn. Keith and I sat in the audience and Jerry and the band took a break. Jerry walked by us and I tugged on Jerry's arm and I said, "My husband and I have something to talk to you about." Jerry said, "Fine. Come on backstage." That was just the way he was. I don't know how many other human beings would have been as out front as I was either. It was a combination of both. Jerry went on back and Keith and I just sat there. I said, "Gosh, how are we going to do this? I don't know that we can just go backstage and do this. This is pretty weird." We continued to sit in the audience.

A few minutes later, Garcia came out from backstage to get me. He came right down in the audience and he said, "I still want to talk to you." Keith was facing in such a way that he couldn't see Jerry. I turned to Keith and I said, "Honey, I think that Jerry's here and he wants to talk to you." Keith looked at me and Jerry and he put his head down on the table and said, "You'll have to talk to my wife. I can't talk to you right now." So I said, "Jerry, here's the deal. Keith is your piano player and I

need your phone number so that we can call you." He had no idea who we were. None. But he gave us the number of the office and his home phone number and he said, "Okay. We could use a piano player." Little did I know that Pigpen was dying and they were going to have to have another piano player.

We called the office a few times and I would say, "This is Donna Godchaux and Jerry said to call." Because I didn't really want to call him at home. So this message never got through. I would call and say, "Look, if you don't tell him that we called, I'm going to have to call this guy at home and I don't want to. And I mean it." I was very forceful. Finally, I did call Jerry at home. He had never gotten the message. He said, "We're having a Grateful Dead rehearsal on Sunday. I'd like for you to come on down." So we went. The rehearsal was at a little warehouse on Francisco Boulevard West right off the freeway in San Rafael.

Lo and behold, the band had not given Jerry the message that there wasn't a Grateful Dead rehearsal. So Jerry was down there alone and Keith and I showed up and Keith and Jerry played. Jerry was really knocked out. He called Kreutzmann and said, "You got to come down here and hear this guy play." The next day, there was a Grateful Dead rehearsal so the entire band was there. Having never played a Grateful Dead song in his life, Keith played with the Grateful Dead and they asked him to be in the band.

At that time, Jerry also asked me to be in the band and I said no. Back in Muscle Shoals, Alabama, I had sung backup vocals on "When a Man Loves a Woman" by Percy Sledge and "Suspicious Minds" and "In the Ghetto" by Elvis Presley. I had worked with Joe Tex, Ben E. King, Joe Simon, and Solomon Burke. But I said, "No. I don't want to right now." I wanted Keith to get the opportunity before me. Maybe that was southern.

richard loren: At this point, Steve Parish was my ally because he was working equipment for Merl and Jerry. I would do the business stuff and Steve would do all the equipment. Basically, the three of us, Jerry, Steve, and I, became very close. We'd get there early at the gigs. We'd hang out. We'd get high. We'd bullshit. Jerry would be backstage at the Keystone hours before the gig. He'd get there at three or four o'clock in the afternoon for a nine o'clock show. He'd sit backstage and play and diddle with his guitar and get high and people would come in

and he'd talk. He was so open that way. In the later days, he'd isolate himself. Everyone would isolate themselves in little rooms and you couldn't get into them. In these days, it was wonderful. In the early seventies, it was free. Everybody respected who he was and we didn't need any guards at the doors. After the gig at two-thirty in the morning, *vroom,* I'd drive over the hill and we'd follow one another. Next morning I'd wake up, go up to his house, and we'd take care of business. At the time, the Grateful Dead weren't yet big enough to smother him. He was allowed to do these side projects, including playing music with any number of groups. I think this was the best time of his life.

merl saunders: Jerry never talked to me about how hard it was to be part of the Grateful Dead. We didn't have to discuss it. I could tell it and hear it. The Dead was not his band. He never did want to be put in that position. It was not his band. He always said, "It's the Grateful Dead." But they pointed to him because he was the influence of the whole thing. In the early seventies, they took a sabbatical. He said, "I just want to play with you, man." I'd say, "We ought to book a tour and I want to book it around the Dead." He'd say, "Don't worry about that. Just book the tour." So everybody started looking at me. I was the bad guy. They still consider me the bad guy. Because Jerry disappeared with me for three or four years.

richard loren: Jon McIntire came up to me and said, "Richard, Sam Cutler is no longer working for us. Would you like to book us?" I went to Jerry. I said, "Jerry, I was just asked to book the band." I hadn't been an agent for years but Jerry had told them that I'd had a lot of experience booking rock 'n' roll bands in New York. Unlike Danny Rifkin and Rock Scully, who'd taken care of the needs of the Grateful Dead when they were living on Haight Street and were perfect at that time, I really had experience in the true business world. While they were doing that, I was learning the ropes as a traditional agent. Jerry said, "Yeah. We'd love you to do it." It was a decision that he'd made. Sam Cutler had been the big man for the Grateful Dead. He got fired for some impropriety. Then Ron Rakow came in and got involved forming a record company called Round Records.

21

ron rakow: It was after Europe, '72. I was riding in the car going to the office in San Rafael when I got a bolt of lightning as to how the Grateful Dead could unhinge from the entire record business. I saw exactly how it would work. What I didn't know was anything about the record business. So I immediately went to Jerry Garcia and said, "I see that the record industry does nothing for the Grateful Dead. It's the other way round. The Grateful Dead should sell its own products through its own fans and make more money and support its own people as opposed to those who don't admire them. I want to investigate this." Jerry said, "Do it." He called in Jon McIntire for me to explain it to him. Jerry was already maximally enthused. That was something I could do to him at any time.

steve brown: Hale Milgrim was the manager of Discount Records in Berkeley and a gonzo Deadhead so anything Dead-related was in the front window, big, with homemade handcrafted displays, arrows, and glossy eight-by-tens. Hale told me since he was locked into what he was doing that maybe the timing was right to go in there and hit them with the idea of doing their own thing. Jerry had seen me over the years. I'd been at a lot of Grateful Dead gigs and I already had a certain amount of credibility from being around productions he was familiar with. I knew people he knew. But he didn't really know me personally. I said I understood that their Warner Brothers contract was coming up and could I propose something to them in regards to an independent venture that they might want to consider for themselves on their own.

With that, I proceeded to sit down and write out my own proposal of how it would work. Meanwhile, they'd had the same idea and had enlisted their friend and previous financier of sorts, Ron Rakow, to also do research on the financial end as to what it would take to do it. He put together

his own proposal known as the "So What Papers" because you'd hand them to a band member and they'd say, "So what?" They'd read it and say, "So what?" It still wasn't anything. It was just words on paper. Although Rakow read my papers, my first meeting wasn't with him. It was with Jerry. Rakow called me in to meet Jerry.

Being a fan of the band for all these years and in and around the scene, I was still in awe of Garcia. "Are we going to hit it off? Am I going to do okay?" This was my shot. I went in there and I had everything I needed to know about the record business just nailed to the tits. Everything he could ask me, I knew I could answer it. He didn't ask me one thing about the record business. We talked about growing up in San Francisco. We talked about what kind of music experiences we'd both had. We talked about the kind of art we liked. We talked about all kinds of music. We laughed a lot, told some funny stories, and barely got into any kind of talk at all about record business stuff. He was checking me out and hanging with me. It was a thing really of vibing out if he could work with me out of the blue.

The main thing I had going for me at that time was the fact that I'd had five years working with Don Sherwood, a disc jockey in San Francisco. From the age of fifteen to twenty, I'd worked at KSFO as his production assistant. He was notorious in his lifestyle and pretty much a San Francisco icon. He'd established himself as a Peck's bad boy, an outlaw kind of guy. My credentials for working with somebody like Jerry Garcia or the Grateful Dead were bolstered by the fact that I'd survived five years with Don Sherwood.

alan trist: We had our huge wall of sound. We had our own sound company. We had our own business thing. But Grateful Dead Records was not really the model that Ron Rakow had in mind. It was a compromise. Because he wanted something much more revolutionary. He wanted to have all the records sold by ice cream vendor type people on the street corners around the gigs. I remember a meeting we all had out at Sonny Heard's place in Forest Knolls where Ron laid this out on a big blackboard. Some thirty of us were sitting there, all going, "Yeah. Yeah. Yeah."

ron rakow: July Fourth, 1972, Ron Rakow Presents the "So What Papers" at Bill Kreutzmann's home with charts and graphs. The entire

project was going to be funded through MESBIC, Minority Enterprise Small Business Investment Company. I got us declared a minority by the United States government, which meant that all we had to do was come up with thirteen hundred and fifty dollars and they'd give us three hundred grand. Bonnie Parker, who was their bookkeeper at that time, said, "Small business? Oh, no. No. No. I worked for an SBIC. The government . . ." I could see the whole meeting going down. I stood up, reached into my waistband, took out a Puma staghorn handle knife that was sharp as a fucking razor, and I cut that part of the chart out. I said, "We're not going to do that part. Don't worry." Jerry was my ally in this. Every morning, I would go to Jerry's house in Stinson Beach. He liked my desire to have a lot of random events going on.

richard loren: Ron Rakow was very very intelligent and I never trusted him from the first day I met him. I think Jerry was very impressed with his mind and with his contacts on Wall Street. He was an action man and a gambler and that appealed to Jerry. Rakow was an outlaw and I don't necessarily say that disparagingly. That was the kind of guy he was and he filled a certain need for them there.

hal kant: The Warner Brothers contract was up and Rakow convinced them to start their own record company and they started two. One was Grateful Dead Records, which produced the Grateful Dead's records, and the other was Round Records, which produced other band members and their own endeavors. I told Jerry that he should focus on the fact that what Ron was doing as president of both those corporations created a terrible conflict of interest because of commingling the band's finances with these other ventures and that the band didn't own Round Records. Jerry and Rakow did. And that wasn't appropriate.

At that point, Jerry blew his top and he said words to the effect of, "I tell you what. You don't represent the record company anymore. You represent the band but not the record company. We'll get someone else to represent the record company." A week later, he took me aside and said, "Gee Hal, I'm really sorry for blowing up like that but Ron is such a weak guy and if we confronted him with this, he'd fall apart. I knew you could handle it but I didn't think he could." He just wanted people who would do what he wanted them to do but frequently he had trouble deciding what that was.

donna godchaux mckay: Jerry and Ron Rakow were in the process of putting together Round Records. If the band was going to go for it, it had to be a band thing. Jerry was very much for it. Rakow was very much for it. Keith and I were for it. I didn't know where the other band members stood at that time. We were having a band meeting to discuss if we were going to go through with this record company thing. We all came to this big meeting to decide whether we formed a record company or not. It was pretty much Jerry's baby. It was his and Ron Rakow's brainstorm. Jerry didn't show up to the meeting.

jon mcintire: He didn't like business meetings. At one point, Garcia and I were alone and he said, "You know what I'd like you to do for me, Jon? I'd like you to be my personal representative and attend band meetings and be my voice. I don't want to be there for them." I said, "Man, I can't do that for you. That wouldn't work." He said, "I just can't handle it. I'm telling you, I can't take it. I can't play and do that. So you gotta do it." It was not that I refused. I just couldn't do it. But Jerry didn't like being the leader and he didn't like taking care of business. To put it mildly.

donna godchaux mckay: If there was something that Jerry did not want to get involved in, he would just be absolutely absentee. On a certain level, Jerry was very out front and aggressive but then when it came to certain things, he was very much a coward. I called him the Cowardly Lion and I would say that to his face.

steve brown: Jerry really had that outlaw side to him. That dark side. And he liked Rakow the phone screamer. Vicariously, he was getting off on it. Because Jerry was not going to get on the phone and yell and scream at people. It would have been very very rare for him to get uptight like that. He'd have to be beside himself. But here was Rakow, this wheeler-dealer. He was our Bill Graham and he was our record company weasel and Jerry would sit in that office and watch Rakow perform on the phone and just laugh and laugh, loving it.

ron rakow: Not on the phone. They would bring them in. They liked it when Bill Graham and I were face-to-face. Jerry wasn't the only one. Phil loved it. Phil would sit next to Bill and Bill would lay out all

the numbers for a tour and I would do them so fast in my head that Phil would only say one thing, "Bill, what the fuck are you doing? Listen to Rakow." I was the family barracuda. Everybody knew it.

steve brown: Jerry liked having this guy whom he knew he couldn't trust but he trusted. It was another one of those "thought he could get away with it" kind of deals for Jerry.

hal kant: Jerry was one of the most insightful people into human nature and character I've ever known and again, that was why he could enjoy and work with people like Rakow and protect them. He wasn't fooled by them. He just dealt with them on the terms he thought worked for him.

ron rakow: Clive Davis sat with the Grateful Dead and me and we had a debate. Should they sign with Clive Davis who was the man in the record business or with Ron Rakow? We were sitting around this phenomenal oval table in thirteen hand-carved Gothic chairs which themselves were a fright trip. Owsley sat down next to Clive. As Clive was trying to score the Grateful Dead, Owsley was talking in a monotone in his ear, saying, "I really have the greatest respect for you but I don't think you really fully understand what this music means to our lifestyle. For example, there are references in Janis Joplin's live album which you put out about her being a loose woman and drinking a lot. . . ." On and on and on he went like this gnat buzzing inside his ear. He was getting Clive crazy. Clive went on a diatribe about Miles Davis and how his relationship with Clive was a stabilizing force and the linchpin in the life of Miles Davis. Finally, I said, "Clive, if you're going to brag about how you take care of your family at a business meeting, that's ridiculous." Miles Davis/Clive Davis. I told him Miles was his brother and everyone went nuts. Then Bob Hunter passed around a little note that said, "Shiva Devil C." Hold it up to a mirror. Except for the "h," it's "Clive Davis" spelled backwards. I had never sold a record in my life and I won.

jon mcintire: Jerry had such a generous spirit to everyone and he would forgive so much and not judge. But all you had to do was disagree with something he felt deeply about and he would go after you ruthlessly. The first time he really dumped on me irrationally, I

thought, "Oh, God, I guess I'm really close now. I've just been dumped on." There were certain things I felt very strongly about and I would go to bat for when I felt that the Dead were being foolish. I don't remember what it was about but I do remember him jumping up out of his chair and saying, "Well, you're not in the band, man," and he stormed out and went down to Bonnie Parker's office. He felt I was forcing my ideas too much and that he knew better and I felt that whatever it was I was standing up for was in their best interest and it was really important so it was worth a try.

But it was really devastating being dumped on by Black Cloud or Blackjack Garcia. I mean, *whoo*. He was extraordinarily powerful. After I composed myself and pulled it together, I walked down the hall and went into Bonnie's office. I think he already knew that he had just blown it way out of proportion because when I walked in the door, he looked sheepish. I kind of squatted down beside him, my knees not touching the floor, and I said, "Look, man. I know I'm not in the band. I know that. Can we just talk a little more?" And we talked rationally about what it was I was really trying to say and why I thought it wouldn't work.

robert greenfield: Jerry Garcia and I spent the last night of 1972 together. He was up on stage playing at Winterland in San Francisco with the Grateful Dead while I wandered through that cold and cavernous, incredibly funky hall, wondering what the hell I was doing there. New Year's Eve with the Dead then was not yet the elaborately staged ritual it would eventually become. It was more an unofficial town meeting for long-haired freaks from up and down the coast, all drawn from their little post-hippie enclaves by what they hoped would be the transformative power of the music. Shoving forward, they fought for space right at the very front of the stage, trying hard to get closer to Jerry and the band so that when midnight came, they would not all be turned back into pumpkins and mice again.

bill graham: There is no space on this planet that is better than the period of five minutes to midnight until ten minutes after midnight when the balloons come down and the lights go on and the Grateful Dead play to bring in the new year. There is no better energy. Anywhere on the planet.

jerry garcia (1988): *New Year's Eve was usually our worst show of the year. It's the night when everybody you've ever known is there and you can't even say hello to most of them and everybody's also partying their asses off. So everybody's drunker than shit or wired or whatever. It's NEW YEAR'S EVE! and we're working. You would love to be able to party but you can't get too fucked up because you can't play. There'd be times when all the balloons would fall on stage and then everything sounds like "VVRRRRVRRRRRVRRRR." You can't hear anything. It sounds awful. I just have real mixed feelings about the New Year's Eve things. They're great parties. Everybody loves 'em but we've never played worth a shit on New Year's Eve. Just passable, you know? Passable is usually the way it goes.*

22

joe smith: When I sent them to Europe, I wanted to write a book, "How We Did Europe on Five Thousand Dollars a Day." We sent them on Air India because we had a lot of Air India due bills and we couldn't get our money out of India. I was thinking, "Holy shit. They'll turn on the whole cockpit crew. They'll get 'em crazy."

ron rakow: The Grateful Dead came back from Europe and I met them at the airport in New York. They had a four-hour layover so I got TWA to give us a private executive lounge. I had a couple hundred slides, a projector, and a screen. They loved Rakow slide shows. While they were looking at the slides, I gave them an item-by-item business report about the record industry. Essentially, I was talking to Jerry, who was the most interested.

Two days before, I had gone to Albert Grossman and I'd pumped him dry. Finally, he got mad at me. He said, "What the fuck are you doing this for? I've been to Grateful Dead shows. I don't get it." I said, "I'm doing this because Garcia is a great guitar player." Grossman said, "That's where you're wrong. Not only is Garcia not a great guitar player, Garcia is not a good guitar player. In fact, he can hardly play at all." I was sitting in the dark at the slide show telling this to the entire Grateful Dead family. In the most childlike voice coming out of that dark cave, Garcia said, "Jesus, Rack. I may not be a great guitar player. I may not even be good. But Rack, I can play a *little*."

carolyn "mountain girl" garcia: After the trip to Europe in 1972, I decided that I wasn't going to tour with them again. In retrospect, that was a momentous decision. I had two little girls and they were going to school. After the trip to Europe in 1972, I could not make myself leave them again. Because I'd left them and it was tough

coming back. They weren't sure who I was. It only took a little while for things to come back on-line but there was a moment when I could feel I was skidding a bit. For a few minutes, it was very shaky and it was a terrible feeling. I never wanted to have that happen again.

justin kreutzmann: When I was born, my dad was touring nine months out of the year and so I would never recognize him. He'd come home and I'd wonder who this guy was until he'd say, "I'm your father, man." And I'd say, "Oh, yeah! That's right!" Because when you're a kid, little blocks of time like a month seem like forever. Annabelle Garcia and I were talking recently and rehashing the old days. In the same year, our parents both went off to tour in Europe. On the night that both our parents got home, we had almost the exact same identical dream. We both remembered the exact same night they came home from this tour when we were both four years old. I woke up to the sound of the front door opening and I ran down in my pajamas and my dad was coming home from Europe and light was coming through the trees and she remembered the exact same thing from the same tour. As a kid, you'd get used to life. For a while, he was the guy on the phone. Then all of a sudden he was back home and everything changed.

carolyn "mountain girl" garcia: As far as Jerry was concerned, it was license to play around. Right around that time, he began to stray pretty heavily and I wasn't able to do anything about it because I had set myself apart from the group to the point where I wasn't in the loop any more. No information didn't get me anywhere. I can look back on that and say that I took my eyes away from stuff I didn't want to see or hear about. I didn't want to hear about it and I didn't want to see it.

jerilyn lee brandelius: Mountain Girl told me one time that in order to get a point across to Jerry when they were having an argument, she would have to turn her back on him. She couldn't argue with him and look him in the face because she loved him so much. When she was looking at him, she couldn't remember why she was pissed off. So she used to turn away from him to try to get her point across.

donna godchaux mckay: Keith and I and Jerry and Mountain Girl lived probably a quarter of a mile apart in Stinson Beach

for a couple of years. Mountain Girl and I got to be very close friends and we would hang out. When we weren't on the road, Jerry would come over and Keith and Jerry and I would sing and play old gospel songs. Jerry would play acoustic guitar. I would sing and Keith would play the piano. We were very much into that for quite a while.

He and Mountain Girl had a very unique relationship but it was hard for her because she could never have Jerry all to herself. Of course she was very defensive because it was like all the women in the world wanted her husband. I was at her house one day and Mountain Girl said, "Now, Donna. I want you to tell me about you and him." And I said, "Mountain Girl, I'm so pleased to be able to tell you that there never has been a thought, much less any action on my part, and I would be very surprised if there was any on Jerry's part toward one another physically or sexually. It's just never been there. Never." She said, "Well, that's good." I could tell something in her didn't want to believe me but she knew me well enough to know that it was the truth. I wouldn't have lied about it. To lie to my friend about it would never have even entered my mind.

jerilyn lee brandelius: Really way early in the game, I was Jerry's girlfriend. I was his girlfriend for years. On the side. I was one of his sweeties. Garcia always had sweeties. I would just hang around and wait for him till he finished at the studio. He'd drive me home, come up to my house, whatever.

donna godchaux mckay: Jerry was one of those people who learned late in life how to have real relationships. It took him a long time. Sometimes with people like that, because they do have so much natural ability and they have so much just naturally, it usurps the place that relationships should have in their life. I think there was a part of Jerry that was very inaccessible because of some of the tragedy that he had early on in his life that affected him. I think it went back to his childhood. Doesn't it for all of us?

23

richard loren: I was booking the Grateful Dead and I was also booking Merl and Jerry and all of a sudden, Old and In the Way started up.

david grisman: We just got together one time in Jerry's living room and started playing bluegrass and Jerry said, "Wow, we ought to go play some gigs." Me and Pete probably needed the bread. Not that we didn't enjoy playing.

peter rowan: Vassar Clements, David Grisman, myself, John Kahn, and Jerry, we all had these nicknames for each other. Because I'd written "Panama Red," I was "Red." For some reason, Grisman was "Dog." Garcia gave him that name. Vassar Clements was "Clem." John Kahn was "Mule" and Jerry was "Spud Boy." That was how we referred to each other. We wouldn't say, "Hey, Jerry." I'd say, "Hey, Spud, how do you like this one?" It was like a world within a world. Just the way that Jerry would walk to his front door and let us in with a banjo on, we couldn't wait to get our instruments out and pick. I remember Garcia's first solo at our first gig at the Lion's Share in San Anselmo. I don't know if it was a sight gag or what but he was looking for knobs to turn on his banjo. This was before volume pedals. He was standing there turning knobs on his banjo that he did not have.

david grisman: Jerry wanted me to be the leader because I was always more of a disciplinarian, wanting to get things tight. Bluegrass is a tight music. It's a precision music. Pete was kind of on the other end of it.

peter rowan: I look at bluegrass music like this sort of glowing ball. The point is to relax the technique around the glowing ball of feeling.

Really, that was what Jerry did. He let the skin of his music settle over the burning fire of feeling. When it got fine, when it got right, and the intensity and the burning sensation of really energetic music was on, Jerry would just gasp with laughter and go, "Oh, my . . . heart."

david grisman: You make music with people. If they're loose and you're tight, you get a little looser. They get a little tighter. We were all having a good time. It was like nobody wanted to take charge. We played these gigs and Owsley was there recording them. He had just gotten out of prison. When he left, he was the soundman of the Grateful Dead. When he came back, he was unemployed. He was trying to re-attach himself to the scene and Jerry just didn't want any of it. He would go out of his way to make it hard on him to even set up his microphones. He'd bump into him. He didn't make it easy for him but he allowed him to come there. Owsley had a stereo Nagra. He followed the band around and taped everything because I guess that was the only thing that he could do. And he made some real good recordings.

owsley stanley: They started doing shows and I had a Nagra tape recorder and I said to them, "If you cover the tapes, I'll do it." I loved that music. I'd grown up in rural Virginia and that was the music I had listened to back there.

peter rowan: We were playing up in Berkeley at that old club, the Keystone. We were standing on stage as usual with Old and In the Way, having a nonintroduction. Nobody had said who we were. A lot of people were out there nodding their heads and going yeah and the big yeah wanted to happen. The big yes was ready to be heard. We were ready but every time we'd approach a microphone, it would feed back. We wouldn't say anything. We'd step back and turn to the other musicians and tune a little more and then approach the microphone, thinking that it would go away. The microphone kept feeding back and I was standing next to Garcia when he nudged me. He said, "Hey, man. Look up in the sound booth. Look at Owsley." And there was Owsley in the sound booth like Lucifer. He had patch cords around his neck. He had wires in his teeth. From way down below, we could only see this maniacal grin on his bottom-lit face. Garcia said, "He really loves his job, you know? He really loves it, man."

richard loren: It was just the band and me. There was no road crew. Bear [Owsley] took care of the equipment and recorded them. I was road managing and booking and there were the five musicians and that was it. It was unencumbering. It was just a lot of fun.

peter rowan: We never stopped playing. In bluegrass, there's a sort of fanaticism about picking. It's because the techniques are so hard. From the day you all get together, basically you don't stop playing until the end of the whole thing. We'd show up at the Boarding House at four-thirty or five in the afternoon and Garcia would already be there with his carton of Camels and his roadie. Garcia would just be sitting there, puffing and playing. The only thing we could do was unpack, tune up, and get with him. He'd look up and say, "Where's it go from here?" and then we'd jump in with material. Jerry had this quality of reciprocal enthusiasm and the ability to give off a kind of a light. If you tickled his fancy, he would just come forth with so much loving energy that everyone would do better. When you played with Garcia, he could make you rise up to your full capacity. He could make you do that and I think it was reciprocal. He felt he could jump to his full capacity surrounded by the players he loved to play with. I never experienced any ego when he played. He was against any discursive criticism of the moment. He could make every player feel that whatever part they had to contribute was part of the overall experience. He was generous.

richard loren: When Jerry was doing Old and In the Way, he would take the banjo on the road with him on Grateful Dead tours. I'd go into his room and he'd be practicing banjo for upcoming gigs with Old and in the Way. Because he cared. He didn't want to bomb. He wanted to play well. David Grisman's playing always inspired Jerry to play his very best.

peter rowan: I remember Jerry at one gig during this super-critical phase of Old and In the Way. After every set, there were players in the band criticizing what we had done and how it wasn't this and it wasn't that. I remember going into the dressing room after a show one night. Jerry turned and looked at everybody. His eyes were glaring and he said, "No thoughts!" He was like a Zen master. No slate. We don't

want to talk about it. In other words, he had a faith in things holding together of their own energy. If it was worth holding together.

richard loren: I loved Old and In the Way. The thing that amazed me most about them was that they were a unique entity. They weren't bluegrass. They weren't rock 'n' roll. Jerry wasn't playing guitar. He was playing banjo. It was so unique because they played some gigs on the East Coast in front of Deadheads. They filled up massive auditoriums and whatever Jerry did, it was great. The mistakes, whatever it was, they loved it. Then right after that, we'd go play at a bluegrass festival where nobody knew Jerry. "Who's that guy with the banjo?" They knew David Grisman. They knew Peter Rowan. They knew Vassar Clements. But who was *that* guy?

peter rowan: During the Old and In the Way time, Jerry would stand in the hallway and those fans of his would be standing there and he'd be looking at 'em and there was a relationship there. Once the Dead were so huge and Jerry was into his habits, I don't think he ever had that kind of contact with the audience again. Old and In the Way was the last time that Garcia could look up on a hill in Virginia and see this hallucination of a herd of buffaloes in cut-off blue jeans and T-shirts running over the top of the hill and waving at Jerry. That was what it looked like to me. That was what I saw.

david grisman: When Vassar Clements came into the group, he really energized the whole scene because he was a hero to the three of us and a legend in his own right. Vassar was at the height of his powers then. It was like being next to Charlie Parker in his prime. We were all in seventh heaven but particularly Jerry because unlike Pete and myself, he had never worked with "real" bluegrass musicians.

peter rowan: Jerry would do a night with the Grateful Dead and then do a night with us. He loved his chops being so up that the transition was effortless. We'd be at the Dead gig hanging out backstage and the next night we'd go play at this concert hall and then he'd do two more nights with the Dead and three nights with Old and In the Way. From the Dead standpoint, I got the feeling that this was not exactly approved of. With the Dead, it was like being in the engine room of a rocket ship.

It was like, "Duck or you'll get stepped on." It was very intense. One night, I remember Garcia turning around during the Dead's set. I was standing beside his amp and he looked at me. He looked right *through* me. I was scared. It was the volume and the electricity and the energy and who knows what else in terms of chemicals and stuff. He was *fierce*. With Jerry and the Grateful Dead, I always thought it was like a sailor who had the best gig on the best ship. When he was ashore, you could have a great time with the guy but then it was, "Hey, the ship's moving, pal." No matter how much you felt a part of his life, when the ship went, he went. The ship was the Dead. And if you weren't on that ship... you know what I mean? With the Dead, that sense of destiny from the inside must have been fierce. All I can say is they were fierce.

dexter johnson: Old and In the Way did a concert at the Corvallis High School auditorium up in Oregon. There was a guy who'd seen me with all these instruments and he was a Deadhead. I didn't know about Deadheads. This was Old and In the Way. This was bluegrass. This was my dream come true—Jerry playing five-string banjo with an all-acoustic hot bluegrass band. Jerry opened the door and the guy immediately threw himself on Jerry and made an ass of himself and I was horribly embarrassed. The guy said, "I live in a dormitory and we play all your music. We only play Grateful Dead and we sing along with all the songs..." I was like, "Oh my God. What a geek!" He'd used me to get in. Jerry just kept saying, "Hey, that's *plush*, man. That's really *plush*." I was so relieved. He didn't say, "Hey, what's this, man? Why did you bring this geek around? Get out of here."

steve brown: At this point in his life, Jerry was just a dedicated guitarist who really wanted to only play guitar. His guitar was pretty much sewn to his body for all those years of the seventies as I remember. He would be on the road playing his guitar while he was in the car being driven somewhere. He would take it to the hotel room with him. He had a little Mesa Boogie amp or before that other little amps that he'd play through everywhere he went. Even when he came to the record company office, he would sit in the kitchen and play guitar. He carried it in the back of his car most of the time so he'd have it with him. His dedication was to that and to coming up with songs and being able to play more.

carolyn "mountain girl" garcia: It was my favorite period. Old and In the Way rehearsed a lot in the living room and the kids all grew up listening to that music. It was as sweet as it could possibly be because it wasn't amplified. It didn't require the infrastructure of people and equipment and gear and preparation and you could just pick it up and do it. So it had a spontaneous quality that was pretty special. Jerry was also playing pedal steel at this time and somehow it served him to be playing in three bands at once. If I say I didn't see very much of him during those times, it was because he was really really busy and that was one of the reasons I didn't worry about him too much. Because I knew what his workload was and I also knew that the less interference, the better. Because he had so much he had to get done and there were only twenty-four hours in a day. Plus he was commuting back and forth from Stinson Beach. He'd get home around one-thirty in the morning and be hungry. I'd have to get up and feed him something and he'd often sleep until eleven or so in the morning. Then there would have to be quiet in the morning. We watched a lot of *Sesame Street*. "Daddy is sleeping. Don't touch the guitars." Still it was warm and a good friendly scene.

peter rowan: Old and In the Way broke up. Dave wanted to do some other kinds of music. Somewhere along the line, we had worked together too long under too much pressure and too many drugs. I know that David had enough and I certainly wasn't evincing great care and love about Old and In the Way. I was probably being very cavalier. When things get weird in a band, you're talking about smoke screens and levels of ignoring each other that make you want to kill yourself. It was awful.

david grisman: We made a studio album and I remember listening to it with Jerry at my house and we decided it wasn't good enough to release and that was the end of the band. Perhaps there were musical differences between me and Peter Rowan but we never discussed them. We were young and didn't see the value of keeping it going. Now I see that one real value would have been for Jerry to have this outlet.

peter rowan: Jerry was like, "Hey, if these guys can't keep it together, I'm not going to keep it together." I'll tell you what Jerry told me personally at the very end. He said, "David doesn't want to do it anymore but I do." Did I say, "Cool. I know this guy named Ricky

Skaggs. Let's call him up"? No. I didn't say that because Old and In the Way was a group. If one of the members of the group didn't want to do it, it was like honor among thieves. We could all agree not to get together anymore because one guy didn't want to. Which was stupid. Because it needed to keep going. It just needed to. It wasn't a throwaway thing for Jerry.

david grisman: Shortly after, I started playing with Richard Greene in this loose acoustic aggregation called the Great American String Band. Jerry played some gigs with us. Old and In the Way got left behind. Like it was not official enough for anybody to start or end.

peter rowan: We should have had more responsibility about keeping the thing going from Jerry's point of view. As something he needed. But we never thought of that. The terrible thing about show business is that aura of stardom. We always thought, "What a star this guy is. We wouldn't exist without Jerry." With Old and In the Way, people finally got to feel, "If we are beholden to Jerry who is actually beholden to the Dead, then where's our own sense of what we can do?"

24

rock scully: When I first saw them, the Grateful Dead was pretty much Pigpen's show. Everybody followed him. That was basically what the early Grateful Dead was all about. They were comping rhythm and backing up Pig doing "Love Light" and "Running down the road, feeling bad," and all those old blues things that they did so well.

jon mcintire: There was a band meeting in the middle of one of the recording sessions and they were attacking Pig. I think Jerry was furious at him about the music. They were saying, "You drink all the time. You just hang out. You're zonking out in front of the television all the time. You don't do anything." And on and on. With this beatific smile, Pigpen would nod and say, "Yup, that's who I am. That's who I am." Here they were saying what to me sounded like the most devastating things about someone that anyone could say. I hadn't really ever heard anybody handle their frailties like that before.

rock scully: Garcia really loved him and respected him, even if they had their falling-outs. They had their tough moments. He tried to have me fire Pigpen one time and Bob Weir too for that matter. He said, "Scully, you go fire them. I can't work with them anymore." He wouldn't do it. He had me do it. He said, "Bobby's not playing electric guitar and if I'm going to get good at my instrument and play the way everybody wants me to play and the way I want to play, I need a solid, electric rhythm behind me." Which was weird because what happened was that Garcia developed his style from having to comp a lot of rhythm. He became sort of a lead rhythm player, which I think made him so brilliant and popular. I went to Weir and I said, "You're out of here." I went to Pigpen and I said, "You're out of here."

jon mcintire: I wasn't there but I do know that Bobby was fired. Although the band at one point said he wasn't, Bobby said, "I most definitely was." He left the room where he was fired and hitched a ride because he didn't have a car and it had been raining and then the ride let him out and he stepped out and fell facedown into a ditch in the mud. Musically, Bobby hadn't yet taken the bull by the horns. Pigpen's timing and pitch were off because of his drinking but Bobby just hadn't matured yet as a player. I would also like to add that it was totally in character that Garcia would ask Rock to do it rather than doing it himself. More properly speaking, Garcia should have done that himself.

sat santokh singh khalsa: Jerry was enormously frustrated with Bobby. Bobby would get spaced out. My experience back then was that when they would be all stoned together and really go out there, I would see Bobby standing on the stage not playing. Jerry would be taking off on his new thing and Bobby would be standing there, holding his guitar.

owsley stanley: Garcia had a background in acoustic music but when it came to electric music, their thing was "Turn it up to eleven and go for it." That produced a monotone on stage. While I was in the joint, they took singing lessons and they became competent as singers. Whereas before, it was hopeless. I would tell them, "Please don't sing. At least not all of you at once anyway. One at a time, that's okay." I tried for years to get them to put headphones on. They wouldn't.

rock scully: Garcia knew what he was doing. He was just scaring their asses. Rattling their cages. They took a couple of weeks off. Weir went and got some more electric guitar training. Pigpen had just moved to a Hammond organ so he got some help from friends and learned how to play the foot pedals and how to expand his knowledge. Between the two of them, we were just getting a lot of fill. We were getting a lot of mid-range mush. Phil Lesh had taken his instrument into a lead bass-playing thing and there was no bottom end. It was totally up to the drummers.

owsley stanley: When you get up on stage, your ego gets amplified. Pigpen was the front man. He was a rooster. He loved to strut

his stuff. He was a very powerful little guy but he was also very shy and he had to drink a lot just to get up on the stage. The fact was that the Grateful Dead never considered themselves Garcia and band or Pigpen and band or Lesh and band. They were always the band. And the bottom line was that they liked to play and they spent money as fast as they got it and they had to keep doing it. Nobody bought their albums much so they had to go out on the road and keep doing it.

jon mcintire: Garcia came into my office one day and said, "Look, we're going to lose Pigpen. I know you know a lot about medicine. Just do some research and find out what can we do. We'll do anything. We'll send him anywhere." So I started doing research and I found out about Sheila Sherlock's clinic in London. Then my doctor said there was a guy at the UC Medical Center in San Francisco who would be as good. We put Pig with that guy but it was already too late.

owsley stanley: Pigpen had been rather sickly. He had ulcers that were a lot worse than anyone knew about. It wasn't his liver that was the problem. It was under control at the time. He'd pretty much given up drinking. He actually asked me for a few joints and I'd given him a couple a few days before he died. But he had a perforated duodenal ulcer and he bled to death. That was what killed him.

rock scully: When Pig died, Jerry said, "That's it. That's it for the Grateful Dead." He said, "The Grateful Dead just died, not just Pigpen." That was how he really felt. This was a heartbreaking thing for Garcia. He loved Pig. As far as Jerry knew the Grateful Dead, that was it. Two weeks later, they reinvented themselves.

jorma kaukonen: When Pig died, a lot of my interest in the band changed. A lot of music that I really loved was personified by Pig and that's not a criticism of them. It was just that I was really rocking with Pig. In terms of Jerry becoming the focus of the band, I don't think there was much of a choice really. In the old days, he was definitely the leader of the Palo Alto scene. Pig was an important color on the palette but the Dead have always been, sorry guys, Jerry's band.

owsley stanley: Garcia always played with his head down and went up to the microphone somewhat reluctantly to sing in this soft voice. The only other one really happy belting them out was Weir. When Pigpen died, everyone wondered, "What the fuck are we going to do now?" It was traumatic.

carolyn "mountain girl" garcia: Pigpen being so sick and then passing away was terrible. And then they took that long hiatus. They quit work for a long time after Pigpen died and went in the studio and poked around and did this and did that and didn't do much.

john "marmaduke" dawson: Pigpen was the other person that they couldn't replace. And they never really did replace him.

25

sue swanson: As soon as coke came in, things got different. That was when I took like a fifteen-year hiatus. I couldn't deal with that drug. We had this office in San Rafael. Jerry came into my little office and he sat down and he said, "So why are you leaving?" He was pissed. "Why are you leaving?" I got defensive. I said, "I'm going home to take care of my kids, man." Before we could have a conversation, these two people came in. I didn't know who they were. They sat down at his feet facing him and he gave them his attention. I got up and left. I said, "You wonder why I'm leaving? There's your answer." Maybe that was why he wasn't a good father. He gave it to everyone else. I didn't even want to try to understand that one.

john "marmaduke" dawson: He'd put up with all these hippies who would come in and lay their trips on him. Every fuckin' hippie in the world wanted to talk to Jerry. They all had some cosmic thing that they had to get him to explain to them or they had to explain to him. Everybody had to talk to Garcia, man.

carolyn "mountain girl" garcia: We used to go to Winterland for the New Year's run, which was four or five or six or seven shows around Christmastime, and it would be freezing in there. You'd get in there at three in the afternoon for the sound check and it was like forty-five degrees and so cold and it wouldn't warm up until the audience came in. They would finish the run and we'd all go home and have the flu for ten days. Everybody would just get sick as a dog. A lot of people wouldn't even make it to the end of the run. They'd be sick by the time we were halfway through it. Going and doing all those shows was hard work.

163

rock scully: It was funky. You were living out of the sunlight in these back rooms in these basements. Walking down cement hallways, cinder block rooms, insurance lighting, bankers and union guys and everybody working in this really cold harsh environment until the lights went down and the crowd was there and the band would go on. Then it would turn into this magical wonderful land.

carolyn "mountain girl" garcia: I decided I couldn't live with going through all those changes all the time. All the emotional worry and obsession. I copped out. That's not quite the right phrase. I went into this state of "I'm not going to think about this. I'm going to cook breakfast and I'm going to cook dinner when he gets home and I'm going to be as nice as I possibly can be, do the laundry, make sure he's got clean T-shirts, and roll ten joints so he can go to work." I was growing pot and I was writing my book on growing and I was doing some painting and reading a tremendous amount. It was really a time that I took for myself.

rock scully: As far as Jerry was concerned, he was living in this box and all he really had was his guitar and a joint. I think what led to the cocaine was a couple of things. One was the show business aspect of the recreational quality of the drug. In the early days, it was very pure and fun. Later on, when we were working seventeen days in a row, it became a tool. Because we were not going to bed until four A.M. and we had to be up at eight to get in the limos or the rent-a-cars to get our asses out to the airport and get on a plane. It was a get-go thing. To a man when we'd get home, cocaine was a done deal. It was a road drug. We'd get home and nobody would care about it. All we wanted to do was sleep. Sleep and be with our families and see our kids grow up for a week or two before we went out again.

laird grant: He was using cocaine to keep himself pumped. The coke was to keep him running. But he was doing a lot. If you ask me, he was doing too much.

carolyn "mountain girl" garcia: I literally couldn't stand the scene at that point. It had become different. It had become chatty without being friendly. It was unfriendly chat and it had become social

in a way. I didn't want to spend too much time trying to figure out what had gone wrong. I just wanted to go find someplace else to be. And we had become the establishment. For all the rebellion and all the craziness that we'd done, suddenly now it was the record deal. It was this. It was that. It was the appearances. We were the establishment and the Grateful Dead was setting higher and higher ticket prices. I could feel it changing and it was a disappointing time for me. I was far more invested in my relationship with him than I was with the group. He had to take care of the band. "We've got to play here, Jerry. We've got to go there." I too would come when called and they called me when they needed me for something. I'd be right there. But I discovered that I could go home and be quiet and nobody would care.

owsley stanley: In '74, they decided they wanted to play these big outdoor shows. That was what they wanted to do. Garcia mostly went along with stuff but it was the others who decided they wanted to play big shows and that was what they ended up doing.

jon mcintire: One time I was driving him home over the hill because I lived in Bolinas. We were going up to his pad and he said, "It's kind of neat having the most impressive pad in town." He had the biggest house in Stinson and he had Deborah Koons in a different house over in Bolinas. It was just the next town. That was awfully close by.

steve brown: I think it was Jerry's decision to get out from the living situation and the relationship he was in at the time. In that sense, I don't think that Deborah came in as the other woman. I think Jerry had already made up his own mind about being his own guy in his own space. It may have had something to do with the extra energy that comes from having young children around and wanting more space. It's hard to speculate on what the actual reasons were. Mountain Girl is a pretty strong person and it may have just been a wearing-out point. I know relationships get that way sometimes.

jerilyn lee brandelius: Mountain Girl was pregnant with Theresa. I don't exactly know how long Jerry had been running around with Deborah behind MG's back but there was a real famous scene that went down at Weir's house when MG picked Deborah up and threw her

through the studio doors. Deborah was just sitting there in the studio. MG came in and gave her the bum's rush. MG was pregnant at the time.

jon mcintire: At one time, evidently he and one of the women in the office had a sexual tryst and he was on the road with the band and she was too. He came off the stage and she looked at him and I happened to be standing right there and she said, "You don't play music. You just play games." I thought, "Wait a minute. We're off the deep end here." After the gig, I got in the car with Jerry because I had to figure out what to do. I didn't let anybody else get in the car because I wanted to have this private talk with him. I said, "Okay, tell me what's going on and tell me what to do about this." And he said, "Don't worry, man. It's just my fucked scene with chicks. It's always been this way."

jerilyn lee brandelius: Jerry was always such a wimp about dealing with these things. Donna Jean [Godchaux McKay] told me that one time Jerry made her pack up all the clothes of the woman he was living with at the time and take her to the airport and he wouldn't even talk to her. He just backed into a corner and freaked and sent her packing. That was his thing with a lot of problems. Throw money at it. Get Steve Parish or somebody else to deal with it. He did that whenever it was too hard for him to face up to things.

jon mcintire: I remember one time MG and Hunter and I were together and MG was talking about how generous Jerry was. Hunter looked up and said, "Generous? Generous with what? Generous with money? Stuff? He doesn't give a shit about money or stuff. That's not generous!" Absolutely so. Jerry's time and emotion went into the music.

carolyn "mountain girl" garcia: One day he just left and I never knew what had happened to him. But he had left once before. He had gone off for a couple of weeks. I was busy. My responsibility level was up. I didn't really have time to go chasing after him.

sue swanson: I stood in for Jerry at the birth of both their kids. One time he was in New York, one time he was in Paris. He thanked me profusely both times. I don't know. Maybe he didn't think he was

adequate. But I stood in for him for both of his children with Mountain Girl.

steve brown: When Jerry left Mountain Girl, he went to live in a rented house in Tiburon for a while where he also shared some time with Deborah Koons, who was then his girlfriend. Either by coincidence as a filmmaker or by her own plan, she got involved when we shot the Grateful Dead movie in October of '74. Then she helped in the editing.

carolyn "mountain girl" garcia: It was around the time Theresa was born that it really started to get to be a problem. He had wandered off and found somebody else to spend time with and then he would come back and that went on like Ping-Pong, back and forth for a while until I realized that I was losing sleep, losing weight, losing energy, worrying a lot, and it wasn't good for me. I started to put my foot down and deliver ultimatums. That was absolutely the wrong thing to do and we had one good solid argument and he stomped off and I didn't see him for a week. I realize now that was an unfair thing for him to do. But at the time I took it the other way. My feelings were hurt and it was a tough time. There was a lot of misunderstanding going on that we weren't working very hard to clear up.

By 1975, it was really getting severe. He disappeared again and I said, "Ah, the hell with it. I can't handle this." I tried to fight it out with him a little bit but he was enjoying himself. I got really upset and went on a physical fitness program and lost some weight and really tried to pull my act together to win him back and I succeeded. Off and on. But he definitely didn't seem to think that home life was enough for him. He wanted more and I couldn't handle it and finally I moved up to Oregon for a year and a half and I bought a little place out on the coast with the money I made from my book because I didn't have any money. He wasn't giving me any.

The first six months, I called Jerry several times trying to get some support money. I kept asking him to come up and visit us but he never did. Meanwhile, I was trying to track him a little bit through our network of friends to find out what he was up to and the news was not good. So I decided to play my hand independently of the group. The news was not good. And now I really was away.

The
Wheel

The wheel is turning
and you can't slow down
You can't let go
and you can't hold on
You can't go back
and you can't stand still
If the thunder don't get you
then the lightning will.

—*Robert Hunter, "The Wheel"*

For me, drugs are just like the softest
most comfortable possible thing you can
do. In a way, it's the thing of being
removed from desire. It's a high state
of being and you can get there all the
time. Every time you do it, you get off.
Except for things like forgetting to
eat and all the other little things in
life. All that shit slips right past you.
That's why people die.

—*Jerry Garcia, interview with author, 1988*

26

justin kreutzmann: From the late seventies through to the mid-eighties was a really dark time. It was weird. Even if the sun was shining on the Grateful Dead world, it was always a cloudy day. They were playing the same songs and they cared and the audience really cared. But if you saw the way the band was acting, you had to wonder, "How can those kids really get off on this?"

alan trist: In the early seventies, the band was growing up and becoming a bigger deal. It required more to look after it and to protect it from the outside world. Still, the desire was to have people who were cool and part of that family scene. The new paradigm we were all talking about in Palo Alto was still operative in Jerry's mind and he wanted it to be that way. He wanted to have people around who were both friends and business associates to take care of what needed to be taken care of and interface with the outside world. For a while, it worked. It was really working. Maybe it worked up until the end, and goes on working.

chesley millikin: I went to visit the Dead at the offices and Rock was there and the New Riders and the Dead were about to go to Europe. Jerry said, "You take care of the New Riders." So I took them on the first half of their world tour. As everything. Cook, slut, butler, baby-sitter, the whole bloody works.

richard loren: We did Europe in '74 and Jon McIntire got fired from the Grateful Dead. Kreutzmann fired him. God knows the reason. I can't remember why.

chesley millikin: Why? Oh, who knows why? Too much of this and too much of that.

jon mcintire: I had been in Paris advancing the gig and I came back and I was dressed up. As the band came off stage, this beautiful woman came running at me and threw her arms around me and I put my arms around her and I happened to hit Kreutzmann in the face as I did it. As he was coming off stage. That moment personified something to him. Here I was looking kind of spiffy with this beautiful woman around my neck and I hit him. Also, there were a lot of drugs going down. At three or four in the morning, I got called by Kreutzmann and asked to come to his room. In front of several people, no band members included, Kreutzmann proceeded to vent all over me. He said, "I realize you could get the band and buck me on this but I want you out of here."

The next morning, I got a call from Richard Loren who said, "I've been hearing weird stuff. What's happening?" I told him and he said, "We gotta talk to Garcia." So we went into Jerry's room and I told Jerry what had happened and he said, "What are you going to do?" I said, "I'm leaving. I'm out of here. I can't do this anymore." He said, "I don't blame you. If I were in your shoes, I'd do the same thing. I'd say, 'Fuck the Grateful Dead.' " Then Richard said, "Jerry, if they've attacked McIntire, I'm next and I'm going, too."

So Richard and I rented a car and drove to Paris. The way Hunter put it later to some interviewer was, "It was a matter of difference in style. McIntire would show up with a ballerina on each arm and no one else in the Grateful Dead could understand that kind of stuff."

chesley millikin: One day on the Europe tour, I came down and Hal Kant, the lawyer friend of mine, was there. I said, "What are you looking so glum about?" He said, "Didn't you hear?" I said no. He said, "The band fired Jon McIntire, Richard Loren, Rock, and I don't know who else. They fired them all." I said, "Who's the new manager?" He said, "You are." I said, "What? These guys?"

jon mcintire: Jerry and I actually talked about this because I was trying to figure out just what it was that I was doing there. In between the times I was manager, we'd have long heart-to-heart talks. I was trying to follow. Trying to create consensus, trying to soothe the pain, and also trying to be in the background as much as possible. It was never my band. Hunter did not write "Uncle John's Band" about me. He wrote it for

Jerome John Garcia. But even Hunter after some years called me Uncle John so everyone assumed it was me.

richard loren: A month later, I became their manager and agent. Now I was not only booking the band, I was dealing with the money. I was called the general manager of the Grateful Dead. At this time, the Grateful Dead were not rich people. "It's not what you make, it's what you don't spend." I quoted that to them many times. The musicians had needs but the salaries were never quite high enough to take care of them. They were all chipping away at expensive drugs. You had the coke and the beginnings of the heroin thing. They were also paying their employees far more than the going rate.

peter barsotti: The thing about the Grateful Dead was that they were like a primitive tribe. That explains a lot about their closed family, about their clan, about the way they reacted to everybody, about the way they dealt with everything that went wrong within their tribe. Basically, no one was ever rejected unless they got to the point where they ejected themselves. You could make a hundred mistakes, you could be stupid for your whole life, you could blow it a thousand times, and you were still fine. Mainly, it had to do with total subservience of your life to theirs and total acceptance of them as it. "Just buy in behind it, man. A hundred percent." They also took pride in having no business sense.

john perry barlow: We were a totally primitive tribe. We were like a completely isolated village in Sicily. We had this sort of mafiosi code of honor that was extremely blunt. There was a great deal of loyalty there but it was a hard loyalty. Part of the deal was that as the Deadheads became more and more sweetness, light, love, charity, openness, emotional evolution, the darker we were.

hal kant: They wanted to produce this Grateful Dead movie and I had killed it and killed it and killed it because I had told them the way they were going to go about it was a crazy idea, as in those days there was very little money. I showed up at Winterland for a series of concerts and four different crews were shooting for four days and nobody had ever told me about it. Rakow had gotten them all into doing it and they had

a budget of one hundred and fifty thousand dollars. I said, "Ron, what you're shooting here is not going to be processed for a hundred and fifty thousand dollars. Forget about anything else. You're not going to be able to process the film."

As it turned out, the processing costs alone were just under two hundred thousand. Jerry, being the wonderful person he was, had a great, great curiosity, creativeness, and inventiveness and all those things went into, "Yeah, let's do a movie. Yeah, let's do a record company. Cool. Great. Let's do it." The way creative people deal with their art is not the way you deal with a business. What's the downside if you do a painting you don't like? You throw it in the corner. Or if you do a piece of music you don't like? You just leave it in the can. All his projects were the same. "Let's try it."

steve brown: The Grateful Dead movie was shot in October of '74. Jerry was very involved with it. From way back, he'd always wanted to make movies. He loved film. We used to go to movies when we were on the road. We'd go before sound checks. He'd get up early and we'd go out to a movie at noon. Jerry really had an artist's eye for detail and he was a superb film editor because he really could see continuity and rhythm and flow. He went through the footage deciding first of all what performances were suitable and what he liked of himself and the band. Later, he helped decide what needed to be in the final cut. He was right there at the table. He was running the thing forward and back himself. He wasn't standing over somebody's shoulder doing it. He was sitting there doing it. In terms of the animated sequence that begins the film, Jerry was the main proponent of that.

gary gutierrez: Their idea at that time was to take a bunch of posters from all the years of posters for the Grateful Dead and use that as a background for a title sequence and we would animate some of that. That was how it began. I went over one night to meet with Jerry where they were editing and we hit it off and I told him I had some ideas. They didn't have much money for the title sequence. I think they had like five or eight thousand dollars. I had learned a lot of things doing animation for *Sesame Street* that made me want to try much wilder things. I saw this as my big opportunity. This thing just grew and grew and it went from eight thousand bucks to I guess eventually about twenty-five thou-

sand. It turned into an eight-minute animated extravaganza of Grateful Dead mythology.

That was partly my fault and partly Jerry's fault because he would see stuff and he would have ideas and he seemed to like my ideas. I remember driving back from L.A. when I heard this "Uncle Sam" song and immediately, a bell went off in my head of a Grateful Dead skeleton as Uncle Sam and then all the other ideas sort of flowed from working with Uncle Sam and using that song as the main basis of it. To use a New Age term, one of the great things about Jerry creatively was that he was really validating. Francis Coppola has a similar quality. Both he and Jerry share that ability to get the best out of you by actually giving you a lot of trust and actually throwing a lot of responsibility on your shoulders. They describe the problem and what they want to accomplish without telling you how to do it and they are open to ideas. Nothing is too corny or weird or out there for them to think about.

steve brown: It was really supposed to be done a lot cheaper and a lot quicker. What wound up happening is the goddamn animation became this black hole where more and more money and more and more time were required. We began refinancing deals. Really, the film broke our balls financially.

gary gutierrez: We were over at Bob Weir's studio where we were doing all of the various sound effects and remixes for the movie. We spent several days in a booth with Jerry. Attached to the basic mixing board were stacks of stuff that they would bring in and plug in and rewire to get weird effects. When Uncle Sam is riding the motorcycle and he says, "All right" or "Wow," it was Jerry talking through a plastic hose that was hooked into some kind of actuator on an early kind of synthesizer to make his voice sound like dry bone. He was in his glory there. He had a lot of fun watching the animation play back, listening to the music, and doing lots of overdubs.

steve brown: The money to set up the record company had come from First National Bank of Boston. Half a million I think to get us rolling. The independent label, Round Records, had Jerry's *Old and In the Way* album and Robert Hunter's *Great Rum Runners* solo album. At the same time, we'd set up production for the *Wake of the Flood* album,

which was the first venture on Grateful Dead Records. That was done at the Record Plant in Sausalito in the late summer and fall of '73. Everything started off really good. We ran it pretty straitlaced, just like the suits would have done. We'd put out an album and run a tour to support it and it went fine. Now we had some merchandise to lay out to people in the way of promotion when we were at the concerts. We'd set up our own booth at concerts and give away postcards and sign people up for our mailing list. This was where the real start of the Deadhead database kicked in. By the time the record company had pretty much run its course and we turned it over to United Artists in '75, we had about eighty thousand names.

ron rakow: Jerry and I got loaded one day on the porch of his music room, which was above his house in Stinson Beach. We looked out at the ocean and Jerry said, "Hey, man. Wanna do something far out? Let's buy our way to the sea." Meaning, "Let's buy every single piece of property that comes up for sale in Stinson Beach that gets us closer to the ocean so we'll have a path to the sea." We didn't have any money but we had this relationship with the First National Bank of Boston. They were our factor. They guaranteed the credit of the stores and distributors we sold our records to. So I went to the First National Bank of Boston and told them that we were going to get involved in other projects around which Garcia had expertise. I asked for a two-million-dollar credit line with no collateral. That was a lot of bread. I told them we were going to be in Boston in three months and I asked them to arrange for the senior executives of the bank to have lunch with Garcia at the bank. Then they would know they were in the hands of a genius.

But I knew Jerry wouldn't show up just for lunch. I needed a cookie to get him there. So I had their chief economist agree to show us her predictions of where the worldwide economy was going. Then I went to Jerry and told him that one of the biggest banks in the world was going to give us a private briefing on the worldwide economy that they only gave to top executives. He went nuts.

Jerry and I and Deborah Koons, who was then his girlfriend, went to the First National Bank of Boston. We walked into the twelfth-floor executive dining room and Jerry Garcia was wearing, guess what, Levi's and a black T-shirt. We sat down with the chairman of the board of the First National Bank of Boston, three billion dollars at the time. The chair-

man turned to Jerry and said, "My daughter wants to play the clarinet. But my music person says it would be much better to start her on the violin. What do you think?" Jerry said, "Let her do what she wants." The guy said, "Oh, yeah!"

The president of the First National Bank of Boston turned to Jerry and said, "We're getting a sound system. I'm going to get EPI speakers. What do you think of them?" Jerry turned to me and said, "Rack, don't we have a deal with them? Don't we trade them records for speakers? What about those?" I said, "They're good." Jerry said, "I've listened to them. I think they're really good. I think you'll be very happy with them." The guy said, "Oh, great!"

After the appetizer, we started walking around the room and looking out over Boston. Jerry walked over to me and whispered in my ear, "We're gonna own this place. This is fuckin' backstage, man." They gave us the money. Did we buy our way to the ocean? We came damn close.

richard loren: In the end, the record company turned out to be the thing that burned their ass because Ron Rakow walked away with a quarter of a million dollars. A quarter of a million dollars was a lot of money at the time.

ron rakow: For years and years and years, the name of the game was that I was the family barracuda. You don't ever want to fuck with your barracuda because the barracuda will do what barracudas do. He will fucking eat you. What happened was that the Grateful Dead became convinced that it was in their best interests to fuck me. Garcia and I had a meeting on it and Garcia looked me right in the eye and said, "It's clear that this is going to happen." Because I went across a really entrenched interest in the Grateful Dead and that was Hal Kant.

steve brown: Ron Rakow was down in L.A. on the rug at the United Artists Records office saying, "Really, the album is in the mail. It's coming now." And there was Mickey Hart up at his barn saying, "Let's put one more drum track on this part here." To really slam back at the treatment he felt he was getting, Ron Rakow cut himself a check for about a quarter million and freed himself from the whole thing and he

disappeared. Now we were really broke. We had to finish this movie and get it out.

ron rakow: Jerry and I were making this movie that was hemorrhaging money. The band had stopped working and the movie was sucking up one huge quantity of money and the band was sucking up another huge quantity of money and there was no output of any kind. My strategy was really simple. I walked into United Artists Records in Los Angeles and said, "I need a million dollars. I'll give you four more Grateful Dead albums, one Garcia album, and one Weir album." They said, "We already have all these Grateful Dead albums. Why do we need to give you a million dollars to have four more? You're giving us nothing." I said, "Not true. Because if you don't give me the million dollars, I am going to bankrupt the Grateful Dead and all the individuals in it and we'll make a deal with Warner Brothers the next day. Because the bankruptcy trustee will nullify all existing contracts."

When I'd told Garcia about this beforehand, he'd said, "Is this true? Can you do this?" I said, "I don't know. Let's find out." Garcia loved it. He fucking loved it. He was jumping up and down and he said, "This is brilliant. You go and do it. I got your back covered. There is no Grateful Dead without Jerry Garcia. I won't let anything happen to you."

I was down in L.A. doing this and on Sunday, a meeting of the Grateful Dead at Front Street in San Rafael was called to explain what I was up to. I had been sick so I stayed down in L.A. My attorney was supposed to go to that meeting to explain my strategy along with Garcia. Fifteen minutes before the meeting was supposed to begin, my attorney was called and told that the meeting had been canceled. But it had not been canceled.

Garcia got there and everybody jumped on him. "What the fuck is this guy doing? Do you understand it?" Garcia had nobody to bounce off of. So he sat down in this secretary's chair on wheels and slowly wheeled himself out of the room. He went into the studio, picked up a guitar, and played scales for four hours.

The next day, I went to United Artists' offices and they handed me a check for two hundred and seventy-five thousand dollars. As the guy handed me the check, with both of our hands still on it, the secretary said, "Emergency call for Ron Rakow." I picked up the phone and my lawyer said, "Ron, I don't know how to tell you this. The Grateful Dead had a meeting yesterday after all and they fired you." I said, "The call you got

has no status and this call does not compute." And I hung up the phone. I knew I had just been fucked. I asked myself, "Do I quietly fold my tent and go away feeling fucked? Or do I make sure everyone feels at least as fucked as I do?"

steve brown: We had this horrible *Steal Your Face* sound track which was recorded badly because a few of the tracks were fucked up by a guy who happened to have a cocaine problem. When Ron Rakow left, Jerry was angry and depressed. I think he felt he'd let down everybody else by having his guy rip us off. Here was Jerry being slapped publicly as it were within the organization by Rakow in front of everybody. I think he was humiliated by it.

ron rakow: I went to a bank on Santa Monica and La Brea and I deposited the two hundred and seventy-five thousand dollars into a temporary account I had set up for the Grateful Dead. I wrote a check for ten grand to a secretary I had hired away from United Artists and could not now employ. I wrote a check so this Hell's Angels movie we had made a commitment to could get finished. I wrote a check to Rolling Thunder, the Shoshone medicine man who had taken an option on some land so Native Americans could move back to it. And I wrote a check for my services for two hundred and twenty-five thousand dollars which I cashed. I had 30 seventy-five-hundred-dollar cashier checks and this big amplifier box filled with Grateful Dead bills I was going to pay. I taped up the box and wrote on it in big marker pen, "Shove Up Ass," and I sent it to the person at the Dead office who had called my attorney to say the meeting had been canceled.

richard loren: They had almost finished the Grateful Dead movie. In addition to all those other things I was doing, I now became the new executive producer of the Grateful Dead movie. They needed forty thousand dollars to finish it. Where were we going to get the money from? Bill Graham lent us forty thousand dollars. At the time, it was a lot of money. Like what four hundred thousand would be now. Bill was not going to give us anything without a hook somewhere. But he never let the band know that. The band were the ones he'd always have his arm around. "There's nothing like you guys." Jerry knew but I had to

tell the other guys, "Bill's your friend on one level and on the next, he's not." What I was talking about was money.

steve brown: Jerry was pretty depressed by the situation but no more so than any other fine mess they'd gotten themselves into. It seemed to be their own weird karma of doing business the way they wanted to do business. As an outlaw business entity. They really never wanted to play the game the real way. They wanted to do it their way and this was the price they paid.

ron rakow: For years, the game for me was "Brothers" and I was good at it. I fucked with anybody who fucked with my brothers. Then the game turned to "Fuck Your Brother." And I was good at it. I was the best there was. But Garcia, that was another story. My first public meeting with Jerry after this happened was at the Grateful Dead house at Fifth and Lincoln. Jerry said, "Rack, you should have been on the last tour!" With the most enthusiasm he could muster, he described to an old friend everything that had blown his mind about that tour. He said nothing about the money. Nothing, nothing, nothing.

All the lawyers went out to a restaurant and made a deal. They came back and I said, "Jerry, it was nice seeing you." He said, "It was nice seeing you and I'll see ya." The other people in the room, McIntire and some of the equipment guys and some of the other guys in the band, were fucking livid. But no one even said, "You fucking dog."

The day after Rex Jackson died, I met privately with Jerry Garcia in a restaurant in Tam Junction directly over the spot where Jackson had gone off the road and died. Jerry and I talked and I told him what my realities were. During that lunch, Jerry said, "I don't blame you. I don't blame you one bit. I've checked out everything that went on around the time of that meeting. We were definitely set up. I don't know if I would have done what you did. But I wouldn't have done nothing, that's for sure. As far as I can see, it was a mass freakout."

I didn't pay them back. Not a fucking penny. We'd made a deal to buy me out for seven hundred and fifty grand. So this was one third of what I was supposed to get by legitimate contract.

peter barsotti: The bottom line was that if one guy didn't want to do something, they wouldn't do it. That was the Dead principle. It was

very unnerving because you could say, "Man, we can do this. We could do this. We could do this." One guy would say, "I don't wanna." This huge beautiful plan. One guy saying, "I don't wanna," and that was the end of it. You'd resent it and really feel frustrated. But if you thought about it, that was the reason they could exist. That was the only way they could possibly go on as a group.

alan trist: Quite honestly, I think Jerry always felt that at some level there was enough justice in what Ron did for him to forgive it. It wasn't that it was cool but it was like Jerry wasn't going to be all that upset about it. At some level, he understood it. I never heard any acrimony from Jerry about it. For Jerry, it was over with. He was willing to move forward. Others felt differently, though.

richard loren: After Ron Rakow left, it started to become more and more difficult for Jerry to keep all his things together. With Jerry, the group came first. Jerry was always looking for somebody else to take the lead. No matter what it was, Jerry never ever wanted to be the leader of anything. That was why he never spoke on stage. He told me one time, "I was on acid once and I had this vision of speaking on stage and it made me feel like Hitler." Or words to that effect. He never wanted to tell people what to do.

ken kesey: Jerry never let anybody pin him down. Drove women nuts. Drove the whole Grateful Dead spectrum nuts. They wanted him to be pin-downable. You'd never see Jerry take a strong political stance. Because he knew that once he did, they'd have a bead on him. Even if the stance he had taken was correct. That had nothing to do with surviving as an artist and providing what he'd really promised as an artist. Like the Beatles sang, "You've got to hide your love away."

hal kant: The Grateful Dead always had a huge overhead because they couldn't have been more generous with employees and they always had a huge number of people on the payroll. By '73, they were worn out from touring but they also didn't know what kind of direction they wanted their music to take. They felt that time off would be a revitalizer. They were going to work on their individual projects and sort of re-energize and come back.

owsley stanley: At one point, we had three staging crews out on the road, building and tearing down stages. It was exactly what I had warned them about but I got the blame for it in the end. It just fell apart. No one could sustain it. That was when they went off on sabbatical for a year.

hal kant: I wasn't physically there but I heard that during the Dead hiatus, Jerry couldn't go a night without playing. If one of his other bands wasn't gigging, he'd go down to a bar and play.

27

john "marmaduke" dawson: I actually got a toke on Jerry's dragon one day. This was probably around '75. He was chasing the dragon down a piece of aluminum foil. Because that was what he did. He never shot it. He would have never been a shooting junkie. He would have harmed himself in any other kind of way but I don't think he would have stuck a needle in. I said, "Can I check some of this out?" He was not willing to share it or talk about it. It was just, "This is what I'm doing. If you want to have something to do with it, I'll give you a hit because you're here and I'm about to do it. I'm not going to stop because you're in front of me. I'm going to do it and if you want a hit, then fine." But he wasn't particularly volunteering it.

elanna wyn-ellis: At the Keystone years ago was where I first noticed him doing it but I didn't understand. I said, "What are you doing, Jerry?" He looked at me and he said, "You're just like Marmaduke. You want to know everything." Instantly, he regretted being snappy. He said to me, "This is what I'm doing," and he showed me.

richard loren: It got brought to us in 1976 and I'll never forget the first time it came. This brown powder. People were saying how wonderful this stuff was. You just smoked it. It was not really heroin. It was Persian opium. People said, "Hey man, let's try it. Whew. This is great." I'll never forget telling Jerry, "Jerry. This stuff is great but I'm going to wait till I'm fifty-five years old. When my bones start to creak and things start to hurt, maybe that's the time for it. But I don't want to get strung out on this now." It was very seductive. So I stayed away from it. I never really got into it. But Jerry did. The guy could never say no. He had what I would call an addictive personality. Whether it was sugar or cigarettes or coffee or whatever, it was very difficult for him to say no. His thing

was, "If you're not having fun, don't do it." Besides music, fun to him was cigarettes, pot, coffee, cocaine. If he had a weakness, that was it. He was human, after all. For all his other incredible traits, this was his weakness.

owsley stanley: Garcia started in '75 or '76. Someone gave him what he was told was opium to smoke and it wasn't. It was ninety-five percent pure heroin base, so-called Persian. I don't think he knew what it was that he was getting. Garcia smoked the stuff thinking it was a very pure form of Persian opium. The thing about heroin when it's smoked is that the material condenses in the lungs in a sort of tar that is soluble and the body slowly absorbs it. So it's like sticking a needle in your vein with a drip. A constant supply. People who shoot up heroin, the body metabolizes it and it's gone. When you smoke it, the stuff builds up in your system to a high level and stays there continuously for as much as seventy-two to ninety-six hours. The result is that many people become hopelessly addicted on just one smoke. Let alone two or three smokes.

john "marmaduke" dawson: I had a couple pokes. I didn't like it. I got uncomfortable. You know how junkies shoot up and then go puke? I felt like that the whole time. I tried to go to sleep and there were ugly pictures in my head. Like those recurrent dreams that you have after you've had too much to drink at night. That loop is a bad loop. It's not a fun loop. Something's bothering you and you keep on thinking that you're working it out and you're not. That was what smack did for me.

owsley stanley: Within a week or so, he was addicted. He liked it. I had conversations with him when he was off it and he said, "I really like what it does." I said, "From the outside, you're not really a very interesting guy to be around when you're on it. You're really an unpleasant person to be around." He said, "That may be so but I like what it does. I like the hallucinations. I like whatever it shows me." I don't think he understood the depth of the changes that occurred in his personality when he was using. Just by looking at him from fifty feet away, I could tell. Simply by the way he stood and held himself and the expression on his face.

laird grant: He was snorting smack. I guess he tried shooting it for a while but it was not his thing. I don't think he had the veins for it

and he wasn't one of those kind of people. He wasn't into the mystique of the whole operation more than to get high. The ritual of shooting up is like being addicted to firing up that cigarette and puffing on it. When I found out that he was doing it, we had some very heated words on that. He was saying that it was cool and he could handle it and I said, "That's what they all say. Look at it on down the line, man." I said to him, "What happened with pot?" He said, "That's not good enough, man. It fucks with my throat. I can't sing on it." When I was seventeen or eighteen, I was into shooting up heroin. Next to good sex, it's probably one of the most incredible experiences in the world. But sex doesn't kill you. Unless you have a heart attack. Whereas kicking that gong ... pretty soon, the gong's going to kick you.

owsley stanley: He wouldn't talk to me when he was doing it. He would turn in the hall and go the other way and say, "I'm busy. Don't come in here now." Or he'd have Parish bar the door. As he grew older and got into heroin and other things which make you very egocentric, Jerry had a tendency to use his power more. Parish became his roadie. Parish was very much someone born in the year of the tiger. The kind of guy who liked wielding that power and being physically imposing.

jerilyn lee brandelius: The Dead and the Who played together in the Oakland Coliseum in October 1976. This was after they came back from their hiatus. On the second day, they opened the show. We were sitting in the dressing room during the break. Pete Townshend came in and he said to Garcia, "I've seen you play three sets and I'm wondering how you figure out what you're going to play. Because it doesn't seem to me like you have a list or anything like that. We've been playing the same set on the entire tour. The same songs." Jerry said, "Gee, man. I don't know. I never really thought about it. We just kinda get up there and do it." Pete said, "Wow, that's incredible. That's just amazing."

A couple weeks after this conversation, we were on the road somewhere and Weir said, "I've been thinking about what Pete Townshend said. I think we should make up a set list." The guys went, "Ahh, Weir. Stuff it." He was going, "No, no, no. I think we should have one." So they said, "Okay, Bob. Make up a set list, we'll play it." They made up this list of songs and they went out there and started playing. They were playing along and they came to a point where Weir was supposed to know

the list. They turned to look at him. Weir looked back at them and they all stopped playing. They just stopped. Because they didn't know what they were supposed to play next.

pete townshend: With the Dead, it was all on stage. They were having a good time. They enjoyed one another's company. One of them might walk off halfway through and go chat with somebody. It was slow. It was easy. They were taking their time. They were being almost mystical about the process. They were not striving for success. There was no stress. There was no success ethic. They were moving like Gypsies across the planet and they just happened in that place. I always knew they would carry on until Jerry Garcia was old and gray.

john "marmaduke" dawson: Jerry would insist on his right to do whatever he wanted. If Mountain Girl got on his case about the smack, she would have been out of there.

carolyn "mountain girl" garcia: A year went by and I was getting really tired of where we were living in Oregon. I packed everybody back in the VW van, rolled up the rug and put all the books in, and off I went back to the house in Stinson Beach. I'd been back about six weeks and there was a knock on the door and it was Jerry. He came in, looked around, and he said, "I'm moving back in." And that was it. He moved back in. I guess he was tired of running around. I never did really find out what precipitated this but he moved back in and things went back to the way they were before and I was thrilled. I was so happy to see him. I was just ecstatic and the kids were ecstatic. At the time, Annabelle was seven and Trixie was three. We'd gotten him back. We'd gotten another go-round. Unfortunately, the day before he knocked on the door, I had sold the house. I'd made a deal with a guy the night before and then here came Jerry and he wanted to move back in. I said, "Well, sweetie, that's great but . . ." Instead, I moved us up to this beautiful house in Inverness with a pool. It was really neat. We moved out there and we went to Egypt. We took the Grateful Dead to Egypt.

richard loren: The Dead went on hiatus. During that period of time, I got a chance to take a vacation. I went to Egypt for three weeks. I loved it. I came back and I said, "Jerry. God, Egypt was really fantastic."

I went back the next year. I was on a horse around the pyramid and I looked at the pyramid and I saw this stage. I said, "Wow, maybe the Dead could play here." I looked at the Egyptian people. They smoked hash, they were high, they had this wonderful attitude about life not unlike the Deadheads. The place had an appeal that was absolutely timeless. I came back to Jerry and I said, "Let me lay this on you because I don't know if this is something you want to do." When I said Egypt to Jerry, his ears perked up right away. He said, "We have to meet with the band." We met with the band. They all said, "Yeah, let's do it man. Yeah, far out." For the next year, I tried to put this thing together. I made three trips to Washington. Phil Lesh and Alan Trist came with me and we met the Egyptian ambassador. Later, we went to Cairo and met with the American ambassador to Egypt.

alan trist: The key moment was when Phil, Richard Loren, and I had an audience with the Egyptian ambassador in Washington. He was the one who was going to say yes or no. He said to Phil, "Why do you want to do this?" Phil gave him a musician's answer. He said, "Over the years, we have learned that we play differently in different places. This is what interests us and we can't think of anywhere we would really like to hear how we would play more than at the Great Pyramid."

richard loren: We didn't announce it to the press until the night before we took off. We did a press conference and we were on the plane the next day. So nobody could cancel it. I was extremely careful because I didn't want this to be a drug bust setup for them. I had the assurances of the State Department that we weren't being set up there. So I felt comfortable going there and sure enough it was a great success. We played three nights in a row under a full moon in lunar eclipse.

mickey hart: We said, "We could be a finger on the hand of peace." This was during the whole Sadat thing. They were having peace talks and it was a time when we could have made a difference. We always wanted to go to the pyramids. It was a Grateful Dead fantasy right from the beginning. This just happened to be the time that the wheel came around in the revolver. And we wanted to take all of our family. The kids, the dogs, the cats. We wanted everybody to go to Egypt for a blast.

sue stephens: Traveling with Jerry through Egypt was a kick. In Egypt, they called anybody with excess hair "The Moustache." In Egypt, Jerry became "The Big Moustache." He just had this presence. We were starting to call him the "Ayatollah of Rock and Rollah." One of the ways that the Egyptians would inspect you was they would make you step out of your shoes and walk around your shoes and then put them back on. Maybe people smuggled stuff in their shoes over there. Poor Jerry. Everywhere we would go on these short little hops, they kept picking on "The Big Moustache." They totally zeroed in on him. Not knowing who he was as far as a rock star or anything. He drew that kind of attention. He was just that kind of person. I think his molecules were more dense than most people's.

ken kesey: They played for the smallest paying audience since the Acid Test. There were six hundred and ninety some people there who had paid. But they would take the spotlights and shine them out into the desert and there would be thousands and thousands of bedouins with camels. There was only a fence and then there was the Sahara Desert. The way the Nile Valley was, they could hear the concert all the way in Cairo.

It started off with Hamsa el-Din playing the oud. He had flown in twenty-four of his old schoolmates. They were blacker than a pair of binoculars and they wore these beautiful pastel djellabas and pastel turbans. Light light blue and light yellows and purples. I couldn't see their hands or their faces. All I could see were their eyes and teeth floating around out there. The Egyptians and the Saudis had come to hear rock 'n' roll and here were these black kids doing this little kid's dance. It was equivalent to "patty-cake, patty-cake." As they worked it, Mickey Hart went out there and began to drum with them. They had tambourines and they were doing this little chant. Phil picked it up. Pretty soon, I heard Jerry pick up the lick on guitar. Gradually, all the Dead were playing this. Without a grinding of gears, those twenty-four dancing Sudanese began to fade back into these piles of equipment.

Without changing the beat or changing chords, the Dead went right into "I wanna tell you how it's gonna be . . ." I thought, "This is the way cultures really get to know each other. Not around the diplomatic table but through music. Taking a twelve-tone scale and a very complicated rhythm and working it right into Buddy Holly without a glitch." It was

the best show business I had ever seen in my life. Bar none. Just absolutely wonderful.

richard loren: I was counting on that show to raise a half a million dollars to pay for the trip. We wanted to do a three album set. "The Grateful Dead in Egypt" with pictures and so on. It was going to be wonderful but what happened was that there wasn't a set out of the three sets that they did that they could even put together to make one album. It was so bad and there was a reason for that. Just before they left America, the piano tuner quit because the crew wouldn't let his family on stage during the show. In Egypt, we couldn't find a piano tuner in time and the piano kept going out of tune. It wasn't because of the King's Chamber or because they tried to do something special. Because of a stupid little thing like that, we lost a half a million dollars. If you don't think that had an effect on the Grateful Dead's finances over the next five years, it did.

mickey hart: We were going to make a record, which never turned out. We were going to make a film, which never turned out. We were going to pay for it, which never happened. We ended up half a million dollars in debt.

alan trist: If he could have, Jerry would have done more of this stuff. Having fun and doing all the interesting gigs. We wanted to play everywhere. The Egypt concerts brought up other fantasies: "Let's go and play in Israel. Let's go play in the Antarctic. Let's go and play Easter Island, India, everywhere. Let's go around the world and play in all the great spaces." The difficulty of moving everything around was part of the problem. The other part was drugs. Because at this point, Jerry was moving into a definite needfulness. That was what withheld him from being able to do the things he really wanted to do.

carolyn "mountain girl" garcia: It was a terrific trip but Jerry was starting to chip on painkillers. John Kahn had broken his ankle and Jerry and John Kahn got into a thing with painkillers over there. All I knew was that Jerry was getting into taking downers of some sort. He was getting into downers and it was really hard for us because we didn't know what the hell was the matter with him. All I knew was

that he seemed to be really depressed. To me, depression reads as unhappiness. To me, that meant he was unhappy with me. So I was constantly trying to compensate for all that and that was a lot of work. I started to get this really bad backache. In retrospect, I can see that I was carrying a huge load at this time. I had the kids. I had a business that was losing money and Jerry wasn't very supportive of me. I couldn't feel his support anymore for what I was doing and I suddenly realized I had to quit that business. I tried to find somebody to take it from me and failed and then I finally did find somebody.

By the time I did, Jerry was starting to get sick. He was starting to become a junkie. I didn't know what that was. I just knew that it was bad and that it was wrong and I couldn't deal with it. None of this language about recovery had yet been invented. No one knew a darned thing about it. As far as I was concerned, I was out there all by myself on the North Pole with it. Basically, I just told him that it was over. Until he got straightened out, I didn't want him to come back to the house. It was not a good scene. Because he couldn't understand why I had suddenly turned on him like that. I said, "Look, man. If this is what you're going to do, I don't want any part of it. I can't have any part of it."

In retrospect, it was the biggest mistake I ever made. I wasn't at fault but I didn't know that then. So I took it really hard when he didn't bounce back. That was really a tough time. Just to get away, I went off to the East Coast. But I remember the appalling sadness that we all felt.

28

hal kant: You have to distinguish the band from the individuals. They all treated their finances differently. Jerry treated his as though he really didn't care about what he was making. As long as he had his per diem and he could create, he was happy.

richard loren: So now we were in debt. We had a bank loan we had to pay, we were in debt from the movie, we were in debt from Egypt. I had to work the next four or five years as a manager trying to get them solvent. I never had the luxury of being with a wealthy Grateful Dead. Before '72, they'd had nothing. They had just been a working man's band. Now they knew what the taste of a new car was. They knew what the taste of owning a home was. A new guitar. Now they had a taste for money. Plus there was the introduction of heroin.

tom davis: I'd first met Jerry in 1971 when I wandered backstage at Winterland at a benefit for the Sufi dancers. I had this beautiful girl on my arm and we'd been taking barbiturates and LSD and the crowd just parted for us and we walked right through doorways and upstairs. I got right behind Jerry's amp and it looked like a joint that he was smoking. I took a huge hit off of it and smoked the whole thing till I discovered it was a Pall Mall cigarette. I had no business being there at all but nobody kicked me off until the show was over. I just smoked his cigarette and he let me sort of drool on the amplifier which at that time had tie dye on it.

In 1978, I was doing *Saturday Night Live* in New York and I asked Lorne Michaels to book the Grateful Dead. He did not want the Grateful Dead on the show because they were not hip enough. I literally got on my knees and begged, "Please, do me one favor and let the Grateful Dead play. Please, please." And he said, "All right, all right." They ended up

playing "Casey Jones." I remember the director put an 'X' on the floor and said, "Jerry, this is Dave the director. Where are you going to be when you're playing like that?" Jerry said, "I don't know." "You've got to tell me where you're going to be or you're not going to be in the picture." Jerry said, "I don't care." At that point, Jerry was ready to walk. He was pissed but they did the show. NBC came very close to getting their entire staff doped that day. Their coffee machine came very close to getting dosed.

manasha matheson garcia: I met Jerry in '78 in Chicago on Mickey Mouse's fiftieth birthday. I was going to Shimer College in Illinois. My friends at college mentioned to me that they had bought Jerry a pumpkin the year earlier when he played in the Chicago area and inside the pumpkin, they had written a note that said, "Manasha says hi!" I didn't even know that they had done this. I'd actually had a dream about Jerry a few nights before he played on *Saturday Night Live,* which was November 12. I had dreamed that he had done the peace sign and when he was on *Saturday Night Live* at the end of their last song, he did do the peace sign so I was amazed.

My friend and I went to the concert that weekend in the Uptown Theatre in Chicago. I thought it would be a good idea to do a pumpkin again. My friend was into topographical maps and I found a spot on the map called Terrapin Ridge and there was a train station that ran through it. It's the highest point in Illinois. So I had a copy of the map and I put it inside this pumpkin and I carved the pumpkin in a hotel. I went to the show and that was November 17, 1978. I went up to the front and I gave Jerry the pumpkin. He had just come on stage. He hadn't started playing yet. He took the pumpkin from me and said, "Thank you," and he was really delighted.

After the show, a studio drummer came from backstage and said, "Would you like to meet Jerry Garcia?" and I thought to myself, "Well, sure." I thought, "Wow, why me?" He told me a time the following day where Jerry would be and I went with my friend. Jerry was there and he let us in and it was like an adventure. We went in and talked to Jerry and Jerry invited me to stay for the show. So I went to the show that night and Jerry invited me back to the hotel afterwards for the gathering. They were having a party and I went back to the hotel and visited for a while. Then I actually slept on the floor. I took the bedsheet from

his bed and I slept on the floor of his room. I had never been in that world before and I think Jerry assumed things were going to happen that weren't going to happen and I told him they weren't going to happen. He was a little bit put off by that but we stayed in touch after that for many years.

I started connecting with the music and I would get backstage passes periodically from friends and sometimes from Jerry and I'd be backstage and we'd visit. We just were friends and I'd call him and tell him that I was concerned about his health. He told me later that he thought that was very dear and very sweet.

bill graham: The night the Grateful Dead closed Winterland, New Year's, 1978, was a great night. Before the show, I wrote a letter to the Dead. Basically, I asked them to rehearse for this gig. I told them there were certain songs that they had not played in a long time. That night, I put a billboard outside Winterland. It said, "They're not the best at what they do. They're the only ones at what they do." Which was something I had said about them in an interview. Right underneath the billboard on the night of the show, some kid was standing with a sign that said, ONE THOUSAND FIVE HUNDRED AND SIXTY-FIVE DAYS SINCE LAST SF "DARK STAR." So I wasn't wrong about the crowd wanting to hear certain songs. For whatever reason, the Dead invited too many bikers backstage. To some extent, that rained on my parade. Two days later, Herb Caen wrote something about how coke was being snorted backstage. The Dead played for six hours.

bob barsotti: There were Hell's Angels there and it got to the point where no one was really in control of what was going on. But the Grateful Dead and the Blues Brothers were a real fitting ending to that place.

donna godchaux mckay: By 1979, the really hard drugs had started to come in. There were so many fights. It was just a fight after every gig. As a couple, Keith and I were fighting like crazy. We half killed each other on the road. One night, I rammed my BMW into Keith's BMW. Three times. Then I drove my BMW into a telephone pole and took a taxi home. We were wasted spirit, soul, and body. It had come to a point where we were discussing how in the world were we going to

quit and we thought, "We're not quitters." There was a meeting at our house and the band came over and they said, "We think it's time for you guys to move on," and we said, "We know it's time for us to move on." It was a very mutual decision.

robert greenfield: A year and a half after being asked to leave the band, Keith Godchaux was killed in an automobile accident, thereby becoming the second Grateful Dead keyboardist to die. The Grateful Dead had already hired a third. Brent Mydland joined the band in April 1979. On stage, he and Jerry had a very close and intuitive musical relationship.

tom davis: After they did *Saturday Night Live* the second time in 1980 and played "Sugar Magnolia," they were a lot more comfortable. Everyone went to the Blues Bar afterwards to hang out. Was it a competition to see who could do the most drugs? That was what those years were called.

jerilyn lee brandelius: I remember when Rex Jackson, who was our road manager at the time decided that limousines were too high-profile. So we went from the hotels to the gigs and the airports in Winnebagos. Actually, it was a lot of fun. But people were running after the Winnebagos and jumping on the ladders and crawling on top of them. I remember some guy jumping in front of our Winnebago and saying, "Run over my arm, Jerry. Jerry! Run over me, please." Like it would be a great honor to be run over by Jerry's Winnebago. Jerry just went, *"Euuuuuh!"*

len dell'amico: Many times I'd sit at the kitchen table at the Grateful Dead office on Lincoln Avenue in San Rafael. Front Street was the macho scene and then there were "the girls," as they called themselves, in the office. Front Street was where the serious doobies would go down. The office was girls, sugar, and caffeine. Many times I saw Jerry sit there. He would just come in to bullshit. As soon as people knew he was there, he'd get a stream of people coming with business. Always, there would be, "This arrived for you. Here's the book you wanted. Here's the tapes. Here's the . . ."

After an hour, he'd have this pile in front of him. Without fail, he'd say, "I gotta go." He'd thank everybody for the stuff and then just get up and leave and leave the stuff. One time, he left an ounce of some really

expensive pot in a vacuum seal bag. Hawaiian or something. I could see the orange fibers. He left without it. What was I going to do? Just leave it there? It was illegal. I ran after him with it and I said, "Don't you want this?" He said, "Ah, okay, whatever." It was like he never kept anything. It was the black T-shirt and the pants and the keys to his car and the cigarettes and that was it.

At that time, he was renting a house at number twelve Hepburn Heights in San Rafael. Rock Scully had the upstairs and Jerry had the downstairs. I was surprised that this guy was basically living in the basement of this place.

carolyn "mountain girl" garcia: Jerry moved from our house in Inverness to Hepburn Heights. We'd go over there to visit him but he was not really in any kind of shape to visit by this time and I'm not sure how the band kept playing. Their income level was really low. I went to live in Berkeley and I was waiting for Jerry to pick up the phone and say, "Let's get it back together here. Let's get a place. I'm going to straighten myself out." But that phone call never came. Every time I tried to call him, the connection didn't get made. After about a year of waiting around, I gave up on it.

nicki scully: This was a house that I found in '79 and moved into and then Jerry moved into it. There was definitely more interaction between us and Jerry in the beginning but there was never a lot. There was no interior stairway between our level and his so I had to go outside to bring him food or he would come up. We were kind of his surrogate family but he would not go out of his way to come up and be familial. That was not his way. The kind of wall that Jerry built was nothing that required any words. It was never articulated. He never yelled "Leave me alone" at anybody. There was just a palpable wall around him that grew larger and thicker and deeper and more consistent, depending on the deepness of the habit.

alan trist: In the early eighties, I remember Jerry and I had discussions about what he was doing to himself. I said, "Is it the exposure to the public?" Immediately, he said, "Yes, that's part of it." Couple that with Jerry's well-known dislike of being put in the place of being the leader. He had a real dilemma there. All of this goes to the business of

experiencing life to its fullness as well as dealing with the uncomfortable aspects of life. Those contradictions were all present in Jerry.

nicki soully: In the fall of 1980, the Dead celebrated their fifteenth anniversary with shows at the Warfield Theatre in San Francisco and then at Halloween at Radio City Music Hall in New York. That run was fraught with difficulties. Rockefeller Center had to close down because there were so many kids camped out waiting for tickets to go on sale that people couldn't get into the buildings to go to work. After the first bunch of people bought tickets, there were none left. They had all been pre-scalped. This was what precipitated the Dead doing their own tickets.

There were also forged backstage passes. Rock had asked me to give this guy a pass. I think I knew this was a squirrelly thing and this guy was their connection. But Rock made it very clear that he didn't want this person backstage. He could go to the show but he had to stay away from backstage. I got to the hall and they gave me my stack of backstage passes and told me to sign them. I went and found the guy and I told him not to come near backstage. But they were re-routing everybody with backstage passes through a backstage entrance so they could monitor who was using the passes.

When two of the roadies saw this guy, they pulled him out, took him into an elevator shaft, beat him up, and tossed him out because he was Jerry's connection. Then they came and found me. They put me up against the wall and said, "Did you give this guy a pass? Did Rock tell you to?" I said, "What the hell's going on here?" I was infuriated and I refused to answer their questions. I refused to lay it on Rock. There was a lot finger pointing and very little understanding and no real commu They were acting to protect Jerry, who never knew anything about it.

jerilyn lee brandelius: One New Year's Eve, my son, who was thirteen at the time, and one of the older kids saw a vial drop out of a guy's bag in a dressing room. Nobody noticed it but the kids. There was a "C" scratched on the top of this vial and they thought that meant "cocaine." When the band came back off after their first encore, the kids were drooling, foaming at the mouth, couldn't speak. My son was screaming, "I'm dead! I'm dead! I'm dead!" Wavy Gravy was going,

"You're not dead, man. Here, look at this mirror. There's fog on it." He was saying, "It must be LSD. I've seen this loop before."

Because they had immediately started feeling weird and nauseous, they had tossed the vial in a trash can. Rock Scully searched all the trash cans. It took all night. Rock dumped out every trash can. Finally, he found the vial. It was crystal LSD and they'd whacked out a couple big lines for themselves. Those kids didn't come down for days. The band did not go back on that night. It was one of the only New Year's Eves where they only did one encore.

Garcia's comment at the time was that he said he realized it was time for us not to tell the kids what not to do but to tell them what to do. They had seen us taking these things rather casually and he said, "This is a real important lesson for us right now because these kids are gettin' to that age where we don't have much control of them anymore. They're like young adults now and we need to help them understand how to make these choices."

justin kreutzmann: It was cool because when I was a kid, Jerry would tell me all about Buddy Holly and about all the people who'd turned him onto rock 'n' roll and all I had to do was trade him for my Marvel Comic Books. There was this one great Superman versus Muhammad Ali and he saw it. I was holding it in the elevator on the way up and I never saw the magazine again. I didn't even make it to my room and Garcia had already swiped it up and read it right in a second.

Jerry in particular was somebody that if you just looked at his side of a conversation, you wouldn't ever know that he was talking to an eight-year-old at all. He never underestimated you and he'd start going off and I'd stop him and say, "Jerry, I don't know what the hell you're talking about." And it was like, "Oh, you should read this book, this book, and this book." I was fourteen by then but I couldn't even pronounce those authors' names.

If I happened to be sitting next to Phil on a plane, stewardesses would ask him what I wanted and he'd go, "Why are you asking me? Ask him." When you were a little kid, you'd think, "Yes!" They never really kept anything like drugs from us. They always gave us the parental thing of, "You know, you shouldn't do this. It's bad for you," but they weren't hypocritical. It was pretty hard to hide what was going on back then but

they didn't make an effort to try to pretend it wasn't happening. They didn't want us doing it but it was not something that was hidden.

stacy kreutzmann: Along with Sunshine and Heather, I was one of the first generation of Dead kids. I think most of us felt closer to the families of other band members than our own biological parents. It was sort of like a musical kibbutz. Like, "Hey, my dad's playing, Jerry will give me some candy." For me, Jerry's voice was a focal point. It was the sweetest lullaby I'd ever known. Because as a child, I would fall asleep at the shows. I would literally fall asleep on the stage. Jerry was always soft towards me because I reminded him a lot of Heather. I remember him saying to me, "You're a lot like my daughter who I never see." People would be surprised at his tenderness towards me. Whenever I'd hear Jerry singing or a loud guitar, I'd get incredibly sleepy. I found nothing more relaxing than listening to that. It just took me right back to being a little kid when if Jerry was singing, everything was right with the world.

david graham: For Creek Hart, Justin, Annabelle, the Scully girls, Winterland was our home. Henry J. Kaiser Auditorium was our home. Those were our homes. Behind the Kaiser, there was this whole other theater that was our kingdom and our domain. There was no child care. We would play football in the foyer. We used to do things like slide tickets through the door and give them to fans.

sage scully: At Hepburn Heights was when I was closest friends with Jerry. At that time, it wasn't a very nice living situation for him. Jerry wasn't healthy. Rock wasn't healthy. I remember one time we were coming back from the New Year's show and it was me and Trixie and one of her friends and we were all sitting in the back of the car sleeping. Jerry woke up and he looked up at me out of the corner of his eye and he went, "Am I crowding you?" That was the sweetest thing ever. I was eight years old and I said, "Jerry, please. Go back to sleep." What happened to me was that you lose what you think a normal parent should be to you to the band and the drugs and the schedule. You begin to take a backseat and I think I felt it and Annabelle must have felt it like I did in my life. It was hard to understand that this was how it was.

carolyn "mountain girl" garcia: I guess it was the winter of '81 when Jerry and I got married at Oakland Auditorium. I

had decided that I would just talk to him on birthdays and Christmases and holidays and try to do it that way. That almost worked out and actually kept the thing going. We came down for Christmas and knew that he was playing with dangerous stuff. I realized that he could die at any minute. I said, "Look, you know you're going to probably croak here or something bad might happen. I would feel better if we were married." The reason we hadn't gotten married before then was that we were still both married to our previous spouses. We also had always both thought that we didn't need a piece of legal paper to maintain our family and our relationship. He said, "You know, I'd feel better, too." I said, "Well, do you want to get married?" He said, "Yeah, you know, I've been thinking about it for a really long time." And I said, "Gee, me too."

We still loved each other very much but now it was through this incredible series of impediments. I had taken the high moral ground and couldn't come back because I couldn't do what he was doing. And he couldn't step out of what he was doing because by now he was really into it. I had really wanted to get married for so long for the sake of the kids and because I loved him so much even though we were so far apart. I thought if we got married, that was going to do it and we'd move back in together. I was really hoping that this would be the thing that would set us back on the road to his recovery from the drugs but he said, "You know, if we get married, I'm still not sure if I want to live with you." I said, "Well, okay, dear, I understand. You certainly can have all the space you need." I was saying all these platitudinous things.

We got married in Oakland Auditorium on New Year's Eve in his dressing room. Before Jerry went out and played that night, he was warming up and he played this thing on the guitar for me, and it was so beautiful that it would have melted a stone. It was glorious and just left us all in tears. A longtime friend who'd become a Buddhist monk did the whole ceremony. In *Tibetan*. I kept laughing all the way through because it was completely incomprehensible. We did the ceremony during the break. It was quick but it was sweet. The kids and I were all back there hugging and talking and it was really nice and then he went out and played and then they did the midnight thing.

When the shows were over, we went in different directions and there was a snowstorm and a terrible flood. We were staying at Hepburn Heights with Jerry and they closed all the freeways, the Golden Gate Bridge, the tunnel, and the Richmond Bridge, and I couldn't get home

to Oregon. Jerry was saying, "I don't think you should move back down here quite just yet. Maybe this spring but not right now. Not right now, you know?"

The flood was so severe that it gave me four or five days there at Hepburn Heights. Things were so strange and uncomfortable that I couldn't wait to get out of there. I remember jumping up and saying, "Oh, it's time to go. I've got to go," and I was thinking, "Poor Jerry, he has built this for himself and it's not very nice." Back we went to Oregon. Jerry would come through on tour or we would go down there to see him but we didn't see very much of him at all. Jerry and I got married but that didn't change a goddamn thing. We got married and it didn't make a damned bit of difference.

29

rock scully: Pete Townshend called me and asked for the Grateful Dead to come bail them out of their European tour when the Who were breaking up. Pete wanted us to be the co-band with them and do London and Germany. It was such a great opportunity. We were going to go to one TV station in West Germany and play this rock TV show that went to thirty-two countries. It was like doing a whole tour of Europe in one city and with the Who. Garcia was very reluctant to go because there were no drugs and he was strung out and he didn't know what to do about that. I had to go to the rest of the band and tell them how Jerry was going to be covered. I had to have Pete call back and say he would have somebody there at the airport to meet Jerry and we didn't have to worry about it. There would be something there for him the moment he arrived. Pete was already clean but he knew where Jerry was coming from. Then we had to convince Jerry. First, I had to convince all the rest of the band that this would be a really good trip to do and then in a band meeting, everybody went, "Jerry, we've got to do this," and then Jerry ‧ fᵒr it.

pete townshend: I think it was in Germany that Jerry said to me, "I know none of this stuff is academic enough for you. Do you want to play some Wagner?" I said, "Come on, let's try. *Götterdämmerung*? What key is it in? Let's go for it."

richard loren: Jerry and I were still very very close but he was doing heroin and I wasn't. Then Rock Scully started coming into the picture. He was not helping Jerry. The last thing Jerry needed was somebody to encourage him to take drugs. Rock was the provider of that need.

rock scully: We got started independently. I don't think it was about the same time. Personally, we had no idea what it was when it came up on us. We figured it was an opiate but we didn't know just how pure it was. It was a smokable thing. Jerry never did shoot it. Me neither. I never shot. We've all known junkies who shoot up. Sticking a needle in your arm is fucking yourself basically. You're into that whole ritual and you're fucking yourself. Women are no longer important and relationships don't matter and it's a very isolating thing. Doing any kind of opiate or any kind of drug secretly is isolating. You end up in a bag you don't want to be in. For Jerry, who was so outgoing, to end up that way was just really depressing. That was what was going on. I was becoming the middleman between the band and Jerry. Because he didn't want to see anybody. So if they wanted Jerry's opinion on something, I had to go and ask him. It was a very tough place. I was between the rock and a hard place. It was impossible for me.

steve brown: Steve Parish was locked in as Jerry's guy. He took care of his equipment personally and subsequently he took care of Jerry personally as I did actually for a little while there, too. We shared that responsibility. We'd be out shopping at Marin Surplus getting Jerry's latest wardrobe of Levi's and corduroy pants and T-shirts. Black and blue. Although I'd throw in a few green ones occasionally just to keep him off balance. Jerry didn't shop for himself and I don't recall too many stories of him ever going to the mall. He'd been getting things taken care of for him pretty much from the sixties on. Having people procure for him and I'm not just talking about drugs. We're talking about taking care of his life. From renting houses to renting cars to paying bills. Even to the tools that he used in his trade. He had that all taken care of for him and delivered and brought up to him. He was pretty much locked into being catered to. Hanging around with other people in the business who had habits seemed to make it feel okay for him to indulge, too. That was the other part of the problem.

richard loren: What happened quite frankly was that I was basically aced out of the picture. I was doing all the work and during the night when I wasn't working, the Rock Scullys and the others were telling the band what a crook I was. On the Europe tour they did in March '81, I got fired. One night, five in the morning, coke-fueled. "Boom, boom,

boom" on my door. "Wake up." I woke up and Bill Kreutzmann walked into my room. He grabbed me by the collar, slammed me up against the wall, accused me of stealing from the band and this, that, and the other thing, and fired me. When they returned from the tour, they apologized and rehired me. Six months later, I resigned. I had never been in it for the money. I was in it because of Jerry. I would have done anything for him because I loved him more than I loved anything. I loved him because he was such an almost perfect person. He was unpretentious. He was compassionate. He was humble. In a way, he was a Buddha.

steve brown: Jerry was very much a catered-to person. Which was not to say that he wouldn't stop off at times at either the Whole Foods on Miller Avenue in Mill Valley or subsequently at the 7-Eleven, depending on which mood was hitting him at that moment. Sightings at both places in the same day were known to have occurred. In the daytime, you'd see him at lunch eating organic. After the gig, you'd see him at night at the 7-Eleven with the Häagen-Dazs and a chili dog. That was him exactly. The guy who would give you the black and the white, the yin and the yang. He could be the pure guy going for the coolest hippest thing to be. He could be a slob like all of us, going for the really easy, not-good-for-you life. He thought he could get away with having both. He was an artist at it. To me, it's pretty much how the true American really is. We have these high goals of the lofty idealistic way that things should be and we go in that direction and he did, too. But when reality sets in, there are a lot of bad things and cheesiness and funkiness.

sat santokh singh khalsa: We used to have arguments about why he was destroying himself. He used to argue in a way that I could never really penetrate, "Why live?" Jerry's worst period was when he lived downstairs from Rock. At that time, I lived right down the street. I saw him many times in Hepburn Heights. Jerry was living like a badger. Rock had the upstairs and that was when Nicki was with him and their two girls.

sage scully: Jerry could also be a bear. He could be very scary. He scared me a lot also. Because he was moody. He never barked at me but he had a bark. He definitely had a bark. My room was right above his and I used to listen to him try to go to bed. I used to like taking these

hangers and I'd write little notes on them and stick them out my window and lower them to him if Rock was down there or I'd go get a broom.

sue swanson: Mountain Girl said to me that they had a conversation where Jerry said, "Isn't it weird that I would pick the one drug that you absolutely will not tolerate?" They had a Christmas up there. After Christmas, Annabelle said to MG, "God, wouldn't it have been nice if Dad had been here?" Dad had been there.

steve brown: By the middle part of the eighties, it was getting funky. I didn't enjoy being around and hanging out during that period. Jerry was not physically healthy and there was a certain attitude of protection that was starting to be reinforced more strongly by the palace guards who were sensitive to his condition and trying not to let it be too well known or too well exposed to outside people. All of a sudden, it was, "Why do you want to see him?" Then there was the kind of shallow pleasantness that wasn't the real Jerry. It was like he was struggling with something and so he smiled at you with this kind of "Leave me alone, just be kind" smile. "I'm acknowledging you and being nice to you but that's all I can afford." There was a gulf that didn't used to be there. Before, there was a lot of talking and laughing and it was easy and free. Now it was like if you had to say something, you better make it cool and if you didn't need to say something, you better not even say anything. You better not even be there. So it felt a lot different.

john perry barlow: At one point in 1984, I went over to Hepburn Heights. I don't think anybody in the scene besides possibly Steve Parish had been there in a year and a half or maybe two years. Nobody dared go in there. But being how I am, a willful fool for treading where angels won't go, I went in there just to see what was going on and I spent the afternoon with Garcia. He was in terrible shape. Finally I said, "Sometimes I wish you'd flat die so we can all mourn you and get it out of our system." He gave me this incredibly dark look and he got up and he padded down the hall. He went into his bedroom, closed the door, and put a DO NOT DISTURB sign on it.

jon mcintire: One time, again when I wasn't manager, I was living in St. Louis and I came back to California and I called Jerry at

home and said, "I'd like to come by and see you and talk to you." He said, "Great, come on over." So I went over and it was the first time we had basically seen one another since he had started doing a lot of heroin. He opened the door and said to me, "I've been a stone fuckin' junkie for the last two years. What you been doin'?" Those were his first words to me. In other words, "Let's pop this bubble right now." He was not at all judgmental. He wasn't saying, "I regret it." He was just saying, "Here's who I am now. Who are you now? What's been happening?" He knew I was going to know this. So let's just bypass the bullshit and go right to the heart of the matter and really talk about what was happening with ourselves in life. That was what he meant. I was there to be intimate. I was there to talk turkey. I wasn't there to be judgmental or to do an intervention or anything like that.

justin kreutzmann: He called that his vacation. His new way to take a vacation for a while. It was a long vacation. Maybe it finally got to him or maybe he just got tired. He described it as just trying to take a break the only way he knew that he could. Because in his mind, with all the pressure from all the overhead, he couldn't stop playing. It must have been a fantastic amount of pressure to have. To be supporting that many people and have everything be so dependent that when he blew a tour, they basically were in financial chaos. That would really bum me out or piss me off. I don't know how you would react to that or towards those people. You'd either probably feel really sorry for them or you'd want them to all fuck off because you were tired of having to be the guy to support everybody. But I don't know.

30

rock scully: Heroin was a great drug and it had worked very well for Garcia in the studio because he could really concentrate with it, but once it became a real habit, this wasn't like cocaine. He wouldn't shower and he wouldn't shave. He didn't shave anyway because he had that beard but he wouldn't look after himself and he started burning up the bedroom and the hotel rooms and so on. His nods got to be very scary. Being his road manager for the Garcia band, it got to be very very harsh.

I knew I was strung out and obviously Garcia was strung out and I was very frightened about his physical condition. In an effort to clean myself up, I told him I was going to quit and I told him the reason I was going to quit was that I couldn't be scared anymore. It was too scary. I didn't know if I was going to wake up in the morning and find him dead, dying, or swollen. Because his ankles were swelling up. This was when the diabetes started kicking in. All he was eating was hot dogs and steaks and Häagen-Dazs.

We had to have all our band meetings up in my living room because Jerry wouldn't leave the house. Even then, coming upstairs was a big deal. It just got to be too hard on me so I called a doctor and I had him come over to the house to take a look at Jerry. From then on, me and Jerry were at odds. He did not like acknowledging the fact that he was sick but we'd had to buy him new shoes because his ankles were so swollen. He had a whole new size foot and he'd never lie down. He'd never put his feet up. He'd sit there on the edge of his bed, play his guitar, smoke his Persian, nod off, and drop his cigarette in his moccasin. That would wake him up, yelling and screaming.

This stuff was starting to happen in hotel rooms and it was too scary and I was afraid that he was getting sick. I knew he was strung out. I was. I understood that part of it. But I couldn't understand why he was getting all swollen and pasty and wouldn't take a shower and wouldn't change his clothes. I couldn't understand why he was getting all feisty

and would not talk to the band and did not understand that there were real-time things going on.

sat santokh singh khalsa: Back then, I saw Jerry once a month. If he was at his worst, he would avoid me because he'd be ashamed. Before he would see me, I was one of the people he would always try to put himself together for. He had all these burn holes on his shirts and on his carpets and we were all terrified about that. We talked to Rock and Nicki about putting a smoke alarm downstairs.

nicki scully: Fire hazard was certainly a definite concern. We tried to keep an eye on things without being intrusive. Rock and Jerry were in it together but Rock always looked after Jerry. He really cared about Jerry. There certainly were some distortions in the relationship because of their unhealthful habits and because of who they were but I never for a minute questioned Rock's love for Jerry. When I began to understand the nature of the habit, I felt Rock didn't have love for much of anything but heroin. That superseded everything and that was true for Jerry as well.

david nelson: I didn't want to believe it but when the New Riders were on the road, one of my roadies told me about Jerry. I kept saying, "No, no! Couldn't possibly be, man." He laughed and said, "You haven't seen one of their shows yet." I said, "Jerry's nodding?" And he said, "Yup. Sorry." I went and talked to Jerry but you don't go to your old friend like a big brother or a priest or someone with that counselor kind of attitude. What did he say about it when I talked to him? "It's my medicine."

jon mcintire: For him, I think accepting the opiates was the desire for the feeling of no-feeling. I remember one time saying to Garcia, "Look, I'm a tremendously independent person yet I depend on you and if I depend on you along with so many others, what's the effect of this on you?" He said, "Don't worry about it. I'm so hard on myself, you could never be as hard on me as I am." For him, the opiates put a veil over things and softened the edges.

sat santokh singh khalsa: I was pretty close to Nora Sage. She was the person taking care of Jerry. At that time, he was totally asexual. The opium wiped out his sexual drive. He just wasn't there.

nicki scully: I used to find these little gardens planted around the house. Nora was being this little elf who came and beautified the place by planting flowers. I said, "Jer, that isn't me. Do you know what's goin' on?" He said, "Oh, that's Nora. She works down at the health food store." The next time I went down there, I got Nora pointed out to me and I thanked her because I did think it was really sweet. She became my baby-sitter and I became dependent on her. She was fabulous with the kids and they adored her.

laird grant: He kept drinking liquids but it didn't do him any good. He just bloated. On top of everything else, he was so fat. His shit was hanging. It was coming over the top of his socks. You could sit there and see the fat bulging out over the top of his shoes. He looked like the Pillsbury Dough Boy. His skin was pasty, pale white. He looked like he could hardly move. I said, "Hey, man. Packing all that weight around, you're going to fucking cack off from a massive heart attack. You ought to get rid of it." He said, "Oh, I puts it on and I takes it off." I said, "Yeah, well, you ought to start fucking taking some of it off, man." And then I didn't see him for a while.

rock scully: Finally, my wife and kids moved out and went up to Oregon and that left me as a bachelor upstairs and Jerry as a bachelor downstairs. This was trouble. We were this mutual denial society.

nicki scully: When I left Hepburn Heights at the end of January '81, Rock's brother Dicken moved in. Rock and Dicken and Jerry were hopeless. And helpless.

rock scully: The doctor came. Jerry didn't want to see him but I forced him down his throat. Because I felt that I needed some backup on it, I told Phil, Bill, Bobby, and Mickey that I was doing it and when I was doing it. Mickey and Phil and Bill came over to the house. They were upstairs. I went downstairs, knocked on Jerry's door, and said, "Look, the doctor's here and wants to take a look at you. I've told you that I can't go out on the road with you anymore until you get looked at because you could be getting very very ill." He was there with his swollen ankles and discoloration and all kinds of scary stuff. Garcia said, "Okay."

Garcia was staring daggers at me because he was very pissed off about

having his personal life looked into like this. Because this guy might stick a finger up his ass or something. The doctor went down there and spent about twenty minutes with Garcia. He came back up, he was ashen gray. He said, "Rock, it's a good thing you called me. This man is about to die." That was what he told me. Then I had to go back downstairs and tell Garcia. I said, "Garcia, now you're going to have to get some blood work done because the doctor is really freaked." He went, "Okay, I'll go in next week. Set up an appointment." I said, "No, the nurse is upstairs. She's coming down now." He went livid. I said, "No, we have to do this. The doctor says you are in desperate shape and it has to be checked out. It has to be. You might die."

He didn't want to hear about it. He said, "Scully, that's it." He was so pissed off at me. The nurse went down and drew his blood. They took it away and did a workup on it immediately. While the nurse was downstairs doing this number on him, the doctor was upstairs talking to the band about his condition because I'd said, "Look, you ought to explain this to them."

I wanted him to tell them that this was not my doing. I knew I was going to get the blame for this, no matter what. Certainly from Garcia. But I was already getting the blame from the rest of the band because I was doing the same drug. I wasn't the only one. God, it was obvious. It was very obvious because they'd used it themselves. They knew exactly what was going on so I was not going to lie about that. I had to be the stand-up junkie, which was not a cool role to be in. I was going to be the fall guy no matter what and I knew it. So I figured I might as well be the fall guy with some fucking effect. That was when I brought the doctor in.

sat santokh singh khalsa: There was a period of time when there was a struggle within the band about Rock. I came from the outside and tried to help push Rock out. It wasn't because I disliked Rock as a person. It was because I thought he was so strung out and that was why Jerry was in that situation.

nicki scully: Many people saw Rock as the root of the problem and tried to oust him. But I think in the end, when they were in that position, they became enablers, too. Just like everyone who loved Jerry.

rock scully: The band never went down and talked to him. Garcia was so livid, he didn't want to talk to them. No way was he going to

talk to somebody. For this, I got fired. About a month later, I was out of there. Because of Jerry's lack of support for me but also because I had to go into rehab. I went off to rehab and I was supposed to come back. I was going to do a month in rehab and a couple of months readjusting to a life without drugs and that was what I did. Jerry and I, we actually had a truce and he said I could come back. It wasn't true, though, because Jerry didn't want to quit.

nicki scully: Few people choose to leave the Grateful Dead scene. If you became a big enough drain for long enough, you'd get ostracized. At a certain point, they'd had enough of Rock and sent him off to rehab at their expense. Billy Kreutzmann came in the limo, we went to the airport and put him on the plane, and Rock was history. I'm sure it saved his life. But when you're history, you're history. No one in the scene supported his recovery after he came out of rehab. Hardly anyone ever talked to him or acknowledged him again. As soon as Rock was fired, I lost many of my privileges as well.

owsley stanley: They drove him out of the scene because he was Garcia's supplier. He wasn't allowed to come to the shows for years. They couldn't control it all but Rock was too close. He was one target they could get a handle on.

jon mcintire: During that period away from the Grateful Dead, I had been a domestic violence and rape crisis counselor in St. Louis. I'd had chemical dependency training. When they hired me back as manager, they knew what I'd been doing. So I came back under the mantle of, "We now want to reform ourselves." I felt it was important to do an intervention about chemical dependency or the things that were keeping people from being really conscious about how they were living. I felt it was pernicious and it wasn't just Jerry. There were the Jerry things and there were the other things and I brought in a counselor to deal with everyone.

rock scully: For me and heroin, that was it. That was eleven years ago. One of the things I learned in rehab and then in the three years I spent in AA and NA is that drugs and drinking, no matter what they are, have a tendency to isolate. Being in the limelight all the damn time,

Jerry wanted to go away into his privacy, into his own private scene, his own private life, with his own private drug. That was what he did. I hate to say it but that was what he did.

carolyn "mountain girl" garcia: That place you come to between sleeping and waking was where Jerry got his inspiration and his energy and his life lessons. The stuff that was important to him happened during that time and I think that with these drugs he was able to spend a lot of time there. It was a waking dream state. To my way of thinking, this was his shamanic quest and I felt somehow very respectful of his desire to pursue that state and could never really call him all the names that some people might think I ought to have called him. For him, that in-between state was the crack between the worlds that Castaneda talks about in the Don Juan books.

sara ruppenthal garcia: I never tried this drug so I don't know what it does but I know he always avoided emotional pain and he had a lot to avoid. Isn't it supposed to make you feel good? I think he was a very wounded soul and wanted to escape. You can see the pattern with his escaping women. Whoever he was connected with in his primary relationship, he was always sneaking around to take drugs or be with another woman. I don't know why. I couldn't read his mind. He didn't talk about his internal crises or his emotional process. Really, I don't think anyone could have stayed married to this person.

sat santokh singh khalsa: The major issue for me which had to do with his addiction was that he didn't feel he was worthy. He told me on several occasions that all the fame and adulation he had embarrassed him. It was amazing that he was so successful because what most people do in his situation is that they feel they're unworthy and then they do things to prove that. His situation with women was to me clearly that. If they gave him affection, there was something wrong with them.

carolyn "mountain girl" garcia: Jerry was a mystic from the beginning. He really wasn't that interested in our small little human world that much. Even though he was not in good condition and seemingly disconnected, to my way of thinking this was intimately connected with everything that we'd been trying to do up to that point. I

couldn't live with seeing him go down like that but frankly, I was a little envious of his ability to just sit there and trip out. In retrospect, I don't think it was a great position to take. I should have been more interfering. Because he went so far, it was scary. He and I had a real communications problem about it. Like I said, I didn't want to challenge him about it. Frankly, I didn't think it was any of my business. My business was different. It involved living things and my kids and family and keeping it together.

When I would get with Jerry, I would feel like I was just spinning my wheels. I'd talk about the kids in school and he'd say, "Uh-huh. Uh-huh." I realized that I just didn't have a lot of clout with those kind of talks. I couldn't get him with any of that stuff anymore so I just let it go.

jon mcintire: I started back with the band and I was taking them on the road. I would go around at night to their hotel rooms to give them road money, talk with them about the scheduling, whatever. This was the darkest period in Garcia's life that I witnessed. He just looked horrid and when I'd go to the door to give him something, he'd barely open the door and I'd slip the money through and ask him quickly whatever I could before he'd slam the door and go back into his hibernation. Back into his stupor.

This one time, he opened the door completely with this grand gesture and his pant legs were up above his knees and his legs were all open sores. And he stood there looking at me. Now, he could have rolled his pant legs down. He could have kept me waiting at the door while he did that or he could have just barely opened the door and grabbed the money and slammed the door. But this time, he flung the door open and he was standing there and I saw these open sores all over his legs and that was when I made the decision to do the intervention. I came back off the road and I thought, "This has got to stop. I gotta do something." Because I thought it was a plea for help. That was what it was.

robert greenfield: In September 1984, Jerry Garcia stepped out on stage in the Veterans Memorial Auditorium at Marin Civic Center to perform at a tribute for Bill Graham being put on by the Mill Valley Film Festival. Because Bill put me there, I was sitting in the second row, far closer to the action than I needed to be. God but Jerry looked awful that night. Not just dead but like a creature who'd returned from beyond

the grave. His skin was so pale that in the lights, it seemed to glow a dull gray-green. Had he brushed his hand across his clammy forehead to wipe off the sweat and come away instead with spots of festering mold and sticky cobwebs, no one would have been surprised.

jon mcintire: When I did that intervention with Garcia, I wanted Hunter to take part in it and he said, "I support you in what you're doing. I cannot take part in it." I was talking to Hunter later on and he said, "One thing we need to realize is we're dealing with a character flaw here that's been there from the beginning. It's not something that just came on with the heroin."

robert greenfield: Unlike other musicians from the Fillmore's golden days, Jerry was not there for the meal preceding the show. He did not come to the dance party that followed. He just played and he left. Once he was gone, it did not seem possible he could keep going like this for very much longer. While freebasing in his BMW in Golden Gate Park four months later, Jerry was busted for possession of twenty-three packets of heroin and cocaine.

laird grant: He had just gone and copped. It was enough for an army, man. But that was his score for the week.

len dell'amico: This was after an attempted intervention. He just could not deal with what they were saying or doing. His way of dealing with it was to go and behave in such a way as to get busted and that wasn't good for him. Look at the circumstances of what happened. To park in a no-parking zone in a big rich car? Why not just put out a sign and ask for it?

jon mcintire: He was on his way from Marin County to a treatment program in Oakland and he was in Golden Gate Park and he chose to stop and turn on in plain view. Essentially, he was saying, "Stop me from doing what I'm doing." Which was going to treatment. Or it may have been a last hurrah. I can't know what was really going on inside his mind. We only know the circumstances.

31

richard loren: Garcia said, "God yeah. I'd love to make a movie. I really love this Kurt Vonnegut book, *Sirens of Titan.*" One thing led to another and we bought the rights to *Sirens of Titan.* Then we renewed it and renewed it and we renewed it. Tom Davis, of *Saturday Night Live* and Franken and Davis, and Jerry were working on the script.

tom davis: He and I actually spent about a month and a half writing the screenplay. It was not in the right form to be done professionally but at the time, Jerry was going, "Fuck it. Write the scenes and don't worry about it." When we worked, Jerry was always in the recliner. Then he would doze in front of the set. I was telling him, "If you keep consuming all this stuff, you're going to get sick in the middle of something."

richard loren: We couldn't get it sold because they didn't like the script and Jerry didn't want to change it to suit the way Hollywood wanted to make it. Jerry wanted to direct it so it was very difficult to make that deal. We got Bill Murray to read the book. He loved it and he wanted to make the movie. We got Tom Davis, Bill Murray, and Michael Ovitz in a room. We signed a development deal with Universal to make this movie.

gary gutierrez: It was Tom Davis and Bill Murray, Jerry and me, and a bunch of attorneys and this guy from Universal sitting around this huge table. The only memorable thing to me about it was that Bill Murray and Tom were at opposite sides of the table and during this very serious discussion about the deal, there was Bill Murray making his mouth like a billiard pocket at the edge of the table and Tom Davis was rolling gumballs across the table trying to get them into Bill Murray's mouth. We did a bunch of storyboards and they were really beautiful.

214

richard loren: Then it fell apart because Bill Murray had that unsuccessful movie of *The Razor's Edge* by W. Somerset Maugham. It flopped and he disappeared for two years. During those two years, the project became orphaned at Universal. After that, Jerry fell apart. He was being pummeled by the drug dealers, his own weaknesses, and the demands and needs of the band prior to "Touch of Grey."

len dell'amico: It was an expensive script. Garcia hung on to the rights to *Sirens* for I don't know how many years, paying that option money over and over and Vonnegut would keep saying, "When are you going to make the movie?" Jerry loved that story and I just wish to hell that it could have happened. It may happen someday based on one of those screenplays.

gary gutierrez: It would have been a great movie and it ought to get made and I thought Tom's script was pretty good. Its only flaw may have been that it was very close to the book and the structure of the book is a very non-film structure. It's a kind of chaotic, rambling story. But it was always Jerry's dream to do it and I was sad that it never came about.

tom davis: If I ever become rich and powerful, I'll do the fucker. I want it to get done and if I don't do it, I hope someone else does it. But it's my fantasy to be able to get it done before I fold.

len dell'amico: Happily, to everybody's delight, by the spring of '86, Garcia was his old self. I remember everybody more or less just beaming about it. He'd done it completely by himself and he was proud of himself and everything was going great. On their tour with Dylan in '86, Jerry was supposed to come to my house in Buffalo, New York, where I was raised, to have lunch with my mom. The appointed hour came and he couldn't do it. He said, "I've got a toothache and I feel terrible." I said, "Have you seen a dentist?" and he said, "Yeah. I saw somebody in Chicago." He didn't sound good. I was concerned but I went off to do a mixdown on a Fats Domino and Ray Charles show I was doing in Texas and that was where I heard he was in the hospital. It was one of those things where you find out how much you care about somebody because your body tells you. I felt like I'd been kicked in the guts.

sue stephens: He broke down in Washington, D.C. At this point, his freezer was full of Häagen Dazs ice cream. Smoking and weighing as much as he did—he was definitely no lightweight as far as his consumptive habits went. Everything to excess. Everybody was really concerned about him but when you would try to approach him about things, he would snarl and lash out. Nobody could be the lion tamer.

david nelson: It had to do with being overweight and totally dehydrated and having an impacted wisdom tooth infection that got into his bloodstream. I was in the van as we were going out of the parking lot at RFK Stadium in Washington and Jerry said, "Anybody got anything to drink? I got dry mouth like you wouldn't believe, man." All I had was a beer. I said, "Anybody have water?" Nobody had water. Everybody was drinking bottled water then but for some weird reason, nobody had water. So I gave him some beer and he was drinking it and that helped wet his whistle a little bit. But because beer dries you out even more, he was going, "Gaaah. Is that all you got?"

carolyn "mountain girl" garcia: The summer tour in '86 was grueling. I got a phone call in the middle of the night from Jahanarah Romney, Hugh Romney's wife. She was calling me from Camp Winnarainbow because Trixie was there. She said, "We heard about Jerry. Is he going to be all right?" I said, "What?" I knew nothing. Jerry was in the hospital in Marin. Nora, his housekeeper, had found him in the bathroom lying on the floor moaning and had called 911 and gotten him out of there and then the hospital had been unable to diagnose his problem.

What they did was get him in there and decide maybe he had a brain tumor or an aneurysm in the brain or a stroke and so they decided they better give him a CAT scan. It was eleven o'clock at night when I got the call and I thought about driving and I thought, "No, fuck it." I called the airlines and there was a plane at six A.M. so I got on that. But I didn't make it to the hospital until almost ten-thirty because the plane was late and I had to take the airporter and then get a cab. Because he'd been thrashing around pretty good in the hospital, they shot him up with Valium to get him to lie still for the CAT scan. Jerry was allergic to Valium. They killed him. His heart stopped. He died. The hospital didn't want anyone to know this but he died. They had to resuscitate him, put him

on a respirator, give him a bunch of zap, zap, zap. Code Blue. They shocked him back. They had to do it twice to get him to come back and then they had to keep him on the respirator for over forty-eight hours before he could breathe on his own again.

I got there and the doctor came out and he said, "I'm really sorry. We don't expect him to live past the hour." I was going, "What the fuck is the matter with him?" He said, "We just figured out that he's in a diabetic coma." I said, "A diabetic coma? It took you twenty-four hours to diagnose that?" Because the first thing you'd check if you were an emergency medical technician was blood sugar. How hard was that? It was a piece of cake. Somehow, they managed to miss the most obvious thing. Meanwhile, Nora had been telling the hospital all this stuff about Jerry's drug use and what a mess he was. I doubt she knew he was allergic to Valium.

Basically, he went into full shock, respiratory arrest, and renal failure. They brought him back and they patched him back together and kept him on the breathing machine long enough that he started coming out of the diabetic thing and they got his blood sugar down with a bunch of insulin. His blood sugar had been fifteen hundred. Apparently, it was the second highest blood sugar they'd ever seen at Marin General.

I knew he was tough. I knew he had the constitution of a horse. Nobody could bounce back from flu as fast as Jerry. Just bingo, he could come back. So I had complete confidence in his ability to recover from this. About one o'clock, I finally got them to let me in and see him. He was lying in bed with the tubes down his throat and up his nose and in his arm and everywhere and he opened his eyes and looked at me. He was *so* glad to see me. He pulled me right down and gave me sort of a little cheeky-cheeky. It was as close as we could get to a kiss. Then he went for a pad of the paper and he wrote on it, "Be tactful." I said, "Okay, I'll be nice to everybody. I promise."

When I went out, I didn't land all over the doctors. I didn't say anything about it to anybody. About a week later, I read his chart. That was how I found out what had happened. They'd given him thirty milligrams of Valium, IV, and it just put him out. They also wanted to do a tracheotomy right then and there because he was having so much trouble breathing. I told them they absolutely couldn't do that. Because of his voice. He would never have forgiven me. I knew he would have been furious about it if he woke up and he'd had a trache. Can you imagine?

I figured he'd pull through anyhow. That was my bet. Because I'd

looked at him when they'd let me in to see him and he didn't look so bad to me. They'd already cleaned up a bunch of the stuff and gotten his blood sugar down and he was getting enough oxygen on the respirator. He was fighting the respirator. That was why they wanted to do the trache. Because he was fighting it and was physically pretty active and they were having trouble controlling him.

jon mcintire: I was the go-between between Jerry and his doctors and the press. In terms of the Valium and his heart stopping, there was a time in the hospital where that happened, yes. The coma also went on longer than the press reported. He was out for days. I know people were saying it was like thirty-six hours. It was much longer than that.

clifford "tiff" garcia: At the hospital, some people were thinking about canceling the Ventura shows and all of a sudden, it was business. I expected that. You have to expect that. They didn't say, "You know, there's a guy almost dying in there." They didn't think that way. It was also part of business. But everybody was concerned. Everybody was genuinely concerned.

carolyn "mountain girl" garcia: The doctor came out and he said, "We don't think he's going to make it. We've rarely ever seen anybody this sick in here." They thought the blood sugar was going to cause so many problems that Jerry wouldn't walk again. They were giving us all the bad news. Peripheral nerve damage, possible heart complications, and then Jerry went into total kidney failure. That took a long time to resolve. So it was one thing after another in there.

david nelson: After he got out of the hospital, Jerry told me about his fever dream. About what he saw while he was in the coma. He saw these bugs running in tubes. He saw these big beetles rushing into tubes. The vibe was not pleasant. It wasn't good. But it was the one thing about it that he did remember.

carolyn "mountain girl" garcia: The coma was really tough. Because he was asleep and dreaming and he was kicking at the same time.

jon mcintire: I don't think Jerry had that pivotal moment when he saw the line between life and death very clearly. In some people's cases, they actually choose to come back. I don't know that Jerry had that. I think also that at this point, Garcia's inability or unwillingness to make critical hierarchical decisions and his acceptance of what was worked against him.

david nelson: After the hospital, I remember talking to him about the smack and he was saying, "It gets to be a drag to have to take care of your monkey before everything. It's a drag. A little chore." So I thought, "With that kind of attitude, it can't get the best of him. He'll always see it that way and just think, 'Ahh. I've had enough of this shit.' " When he got out of the hospital, he said, "God, I was so glad to get off of that."

justin kreutzmann: I didn't understand his take on it till after he'd gotten clean in '86 after the coma. He came out and he said that because of how much money he made, he didn't have to be that guy on the corner who steals to cop dope. But he said he would have been if he had to. It was like, "Whoa. Shit." He said, "The only difference between me and that guy on the corner is that I play in a successful rock band and I could maintain my habit." Everyone else in the band had their own little things, too. It was just that his was the most apparent and I think everyone thrust their own paranoia on that. Because he was the only one really into heroin and since he was the main guy and everyone was looking to him, to have him looking so bad and being just sort of day-to-day brought everybody's anxiety up and made things a lot less comfortable. Because sometimes you never really knew. Sometimes he'd look so bad that you didn't know what the hell was going to happen.

laird grant: I wasn't there when Jerry came to but I heard what he said. "I'm not Beethoven." When I heard that, I said, "He'll be okay. The guy comes out of a coma and he's making jokes." Like, "Why are you looking at me? I'm not Beethoven. I'm not dead."

carolyn ''mountain girl'' garcia: He said, "I'm not Beethoven." As in, "I'm not deaf. I can hear what you're saying." I'm sure that was what that was.

len dell'amico: I got back there as soon as I could and I saw him in the hospital a bunch of times. The first time, he was barely awake. Jerry was talking to his brother, Tiff. They were reminiscing. Basically, Tiff was reconstructing memories. The next time I saw Jerry, he was with Annabelle and he was walking around.

sue stephens: It was terrifying for me to see him fail like that and know that he was not indestructible. I was there when he was conscious but he still had the tubes down his throat and all that. What was terrifying was that vision of him as no longer being the zooming-through-the-airport, indestructible kind of guy.

carolyn "mountain girl" garcia: Luckily, my girlfriend, secretary, confidante, and baby-sitter lived three blocks away in Kentfield and so I was able to borrow her rickety old Schwinn—the wheels went *blubl-blubl-blubl*—and ride over to the hospital in the morning and go in there and hang out all day until they made me leave at night.

laird grant: When I called MG, she said, "Get down here right now. We need you." The Angels had been handling security for Jerry there real nice. Which freaked the hospital out. The Hell's Angels had taken over one of the top floors. It was like, "What's going on up there?" I spent a week there and took care of whatever business I could for the man.

carolyn "mountain girl" garcia: Jerry was in the hospital for almost four weeks and they tried to kill him so many times in there, I can't tell you. He had total kidney failure but he still had to eat. But there were all sorts of things that he couldn't eat because his kidneys were shut down. If you can't process this stuff, you die of all the poisons built up in the body. They would bring him food and it would have all the food groups and two thirds of them would be things that he was absolutely not supposed to eat. There it would be on his tray, salt, tomatoes, all those things. There were a thousand things like that in there. The hospital is a terrible place to be sick.

sara ruppenthal garcia: Jerry was no longer in the coma when we got to the hospital. He recognized Heather and he cried when he saw her and Annabelle together. These girls had never met before and the two of them looked so much alike.

carolyn "mountain girl" garcia: Annabelle and Heather were there at the hospital. They had never met. Sara was there. Her husband came over. Tiff was there with his wife and kids. Nelson. Hunter. A lot of the time, Jerry was too sick to see people so I would have to go see them outside. Basically, we had our own waiting room. Just for us. John Cutler, the truck drivers, the stage manager, they all came by. So did Ramrod, who's not much for hospital scenes. Big Steve Parish would come by. They would all come by for some period of the day and then I could go get a sandwich. But the staff would wake Jerry up four times during the night to take blood. It was ridiculous. It was insane what they were doing in the hospital that was policy.

jon mcintire: In some very important ways, he was not emotionally up front. When he was in the hospital with the diabetic coma, he asked me to go and have the woman with whom he had been living leave the house. So I went and divorced him from his prior caregiver. He had me go deal with her.

32

carolyn "mountain girl" garcia: When Jerry came out of the hospital, he was really, really, really weak. So weak that we had to help him everywhere and he hated that. He was trying so hard to be a good patient but his patience was really wearing thin. Plus, he wouldn't pick up a guitar. The last week Jerry was in the hospital, Steve Parish brought over his guitar and stood it in the corner of the room. I had to put it in the closet because it was really upsetting Jerry. Because he couldn't play. His hands were too weak. It was sort of a macho challenge thing. "Come on, asshole. Get better or your guitar's not going to love you anymore."

david nelson: When Jerry got out of the hospital, the doctors said that anybody who'd been in a coma, it was good for them to see old things. So I brought old tapes to his house of the stuff we had listened to in the Wildwood Boys. His hand muscles were a little shaky but that was all. He was totally there and totally back. I'm sure he was grateful to be alive. For him, it was the second time. The first was that car accident in Palo Alto.

sue stephens: When he came off that one, that was like—this is not your average bear.

carolyn "mountain girl" garcia: All I wanted was to just get our little family scene back together for a while and that did come to pass during that period of his recovery. He spent a lot of time just walking around the house. We were still at Hepburn Heights. Rock was gone. Nora was gone. Nicki was gone and the place was insane.

laird grant: I helped take apart the whole place where they were staying. I had to go through everything and see if there were any stashes.

I found stuff in places you wouldn't believe. In books. Album covers. Underneath the rug. Tucked in the heater vents. It was the nature of the beast. It started out as an incredible seductress and ended up being the bitch from hell.

carolyn "mountain girl" garcia: We were cleaning, cleaning, cleaning, and throwing stuff in the Dumpster. I was frantically looking for another place for us to live and we had no money. I had saved up five thousand dollars from the sale of my cows in Oregon and we were living on that for the first couple of months. There were folks coming to the door twenty-four hours a day. "Ding dong" and I'd get up and say, "I'm really sorry. Jerry can't see anybody right now." I absolutely exhausted myself with this. Plus, we were trying to feed him really well to try to get him to rebuild his blood supply because he'd had all this emergency dialysis in the hospital, which just racked up his blood cells like crazy. So he was just super weak.

The kids started to deal with the mail. We got two Dumpsters full of mail. After Jerry got out of the hospital, it was great fun to go through the mail. He'd take all the Hallmark cards and line them up. "These are the ones that sing this little song and this is the Snoopy card and this is the Little LuLu card . . ." and we'd have twenty-four of these and eighteen of those and we saved all the ones that were hand-drawn.

len dell'amico: I happen to believe that the thousands and thousands of prayers that were going on, and they were deep and heartfelt prayers from all over, had a lot to do with his recovery.

carolyn "mountain girl" garcia: After about three weeks, Jerry felt able to really start seeing some people and we got Merl Saunders to come over to the house. John Kahn came over to the house and they started talking about music and getting him interested and it went from there. But that first three weeks back at the house was really exhausting.

len dell'amico: I visited Jer at Hepburn Heights. Mountain Girl had come back into the picture. At the hospital was the first time I had seen her since 1980. Those two, they were made for each other. Jerry was a Leo and she's a Taurus. It was like you do not want to fuck with this

woman. She was the kind of woman you wanted on your side when you were in trouble. Watching that come back together was a beautiful thing.

manasha matheson garcia: I went to the hospital to see Jerry and I saw Bob Hunter and Bob said, "He has tubes in him and you wouldn't want to see him this way." So I sent some books up on holistic health.

merl saunders: I went in to see Jerry in the hospital every day. When he got out the hospital, I would go see him at the house. I never did mention the guitar. I would sit at the piano though, noodling. I knew I could get him that way because he loved me to play. I'd be playing and talking. "Here's this new song I learned. When you back playing, this is the song I'm going to teach you."

When he finally picked up the guitar, I'd say, "This chord just goes like this." He'd spend four or five minutes just getting the chord. Then he'd set the guitar back down. It was so bad. He couldn't form chords. He couldn't do nothing and he'd set it back down. I would never say nothing. I'd just keep on playing. We'd talk and I'd say, "Let's go for a walk." We'd go outside, take no more than four or five steps, and he'd say, "I'm tired." I'd say, "Let's go back." Back inside, I'd say, "Okay, let's do the chord again." It would take maybe two hours for him to do two or three chords. We'd do it and process it until he felt he could do it. This went on every day. Every day I would be there.

len dell'amico: I visited up there in August and Merl Saunders was teaching Jerry how to play. It was really something for me to come into that room and see one of the greatest players who had ever lived stumbling around with the guitar with this hangdog, lost puppy look on his face while Merl was very brightly sitting at the piano saying, "This is what we got to do." It was all I could do to keep my emotions in order and say, "This is great. Everything's going to be great. It's going to all come back together again." Because at that point, it was not at all apparent that it was.

merl saunders: He had forgot how to do it. I couldn't help him on the mental part. I would just make him do it so much that he would say, "Oh yeah. Yeah. Yeah." Then I would say, "That's it. That's

it. Look at your hand, Jerry. Look at it. That's it." It was either the chord or a new way he formed it.

The one thing that I'm very good at, and I knock on wood about this, I'm good with children. He was a child again. It was like teaching my kid to go potty. I thank the man upstairs that gave me the courage and the things to tell Jerry because I didn't know what I was doing. But I kept coming. Nothing was going to stop me because this was my friend that I loved. I'd come there, kiss him on the forehead, and kiss him when I left every day. I let him know that I loved him. I wasn't there because he was Jerry Garcia. When first I met him, I never did know he was Jerry Garcia till about a year later. So he knew I wasn't around him just because of that.

We started very slowly. It was like the baby crawling. It was just like teaching a baby. Crawling, then he wants to stand up and hold on, and then he wants to take the first step. It was just like that. Then, "Hey, I'm jogging!" *"I'm back, I think."* That was what he said. And then he went out and played.

len dell'amico: Lo and behold, goddamn, it all did come back together. One of the great things we did was go see Los Lobos at New George's in San Rafael. Me and Jerry and Annette Flowers and Sue Stephens. This was his first time out in public and Mountain Girl made me promise to have him back after the early show. It was not long after the hospital and I said I'd have him back. After the first set, we went backstage. Carlos Santana was there. They hadn't seen each other in years. Big reunion hugs. Then he met David Hildago and the band and the same thing happened. Now we were staying for the second set. Off Jerry went. He was dancing with somebody in front of the stage. I was like, "He's drinking! He shouldn't be drinking! He had a drink!" I was like, "He's out of control! I can't stop it!"

In the middle of the second set, they called him up on stage. Now he was up on stage and they were doing "La Bamba" and it was like "He's playing!" He was playing a guitar that he'd never held before and he dropped in this incredible solo and that was it. He was back. In big letters.

Then it was two in the morning and we couldn't find him anywhere. The place was closed and Sue Stephens and I were freaking out, saying, "We lost him! Mountain Girl is going to kill us." Finally, we walked out into the street and there he was waiting for us, talking to the fans one at

a time. As I was driving him home, he turned to me and said, "You know, I haven't talked to these people in years." It was like he didn't really remember how much they cared for him and had missed him.

sandy rothman: David Nelson told me about Jerry's illness and we said, "We've gotta go see him," which we hadn't done in a long time together. We went over there and Mountain Girl made us dinner and we brought our instruments. At the time, I think he was still in the process of getting back his guitar playing. That day, he played banjo. I was always trying to encourage Jerry about his banjo playing because for years he had been down on himself for not keeping it up any better than he did. Mainly, we sang a bunch of trios. That was probably what MG found to be the healing part. It'd been a long time since she'd heard him let loose on that kind of stuff. Traditional ballads and stuff. She and Sunshine were sort of standing there rapt because they hadn't seen Jerry feel so good and have such an obviously unfettered good time in a long time. She felt this visit was very useful for Jerry, to have a couple of old friends come by.

Very shortly after that, Jerry called and said, "Why don't you guys come to the Thanksgiving party and bring your instruments?" This was a "company party" that the Grateful Dead family had every year. They'd have a big Thanksgiving party and then Grateful Dead Tickets would host a Christmas party at which Nelson and Hunter and I played for the last three or four years.

david nelson: We went to the Log Cabin, which is this neat little log cabin that is an American Legion post in San Anselmo, for the Grateful Dead family's big gala Thanksgiving dinner. After dinner, we got out the banjo and guitars and me and Sandy were just having fun. There was no pressure and we were remembering old tunes and it turned out Jerry remembered more words than we did. It was really incredible. That was a charge for everybody because we were saying, "Oh, good. We're not going to have to be feeling sorry for this guy."

sandy rothman: We sang just about everything we could remember that we used to do. It was probably only about a third of it but still quite a lot. Jerry was pretty excited. In terms of us going out and playing together again, I remember he said, "We can make us some folding money."

226

carolyn "mountain girl" garcia: Jerry and I actually rented a houseboat on Lake Shasta, goofed around, and swam in warm water for a weekend and that was really pleasant. I had to move down from Oregon. We both went up for a week and I parked him over at Kesey's to be entertained during the day while I was packing out my house to move back in with him. That was what he wanted so I was totally ready to do that. As far as I was concerned, it was a matter of life and death. We really didn't want to lose him and the kids were just thrilled to have another period of Dad, nonstop. Really, we had a great time. He was clean for the first time in how many years? He was there. He was available. He talked. He smiled. He wasn't smoking any cigarettes. He talked a lot about what had happened. He felt like he had a new chance. A new chance to make stuff work for him. He felt like he had transcended the junk and the drugs and that he had an opportunity to go back to work and be his full being and he was excited by that process.

He really wanted to write some tunes but he was so physically exhausted. It took him an awful long time to get that back together. With all that was happening, I didn't have time to consider what it all meant as I was doing it. I was just doing it as fast and hard as I could to get him back on his feet. I remember that period as being one of the very happiest periods that we ever had. There was little conflict. There was a really clear chain of events going on. We were clearly working toward a goal together. It was fun.

Dark Star

Dark star crashes
Pouring its light
into ashes

Reason tatters
the forces tear loose
from the axis.

—*Robert Hunter, "Dark Star"*

He was the focal point. The central catalyst. If you look at it in electrical terms, when you've got a huge field that is reversing polarity, the induction is intense. You get this induction as the field collapses and rebuilds that energizes everything around it. That's the dark star. The neutron star that sucks everything in and blows it out. And sucks it in and blows it out.

—*John Perry Barlow*

33

len dell'amico: Nineteen eighty-seven was the big year. Basically, from the fall of '86 all the way through '87 was the year when the Grateful Dead went to the next level. There was so much going on. I worked all day every day that entire year for the band and so did everybody else and it was more fun than anyone should have been allowed to have. It could have been because of Garcia's energy or because of the band's commitment to what they were doing or because they were going to make the album that became *In the Dark*. The album came out in the summer. But the train was rolling way before the album came out.

carolyn "mountain girl" garcia: We tried being a family again and it worked out for quite some time. It was really really nice. We bought a great house in San Rafael. But nothing lasts and the Grateful Dead had to go back on the road. Seeing Jerry trying to go play, that was so cruel. It was really tough. The Dead did their first show on December 15 and it was way too soon. It was much much too soon but Jerry's ego was not going to let him sit in that chair any longer and he forced himself to go and do those shows, which he did partly sitting down and it was much too soon.

merl saunders: I left town when he played because I wasn't invited. I wasn't even told when he played. I was furious. This was the Grateful Dead and they were always protecting him and they knew I had this connection to the man. Whatever they put up, cement or whatever, I could just put my hand right through it to Jerry. It was something they just didn't understand.

justin kreutzmann: In December '86, right after Jerry came out of the coma, I remember him sitting down backstage in Oakland and

saying, "God. I never realized what a great band this is. I haven't been listening for years. Mickey and Bill just played so well and Phil and Bob were just so *on* tonight." He was like a Deadhead. I wished I'd had a video of it to show him because the next week, it was, "Fuck, man, they played outta time. Jesus Christ!" Just for that one moment, it seemed like he really got off on the music. It was cool to see him like that because they were so critical of themselves. Even if it was in some really boring town in the middle of some tour no one was all that happy about, stuff would happen that would remind Jerry why they were doing it, and those were the moments that they lived for.

carolyn "mountain girl" garcia: Back on the road, Jerry decided that maybe family life was a little bit too limited for him. When they went back out on the road in March was when Manasha showed up. That was a real surprise to me.

laird grant: Jerry had stage fright from day one. He'd be scared shitless, man. He'd be backstage and I'd be talking to him before he'd go on and he'd be a nervous fucking wreck. Then the minute he went up there, it was gone. He'd zero in on somebody in the audience while he was playing. He used to say, "There are people out there with good vibes and people out there whose vibes are bad. If I can lock into one of the good ones with that good energy when I get up on stage, I can work that energy and work that whole audience through that person and we have a good evening. If I lock in on a bad one, it's fucked."

sandy rothman: Jerry always looked out at the audience. He was quite tuned in to who was out there when he played. That was how he met Manasha. She was a front rower for a long time, I'm told.

manasha matheson garcia: Jerry was on stage playing and we knew each other already. This was at a Dead show at Civic Auditorium in San Francisco. I had longer hair then and I cut my hair off in the front row. He looked down and I was cutting my hair. I guess he was laughing. Later, he told me he thought it was funny. I'd had a class back at college in living art. Fluxus, Yoko Ono, John Cage. I did it as that kind of avant garde weirdness.

justin kreutzmann: Jerry or Annabelle told me stories of how Jerry would fall in love with people on the road. If he saw this particular girl in the front row at every show, he would do a great show and he'd play the songs for her. I was laughing because I thought of all those Deadheads out there who have said, "Wow, he's playing for me tonight." But this one woman, she actually was playing Jerry. Had she known, it probably would have been awe-inspiring.

manasha matheson garcia: In 1986 when Jerry had his near-death experience in the hospital in Marin County, he told me that he promised himself that if he made it, he was going to see me. If he lived, he wanted to get together with me. This was what he told me later. In March '87, he was back on the East Coast at Hartford. I called him and I said, "Jerry, I'd love to see you." All these years we had almost been getting together but it didn't happen. He was reclusive. We'd talk a lot on the phone. We'd visit backstage but he was always doing something else. He was otherwise occupied with women. In Hartford, he invited me to his room. He said, "Could you please come by? I'd like to see you now." I said that I had heard that Mountain Girl had moved back and he assured me that it was just a friendship and that they weren't involved. I went and then we got together and hung out and talked a lot and I told him that I really cared a lot about him and that was when he told me that while he was in the hospital he had made a commitment to himself that he was going to see me and wanted to become involved with me. I thought about it and I went on that tour with him. During that tour, I talked with him a lot in detail about his family and the feelings he had about them and I told him I wished that we could be together and have a family. He thought that was a good idea and he told me he thought it was very dear and very sweet. He wanted a child. Because up to then, he had been an absentee father and I think he felt guilty about that.

The last show on that tour was in Chicago and that was where he told me he loved me. I went back to my parents' house and he gave me the phone number in Los Angeles where he would be. He was working on a video project and he asked me to get in touch with him after the tour. So I called him and he said, "Why don't you come out here where I am?" He sent a ticket out to me through the computer at the airline under my name. I met him in Los Angeles and then he asked me to come back up

to Marin County. I was at a crossroads. I wasn't sure if I was going to stay back east or if I was coming out here.

len dell'amico: They were going to make *In the Dark*. Simultaneously, we were editing the video retrospective *So Far,* which Garcia and I co-directed. *So Far* was at least as much Garcia's vision as mine but more to the point, it was a vision. It was its own vision. It was not like anybody made it. This was the second or third thing we'd done together and it was a known thing that nobody was in charge. The key to understanding Grateful Dead was that the situation was in charge. This was credited to Steve Parish but it was a truism. If you could understand that and internalize that concept, you could get along with them. If you could be in that flow and wait or have patience or whatever it took until it became clear, then what was supposed to happen would happen. Once you saw it in action and it became a lifestyle, you didn't question it and you didn't need to have words to explain it. It just was. When I saw this translated to stadium tours and ninety thousand fans, eighty-ton cranes and semi-truck trailers, and all of the logistics, I realized it could be done this way.

carolyn "mountain girl" garcia: I often think that everything after '86 was a total gift because Jerry came so close to dying so many times when he was in the hospital. There was one crisis after another. The outpouring when he went into the coma was pretty major. Everybody noticed and it raised the interest level tremendously in the Dead. I think it multiplied their business by about a factor of ten.

len dell'amico: They had fulfilled their contract with Arista with *In the Dark*. Clive Davis had been after them. Jerry treated Clive with great respect but he referred to all people in the record industry as "weasels." Starting in '85, I began going to all the Grateful Dead board meetings because I was now in the circle and I would hang out. Davis wanted them to re-up and sign a new contract and they were like, "All we've got to do is deliver this album and we're out of the contract. Do we want to sign a new one? He wants to make a long-term deal. Obviously, the smart thing to do is to be free of any contract. Have a hit album and cash in." So then they were like, "Ah, we don't want to talk to them about it." Davis wanted to meet with them personally and they went,

"You tell Davis that if he'll come to Front Street and meet with all of us by himself, we'll meet with him." They were all going, "He's not going to do it," and I was hearing, "It's done." All he had to do was have the nerve to walk into a room with these guys and he was made. He did that and it was. He outbid everybody for *So Far*. Now they were in business together on this video.

carolyn "mountain girl" garcia: It was so cool because suddenly they had a hit record. When they began to notice that the ball was rolling, they jumped on it very strongly. They did "Touch of Grey" and then they started getting into the videos. Jerry just loved doing those. That was a big challenge for him and he got to hire his friend Gary Gutierrez to do them. We adored Gary Gutierrez and they worked together really really well and were very simpatico. Jerry was excited about these projects and spent a lot of time plotting them out, making sure that everything went right.

gary gutierrez: Jerry sent me the album or at least most of the songs and asked me for my take on what would be a cool video. I listened to it and I called Jerry back and I said, " 'Touch of Grey' is the hit on this album." He said, "Yeah. That sounds cool. If you have an idea." I said, "It's about surviving and going on, no matter what. So what if we made these full-sized skeletons of you guys and at some live concert, we build a rigging over the stage so we can puppet them like marionettes and then at some point they would transform into the real band to do the last verse and chorus." He said, "That sounds cool." Then he started laughing. He just couldn't get over the idea because it was so weird. "You mean, like each band member would have a skeleton of themselves?" I got these puppeteers backstage to a concert and they watched the band. They watched their basic attitude and their posture and their little ticks. Then we went to Laguna Seca Raceway in Monterey and we built this big scaffolding up over the stage. The puppeteers sat up in that scaffolding and they each had a little monitor focused on their puppet. After the concert, they asked the crowd to stay and be a part of the making of this video. Most of the twenty thousand people stayed. They reacted to the skeletons being puppeted on stage to the playback of "Touch of Grey" as if they were the real band. They thought it was hilarious.

The skeletons were full size. We bought anatomical medical skeletons

from a medical supply company and then the puppeteers reconstructed the skeletons so they had the same height and body posture of each band member and we got duplicate clothes. Without moving anything, the band members then took the same marks on the stage so we could dissolve between one and the other. Jerry hung out for a long time watching that night because he was interested in the process.

When I finished "Touch of Grey," I showed it to them while they were rehearsing with Bob Dylan at Front Street. They were really tickled. The video itself got one of the biggest test scores ever on MTV and it was the only one of their videos that got much air play. Primarily because it was the only real hit. The song was the great thing. It was one of those anthems that people could relate to. It had a great feeling about it and I recognized that instantly. I really love the moment in the video when the skeletons come to life and Jerry shakes his head the way he does and says, "I will survive." That shot is a classic image of Jerry.

carolyn "mountain girl" garcia: It was really the first time that they had tried anything quite so radical. Then they went on and did "West L.A. Fadeaway." That was a lot of fun and they did the "Hell in a Bucket" video. It was play for them. It was like, "Finally we're getting to the point where we can actually play with this stuff," and that felt really good to the band members. Jerry loved it.

len dell'amico: When he was with Mountain Girl and doing well healthwise, I was a regular at their house. I'd go to dinner up there and we'd go to movies and we watched a couple of Super Bowls together and worked on projects.

sandy rothman: I was still in my homeless-with-a-car mode and Jerry knew that. At some point when I was hanging out at his house one day, he said, "Why don't you just stay here?" which was typical of Jerry in those days. So I moved into a spare bedroom that Mountain Girl had there. This was after they'd moved to their big spread in San Rafael with the swimming pool, the last place they had together. Basically, I lived up there for a couple of months and my room was right across the hall from Jerry's room. Whenever we were sleeping, we were about ten feet apart so I became rather intimately acquainted with his sleep habits. Also from hanging out in the main room, where he had these two great big

leather recliner chairs. We would sit there watching movies and talking and listening to music and he would nod out a lot and I wondered if it was drug-related. After I had been staying there for a while and I saw his sleep habits, I realized this was common among people with apnea. Such people catch their sleep when they can because the apnea pattern is that you wake yourself up by your own suffocation. You close off your own glottis. I'd hear him doing this constantly at night while he was trying to sleep. He would wake himself up. Usually, he would turn the light on and read and smoke in bed. All his books had long cigarette burns on them.

carolyn "mountain girl" garcia: Actually, I can blame myself a little bit for that. I was smoking at that time myself. There was some stress. I was smoking Camel Lights or something like that for a couple of years and Jerry filched a couple of cigarettes from me. Actually, I think Willie Legate gave him his first cigarette after he got out of the hospital. Willie came over to visit and sat down and smoked a cigarette and Jerry said, "Gee, man, can I have one of those?" Rather reluctantly, Willie gave him one. I don't think you could change him. Even with a life-threatening illness, he was going to be who he was. He did it his way.

sandy rothman: Jerry had a side to him that he tried really hard to develop: This very honest hardworking guy with a family life. He tried this with Sara and it didn't work all that well for him. But he was suited for it schedulewise. He liked to get to gigs early but when he was done, he was ready to get out of there, go back home, watch TV. He might paint or get stoned or whatever but he'd go to bed and then Jerry was always up in the morning. I have always been a lifelong late-night person but Jerry was not. If I wanted to catch him over at the Front Street studio, the best time was always about ten or eleven in the morning. He was there. When I was staying at the house, I would often go out with him because I'd get up early too sometimes just to do whatever he was doing. I ran up to George Lucas's Skywalker Ranch studio with him. He wanted to show me around and he was real proud of knowing the whole layout up there. Mostly, I would sleep much later than him. I would get up and he would already be napping in the front room in the big leather recliner with the TV on.

justin kreutzmann: He liked Scorsese movies. He loved *Apocalypse Now*. We had great discussions about Francis Coppola's *Dracula* and he'd talk about how the good parts were great because they were the parts in the book that were great. But then when the book gave up on its narrative, that was also when the movie fell flat. Which was neat because when am I ever going to read *Dracula*?

sage scully: We decided to go see the movie *Rain Man* and it was Trixie, a friend of hers, Jerry, and myself. We got in the car and it was pouring down rain. We drove out there and smoked a joint and I was kind of paranoid about his driving because it was the first time he'd ever driven the car with me in it. It was right when he got that big black BMW that he loved so much. We got there, finally found a parking spot, got in line, and Jerry had forgotten to bring money. Actually, I think he was searching around in his pockets and he pulled out a twenty and the manager let us in for free anyway. There were no seats left inside so we had to walk all the way up to the front row and we sat down and we had people come up to get autographs. The movie started and he fell asleep and started snoring so loud that I lost it and started to laugh hysterically. He snored through the entire *Rain Man*.

sandy rothman: He was an excessive person but he also thought excessively. Jerry couldn't turn himself off. I'm not a God person but if you want to look at it from the strictly spiritual point of view, why did anybody give him sleep apnea to wake him up every fifteen minutes? It was his brain and at that point, it was also his body. Because he was so heavy, it was hard for him to lie back. A hospital bed would have been small change for him to buy. It would have been a lot easier for him because he could have napped much more comfortably. Instead, he had his recliner in the front room.

carolyn "mountain girl" garcia: We started taking family vacations together and that was wonderful. During this period of recuperation, we went to Hawaii. Up to this point, we had never taken a vacation. There was always work. They always had a show to go to or a record to work on. For Jerry, playing with all those different bands, there was certainly no time for vacations. We went to Hawaii and we loved it so much. There was a cockroach in our room that scared the hell

out of both of us. As soon as we'd turn out the light, this cockroach would start to fly around the room and bang into things. Jerry said, "What's that? What's that?" He'd hit at it and turn the light on and the cockroach would immediately dive behind the bed. He'd rip the bed out of the wall and take his briefcase and try to smash it with his briefcase, chasing this cockroach all over the room.

He went out on his first dive and he loved it so much and I couldn't do it. Literally, I have claustrophobia. I had a panic attack and they went off merrily diving. He took Annabelle and Trixie and they dove down and they saw all sorts of wonderful things and I was absolutely unable to get it together to go down there so they left me behind and I was furious. I think it would have helped if I'd had a different instructor but the instructors were all focused on Jerry.

I was cooking and I was cleaning, same old stuff, and my feet hurt and I was a little bit crabby but I really really really loved it. And he blossomed. He adored it. He went out and got a vicious sunburn and had a great dear time. We shopped for Hawaiian shirts and we did all that silly stuff you were supposed to do. We had drinks with parasols in them, ate great seafood, and met a bunch of really nice Hawaiian guys who were dive people and Jerry just fell in love with diving. For him it was the other world. We went home and we said, "We're going to go again." So we did. We turned right around and came back a couple of months later and did it again and went over three or four times.

laird grant: Jerry was feeling bad about not coming up to see me at my house so he sent me a ticket to go diving with him in Hawaii. I went over there and Jerry said, "Hey, man. We'll go to the shop and have the guy take you out and certify you. I'll cover it." I said, "God, Jerry. That costs thousands of dollars." He said, "So what, man? If you want to do it, go do it and then you and I can go down to a hundred feet and fuck around with stuff in the dark." I said, "Fuck you, Garcia. I ain't going on no night dive." He said, "Oh yeah, you are, man. I'm going to pay for your diving so I'm going to get you down there at night."

len dell'amico: Nineteen eighty-seven is a book all by itself. Touring with Bob Dylan. For me, it reached biblical proportions. Ninety thousand people. Daytime shows with screens the size of my house. It literally took an eighty-ton crane to put the show in place. I was at the

board meeting at Front Street where they were saying, "Who should we tour with in the summer of '87?" Dylan's name was thrown out there. By me actually, and they picked it up and ran with it. I'd always been a Dylan-phile. I noticed that Jerry did Dylan material so as soon as I was a friend of Jerry's, I started asking him about Dylan and he was a little reticent. He didn't really want to talk to me about Bob. He said, "We talk on the phone." I said, "What's he like?" "He's a great guy." I said, "What do you do together?" Jerry said, "We were playing in New York and he called me up at the hotel. He came over in his van and picked me up at the hotel and we drove around the city all night. He showed me places that he thought were cool and we talked all night."

While Jerry and I were editing one of those Dead video projects in '81, Dylan was on his Christian tour. On that tour he was abandoned by the press and the media. I wasn't eager to go see this material. I was at Garcia's house working on the video when Rock Scully came in and said, "Jerry, I hear that Dylan's playing at the Warfield and it's not even a quarter sold out." Jerry stopped and he said, "Yeah?" Scully went, "Yeah. You don't want to see it or anything?" Jerry said, "I want to play. I want to go down there and play." Scully was like, "Oh, okay." It was very clear to me that Jerry was going to make a statement. There was a little discussion there about, "Do you know what Bob's into now?" Jerry said, "Aah. Fuck that. I'm there." He was saying, "I want to be there. I want to help." That showed me something about solidarity and about stars not being in that world of their own image.

nicki scully: Bob Dylan was doing his "You Got to Serve Somebody" tour and he was playing the Warfield and it was not selling well. Bill Graham got this bright idea that if he got Jerry to play with him, he'd fill the house. So he called up and got me on the phone and said, "Will you go down and ask Jerry if he wants to play with Bob Dylan?" I got really excited and I ran down the stairs and I said, "Jerry, do you want to play with Bob Dylan?" And Jerry said, "Who wants to know?" I said, "Bill's on the phone. He wants to know if . . ." He said, "Is it Bill or is it Bob who wants me to come play?" I went up and I asked Bill and Bill said, "Bob." I went down and told Jerry and he said, "Yeah." Parish showed up with his guitar that night at the show and Dylan's people were like, "What the hell's going on?" Jerry showed up and got this whole sort of nothing vibe from Dylan and his people. The show sold

out and Jerry played in the background but it was done and it worked. Jerry got home and he said to me, "Dylan didn't know I was coming." I went, "Oh, shit." I felt like the scum of the earth. Like I was going to be on his shit list forever. Then he said to me, "But it was worth it. Because it has always been my dream."

len dell'amico: What I saw in '87 was that Dylan loved being in the setting. He had a bodyguard but by the time he'd come to the door at Front Street by himself, he was the most ethereal presence I ever experienced. He loved it. He'd come in there and the crew would go, "Hey, Bob" and then turn their backs on him. The Grateful Dead crew was just perfect for that. He was treated just like anybody else and maybe that was where that pedal-to-the-metal thing started because when they were rehearsing, everybody knew something big was coming. When they went out on the road that summer, Dylan had trouble with the Dead because compared to his garage bands, the Dead were like an orchestra and so I think he was very intimidated. When they rehearsed, it was looser but once they got on with the shows, it was probably hard for Dylan to go out in front of seventy and eighty thousand fans who were there for the Dead and then try to fit his thing into this wall of sound.

justin kreutzmann: At the end of a show, we'd always rush to the vans because we wanted to beat the audience out. We were out by like six seconds after the encore tune and usually we'd get into two vans and we'd have a police escort, which everyone was really embarrassed about because we never needed it to drive through these little backroads districts. As we'd go through these little towns, Garcia would always laugh with Weir and say, "With the police pulling up and the sirens going off, you can almost hear people flushing their drugs down the toilet." Then they'd get to the hotel. In the early days, Weir's room always doubled as the party suite. Sometimes Jerry would come in and be really social. He'd sit on the floor with his shoes off and rap with the girls about stuff and we'd drink some champagne. I remember this one girl sitting there. She must have been sixteen or seventeen from either North or South Carolina and she was pretty. Because to enter the Weir ranks and inner sanctum, you had to be pretty good-looking. Jerry said, "Okay, I'm going to tell you this story. But I'm going to need fifteen minutes to collect my thoughts and then I won't be able to speak to you for five minutes after I've told

you the importance of the story." She was like, "What?" Then he went into this thing and I was thinking, "I wish I had a tape recorder for this." Because it was just so him and it was so cool and it made so much sense. If you ever detected any cockiness in Jerry, it was always so hidden in humor. Like when he and I would be watching MTV, it'd be funny listening to him comment on those guitar players. This was in the eighties when heavy metal was totally all you saw on MTV and he was like, "I don't get it. God, it's just so mindless."

34

carolyn "mountain girl" garcia: And so, the old familiar friends came back to grace or curse him as you will and Jerry started to use again. All his friends were really worried about him but Jerry was very good at hiding what he did.

sandy rothman: At that time, I didn't know about the heroin. I wasn't aware of it.

david nelson: Jerry and Sandy Rothman and I and John Kahn had just played together and we were in the back room and we'd done four or five traditional songs, old-timey stuff and some bluegrass. Bill Graham came in and he was raving. "That was great," he said. "I could see where the roots of your music and the Grateful Dead music come from." Jerry was going, "That's right, Bill." Bill said, "This is such a thing. I've got to take this somewhere. I've got to put this on somewhere. But I don't know where. I need an idea." Jerry went, "Uh, take it to Broadway, Bill." And we all went, "Yeah. Right." It was just a joke. And Bill went, *Broadway!*" He left the room and the next thing I knew we were booked to do eighteen shows at the Lunt-Fontanne Theatre. They all sold out as soon as they went on sale. They sold out in a matter of hours.

bob barsotti: The Nederlanders took out a full-page in *Variety* congratulating the Jerry Garcia Band on having the biggest first day of sales in the history of Broadway, a record which was broken about six months later by *Phantom of the Opera*. Prior to Jerry, it was a record that had been in place for many years.

david nelson: It was like a drug being on Broadway. I mean, how were you going to say no to that, man?

sandy rothman: It was an incredible dream. I will always consider that to be certainly a pinnacle of anything I ever did in music. It was simply incredible. Jerry was in heaven but that tour worked him way too hard. Setting it up the way he did where he was opening for himself was about the hardest thing there is to do.

david nelson: Those matinee shows were really work for Jerry. We'd have to put him to sleep up there in the upper dressing room which had been Vivien Leigh and then Mary Martin's dressing room. On those matinee days, he'd have to take a little nap.

sandy rothman: He was playing in two bands. The tour's name was *Jerry Garcia, Acoustic and Electric*. We'd play acoustic for at least forty-five minutes. Then he'd take a break. Go up, eat, whatever, and then come back with the electric band and play a blockbuster. Jerry was in heaven but in an overarching sense. It was heaven but it was really hard. We also did rehearsals. Oftentimes, there were sound checks every day. In fact, some of those sound checks were better than the shows. Jerry was probably in that theater from one or two in the afternoon till after midnight.

bob barsotti: The first night, Jerry was sitting up in the balcony and they were doing some sound checking and lighting checks and he was just sitting up in the balcony doodling. The fire marshal was a young guy. After about two minutes, I realized he was a Deadhead. So I said, "Why don't we go upstairs and I'll introduce you to Jerry." This guy went, "Oh. Jerry's here?" I took him up to the balcony. "Jerry, I want to introduce you to the fire marshal." "How're you doing?" Jerry was shaking his hand and being really friendly and the fire marshal was about ready to fall over. By the time we were done, he'd approved every one of the innovations I'd come up with. "Oh, dancing in the lobby? No problem. Speaker cables across the floor? Just make sure they're taped down." All these things that had never happened before in a theater in New York were happening and it was simply because this guy had gotten to meet Jerry. Later that night, I came back to Jerry and I said, "Jerry, you wouldn't believe what you did for my meeting with that guy." And he went, "Oh, I could tell." He absolutely knew what I was doing by introducing him to the guy.

sandy rothman: Jerry had so much self-vision that he could sometimes caricature his own caricature. When we were playing those Broadway gigs, Steve Parish would come up to get us ready to go on and say, "Okay, ten minutes." And Garcia'd say, "Yeah yeah yeah" and we'd all be ready and all tuned up. And there would be Garcia smoking a couple more cigarettes, eating some cheese or something, and it would be time to go on. It would be past time to go on. Parish would come back. Now, in my world of music playing, you don't do that. When it's time to go on, you're out there. But the rock world and the Grateful Dead world is different. Jerry and Parish would play-act this thing and I'm sure it had happened a lot in Dead scenes. Parish would go up to him, "Come on, come on. It's time to go." Some days, Jerry would go and be sprightly about it. Then there were a couple of times when he would play-act this thing like he was being led off to a dungeon. Jerry would bow his head down really low and droop his arms down primate-style. Parish would have his guitar and Jerry would just be this limp doll and Parish would be pulling the edge of his coat collar. Garcia would play it to the hilt. He'd say, "Okay, Steve. Yeah, yeah, sure, man. Yeah yeah yeah, I'll go. I'll go..." He would have us all in stitches.

bob barsotti: There was a set of people who were there every night and then there were people who came in shifts. The great one was standing out in front of the theater and seeing these three young guys come walking up from the subway. They all had gym bags and they all started taking their suits off and stuffing the coats into the gym bags and pulling out their tie-dyed shirts and putting them on. Then they went in with their T-shirts over their slacks and their hard shoes. It was really a trip. Those shows added a dimension to Jerry that hadn't been there before. He'd done Old and In the Way and he'd done the New Riders but they were all club things. By going on Broadway, he put this certain stamp of class on rock 'n' roll that had never happened before. He didn't even have to change what he was doing to do it. He got to be himself and go to Broadway.

35

gloria dibiaso: Jerry and MG moved into a big house in the hills of San Rafael where they lived together for a while and then they split up. Jerry bought a house in the Dominican College area of San Rafael where he lived by himself. Around that time, I met Manasha on a bus on my way to a Dead show at the Oakland Coliseum. She was very friendly and pleasant. Weeks later, we met again at the health food store next to the hologram gallery I was managing. When she told me that she was pregnant with Jerry's baby, I was floored. I almost fainted. It was so mind-boggling to me.

manasha matheson garcia: I found out that I was going to have a baby. Jerry was really thrilled. He was happy that I was going to have the baby. He offered to rent us a house and I didn't act on it right away because I felt kind of odd about it. So I stayed here and there while I was pregnant and then towards the end of my pregnancy, I finally said, "Yeah. Okay." Keelin was born in San Anselmo at the end of '87. Actually, her due date was Christmas. Jerry wanted to move into our house that he was renting for us. I gave it a lot of thought and I thought it might be better if we had a separate place because it was a small place and I thought he needed his privacy somewhat. He seemed to need a lot of solitude. So he didn't move in. Even though he had maintained that he didn't have a relationship with Carolyn all through that time, he enjoyed being with his two older children because he hadn't had the time to do that before. I thought that was good for him and I didn't really want to disrupt that. So I said, "Why don't you stay there and see how things work out?"

carolyn "mountain girl" garcia: Jerry never really wanted to marry anyone. He claimed he was not the marrying type. In

terms of Manasha, she was somebody for him to go visit, somebody to surprise. Then she had a little girl and I think that was attractive for him. He really enjoyed that little girl. Our kids were older. Annabelle had moved off to Alaska. Trixie had moved into a place in Oakland so she could go to college over in the East Bay. They were each off on their own trip and he just didn't seem all that interested in what they were doing. For him, the magic was in this relationship with that little girl and there was nothing I could do about those things so I just let go. That was extremely hard to do but it did get done.

vince dibiase: At the shows, one night you'd see MG. One night, you'd see Manasha.

len dell'amico: In '87, we were mixing *So Far*. When we shot the Dead doing "Throwing Stones" in Marin Civic Auditorium for it, one of the drummers did some upchuck thing they'd never done before. Garcia looked up and gave this big grin. They went into this big instrumental and Jerry was grinning and looking all around and Bobby was singing these incredible lyrics and Jerry just screamed out, "Yeah!" into the mike, which was something he never did. The picture was all cut and we were in final mix on it and Jerry went, "Of course we've got to take out that 'Yeah!'" He wanted it out because it was not music. He was a purist and they were all always that way. No artifice. I was crushed. What the fans were dying to see was the expression of real emotion and it was real. Why would you ever want to take it out? I thought he was pulling my leg. I said, "You can't do this to me." When Arista showed it in theaters in premieres, they had audiences full of Deadheads. In one theater in L.A. when they showed it, the Deadheads made the person in charge of the tape deck play that section over and over again.

bob barsotti: This was in '87 right after they'd hit it really big. Right at that point in his career, Jerry was healthy and he was clear and he was playing his ass off, doing some of his best music, I think. Really, really challenging stuff and he was getting offers from everybody all over the place. All the great musicians in the world wanted to do stuff with him and he lined up this improvisational tour that he was going to do with Edie Brickell and Bruce Hornsby and Branford Marsalis and a really great drummer and a bass player. They were going to go into theaters

and walk out on stage and talk to the audience for a few minutes about subject matter. "Okay, we need some subject matter for the songs tonight and we need some general direction on what you'd like to hear and in which direction we should go." They would get some feedback from the audience and Edie would write down some subject stuff and then they'd just try playing for a couple of hours and see what happened. All improv. Jerry's people got all the managers to agree to the deal. Then his girlfriend, Manasha, accused him of wanting to do it because he was having an affair with Edie Brickell. That was why he wanted to do this whole thing and how dare he get into this project and blah de blah de blah and she put all this pressure on Jerry until he bailed. I don't believe he was having an affair with Edie Brickell. He just loved to play music with her because she was a great improvisational musician. Only she was a singer and she could sing lyrics improvisationally, making them up as she went along. That was the kind of thing that Jerry was all for. But he didn't have it in him to stand up and say, "This is what I want to do." Instead, he just escaped further into his trip. I could see that each time one of these great projects slipped away, so would he. It happened over a couple of years and it was sad.

laird grant: After you've got two pockets full, what the hell do you need any more for? You played for a hundred thousand? Next time they're giving you two hundred and fifty. You're playing the same goddamn song but they're going to give you one and a half times more because that's how much bigger the interest in you has become. But they did good things with their money. It did not all go into their pocket. I ended up with a four-wheel-drive fire truck from them. The Rex Foundation gave me ten grand and I started my own fire department up here on the mountain. It went back to musicians, it went back to kids, it went back to the rain forest.

sue stephens: The post-'87 success made it worse for him. It was just too much. He'd be funny when they were talking about income going up. Garcia'd go, "Oh no. Not more money!" Because the more he had, the more of a problem it became with people wanting to get it from him and him having to deal with it.

john perry barlow: I have what I call Barlow's law of economic insufficiency, which is, "The more you got, the shorter it feels."

The way that applied to the Dead I used to call, "Big hand, big mouth." There was co-evolution between the monstrosity of the two. In effect, the beast itself was a completely independent being. Completely. It did what it did. Jerry and I had this conversation one time and we were talking about the beast that was the Grateful Dead. Have you ever seen the movie *Dragonslayer?* They had an especially great dragon in there. It was old and cranky and it had just about had it with everything. It was nothing to mess with. We decided that in its essence, that was what the Grateful Dead looked like. It was that creature. Spitting fire and coughing and an awful lot of smoke.

bob barsotti: I think that what happened to Jerry was that he got stuck in this cycle of being the provider and he was provider for the Dead. He could have done so much more but he got stuck. What happened was that the Dead were making so much money and he had this thing about not walking away. Because the day he walked away, all these people would lose their job. The other reality was that he could play in a band that he loved and he had the respect of the world and he could be whoever he wanted to be and it was just fine with everyone. So why not take the path of least resistance? The one thing he knew he could always do was make more money. Somehow, his solution to it all was to just play more shows and not hassle about it.

justin kreutzmann: After shows, there were some meetings where they'd sit around and be talking about songs or the way this guy played on that song or that guy played on that song. After all these years, I thought these guys were all supposed to like each other. It wasn't like they were trying to say, "You know, *maybe* you could do better." It was, "Hey, that was *shit,* man. You know? Why don't you get back to the music? Why do you keep fucking us up?" It was just merciless. Even guys in the crew were leaving the room. That amazed me. There was still that much spark in what they did.

len dell'amico: From my point of view as his friend, I realized that all this was a burden and it got bigger and bigger. After '87, it was. "Oh, boy! Now we have a hit. Isn't that great?" *Not!* It just got harder and harder. Bigger hall, bigger questions. Someone would come in with the news that the DEA was using the Dead as a magnet to bust people.

Knowing that there would be certain illegal substances used there, they would target the shows. "How do we want to deal with this? Do we want to go on record with a statement that you shouldn't do these things?" Then Garcia would say, "Why don't we *not* do these stadium shows?" The unspoken response was that because they had this nut to pay. Hello, fifty employees.

bob barsotti: The Deadhead scene all of a sudden had people involved in it who really didn't give a shit about anything. The after *In the Dark* crowd who got interested because the Grateful Dead had a top ten single. All of a sudden, they became Deadheads. They might be able to tell you the songs on *In the Dark* and that was about it. They were young kids who saw this incredible party scene. Or guys who had these vast arrays of drugs and vast experience in handling weird parking lot situations who were able to exist on the outer edge right in the middle of society. It fascinated young kids to see this kind of freedom because they'd grown up in the Reagan era with the war on drugs. They equated these ideals with the sixties but actually it was just a big party scene on a Saturday night.

justin kreutzmann: Jerry and I were riding up in this elevator and it was one of the times where Deadheads were also staying in the hotel. Jerry got in the elevator and we stood in front and there were three Deadheads behind us. They were staring at him, giving him that polite distance but awestruck and staring. Then this businessman in a suit with a little briefcase got on. He looked back at the Deadheads and looked over at Garcia and me and looked back at the Deadheads and looked over at Jerry and said, "Are you famous or something?" Jerry said, "No, man. I just play guitar in a rock 'n' roll band." With perfect timing, the doors opened. Jerry and I walked out and the Deadheads were going crazy. The guy looked around and said, "God, I gotta check my record collection."

Jerry just wanted to be known as a competent musician. I don't think the fame was part of it for him. He told me his analogy for fame was that it was like a little dog you took to restaurants. Sometimes you had to excuse it if it crapped on the floor and sometimes you had to pet it and be nice to it. Fame was like a little dog you had to take with you everywhere you were going.

laird grant: Jerry said to me, "This scares the shit out of me. Some people at the shows think I'm some kind of a fucking prophet or something. That makes me crazy, man. I'm afraid to say anything because of what people are going to take from it." He said, "It's like that Manson thing. You get caught up in that kind of fucking power. I don't want it." He said, "God, if I could play my music and not have to deal with any of this, it would be the happiest day of my life."

carolyn "mountain girl" garcia: Jerry's name became a household word and that was really a surprise. We capitalized on it quite nicely but the effort it took to make all that happen was gigantic and all-consuming.

sue stephens: With the Cherry Garcia ice cream, they had put that out without even asking us and everybody thought it was a wonderful thing. Jerry certainly didn't want to have to bust these people. But it was after his diabetic coma and the last thing on his list of eats was ice cream. That was a definite no-no. So the poor guy couldn't even taste any of it himself. But we had to go after them on a licensing level. It was his right to publicity and we had to get the lawyers involved. We gave them the opportunity to either stop making it or pay him a small percentage and they immediately said, "We'll just stop making it then." Twenty minutes later when they realized it was their number-one seller, they called right back. He did get a very small percentage of that money and it turned out to be a good paycheck for him every time it came in as well. His basic take on it was that he was thrilled to have been paid tribute that way. He said he was glad it wasn't motor oil that they'd named after him.

laird grant: When you're making that much money, if you don't spend a whole bunch of it, then Uncle Sam takes it away and makes a nuclear trigger out of it. Jerry could have been in a '63 Corvair that smoked like the one he used to have. Eventually, the totally buffered comfort and lifestyle of the rich and famous was around him. He was surrounded by it.

justin kreutzmann: Being on the road with Jerry always had more to do with what was going on in his head and musically than the actual rigors of being on the road. By the time I started hanging out

with him a lot, their life on the road was pretty comfortable. They had made it as easy and as comfortable as it could be.

john perry barlow: I used to put out sort of a semi-annual little newsletter about what was going on in my life. Right after *In the Dark* suddenly got big, I wrote an article about the irony of the anti-materialist Grateful Dead suddenly being incapable of staying anyplace but the Four Seasons hotels. It was the closest I ever saw Garcia come to wanting to hit me. He was *so* angry. I came into Front Street and he said, "If it isn't the author of the celebrated Barlowgram who thinks he can sit in the seat of judgment." I said, "Well, it *is* funny, isn't it?" And he said, "Maybe you think it's fucking funny. But I think it's *betrayal*." I said, "I try to call them as I see them." He said, "You know, if you want to stay around here, maybe you should call them as they *are*." I said, "None so vigorous in their own defense as the justly accused." That made it worse. Part of what Garcia was saying was, "You're not that great a lyricist and look how much money you're making. So you're biting the hand that feeds you." I said, "I would be biting the hand that feeds me *not* to tell the truth. That's my job. That's what I'm here for." He was saying that I was not permitted to tell that truth. The thing I was most grateful to the Grateful Dead for was putting me in a position where I could make a living and say what I thought. Of course, I didn't mind staying in the Four Seasons, either. Mostly, I was just abusing the paradox. But I was being accused of hypocrisy. That was not what I was saying. I'd never heard any complaints about it from the Deadheads. I turned and walked out and wrote him a long letter about how I wasn't going to be intimidated. Then silence fell on the scene and nothing went on for a long time and then I saw him again and it was as though nothing had ever happened.

robert greenfield: In June 1988, I spent the better part of a day at the Grateful Dead warehouse on Front Street in San Rafael interviewing Jerry Garcia, Mickey Hart, and Bob Weir for the book that the late Bill Graham and I were doing about his life. For an obvious outsider, the atmosphere at Front Street was not nearly so warm as the weather. Garcia himself however was a revelation. Before I could ask him a single question, Jerry grinned with glee and said, "Oh, boy! I get to talk about Bill, right? And he's not here? What a *score!*" Then he began laughing

like a joyous child. When I leaned over to clip my tiny lavalier microphone to his shirt, Jerry took it from my hand and began to do the job himself. I said, "Only the real media guys clip themselves. The veterans." Picking right up on the riff, Jerry said, "Vets. Battle scarred. Word worn." With no further prompting, he began to talk about Bill.

At some point in the proceedings, Jerry determined that not only was it time for lunch but that we would order out. He asked me what I'd like to eat. Having been on tour with the Rolling Stones, a group of individuals for whom no menu was ever good enough, I let him do the ordering. I said, "Whatever you're having will be fine with me." What Jerry Garcia was having for lunch that day was the largest, coldest, greasiest slab of dead red meat masquerading as a steak in the history of western takeout. The sandwich wasn't just not good. It was not edible. I did not even come close to finishing mine. Jerry devoured his with great relish. As I reached for the can of Pepsi that had come with the sandwich, it occurred to me that the Grateful Dead had dosed Bill Graham with LSD just this way. Trying to make a joke, I said, "I can drink this, right? I mean, I've got to watch the Laker game tonight." "Go right ahead," Jerry said, grinning as though the can contained far more than Pepsi. "You'll enjoy it."

After we were done talking, there was no doubt in my mind that, much like Pete Townshend of the Who, Jerry Garcia would have been famous even if rock 'n' roll had never been invented. His basic decency and great good humor were extraordinary. To be sure, it was a good time in his life. Jerry was clean and the band was making money. In terms of our interview, it seemed to make him happy to be able to talk for a change about someone other than himself. Still, I was impressed. In every way, the man was definitely a *mensch*. No way I would ever let him order lunch for me again, though.

sat santokh singh khalsa: At that time, I had Jerry's ear as much as anybody and probably more than many other people. I proposed to him that we do a benefit for the rain forests and I was the coordinator of that benefit at Madison Square Garden. It took me a long time to sell Grateful Dead management on charging fifty dollars per seat and two hundred fifty dollars a seat for sponsors. Jerry and Bobby were for it so we persuaded them. We sold 1,000 two-hundred-and-fifty-dollar seats and we sold out the entire show, no problem. We had a press con-

ference at the UN. This rain forest thing was the first time Jerry actually spoke out on an issue at a press conference. I also organized a party after the show. That was harder to organize than the benefit. I persuaded Jerry to come to the party and that was my mistake. I told him he could relax and hang out with people. I thought New Yorkers were sophisticated but he spent the whole party signing autographs, which pissed him off. It wasn't fun.

merl saunders: For the *Blues from the Rainforest* album, the music came to me in a dream. To do it in the studio, I had to get musicians who understood me. I didn't have to say nothing to him but, "Here it is, Jerry. I need a melody to go out there. But at the end, I need a hook." He played it. I said, "That's exactly what I want." But Jerry got very paranoid about doing *Blues from the Rainforest*. When I told him what I wanted to do, he said, "Do it, Merl. Do it. Don't tell nobody." I said, "Whatever you want, Jerry." When *Blues from the Rainforest* came out, no one knew. They was shocked! We did the whole thing in my house. We cut it there. We rehearsed there. My house was his escape. For about four or five years, he came there. Drove himself over, came in, laid on the couch. I'd come down and see him there. He knew I'd always leave the door unlocked.

david grisman: In five years, Jerry did over forty sessions in the studio in the basement of my house. He would come over at noon or one or two. When he was with Manasha, six o'clock prompt, she'd start calling. She really had him. I never saw anything like it. At six, he'd say, "Oh, I got to get out of here." Jerry had a lot of different lives and he kept them all separate. He wasn't a guy you would go socialize with. But he'd drive himself over here. He didn't have a limo. He didn't have a scene. He didn't have an entourage. He was just here. I knew that he was overburdened with too many things. I think it was the pressure of keeping all those people supported. I guess he was trapped.

manasha matheson garcia: He wanted to be home. He loved Keelin and he told me that it was the first time in his life where he felt like he had a family. He said he had a difficult time growing up and he told me that our relationship actually helped him resolve some feelings with his mom. That made me feel real good.

vince dibiase: Manasha was in control but he liked her unpredictability. He told me that in Europe. We were about to go out looking for apple juice for Keelin in Paris. As we were heading out to find some, Jerry said, "That's what I love about Manasha. She's so unpredictable. I'd be bored to death otherwise." Bruce Hornsby was sitting in the lobby reading a newspaper. As we passed him, Jerry went, "Hey Hornsby, you speak a little French, don't you? Come on, we've got to find some apple juice." Hornsby said, "Oh yeah, man. That's cool." We went out cruising Paris for apple juice and we couldn't find any that wasn't alcohol-based. Then we found this one quasi-futuristic health food store and they had some. We bought up all the apple juice in the place, maybe five or six quarts.

stacy kreutzmann: Jerry met my husband about three days before we got married. We were in the office and he came in and I said, "Jerry, I'm getting married on Saturday. This is Mike. We're getting married." Jerry shook his hand and said, "That's totally cool, man. Everyone should try marriage once or twice in his life." I never forgot that because it was so cynical. Like, "It ain't going to work. But have a good time."

255

36

robert greenfield: On July 26, 1990, Brent Mydland, the Grateful Dead's keyboard player, was found dead in his home in Lafayette, California. Mydland, thirty-seven years old at the time, died of an overdose of cocaine and morphine, commonly known on the street as a "speedball." Joining Pigpen and Keith Godchaux, he became the third keyboard player that the Grateful Dead had lost.

carolyn "mountain girl" garcia: I was on vacation up in Oregon when Brent Mydland died. That was really sad. But we all knew Brent was extremely volatile. I was scared for Jerry but I also knew that Brent was a far more volatile person than Jerry. He was extremely emotional and prone to doing really crazy stuff like driving his motorcycle the wrong way down the freeway. Jerry never did stuff like that. He was physically cautious and he had somebody drive him. He didn't take those kinds of risks. He was sensible.

john perry barlow: I remember after Brent Mydland died. It was such an incredibly hard time for everybody but the way in which it was dealt with inside the family of the Grateful Dead still makes me angry to think about. We just shook it off like, "Hey, shit happens. You can't make an omelet without breaking eggs." That primitive kind of response. When one reindeer gets crippled, the rest of the herd doesn't stop and try to take care of it. They just keep moving because winter's coming on. It's a very simple straight-ahead form of self-preservation. The people inside the organism that was the Grateful Dead were all pretty evolved individually but the thing itself was a beast. A cranky, hard, crusty old dragon that knew how to survive.

justin kreutzmann: In the funeral parlor, there was this little side room and the five guys in the band were sitting there and there

were different models of caskets you could get. Jerry saw this little one filled with black stuff and he said, "Is that for black people?" I said, "I don't know." They were all sitting around and finally they were like, "What the hell are we doing sitting here?" Then they took the coffin and the five guys in the band walked it down to what they call the interment or whatever, and Weir was pretending he was dropping the thing and I was just going, "Oh, God. These guys are never going to be serious." Then again, they wouldn't have been doing that if it was Pigpen.

john perry barlow: I was one of the pallbearers along with the five still living members of the Grateful Dead and we were off in this room together. It was like halftime at a basketball game and our team was winning. There was a lot of very lighthearted juvenile grab-ass and I was really stricken by it. I rode to the grave with Garcia in his limousine. It was just the two of us. I said, "You know, I've been watching this thing get darker on our side and lighter out front. I'm the only one at liberty to cycle back and forth here and I'm starting to think that I can't do that anymore." And he said, "You may be right. It may be a deal where you've got to be on stage or off stage." I said, "If it comes down to that, I guess I'll just go out front." He said, "I would, man. If I could." He wanted to be in the audience. He wanted to be with the Deadheads. He said, "It looks a lot safer out there. But how would I know?" When they were running in a pack, he was like everybody else in the band. As soon as he was off by himself, then he was Jerry and he was really sorry. He was really stricken.

robert greenfield: The Dead themselves had come off the road only three days before Brent Mydland died. Enlisting Bruce Hornsby as their temporary piano player and Vince Welnick, late of the Tubes and Todd Rundgren's band, to play synthesizer, the band regrouped yet again. Six weeks later, the Grateful Dead were on the road again.

justin kreutzmann: I had a drug intervention in 1990 and Jerry and Phil came to it. That'd blow your mind. I sat down with all these people and there was Jerry Garcia and Phil Lesh at my drug intervention. Like, "Holy shit, I must have *really* fucked up now." I found out later that before it happened, Jerry really challenged the lady running it. He was like, "Why are you lying to somebody to get him some place

to try to help himself? Why not be honest with him about what's going on? Why are you lying to him to get him here?" She told him, "Okay, you can sit here but you can't say anything." He got up to leave and it was like, "No no no no, you have to stay. You have to stay." Because Jerry thought it was a crock of shit, they totally changed the way the intervention was run. Because my dad was away at the time, Jerry was like playing the father guy.

stacy kreutzmann: As my husband often said about Jerry and the guys, everyone really bowed to him like he was a god or something. Nobody in the room would say anything to Jerry because he was Jerry. Before the intervention started, Jerry's exact words to my husband Michael were, "These things always feel like a lynching to me. If a good friend wants to come to my house and die on drugs, that's okay." Michael said, "The bottom line is that is not okay. You're helping him die. Don't you see this, Jerry?" Everyone was like, "Oh, my God. I can't believe that this nobody, Stacy's husband, is fighting with Jerry Garcia." But Jerry heard something because they talked for about five or ten minutes about this. Michael started to cry and said, "I have a brother who's a drug addict and an alcoholic and I don't want him to die and I don't want Justin to die." At the end of the intervention, Jerry said what he did as if he knew Justin needed to get some help. He was very choked up.

justin kreutzmann: For those people who don't know about interventions, they go around in a circle and everyone explains what they think you're not seeing in your life which is making it so fucked up through your use of chemicals and alcohol. Jerry was the last person to speak and he looked around the room and said, "Do you really need to hear anything else except that I love you? Just remember that." And I was like, "How cool!" And he had tears coming down his eyes.

stacy kreutzmann: You know why my father wasn't there? He was in rehab up in St. Helena at the time. I thought I was going to lose my mind. I was going back and forth between family days at the two rehabs. Life in rock 'n' roll, man. This is the fun side of rock 'n' roll.

carolyn "mountain girl" garcia: In 1990, I gave up. I just let go. By 1990, I realized that it wasn't going to work out any

further and that all Jerry's energy was going elsewhere. Basically, I would say that he was bored with us. But that wasn't the right word. I just think that his creative energy was taking him way out. Far from where I was at. For me, it was time to stop doing it again because it was wearing me out. I was worn out. I said, "Listen, you've got to go find your own scene. I can't keep supporting you in this way. I just can't." And he very graciously got up and left. He went and found his own place and the whole scenario kept evolving from there. He had two or three different girlfriends, some of whom I liked and some of whom I didn't like.

manasha matheson garcia: We moved into a larger place in '89 and then in August '90, he moved into our place. He was spending most of his days with us and he brought Keelin and I on tour. From the time of my pregnancy in '87 until the beginning of 1993, I was pretty much on every tour with him and also living with him from 1990 to the end of '92. I loved Jerry's music and I realized that was his way of worshiping. I felt it was his way to God and I told him that. He liked that about me because he didn't think that I had a problem with him playing music. He said that some of the other women he'd been with had some problems with the Grateful Dead and with the music. I am now friends with both Mountain Girl and Sara and I have much respect for both of them. I had a problem with the Grateful Dead apparatus working him too hard and I felt there was a conflict between him being over-worked and my being concerned about his health. At one point, he wanted to be concerned about his health and lessen his load but he just had to continue.

justin kreutzmann: Cocaine and heroin are not two drugs that you usually get a large roomful of people to sit around and do. On the road, you had your camps. You had the people doing coke and you had people on pills and downers and the drinkers and so everybody had their little clique of people. They'd get together to be the Grateful Dead but even then Jerry had another dressing room for a while. Not out of any star weirdness trip. Just because he needed a place to get high. When he would be sober, he wouldn't want to be near that room. When he wasn't strung out, he would never leave the stage because he wouldn't ever have to go get some privacy. That became sort of a giveaway. Because he'd leave the stage for breaks. Otherwise he would go up there hours

before a show, sit down, and he wouldn't leave until he'd left the hall. That was how you could always tell. At least how I could always tell.

vince dibiase: The thing is that he would nod out. But his blood was thicker than molasses anyway. The guy was never getting enough oxygen to his pistons and there were times when he was clean when he would nod out because of the lack of oxygen in his system. At that point in time, he was hiding it. Manasha claimed she didn't know about it and I don't think she did.

manasha matheson garcia: I thought he had some lingering health problems from the coma. I said, "What's wrong with you? Why are you always falling asleep?" He said, "Ever since that coma, I don't have the stamina I used to have." I believed him and I remember he'd fall asleep in the chair and drop cigarettes and burn the floor around the chairs. It made me nervous. Later I figured out he was doing it in the bathroom because there were some plumbing problems. Every time he'd come over, I'd have a stopped-up plumbing problem. I'd call Roto-Rooter and they would fish out a plastic bag and that was when I started really being concerned. But that wasn't until he moved in with us, which was in '90. I kept questioning him. I said, "What's going on with you? This doesn't seem right to me, Jerry."

vince dibiase: This was right after Brent died. At the end of a tour, I think it was in Denver, I was told that the band tried to do an intervention with Jerry. But he was stronger than everybody put together. Basically, he told them to leave him alone.

gloria dibiase: I think he said that because he didn't like to tell people, his kids included, what to do and he didn't want anyone to tell him what to do. Soon after the big confrontation, he did the cleanup.

vince dibiase: He came home and he did do an outpatient program. Leon, his driver, or I drove him there every day. The clinic was in San Francisco one block off Van Ness. We went first thing in the morning. He'd go inside and get his treatment and he'd come out. He was doing it his way but Manasha was also in the middle of it.

manasha matheson garcia: Jerry told me he was going to go into the Cleveland program to help him stop smoking. He told me the band had held an intervention with him and he was going to get his health together and he was going to stop smoking. I thought, "That's odd. He needs to go to the Cleveland Clinic to stop smoking? Okay." When I came back to California, I talked to the doctor, Randy Baker. Randy had a conversation with Jerry and asked Jerry if it was all right if he told me what his problems were and so he did. Jerry didn't go to the Cleveland Clinic. He was going to the methadone clinic in San Francisco. It worked for a while, I think.

dr. randy baker: I really started working with Jerry in the summer of 1991 when I was trying to help him address his drug problem. At that time, he actually did undergo treatment and withdrew from narcotics. I don't know the full story but I think he was being pressured to do so by the band and organization who were once more concerned about his problems. He actually went on his own to a methadone treatment center. He just wanted to be treated like anyone else. He didn't want any special care. Over a period of weeks, he withdrew and I also arranged for him to have some counseling at that time. For a while, he was doing some outpatient counseling to explore the psychological aspects of drug addiction.

david grisman: Sometimes, he'd bring it up. Like when we were shooting this video for "The Thrill Is Gone." Justin Kreutzmann and my daughter, Gillian, produced it and Justin actually got Jerry to put a suit and tie on. We looked like gangsters. The day we were shooting it, Jerry was telling me that he was going every day down to the Tenderloin to a drug rehab clinic and standing in line with these derelicts. He was driving himself down there to get methadone. He was undergoing treatment and he was talking about it. At those times, whenever he brought it up, I would always say to him, "Look, if you ever need any help . . . if you ever want me to do anything for you." But I never tried to tell him what to do. I mean, really, what could I have said?

robert greenfield: During a fierce rainstorm on the night of October 25, 1991, Bill Graham was killed when the helicopter in which he was a passenger struck a utility tower. The night before the funeral,

the Grateful Dead went on stage to play as scheduled in the Oakland Coliseum. A week later, the Dead performed and then backed up John Fogerty, Neil Young, and others at a huge free concert in Golden Gate Park to honor Bill.

david graham: The show in the park was a beautiful day. The irony was that the first show we did without Bill was the biggest show we'd ever done. With my sick sarcastic humor, I was joking and telling everybody, "My dad outdrew Jerry, man." But it was only because on that day, Jerry drew for Bill. There was a definite vibe. Nobody wanted to pull off the killer solo. Nobody wanted to go nuts. Jerry was certainly taking it seriously.

bob barsotti: There was something in the character of those two guys that was like the positive and the negative of a magnet. They were exactly alike and they repulsed each other but they were totally simpatico. It came down to the story of when Jerry first met Bill at the Trips Festival. Jerry was this guy with a broken guitar and Bill was this guy in a cardigan sweater who was trying to fix it for him and that was what their relationship was always about.

On the Jerry Garcia Band tours, we'd be in these big arenas back east. The way Parish ran those tours, nobody was backstage. It would just be eight or ten people sitting around the dressing room every night and at intermission chatting it up and I would get Jerry to talk about the old days. Jerry said, "Bill got us out of the rut that the scene was in. There was this one guy out of North Beach who booked all the topless places and all the nightclubs and if you wanted to work anywhere in town, you had to pay this guy his twenty-five percent and he'd get you these gigs. They were always these really shitty gigs in really shitty places and nobody gave a shit about you and it was all about this guy."

All of a sudden, they got a chance to play in places where they had the right size stage and the right kind of lighting and the right kind of power and someone treating them with respect. It gave them the ability to get out of that hole and go more free-form. More than anything else, Bill knew how to take care of people. It wasn't good for Jerry when Bill died. With Bill gone, there was one less person around who could cut through the shit.

37

john perry barlow: I could always tell if he was starting to mess with it. He would definitely quit looking at me in the eye and he'd get real antsy and hostile towards me. Because he felt my judgments and was always after me about being judgmental and moralistic even though I'm not appreciably more that way than he was. In a funny way, I'd say I'm one of the least judgmental people I know. But he identified me as being a source of major judgment.

eileen law: When this other side of Jerry would pop out, he would become another person. He would stick more by himself. When he was straight, I thought he handled himself much better around all the people and the celebrity. I always felt the times when he wasn't doing too well was when he couldn't handle it. I always thought the cranky side of him came out then. I didn't even know if he was using or he just felt crummy.

jon mcintire: When he was using, he was a jive-ass. It was almost like talking to some stereotypically Hollywood person just throwing out this jive on whatever they thought you wanted to hear.

david grisman: The first time Jerry ever came over to my studio in '89, he said his doctor had told him that if he didn't quit smoking, he'd be dead in six months. Sometimes when he'd come over, he didn't look well. But he was always clear. He had an incredible mind and was sharp as a tack through it all. I always looked at him as sort of a big brother. I couldn't bring myself to get judgmental. I didn't feel it was my position. I didn't feel that I had the authority to confront him with something like that.

justin kreutzmann: On the road every night, you pick up the bag before you get in the infamous van home and Jerry would have

the bag full with the really healthy stuff and a towel on top and then below, he'd have a steak sandwich and the Cokes. A guy like that, he was going to do whatever he wanted anyway. Whether you really liked it or not. He'd listen to you once but if it was something he really didn't want to do, you'd probably have to stop short of putting a gun to his head to get him to actually do it. He went through phases when he could use drugs in just a maintenance way and then when he would become dependent upon them. He once told me that when it became just you and your drugs, that was an intolerable situation. Why he kept getting to that place, I don't know. He would be the only guy who could really answer that.

john perry barlow: It just depended on what cycle he was in. I watched Garcia's weather cycles breaking my way for years and years. Whether he was in the light or the dark. The sun was coming out—everything was groovy. Now he was down back in there and you could see it coming a long ways off. I think it was one of those millions of pendulum swings back and forth that run through the universe.

john "marmaduke" dawson: Say I wanted to get him to come and play on a record? I would try to call him up. I'd get through to Steve Parish, who'd say, "What do you want, Marmaduke?" And I'd say, "I want to talk to him." "What do you want to talk about?" "I want to ask him a question." "What question you want to ask him?" Along with Sue Stephens, Parish was the keeper of the gate.

bob barsotti: If you think that Steve Parish could control Jerry, you're crazy. Jerry really was his own person and he chose to isolate himself and he chose to put those walls around him. Just about every project that Jerry was involved in happened because someone ran into Jerry at the health food store when he was out on his walk or something like that. They started talking to him and got him hooked to do some gig. Just that amount of contact kept his schedule completely full all the time. He couldn't deal with having to say no to people anymore.

sat santokh singh khalsa: I saw him in Sacramento and he did something he had hardly ever done. He rarely displayed much emotion. But that day he actually gave me a hug. That maybe had happened twice in our relationship. I said, "I missed you." He said to me, "Me, too. Speak to Dennis McNally. Dennis will get us together." I kept

calling Dennis [Grateful Dead publicist] and then all this stuff started happening about Jerry's marriage and this, that, and the other thing, and we never got together again.

vince dibiase: Nobody talked to Jerry about everything that was going on. Nobody did. Maybe in the old days, they had. But in the last five years, nobody came up to his house and nobody confronted him with anything.

sat santokh singh khalsa: Three times I arranged to go to a show and I did not go. I'd acquired a certain amount of dignity as I got older and I found the prospect of going to a show just to see Jerry and not being admitted by Parish or not being able to communicate with Jerry too much to accept. I didn't have his phone number anymore because the only person I ever got it from was him.

vince dibiase: Even the people who got through to his house, Jerry wouldn't answer his messages. I would write them down for him and say, "Jerry, here are your messages, man." Sometimes, he wouldn't even return phone calls from his own family. He always told me, "Don't ever worry about getting me the information or giving me all the messages. Because by the time it reaches you, it's already come to me from five different sources." Sidestepping was an art and he was a master at it.

laird grant: Heroin makes you extremely lackadaisical. You don't care because it's a great buffer zone. Which it came to be between Jerry and his kids and everybody else, including me to a certain degree. I fought back and really got into his face about it. He reacted by saying, "You're absolutely right." He apologized but he said, "Hey, man. You know you're my lifelong buddy but the world has changed. It's gotten mean out there." I said, "That doesn't mean you have to be that way, though." Everybody wanted a piece of him. All I ever wanted to do was go back and give him a hug and say, "Hey, man. Kick ass!" It got to the point where it was good for me to show up because when I would, Jerry's whole attitude would change. I was somebody he could talk to. Somebody he knew was not there to take anything from him but to give.

bob barsotti: He was just unable to say no. That was the story on him. He never wanted to say no to anybody on anything. So his so-

lution was, "Oh, I'll just leave. Oh, I'll just stay home. Oh, I'll just hole up, keep these walls around me, and keep everyone away so I don't have to say no to people when they ask me to work on their projects. Because every time I talk to one of my old friends from the music scene, they always ask me to record this record or do this benefit." So his solution was to just stay home more and more.

barbara meier: In '89, my book of poetry, *The Life You Ordered Has Arrived,* came out. Hunter saw it in a bookstore and he bought a copy for Jerry. According to Dennis McNally, Jerry read the book and said, "Give me a paper and a pen and an envelope right now." He sat down and wrote this letter to me that said, "I love your poetry. It speaks from the heart. I've always loved you and still do." I was living in Boulder, Colorado. I was a Buddhist practitioner with Chogyam Trungpa Rinpoche, directing conferences and doing a little teaching while getting my master's degree in fine arts from the Naropa Institute. I had a great gig, I was in a great relationship, and I was happy. I looked at his letter and thought, "Right," and I tossed it away. I kept it of course but what could I do with it?

Once, when the Dead played in Colorado, Dennis McNally called me and said, "Jerry would like to see you." I went to the show and then he wouldn't see me because Dennis went back and said, "She's aged quite a bit better than you have, man." Jerry told me later that he was strung out on heroin and he didn't want me to see him. I stayed and watched him play but I was into the Talking Heads. The Dead weren't really my thing. I could see how the concerts had shifted into a scene. It had become this world where people could take drugs, open up all their shutters, connect deeply with other people, and suddenly find themselves in the back of a VW bus making love with some girl with long hair, and it was the first sense of family or community they'd ever had in their whole lives.

The following year, I went to the Bay Area and did a reading tour with another poet. I arrived at one of the readings and the bookstore manager said, "There's a note here for you from Dennis McNally. Would you please call him?" The note said, "Jerry really wants to see you." So I said, "All right, am I actually going to see him this time? I don't want to do this again." Dennis said, "You've got to understand he's with this really intense chick right now, Manasha, and she won't let him see anybody."

I went backstage at Shoreline Amphitheater in May of '91. I hadn't seen Jerry in almost twenty-eight years. I went back and my heart chakra

exploded. Aside from the fact that he was in a different body with white hair and white beard, nothing had changed at all. He was sitting there and he was very nervous and smoking but we entered a timeless space and we were right there where we'd left off.

He said, "I'm so glad to see you. You probably won't believe it but I've thought about you every day since we left each other. I've never forgotten you. I've never let go of you. I've always loved you. I love your poetry. I'm so happy to see that you're writing. You're so wonderful." He went on and on and he said, "I especially like that first poem in the book"—implying that he assumed it was about him. And I was thinking, "Oh, really? That's interesting." I had written this poem called "El Gran Coyote" for Trungpa Rinpoche. It has a coda by Charles Resnikoff in the beginning that says, "Not the five feet of water to your chin but the inch above the tip of your nose." So the poem is:

Winking
he bit me on
my cheek
Turning up
the amp
he pushed me
off a cliff
"Good luck,
sweetheart—
Ms. Shy & Confused . . ."
The wizard
left me
swimming
in gasoline;
his ironies
rogueries
rearranged
my molecules
In all my
human lifetimes,
I can never
thank him
enough

Although it was originally for my Buddhist teacher, it fit him. And I feel it is about Jerry as well, absolutely. So we sat for about half an hour together, holding hands, raving. We talked quite a bit about our respective journeys and consciousness, which was what I loved about him so much. He was infinitely inquisitive and curious about the nature of consciousness. He called it his hobby. He loved the interface between what is this hardware brain that we have and then this field of information that we call consciousness that we are all of but separate from and swimming in and participating with?

This was between sets. Let me tell you what an incredible set he played afterward. Not because of me but what he had allowed himself to open up to in terms of what he perceived that I represented to him. I never for a minute thought it was me. I always knew that it was something that he allowed himself to open up to within himself. The Dead were coming to Denver in a month and he said we'd get together then. I went and met him at his hotel and we had some time together, which we had to frame as an interview so Manasha wouldn't freak out. I went ahead and taped it. Just recently, I sent a copy of the cassette to Hunter and Hunter said, "There's not one sad note in the whole thing. It's all there." Jerry and I were ecstatic and Hunter wrote to me that it was hilarious listening to the two of us "pitching guarded woo."

After that, my life just started unraveling at quite a clip and I started creating every opportunity I could to go to the Bay Area where we'd go out to lunch or just hang. It was just so obvious that he was in a stressful scene with Manasha. Everyone was saying to him, "You've got to get out of this relationship. You have to get out of it." We once hung out over at Hunter's with Bob and Maureen and Jerry and I were feeling, "This is the way it was supposed to be." It was just a question of how we were going to pull it off. Because this was the way it was supposed to be—for everyone. Creative connected family. Not just him. Not just me. But the entire scene.

38

carolyn "mountain girl" garcia: I think that creatively Jerry felt a little bit stifled. The Grateful Dead were creative up to a point but they could be formulaic as well. My feeling was that his creativity was so strong that he needed other outlets until the artwork became an outlet. He worked really hard on some of his artwork.

vince dibiase: After one tour, Jerry said, "I want to talk to you for a minute. Let's go outside on the porch." He said, "I'm making some changes in my life. I need somebody that I like and I trust to manage this property I've got in San Rafael and also I need someone other than Nora to do the art." He made me a very generous offer. I said, "Wait a minute, man. Thanks but no thanks. Because this is all you. I'm honored to be part of this and of course I need to make some money but I don't need that much." He said, "Hey, man. Luckily, I've already got a job. I just want to see how far the art business can take me as a legitimate artist. So if you can do that, you deserve to get that much." He was really like, "I don't care about the money."

When I first took the art business over, which was in the summer of '92, Jerry was going on tour and he said, "I'll leave you a bunch of my sketchbooks." I went over there and there was a pile. He did most of his work in small sketchbooks. He'd open up a book and he might start in the middle. The next page might be ten pages back or he might have gone ahead. He would turn it upside down. You'd never know. But it was up to me to determine what to show the public. He said, "I don't want that responsibility." But if he didn't want something to be shown, he would say so. I would physically cut out of the art book what I wanted to use and then I'd compile everything and number everything on the back and then I'd give it to him. We'd sit down when he had time, which

might be months later, and I would give him one piece at a time and he would look at it, title it, and sign it. Or he might say no.

Then he really got into sketching, scanning, and finishing his artwork on the computer. He was into cutting out these friskets and then airbrushing them. He'd take a piece of clear plastic, cut out a shape, and use it as a stencil. In the early days, he would do that physically. He was good at making them but not at cleaning up the mess. What he could do with his computer was use a Mac software program called *Fractal Painter*. It had friskets so he could do that all with his computer and he loved it. Plus, he could experiment.

owsley stanley: I never thought the artwork that was offered up for sale was his best work. It was done after the heroin and they were all kind of sloppy and loose. Although they had weird ideas in them, they didn't have this dimensionality and this intricate exact perfection of detail about something most of us could see inside our heads when we were high but wouldn't have the slightest clue how to put out once we came back down.

vince dibiase: Nora would go out there with his artwork and blaze a trail and do whatever she wanted to do. Originally, the Ambassador Gallery in New York City set her up with Stonehenge ties. Jerry did not want to do the ties. I brought the proposal to him. Nora thought it was a great idea and Jerry said, "Ties? Do you know what I think of ties? This is what I think of ties." And he pulled an invisible tie up over his head like a hangman's noose. I said, "Okay. I'll never mention it to you again." Then Nora got a lawyer to call him in Hawaii on his vacation and Jerry didn't say no. He didn't say yes but he didn't say no. I told them all, "He doesn't want to do it." But they ignored me. It was a big embarrassment to him. He didn't want that done.

sue stephens: The tie thing was something that more or less got away from him. He certainly didn't go out seeking to design neckties. The tie people approached the person who had his artwork to license. They took little pieces of a piece of art and duplicated the design and then added their own colors. Jerry said he wouldn't even recognize his own art on those ties.

john "marmaduke" dawson: Half of those pictures were what Jerry saw in his brain when he was on DMT. DMT makes thousands of pinpoint images go through your brain at the same time. DMT is like Alan Shepard's first ride into space. Up and down, fifteen minutes, that's it.

gloria dibiase: Are you asking whether or not he had any hand in designing the ties or choosing the images and stuff like that? No. After they were done, he saw them. They took his signature for the label from his signed prints. We all laughed when Jerry had trouble recognizing his own images or knowing which paintings they were from but I think some of the ties themselves are lovely.

john "marmaduke" dawson: It was clip art to the tie manufacturer. They said, "What section of this painting do we want to use for the tie? Let's see. I think it should go about right here."

vince dibiase: Number-one-selling tie in America. The President, the Vice President, and half of Congress were wearing them. I also turned down a five-million-dollar deal for boxer shorts. I didn't even tell him about it because I said to myself, "I don't need the money that bad." To them, I said, "I don't want people sitting on Jerry's art." There were other big deals like that. Remember the last Olympics with the Lithuanian basketball team wearing those great tie-dyed shirts? We had a deal with Hanes going for this Olympics but that just got hindered and it never happened.

sue stephens: There could have been a special line of Jerry Garcia VW vans. But he was not in the capitalist world where he would run out shopping himself around. Like Jerry said, he was not opposed to selling out. He just wanted to know who was buying. The integrity had to be there. What happened was that the mainstream joined him. People wanted to be close to him and get some piece of him somehow, so he could have put his name on it and sold anything. Just about.

vince dibiase: We had big book deals with Hyperion Books and Ten Speed Press/Celestial Arts. We were going to do three books. A postcard book with tear-out postcards with his art that could have retailed

for ten bucks or so. We were going to do another art book similar to the one that he did with Nora at Ten Speed. Just his artwork and a little text. Then we were going to do a third book with him that would be all computer generated. Jerry said yes up until the last minute and then he said no. Lucy Kroll, who was his literary agent in New York, was talking to Hyperion about a book and all of a sudden, this offer came in from Hal Kant from Dell. At that point, Jerry could have probably generated enough income from his artwork alone for him to live without ever having to leave his house.

hal kant: Jerry turned down doing his autobiography any number of times. A friend of mine who runs Dell called and said, "Will Garcia do an autobiography?" and I said, "No chance." Then I said, "I have an idea. Let me go talk to him and if I can sell him on it, I'll get back to you." The idea was to do what he did, which was to have a book with one page of drawing or painting and the other page saying something about it. It was to be a nonlinear autobiography. He wouldn't have to go from year one.

vince dibiase: He would come to do his signings of the art book and we had to scope the place out to see how to get him back out. We had to check for a back door. When we ushered him out of the place, I had to stand in front of him and push people away. It was not what I liked to do. But it was what I had to do to protect the guy.

39

bob barsotti: I used to get really mad about what was going on with him but I was the guy who booked all his Jerry Garcia Band shows so I was as guilty as anybody for keeping the guy working. But he wanted to work.

laird grant: As long as Jerry had some Tang to drink in the morning, as opposed to fresh-squeezed orange juice, he was happy. He drank Tang every day. There would be fresh orange juice in the refrigerator and he'd get out the bottle of Tang and some tap water and stir it up and drink it. He grew up on hot dog stands in the Mission District. He grew up eating wino sandwiches down on First and Third streets and a chocolate milk. Hot dogs, french fries, ice cream. If there was a decent meal put before him, he'd eat it but it could just as well have been a greasy cold burger with some beans on it. Same with his cigarettes. He went through packs and packs and packs a day but if you looked at his guitar strings, there were always dead butts stuck on them. He'd leave them there and they'd burn out and the ashes would fall all over the place. He'd get maybe a couple of hits off each smoke. He smoked a whole bunch but he never really had time to seriously smoke a cigarette. A cigarette was one of the things he used to fill his hands up when he wasn't doing something else with them.

gloria dibiase: My son Christopher and I were on the road with Jerry down in southern California on his fiftieth birthday. In fact, we actually celebrated his fiftieth birthday with him in his hotel room with Manasha and Keelin. We were listening to a Jimi Hendrix CD and Jerry said he was feeling weird. As though someone had dosed him with acid.

manasha matheson garcia: We were in San Diego and he was perspiring heavily and I was concerned about him. I was

concerned that he was losing too much potassium. I had some tea that had a lot of potassium in it and I kept giving him that throughout the show. I didn't want him to do that tour because I thought the summer tours were too hard on him. This was right after the Grateful Dead summer tour. He'd done the summer tour and instead of taking a rest and doing something to rejuvenate himself, he went and did one more tour with the Jerry Garcia Band.

vince dibiase: While they were gone, I was in the process of moving them to this house in Nicasio. The movers left around ten P.M. and at midnight, Jerry, Manasha, and Keelin all walked into the new house. The next day, everything seemed to be okay. We were at our house. They were enjoying their new home. Tuesday morning, Jerry came downstairs. Manasha said his lips were black and he was really pale. His shins were all black. Like they were black-and-blue. It looked like a circulation problem. He was slipping in and out of a coma and she got Yen-Wei right up there.

manasha matheson garcia: We came back to Marin and he was in bad shape. We had moved into this larger house and it was moving day. Someone else had brought all of our stuff over but then we moved into the new house and I thought, "Oh, gosh. Jerry's getting sick on our first day in the new house." It gave me real bad feelings about the house. Jerry was out of it. I would have to wake him up. I'd say, "Jerry, wake up. Don't leave." I felt he was drifting. At times, he was unconscious so I would shake him and say, "Come on. Come back. You can't leave. We love you. Stay." I didn't know what was happening. I called Yen-Wei and Yen-Wei came over and did emergency acupuncture on him and I've never seen anything like it. He brought him back a hundredfold. Jerry was animated and talking but still very weak. At one point, I actually asked Jerry if he didn't want to go to the hospital. "No. No." So I sent for Yen-Wei and Yen-Wei did it.

yen-wei choong: From Chinese medicine viewpoint, it was heart exhaustion. Heart *chi.* When I went there, he was really sick. I noticed he had a big sweat and that sweat was different from regular sweat. The sweat was like big drop and like oily sweat which was not healthy from Chinese medicine viewpoint. His pulse was extremely rapid.

I did count. It was one hundred thirty per minute, very weak, very rapid. That meant the heart lung was collapsing. Not a good sign and actually that was very critical. He had swollen legs, swollen cold feet, cold hands. The lips very pale and purple. That was a very critical sign. And the tongue was very very white.

Very rare I see a case almost bad enough as emergency and it was my honor to be the first practitioner to be sent to work on him. I called my office immediately and asked my ex-wife to prepare herbs. I did some acupuncture. I burned some *moxa* stick. Chinese incense. Long, shaped like a cigar. I burned that around his belly, a *chakra* point, to enhance, to tonify the *chi,* to avoid the *chi* collapse. When Dave, the chauffeur, came back with herbs from my office about a half an hour later, I rushed in the kitchen to cook the tea for him. He drank the tea. Since the sweat was reduced a little bit, he was a little bit better. I came back the same night.

vince dibiase: Manasha called us and said she was calling Yen-Wei back up because Jerry was not doing too well and that Randy Baker was coming up later on in the evening. Even though it was the second time in the day he was there, we brought Yen-Wei up and then we stayed. Jerry was out. He was comatose. I don't know if I said we should call an ambulance but I was certainly alarmed because I could see the man was suffering. I was not a medical doctor. I didn't know how to determine what he was going through.

dr. randy baker: I got a call from Manasha saying that Jerry was sick but he didn't want to go to the hospital. I lived in Santa Cruz, a couple hours away. I told her I would arrive as soon as I could. I drove up and did a house call and Jerry was definitely sick enough to deserve hospitalization but he didn't want to go into the hospital so we did very intensive treatment based in his home over the next several weeks. I semi-lived in his house for a period of a few weeks closely supervising his treatment.

yen-wei choong: The second time I went to his house, I did something similar. The needle, *moxa,* and I cooked some herbs. He was a little bit better, sweat less. Both feet were swollen and Manasha was saying Randy was on the way there. Randy give him some shots which

275

also I believed would be helpful. Maybe two days later, Manasha called me and I was there again but the situation was a little more controllable. More stable, sweat less. The face was not so pale, the lips looked better. He was slowly getting better. One week later, the swollen legs were better. Randy give him some drugs, maybe vitamins, I don't know. So Randy and I both work on him. A few days later he feel much, much better. Maybe two weeks later, the swollen legs were completely gone and there was no sweat.

vince dibiase: Randy didn't get there until later but Yen-Wei had already revived him with his acupuncture. Yen-Wei was the one who revived him.

dr. randy baker: This collapse was primarily due to congestive heart failure. In left-sided congestive heart failure, the lungs fill with water. But he had right-sided congestive heart failure. With right-sided congestive heart failure, the backup of fluid is more in the extremities and in the abdomen, which was fortunate for him because he had emphysema and his lungs couldn't have tolerated filling up with very much water. His right-sided congestive heart failure was primarily caused by his significant emphysema related to years and years of smoking. The right side of the heart pumps blood to the lungs and it met with increased resistance because of his lung disease. So the right side of the heart enlarged because it was having difficulty pumping blood through his lungs and this eventually led to his congestive heart failure.

vince dibiase: Everybody around the Dead was starting to freak out because nobody knew what was going on and they didn't trust Manasha. They were very nervous but at the same time they couldn't do anything about it. They felt comfortable with Gloria and me because we would report to them daily about what was going on with Jerry. As long as they knew he was okay, they didn't want to call up there and bother him. They were uneasy but they were okay with it. What could they do?

dr. randy baker: During this time, he demonstrated truly amazing healing abilities. Seeing the extreme need, he totally stopped drug use and cut down on cigarette smoking. He went on a strict low-fat vegan diet and over the next three months, he lost over sixty pounds. He started

a program of exercise and made a remarkable recovery. He also had developed a recurrence of his diabetes.

What was interesting about his diabetes was that he'd had this diabetic coma in 1986 but when he left the hospital, he had virtually no signs of being diabetic, which was fairly unheard of. His diabetes was highly related to his weight. When he weighed in excess of two hundred and eighty pounds, he was diabetic. When his weight came down to two hundred and twenty pounds, he no longer was diabetic. I did treatments on him with Western medicine but I also worked with nutritional supplements and herbs and he received a lot of acupuncture as well as homeopathic medications.

manasha matheson garcia: Jerry was very frightened and now he was finally real receptive to changes in his diet. He got the message. He didn't stop smoking. But he lost seventy pounds and looked very healthy. Caring for him became a full-time job. I was like a nurse. I set the stage for all the health practitioners. I made sure people came and went and made sure he kept his appointments. He would often say to me, "I need you to stay alive." He wanted me to watch his health.

yen-wei choong: Manasha concerned about his health so much, she asked me to treat him very regularly, intense like three times a week. So I did. Went to the house, back and forth. I always brought some herbs and at that time, he was very good. He completely accept acupuncture nerve stick all the time. Three times a week until the end of '92.

gloria dibiase: Manasha took charge of Jerry's alternative healing program. A lot of people didn't understand what she was trying to do. She was only trying to help Jerry in the way she believed was right. And the program worked beautifully. Jerry lost sixty pounds. They had to readjust the mike on stage because he was standing up taller. He looked so handsome. He had a wonderful glow about him. He was recovering his health through alternative natural methods.

dr. randy baker: During this time, I took him to the best cardiologist I could find. You don't have to be a genius to see that someone who was an overweight smoker with a history of diabetes who ate a lot of meat was at risk for heart disease. I had tried to arrange for that in

the summer of 1991 but Jerry hadn't followed through. But in the summer of '92, we did do some cardiac testing. He did a treadmill stress test including a stress echo cardiogram, which confirmed his right-sided heart failure but showed absolutely no evidence of blockage of his arteries which totally amazed me.

No medical test is foolproof but this test will detect significant coronary artery disease about ninety percent of the time. The very best test would have been a scan where you inject a radioactive dye and then put someone on the treadmill but Jerry chose not to do this test. I spent a lot of time trying to explain that the risk of getting harmed from this small amount of radioactivity was minuscule to the risk of his dropping dead tomorrow from a heart attack but that was all to no avail.

manasha matheson garcia: We went to the hospital and did a bunch of tests. Jerry didn't want to do the test with radioactive dye. He told me he didn't really care to.

dr. randy baker: So we did the next best test and it was a pretty good test. But once more, no test is perfect. The thing was that you could have fifty or sixty percent blockage and it might not show up on that test. That test was going to show more extreme blockage. I'm sure that he had some blockage at that time but it wasn't enough to significantly interfere with blood flow to his heart. From that point on, he was following a really excellent diet and losing a lot of weight, cutting back significantly on his smoking, and starting an exercise program, all of which should have lowered his risk of heart disease.

vince dibiase: For a month, no one would even come up to see him. Cameron Sears, who was managing the Dead, called and I talked to Phil a lot. I talked to a lot of people from the Grateful Dead family. Randy wasn't talking to anyone at the time and I had to take Randy aside and say, "Randy, you've got credentials, okay? You are his doctor. You are his primary physician. You've got to let these guys know that. You need to meet with the band and all these guys and let them know you went to the University of Michigan and Stanford Medical School, okay?" So he had a meeting with them, which reassured them about his capabilities.

dr. randy baker: In the summer of 1992, I met with the band and management several times regarding Jerry's health. We had a dilemma because I knew that touring was very stressful but at the same time that was also what Jerry lived for and that was his life. Which was another tricky area. I recommended that the tour schedule be made less rigorous. I wanted them to play more shows in the Bay Area and less shows traveling around the country. I also thought it would be an excellent idea if I traveled with the band on tour to supervise and to keep an eye on Jerry's health. There was also obviously some self-interest in this for me. Being paid to be on tour with the Grateful Dead. Jerry had told me that he would like to see me become the so-called tour doctor but said the band would have to approve it. I proposed this but my proposal was turned down. I wasn't given any reasons.

manasha matheson garcia: There was an upcoming Grateful Dead tour. He was very ill in August and the tour was scheduled to begin in September and people in the Grateful Dead establishment were pushing this other doctor on us who Jerry didn't care for. She wanted to do a quick patch-up repair job so Jerry would get back on the road again and I said absolutely not. Jerry didn't want this. He wanted to get well. He wanted to focus in on his health. He told me he wanted to take the time off and I supported him in that. It wasn't that he was never going to play music again. He wanted to get back on the road in December but in September, he wanted to take some time off. He wanted the tour to be canceled and I think I became out of favor at that point with the organization because they believed that I canceled the tour.

dr. randy baker: Certainly, Jerry himself could have hired me to go out on the road with him but he did not do this. Jerry definitely ran his own life and he didn't like people telling him what to do. In terms of falling into old habits on the road, Jerry had stage fright. He was very frank about the fact that he felt very nervous before he'd go on stage. Once they'd start playing, he was okay but I think that his stage fright was one of the reasons why he would turn to both cigarettes and drugs, to try to cope with that. I think the rigor of the road for him was having to go out and perform in front of fifteen to fifty thousand people who were expecting to have the time of their life. He might feel bad but he

had to go out there. Basically, his health remained in pretty good shape in 1993.

manasha matheson garcia: Actually, Randy did come with us when the Dead were on tour in December in Denver. So they did bring him there. But then something odd happened. Jerry and I were planning to go to Hawaii with Keelin in January. Other people, I'm not going to mention anyone's name, organizational people, organized Barbara to come in. She came in and Jerry thought he was going to rekindle his first romance and he left. The day he left, he told me he loved me.

40

barbara meier: We danced around the edges for another nine months. The Dead came to Denver again in December of '92 and I went to see him and I said, "You tell me what's going to happen. Are we going to do this or not? Because if we're not, I'm going to leave the country. I want you or I'm going to Latin America." And he said, "Let's go for it." We threw the I Ching and came up with the "Joyous" hexagram with no changing lines. It was December and he said, "I can't do this. I can't leave before Christmas." He just went into a panic. But the entire scene mobilized like a military operation and for a month, all these people called me every day and said, "It's going to happen. Come out here."

I flew out to San Francisco the day before New Year's Eve. Jerry came over to Hunter's house. He literally went out for a pack of cigarettes and didn't go back. We were at Hunter's and Jerry was freaking out. "I can't do this to Keelin and I can't do this to Manasha. I have to do it. Oh, God." He was looking at me and saying, "I can't do this to her. It will kill her. Not only that, she'll kill me. I'm afraid that she's going to kill me." I said, "Jerry, you say, 'Manasha, I'm in love with another woman.'" He said, "Oh, I can't do that." So he just left. He didn't say anything to her. That should have been a red flag for me but of course I ignored it.

manasha matheson garcia: Jerry said he was going out to do some work and he just never came back. The month before, I had given him an ultimatum because I saw that he was going downhill. I didn't mean to but I had a five-year-old and I wasn't taking any drugs and I saw that something was changing with him and I was beginning to wonder if he was doing drugs again. So I said, "Look, you either get help and stay with us or else you're going to have to pursue the drugs." I got emphatic about it. About a week to ten days later, he was gone. I

never saw him again. That was it. Then I heard that he was on the road with Barbara and that they had gone to Hawaii with these other people. I was real hurt because all these other people had come to our Christmas party and they were well aware then of what was going on.

vince dibiase: I had to deliver the "Dear John" letter. Manasha knew something was up because Jerry had left in the morning and was due home at five or six o'clock and it was now seven-thirty or eight at night and she had been trying to track him down. Jerry called me so I went up to Hunter's house. Phil and Jill Lesh were there and Maureen and Bob Hunter and Jerry and Barbara. Jerry had written a very short little note. He said, "I just can't do it." Then he asked me if I'd deliver it. I said, "Sure." Barbara said, "Good thing it's today because if it was the good old days, you know what they did with the messengers."

barbara meier: They walked up to Jerry and handed him plane tickets and said, "You have reservations in Hawaii. Get on the plane." Leon was there with the limo and he took us to the airport. We spent the night at the airport, got on the plane, and we were gone. We went to Maui for three weeks and then we went to the Big Island.

vince dibiase: I had to go up to Nicasio, which was a long lonely ride. Manasha wasn't home when I got there. One of her friends was there. He let me in and I waited. She came by within half an hour, furious and frantic, and I said, "Manasha, if there's anything I can do, I want to help." And I handed her this letter. She left very upset and I stayed for a few minutes and then I left. I'd done my job. It was very hard for her. Gloria and I stayed in the middle of things with her. She held it against me for doing that but she also told me a couple of months ago that she forgave me for it because she knew I was doing my job. But Gloria and I stayed friendly and supportive with her because we wanted to be helpful to Jerry and we wanted to be nice to her.

barbara meier: We had this idyllic month together scuba diving, lolling around, and it was just exquisite. People who didn't know him, people who had no idea who he was, like old Hawaiian men, would stop us on the street and say, "My God, I have never seen a man and woman so in love together." It was like an extended Ecstasy trip. A week

later, the Hunters came over. Bob and Jerry wrote six songs together. They hadn't written for years and I believe they didn't write any songs afterwards. They wrote six songs in three weeks and the energy was incredible.

Jerry and I wrote a collaborative poem together called "Gaspar's Parrot." Gaspar De Lago is his alter ego's name and it was a fabulous sestina, absolutely hilarious. We were having so much fun that we were literally peeing in our pants. He was not using at all and everyone said this was the longest time he was off drugs. It was great and he asked me to marry him. I said yes. At the time, he was still married to MG. Actually, I was still married to someone, too. It was like, "As soon as we get our divorces, we'll get married." There was this wonderful scene of diving and raving and hanging out and we were watching movies and writing poetry and I was painting the whole time and bonding with Maureen Hunter and Jerry was writing all these songs and composing.

gloria dibiase: The day before Jerry and Barbara were coming back, Jerry gave me twenty-four-hour notice to find him a temporary rental. He said, "Get us a place with a nice view in Sausalito or Tiburon. We'll only be there for a month." Famous last words. He ended up living there for a year.

barbara meier: Because he had nowhere to go back to, they got us this furnished condo in Tiburon. Immediately, everybody just jumped on the scene and said, "Oh, this is so great. Now he's with you, he can quit smoking."

dr. randy baker: There was even a period in early '93 when Jerry totally stopped smoking cigarettes for a while. However, then he went into the Grateful Dead spring tour and he eventually started smoking again.

barbara meier: We started walking an hour together every day. We would go to the chiropractor one day, the acupuncturist the next. He was working with a hypnotherapist and a personal trainer three times a week. We were drinking carrot juice, we were doing Chinese herbs. His snoring was so appalling that the first three nights we were together, I didn't sleep. Then I just said, "Okay. I am going to learn to sleep

through this." I said, "I'm definitely going to sleep with my husband" and I did. I managed to do it. I'm very proud of that. It was something I created very deliberately with my intention.

gloria dibiase: We were so optimistic for Jerry when he got together with Barbara because we thought it was romantic for him to be reunited with his first love. Jerry and Bob Hunter started writing music again. Jerry was looking good. He was healthy. He was strong. He was happy.

barbara meier: Then I made a huge mistake. I didn't realize it at the time but I felt I needed to go back to Boulder and bring back some stuff. I just had the suitcase I'd used to go to Hawaii and I needed a house sitter. I needed to check on Esme, my daughter, and I was gone literally four days. I called him several times every day. I came back. He hadn't slept in the bed. He had slept on the couch when he'd slept and there was this huge ring of cigarette ashes around where he had been and open food containers. This man was absolutely and totally incapable of being on his own. Completely incapable. He'd been freaked out about me leaving and I'd kept saying, "Oh sweetie, don't worry. I'll be right back." I was so naive. I had no idea that he would lose it so badly.

A week or so after I got back, he said, "I ran into this woman I used to be with. Deborah." This was someone that he'd told me about when we were in Hawaii. I was still thinking that Manasha was a problem. Meanwhile, here was this other woman coming in the room and I wasn't paying any attention. I wasn't relating to her presence seriously. So I just said, "Oh, sweetheart. No problem. We're solid. Don't worry about it. Baby, we can work anything out. We're together. That's all that matters and we'll work anything out." I believed it. I totally believed it.

gloria dibiase: Jerry was always hopelessly in love with whatever woman he was with at the time. But when a woman wants a man, she can get him. Think about it. When a woman wants a man, she can get him.

barbara meier: In the interim, I had met Sara, MG, Heather, Annabelle, and Trixie, and totally, totally fallen in love with all of these people. Jerry was saying, "We're a family now. It doesn't matter. Your

kid, my kids. We're all one family and this is it. We're here together for the rest of our lives and this is all I've ever wanted and this is it. This is perfect." And I believed him. We were a family. I totally fell in love with these people and I wanted them in my life. I did everything I could to get them to come over to the house or for us all to get together. All the boundaries were down. Everything was open.

vince dibiase: Jerry played a chess game in life that kept everybody scratching their heads. He took pleasure in that. Everybody was always trying to figure out what Jerry was talking about and doing and nobody could ever do it and that was part of his game in life because he was bored with everything else.

barbara meier: One of the most fun things we did was to play games with the *OED*, the *Oxford English Dictionary*. We would find words that we'd never heard of and then we'd start incorporating them into our conversations and then we'd mix them up together and it was constant running hilarity. But then some creaky stuff started to happen. I had my own music and I was into some fairly avant garde stuff and he hated it. Another thing that started to be a problem was that I had a lot of men friends and he started getting extremely upset about that. I was very close with my ex-husband and Jerry had a hard time with the phone ringing all the time and he would say, "It's another one of your bozos." It was very unlike him. But it was a part of him in the sense that he had a very jealous and possessive streak.

As far as I could tell, everything was wide open and happening. He was writing with Hunter, he was doing his work with Grisman, he was doing work with Heather and the Redwood City Symphony. We were ecstatically happy together. He was getting healthier. He had quit smoking. What I didn't realize was that he had started using again. I didn't know that. I was so stupid, I had no clue. He was being a bastard and I thought that was just because he was quitting smoking. I thought he was just being a bear. Oh, he was vile. He was cold and he was withholding.

By then, the shows had started and I don't want to name names but there were certain people in that world who used and they thought a little chipping here and a little chipping there was no problem. I thought that Jerry was nodding off during dinner because he hadn't slept well the night before. I thought he was shooting the nasal dilation thing up his nose

because he had a cold. I thought the sweat on his forehead was because maybe he was coming down with a fever. I was an idiot. I'd never been around hard drugs before so I never had a clue.

The kicker was that I had created this very interesting lifestyle for myself before I left to be with him. He'd asked me to drop all that because it was in Colorado and New Mexico and I said, "Okay. But I've made a commitment to teach one last course here in the Bay Area." It turned out to be a ten-day course and I was gone from nine in the morning until seven at night. He hated it. He despised the whole premise of it. He would sit and rant at me about it and challenge me and I would just lovingly tease him.

Because the basic premise of this belief management course was that you create the world that you live in by the beliefs that you hold. If you hold the belief that you're unlovable, you will constantly create situations that will confirm that. He'd say, "Take this scene. No way did I create this." And I said, "Who did?" "Oh, man. Shit just happens." "Oh, really?" What was so odd was that he could completely and one hundred percent take total responsibility in the realm of his music. He would get to the sound check at two in the afternoon and be there until the show started working out the bugs. But that was the only realm in which he would do that—take responsibility. In every other realm, he just let everything skid.

He'd been seeing a hypnotherapist to help him stop smoking. One night he came back and said, "She said I need to tell you that I'm having thoughts about Deborah and I don't know what I'm going to do. I'm very scared. I love you. I want to be with you but I feel like she has a hold on me." I said, "I guess you're going to have to choose 'cause if you're with her then you won't be with me and if you're with me, then you won't be with her. You need to decide what you want to do." He said, "I love you and I want to be with you." I said, "Then that's your decision and there's no problem."

The Grateful Dead tour started in March '93. We went on tour and he was cold and withdrawn. He was being a real bastard and it was awful. We were in Chicago, which was really cold, and this went on for three days. I was in tears the entire time, feeling shut out and wondering why. The last night, I was wondering what the hell I was doing there. I was sitting alone backstage at the show on the black equipment boxes and I was writing the whole time, trying to take notes.

Randy Baker came up to me and he said, "Barbara, is Jerry using?" I said, "No." He said, "What makes you think so?" I said, "He says he's not." He said, "Do you know what the symptoms are?" I said, "Like what?" Then he started enumerating the symptoms and they all started vectoring. I went, "Oh shit. Oh shit." I thought that he was just quitting smoking. And then immediately this other part of me kicked in and said, "Oh God, that's what it is. Thank God that's what it is." Because I have the belief that you can work with anything. I believe that anything is workable. That was one thing I learned from Trungpa Rinpoche. You never give up on anybody.

That was during the break. I went up to Steve Parish and I said, "Listen, man, you tell me the truth 'cause I'm losing it. I'm in real pain here. You have to tell me if this is true or not." He said, "The first thing you need to know about Jerry is that he can handle it, okay? Yes, it's true. We didn't want to tell you 'cause we didn't want you to be freaked out. We didn't want you to leave. Everything is coming together now that you're here and this is the best he's ever been and the time you've been together is the longest he's ever been off it. As soon as he quits smoking, he'll be able to do this and it's all going to work out. Just hang in there with it. We don't want to lose you. You're the best thing that's ever happened." I said, "I'm not going to leave but you can't leave me out."

He said, "Yeah, he was chipping and he got hooked and he's been on these pills. He's been off it for the last three days, that's why he's such a bastard but he's got these pills from the doctor and so he's kicking but he can do this. He can do this. He can go and kick." He said, "The main thing is just act like you don't know about it and hang in there with it 'cause it's all going to be fine. I promise you. It's all going to be fine. We're going to be fine. Hang in there for a week. Don't worry about it."

Then he went back to whatever he was doing and I was sitting on this black box thinking, "I've just been told that the man I love is using heroin. I've been asked to go into denial about that and pretend that I don't know and enable him." I thought about Trungpa at that moment and realized I was having a profound Vajrayana experience. I had gone from the god-realm of being with Jerry in Hawaii to being on the black box backstage in this cold hall in Chicago and now I was in a hell-realm. I couldn't believe it but there it was.

So we went back to the hotel room that night and ordered some hot chocolate and he was actually very sweet. I said, "Jerry. I've got to tell

you something. I want you to know that I love you. I'll always love you. I'll never leave you. I want you to know that you can do whatever you want. You can do whatever you want and I'll be here with you but you can't exclude me and you can't keep secrets from me. I need for you to know that I know that you're using and that's okay. I love you. Just don't hide it from me 'cause I'll go crazy. I grew up with alcoholics. I can't do that."

He said, "What the fuck are you talking about. Who told you that? Did Randy tell you that shit? Fucking Randy." He was up and pacing and freaking out and this corrugated steel door, a psychic door, came down between us. He said, "I think you'd better leave now." I said, "What do you mean? I'll never leave." He said, "No. I think it's time for you to leave." I said, "I thought we were getting married?" He said, "Yeah, well. I meant it at the time." I said, "You have to talk to me. Do you k̲n̲o̲w̲ who I am? Do you know what I'm made of? It's not going to work like that. I'm *Barbara*. I'm not a groupie."

We stayed up all night, until six in the morning. I kept saying, "Is this about Deborah?" "No. It has nothing to do with Deborah. Nothing, nothing, nothing, nothing." Finally, he looked at me and he said, "All right. I'm in love with another woman." I said, "Deborah?" and he said, "Yeah. I can't shake her." Part of me was remembering that this was what I'd wanted him to say to Manasha! But here he was saying it to me and I was thinking to myself, "No, no!" But I was also thinking, "Yes. *Fantastic!*" He'd finally taken a fucking stand. He'd made a decision. I was devastated and I was on his team all at once. It was really quite a multi-dimensional experience.

I said, "Okay, man. If you've got more love with her than you've got with me, then I want you to have it. If that's what you've got, then go for it." The bottom line was that I said, "Okay. I'll go but we've got twenty-four hours to be together and I want them to be as exquisite as they can be and I want to use this time for as much psychic reclamation and closure as we can do."

We spent another day and evening together and slept together and made love. He said, "I never thought anything would happen to blow the best thing that ever happened to me out of the water. You saved my ass. No one else could have done it." Meaning, "You got me out of the thing with Manasha." He said, "I really want to help you. I'd like to help you put your daughter through college and I'd like to help you with your art." I

said, "Okay. That would work for me 'cause that's what I'm going to need to do now." He said, "Let's figure out what that's going to be and set it up and we'll do that." I said, "I'd like to do this three-year program."

Two weeks later in New York, he said, "What do you need?" I gave him an amount and he said, "How 'bout twice that?" I said, "That's great," and that was it. That was April '93. I never saw him again.

said, "No." Then I said work in the band, that's what I'm going to need to do now. He said, "I've figured out what that's going to be and we need your help with that." I said, "I'd met this there very very much." Two weeks later in New York, he said, "What do you need?" I gave him an amount and he said, "That's how much money I need." "That's great," and this was April '95. I never saw him again.

41

barbara meier: I played it all wrong. My way was to just appreciate and love him unconditionally and give him unconditional space. I realize now that the nature of his wound was that he needed to be in a situation with very strict boundaries. Even though he despised them, he couldn't live without them, and the way it worked was that he couldn't do that for himself. He had to be with a woman who played out his shadow for him. He had to be with someone so he could say to people, "Oh I can't do that. Manasha won't let me. Oh I can't do that. Deborah won't let me. I can't do that." I now feel tremendous empathy for Manasha, and for that matter Deborah, or any woman who ever loved Jerry.

vince dibiase: Barbara came back and packed up and split. Jerry came back from that tour and he lived in that Tiburon apartment for about a year.

manasha matheson garcia: I got a notice in the mail from Jerry's attorney saying that we had to leave the house in thirty days. That broke my heart. Years prior to this in '90 when he moved in, he'd asked me to marry him and I'd said yes. We were supposed to be married on Easter when he was free. I called him up Palm Sunday and he asked me if we could all get together, Keelin, Jerry and me, and I said, "I'm really disappointed in you and I'm disappointed in the way you left and I feel really bad and I have made other plans for Easter so I don't know if that's appropriate right now." I said, "Maybe sometime in the future. Maybe in May." He said, "I want to keep trying so whenever we can get together, let's get together."

I put him off at that point and then the next time I called him, the woman he was with answered the phone and she said, "Don't ever call here again. You're not to call here ever again." Those were her exact

words and then I let it go. But in the meantime I was real worried about Jerry so I called Cameron Sears and I asked him to hire Randy Baker for the Grateful Dead. I felt like Jerry loved us. He seemed to suffer a lot after he left us. He seemed to have suffered from a broken heart.

cassidy law: We went to the White House in 1993. Bill Clinton wasn't there that day so we went and saw Al Gore. I think Al knew a little bit about us but Tipper was definitely into it. Actually, we hung out with her the most. It was so funny walking into the White House. All of a sudden, we heard, "There's Jerry Garcia! There's Jerry Garcia!" People were flying out of their offices and flocking to him. That guy had so many photos taken that day, it was incredible.

I was really feeling out of place and Jerry picked up on that right away. He said, "Don't you worry about that. You're with me today." Any time someone went to introduce us, he was right there with me and I thought, "What a gentleman." That night, I went with Jerry and all the band members and their wives to Al Gore's house for dinner.

It was a private intimate dinner so we were being the nicest that we could be. Al and Tipper were running around shooting the breeze with everyone. I was also there in Washington a year later when Strom Thurmond came running up and said, "Jerry Garcia!" The whole place fell silent. Jerry loved it. That was his kind of humor. Very absurd.

chesley millikin: Jerry called me up and he said, "I'm going to Ireland and I don't want to go without you. Can you come along?" So we flew to Shannon in July '93 and we did all kinds of things like tourists. Deborah set it up and it couldn't have been done any better. We had a great time. Matt Malloy, who's one of the Chieftains, we went to his pub in the County Mayo. Then we went to a pub up in Donegal where there was a bluegrass band playing whom Jerry had seen, I believe he said, in 1974 at a festival in Philadelphia.

The girls would stop off at all these old places where there were buried monuments to death. Jerry wasn't interested in any of that but one time we pulled up at the base of this famous mountain in Ireland and he was sitting there. The girls had gone off to look at one of these tombs. The tinkers, who are the Gypsies, a traveling people, had made a camp across the road so there was a horse tied up to this lightpost. The horse was going apeshit and all of a sudden, Jerry took out his banjo and he started

playing. These very stern tall German women were walking by and they looked into the van and of course they had no idea who the hell it was. He was playing and the horse settled down. It was like the horse understood.

We also went as far west in Ireland as you can get before you step in the ocean. We were driving around in this van and we drove down this very narrow road only wide enough for the van and a bike. Out of nowhere, a little motor scooter flew past us. Jerry turned around and said, "There's a leprechaun!" So he saw a leprechaun in Ireland.

When we were in Ireland, he asked me if I knew a good jewelry store and I told him which one. He was going to take Deborah and himself there and I said, "Jewelry store?" He said, "Yes," and I looked at Deborah and she said, "Jerry likes to spend money." No matter where he went, he tipped fifty percent and that was because he felt that he had come by it so easily and these people were just making a living.

He didn't really know much about his Irish ancestors but he loved Ireland. He felt very peaceful, very quiet. Also what was great to him was that nobody bothered him. Most of the people didn't even know who the hell he was. Any that did stood their distance. We ate well and we traveled well and he had a great time and he really loved it. I don't believe he was too happy about going back. The only thing that he had been looking forward to was that he was going to Japan.

vince dibiase: We were in Hawaii on our way to Tokyo for his art shows. We'd had high-ranking government officials working for us to help set this up. We'd had people in the State Department over here getting his working visa. The head Buddhist monk in all Japan was going to be with us. Kitaro, the great Japanese New Age musician, was to be our personal host. He was the one setting up this spiritual quest with Jerry Garcia from the West, the head monk from the East, and himself. In the equivalent of *The New York Times* in Tokyo, there was a full-page ad on the back of the front section. Part of Jerry's face with the words, "Your Great Uncle Jerry Is Coming."

He was on national TV ten times a day. They'd sent a film crew over from Japan and he'd done an interview and they'd cut it into fifteen and thirty second spots. They aired them nationally ten times a day starting October 1 and the art exhibition was scheduled to open on the twentieth of October. Three weeks of seven days a week on national TV. Billboards

in downtown Tokyo. "You Know Your Great Uncle Jerry Is Coming." This huge conglomerate over there sponsored the whole thing. They were inventing Jerry fever over there.

Two days before we were to land in Tokyo, Jerry canceled. It was like, "You don't do that to Japanese. They don't understand that." He was afraid on a lot of different levels and he wasn't doing all that well physically. He was really tired and I didn't think going would have been the right thing to do. I saw millions of dollars go right out the window plus a potential huge lawsuit because they'd spent a lot of money hyping him over there.

But the minute he said that he didn't think he could carry Japan, I said, "Okay. Let's not go there." I didn't hesitate because what was important to me was him surviving. A day and a half after we were due back on the mainland, he was going off on this sixteen-city tour with the Garcia Band. If he was tired before he went to Tokyo, he was going to be exhausted when he got back and then a day and a half later, he was going to go on this tour.

The shows of his art went on but without Jerry. My family over there was literally disgraced. But it gave me a chance to sit down with Jerry friend-to-friend and talk about my life and his life. At one point, he looked at me and said, "Man, I love you." He got up and gave me this bear hug. In the big picture, it was more important for him not to go.

carolyn "mountain girl" garcia: When Jerry came out of the hospital after the coma, his hair had gone pretty white and he was really gimping around. He had trouble making it up stairs for a long time after that and so he really had the appearance of an old man. But he did come back. He got into diving and he was walking on the treadmill and doing the McDougal diet and all these things that were so uncharacteristic for him but actually, they were life-oriented activities. At the end of '93, I felt he was really doing well and then it all fell apart for him again.

gloria dibiase: Jerry didn't go to bed like most people did. For the last two and a half years of his life, it was like one long day where the sun would rise and it would be light and then the sun would go down and it would be dark again. He didn't take off his clothes, get into pa-

jamas, and get underneath the covers. He slept on top of his bed in his clothing.

vince dibiase: He'd doze. It was not like he'd go to bed at two in the morning and get up at six. He would work through the night and he would doze. This was twenty-four hours a day. He was absolutely on his own time.

clifford "tiff" garcia: It would have been nice if Jerry had walked around the block now and then and gotten some normal exercise without putting himself in a machine. He had all this equipment in his place. Never used it. He loved to be that way. He would always explain to me how healthy he was. "I'm in good shape," he'd say. "I'm getting muscles." And I'd be thinking, "Wonderful." I'd look down and he'd have a cigarette in his hand. But he was doing good. He had a good creative period with lots of things going on and then all of a sudden, it started to get flat again. I could see him coming down again. He was losing interest.

gloria dibiase: Jerry still loved Keelin very much. She was the apple of his eye. He would send me out to buy Christmas and birthday presents for her. He just didn't have physical contact with her. But she was always in his thoughts and in his heart.

vince dibiase: He'd really tried to be a good daddy to Keelin. I'd go in the house when he and Manasha were still together and he'd have Keelin on his lap at the computer with some kid's programs, teaching her things. Or they would play the piano together. Go out feeding the goats and watching the sunset. Gloria used to dress Keelin up in her belly dance costume and Keelin would dance and Gloria would sing and Jerry would play for them on the guitar.

manasha matheson garcia: Jerry got us another house as an alternative because he wanted to get us a place to live. I tried to set up a lot of meetings between him and Keelin where I wouldn't be there but it never happened. It just never happened.

dexter johnson: I went backstage to see Jerry and David Grisman at the Warfield in January '94. There were problems at this gig because both Jerry's and David's sound crews had come and neither of them wanted to bow out. Jerry just wanted to play and have a good time. After the first set, he was so pissed that he tore off his headphones. Then he walked straight off stage. Didn't look at the band or the audience or anyone standing backstage.

Downstairs, Jerry was walking back and forth and everybody was giving him room and he was literally steaming but nobody did anything. Finally, I went up and put my hand on his shoulder and said, "Jerry, what is it?" He said, "I can't hear anything. They pay good money for these shows and I can't fucking hear the guitar. Nobody can hear right. This isn't the way it's supposed to be." I said, "If you think it's the pickup, maybe I can help." I'm a guitar maker and he was like, "Yeah. Get the guitar to Dexter. This is lucky! We got Dexter." He was happy.

So they were told to go get the guitar. Jerry went off to sit in the back room with David and I started waiting. After ten minutes, there was no guitar. I went up the stairs to the stage and there was one of his roadies with the guitar in his lap and a cigarette going and he'd put three new strings on it. I could have easily strung the guitar in moments. I said, "Oh, hey. I was going to work on the guitar for Jerry." He said, "We got it covered, man." And he just waved me away.

I went downstairs and I said, "David, they won't give me the guitar." He said, "Did you tell Jerry?" I said, "I don't want to upset him again." David turned around and went in the back and yelled, "Your fucking roadies! I've had it with them." Jerry stood up. But he'd mellowed out somehow. He said, "Forget it. We'll just do the rest of the show and it'll be fine." We told some stories and visited and laughed and he went out there and finished the show and played a great second half.

Later on, I was told that when I went up and put my hand on Jerry's shoulder and said, "What is it, man?" one of the big bodyguards who were at every door lunged towards me and said, "That guy shouldn't be talking to Jerry." All these guys in the back room were playing cards during the show. They didn't even listen to the show. They were talking about meeting some broads later and playing cards. The whole thing saddened me. To me, it didn't seem like a fun place to be.

carolyn "mountain girl" garcia: Jerry went off and he filed for divorce at the end of '93 and he remarried about three weeks after our divorce was final. He had been making the rounds of his old girlfriends and I had never met Barbara before but I really liked her and enjoyed her. She seemed to be okay. But when he got together with Deborah, that was it for me. I said, "Oh, I can't do any more here."

rev. matthew fox: It was Deborah who called me and she said that she and Jerry had read my book *Original Blessing* and were very turned on by it. I had to tell them that the pope was not too happy with what I was doing and they said, "Oh, great. An outlaw priest for an outlaw marriage." I sat with them before the wedding. Jerry came late and he seemed very joyous, very happy. I was not a Deadhead but I was certainly charmed by him. He and Deborah were cooing and very loving together. I don't do windows and I don't do weddings but I was pleased to do this for them and in fact, I did get seats for a Dead show after the wedding. I very much liked the ritual aspect of it but would have liked to see it more organized.

clifford "tiff" garcia: Jerry married her because she had this business sense. He was starting to like that in women and she was trying to do movies and he liked that artistic ability, too. They lived separately.

gloria dibiase: After Jerry married, he continued to live by himself in his own house. That's the way he wanted it to be.

rev. matthew fox: I'd played them a twelfth-century version of "Ave Maria" that they'd liked very much and with all the talented people they knew, a friend of Jerry's, David Grisman, played it on the mandolin for the ceremony. When they came to me, I was a Dominican father but by the time I married them, I had become an Episcopalian. Not an Episcopalian priest so I had to have an Episcopalian priest assist me in the ceremony. Jerry was half an hour late for the wedding and very upset. His limo driver had not come and so he was a little frantic there for a while but once Steve Parish calmed him down, he was joyful again. I believe he was wearing a tux.

vince dibiase: I had acute pancreatitis and I got snowed in in New York and Jerry wanted me to get him his wedding shoes. He said, "Vince, I want a pair of glove-leather soft shoes. No seams. Black." There I was in eighteen inches of snow with acute pancreatitis but I finally found them and shipped them to him. They arrived on his wedding day. Those were the pair he wore. He had four other pairs of shoes that people had gotten him. Not even close. But I found them.

rev. matthew fox: The marriage was done in a small Episcopal chapel. Because it was to be kept secret from the press, it was a small, intimate ceremony, not very grand at all. After the ceremony, I actually did do a sermon in which I talked about the postmodern marriage. When it was all over, there was a reception at a club in Marin County.

gloria dibiase: The reception was in Sausalito at a yacht club. All the details were kept secret until the day of the wedding and then we were told where to go. The whole band was there. David Grisman was there. Jerry seemed happy.

carolyn "mountain girl" garcia: After that, I didn't see him much except at Rex Foundation board meetings.

hal kant: The structure of the Rex Foundation was my idea because for a lot of corporate and tax reasons, it was not appropriate for the Grateful Dead to give large sums of money directly to charity. The idea of the foundation was a mechanical concept. The idea of giving money was their idea. The band itself was always a minority on the board. They'd all have a lot of fun at those meetings because as I am the designated conservative in the Grateful Dead family, I was always questioning what they wanted and they were resisting what I wanted. Oddly enough, at the last meeting Jerry attended, we joined with each other on almost every item against everybody else. Trying to be more practical and I would say from his standpoint, a lot more conservative.

rev. matthew fox: I remember going to dinner with Deborah and Jerry after the wedding and he was just like a child. He had gotten a new telescope and he was so pleased to be setting it up and showing it to me. Like a four-year-old with a new toy. Then he took me over to his

computer and showed me how to paint on it. I had never worked with anything like that before and he was delighted when I started getting into it. Really, the joyous childlike side of him was remarkable. Especially considering how much else was obviously at work in his life. I'm fifty-five. The childlike joy that he had at fifty-three was remarkable. We discussed many things at dinner, theology beyond Catholicism, and I realized that this man was a philosopher.

gloria dibiase: Jerry needed a bigger place to live. He wanted four bedrooms and we looked at all these different places for five or six thousand dollars a month rent. They were beautiful places but we wanted to be a little bit more economical. This friend of mine, a real estate agent, said, "I want you to look at one more place." It turned out to be this incredible house on Audrey Court in Tiburon. High on a hill. Beautiful view. You could see part of the Bay Bridge, San Francisco, the Golden Gate Bridge, and Mount Tam. He was the king of the hill.

vince dibiase: He said, "Take it and I'll look at it next week." He did stuff like that all the time. We weren't buying the house. It was a rental but still, he did that all the time. He did that to me in the art business. I'd go and proof his art and do press checks and everything. He wouldn't come and do it so I would go up and do it for him. Then I would have to sit there holding my breath as he looked at it to let me know if he was going to accept the job or not. Usually, he did accept it.

gloria dibiase: Jerry loved the house. He wanted to buy it later on. According to Jerry, Jerry and Deborah were going to move in together at some point, which they never did. She kept her house in Mill Valley. Then he wanted to buy this place because he loved it very much but he couldn't.

42

clifford "tiff" garcia: By this time, I think he wanted to be straight but he was traveling around with all these heavy suppliers and it was hard. When he'd been with Barbara, Barbara was glued, man. They were together all the time. Every time I saw her, they were together.

bob barsotti: We were doing a Jerry Garcia Band date in Phoenix in May '94 and he was looking really really bad. It was our last date in this little swing of dates and he played the first set. He came off after about forty-five minutes and he went into his dressing room and he collapsed. Steve Parish went in and saw him and he said Jerry looked like he had when he went into his coma. The same look on his face and the pale skin. Steve said, "Bob, he has to go." I said, "Let's send him to the hospital." "No, he wants to fly home." "Why don't you just take him to a hospital?" "No, no, no. He wants to fly home." Steve had the pilot call every town on the way to make sure there was an ambulance number or a doctor on call there. They had a private jet so they flew him home and then it took a good day or two before he actually went to the doctor. He wouldn't go.

vince dibiase: Gloria was at Jerry's house in Tiburon when he came home after walking off stage in Phoenix when he got sick. Gloria called me and said, "Vince, Jerry doesn't look good." I remember going over there and he was wheezing badly while he was trying to breathe. We got Randy on the phone.

dr. randy baker: In the spring of 1994, he started developing problems again. He had a recurrence of his diabetes. And so I worked with him a lot in 1994 trying to help him handle his diabetes, working

with medication and herbs and diet and lifestyle. I even created visualizations to help him with the diabetes.

vince dibiase: The following day, he was supposed to go to Ireland with Deborah. She hadn't seen Jerry yet because she had not gone on that Jerry Garcia Band tour. I think she stayed to go to George Lucas's fiftieth birthday party, which really upset Jerry a lot because he wanted her on the tour with him. I said to him, "You're going to Europe tomorrow? How can you go to Europe tomorrow?" I said, "You're going to come home in a box if you go, man. Look at you." He said, "No. I can't do it. I can't do it. I just can't do it."

Deborah went off to Ireland. We moved in with him in Tiburon and we stayed there for at least four weeks, just Gloria and I. He wanted us there to monitor him, which worried the hell out of me because normally he never complained. He wouldn't say things like that so I knew he was sicker than anyone let on.

Gloria's a night owl. She and Jerry would often cross paths in the wee hours of the morning. One time she was in the middle of a project in the kitchen and Jerry walked in and said, "What are you doing up?" Gloria said, "What are you doing up!" It was like, "Wait a minute. You're the sick one, Jerry. We're supposed to be monitoring you." He couldn't shut off. I think the use of drugs helped him shut it off. Because the creativity was there round the clock. It just kept on coming through him. It was almost a curse. And a blessing.

bob barsotti: We had to cut back on Jerry Garcia Band shows because he wasn't capable of doing it anymore. We had to keep canceling shows and stopping tours because physically he wasn't able to do it. That was why he used to play twenty times a year at the Warfield Theatre in San Francisco. The only place he could get it together physically to play with the Jerry Garcia Band was by getting in his car and driving for a half an hour to the Warfield. If he could do that, then he could play. But if it was any more than that, even like a San Jose gig or Santa Cruz, he couldn't deal with it. He didn't want to do it.

yen-wei choong: For almost one full year, he didn't get a treatment. I think in the fall, September '94, he was sick for some reason.

Then Vince, his personal secretary, called me and asked me to go there to treat Jerry at the house. So I been treating them almost every week. Until February '95, that was last visit. For the whole winter, I've been treating them regular. Sometimes at Garcia's house, Tiburon. Sometimes at Deborah's house in Mill Valley. It varied.

vince dibiase: Jerry had told me six months earlier that he'd met Bobby Kennedy, Jr., and that he'd agreed to do something with him. The idea of doing a Jerry Garcia-designed T-shirt for the Hudson River-keeper Project came down and Jerry was on tour. It came to deadline and I was getting a lot of trouble from other people around him who didn't want the project to happen. It came down to me actually giving them the okay to do it without Jerry's approval because we couldn't get through to him on the road. But if I didn't say yes on this one particular day, they were going to cancel the project and push it back at least two years. So I gave them an okay. Two days later when I finally got through to Jerry, he said, "I told you it was a done deal, didn't I?" There were people associated with his art business who were trying to stop this from happening in order to get me out of his art business. It was amazing because there was enough to go around. But they didn't see it that way.

dr. randy baker: We got to early 1995 and the diabetes was becoming progressively worse. Diabetes greatly accelerates the process of coronary artery disease. The single most important thing that a diabetic can do is avoid eating sweets and I was getting reports from people surrounding Jerry that he was eating lots of sweets. Now, insulin is a great drug but it's very powerful and potentially dangerous. If someone's using insulin, they need to carefully monitor their blood sugar and if they take too much insulin, it can kill you from insulin shock creating low blood sugar.

I talked with Jerry about using insulin. He wasn't particularly interested and I really didn't think he was a good candidate for insulin because he wasn't taking much responsibility for his health. The potential danger of his taking too much and dying was fairly high because he didn't want to monitor his blood sugar regularly. Frankly, I also didn't want him to become too comfortable with syringes. At the time, his drug use was primarily through smoking and I thought that was less dangerous.

vince dibiase: Randy had no control over him. Randy was a Deadhead. When Randy got near Jerry, he was a Deadhead, not a doctor. Because he couldn't persuade Jerry to do what he wanted him to do.

gloria dibiase: Randy wasn't persuasive or forceful enough to get Jerry to change his ways. But then nobody was. Jerry was bored, frustrated, and unhappy and he didn't want to try.

yen-wei choong: If you use cocaine or heroin, that can cause the toxic dampness and heat inside. Particularly the liver and the lungs. He had a great deal of dampness and heat. Acupuncture can reduce somewhat but more important is the herbs. I did send a lot of herbs for his heart, for his diabetes, but unfortunately, he didn't take. That was really frustrating, to be honest. I know he does not like the taste of the tea. I tried to order extremely concentrated herbal powder in the capsules. I told him many times, "You better take this." I left them there. I know he didn't take because when I come back three days later, it's still the same amount. Sometimes, I leave the herbs in both his Tiburon house and Mill Valley, which is Deborah's house. I did try my best because many many fans encourage me but he didn't take. I'm absolutely sure that can work but the patient must be very cooperative.

vince dibiase: The Chinese herbs were helping him when we could get him to take them but it was very difficult because he was a very difficult patient. An incredibly difficult patient but Yen-Wei would stick with him.

bob barsotti: In February '95, we had to cancel a Jerry Garcia Band show at the Warfield. Jerry had been on vacation diving and something had happened to his hand. I think what had happened was he had fallen asleep on it. He basically let it get to the point where the entire house was in, we'd all eaten dinner, the sound was in, everything was in for the show. It was five minutes to eight o'clock and this hand had been bothering him for two weeks and he knew it didn't work well.

Finally, Jerry went, "Hey, you know what? I don't think I can play." Steve Parish said, "Hey, Bob. Come here. Jerry doesn't think he can play." I said, "Come on." We went into the dressing and Jerry said, "Bob, something's wrong with my hand. I just don't think I can play." I said, "What

happened?" "I don't know. I got stung by a lot of jellyfish and I woke up funny on it one morning." I said, "So what do you want me to say? It was jellyfish?" He said, "No, no. I don't want you to say that. It just isn't working. I'm not feeling up to it, you know?"

We went round and round and I said, "You know what, Jerry? We sold the show as 'An Evening with the Jerry Garcia Band.' So why don't I just take a couple of couches, put them up on the stage, and we'll go up and sit down and shoot the shit like we do down here." He said, "Wow, that's a great idea. That would be really wild." I had no intention of doing this but I wanted to see what this was all about. I said, "No, I don't think that's a good idea because then you might get asked questions you don't want to answer," and he said, "Oh, yeah. Oh, yeah."

I said, "Do you think you'll be able to play tomorrow night?" He said, "Yeah, I think my hand will be better tomorrow night." We had Monday free. I said, "So why don't I just say that we'll take the Friday show and we'll switch it to Monday, and if you can't do it, they'll get a refund and I won't kick everybody out right away. I'll let them hang out." He said, "Yeah, that's a good idea." I said, "But I'm not going to do this until you leave." He said, "I'll just wait here." I said, "No, you got to get out of here now. It's ten after eight now. Let's not make these people wait too long before they know they're not going to get anything."

A long time ago, Bill Graham taught me something. When talking to an audience from the stage, use the star. Jerry was the star. So I went out and I said, "Jerry asked me to come out and tell you something. He went on vacation recently, he was doing a lot of diving, he injured his hand. It wasn't feeling right and he thought it was getting better. He's been working on it the last week exercising it and he really thought he was going to be able to play tonight. He came here and he tried to sound-check and it got to the point where he didn't feel like he could give as good a performance as he wants to give you. So he's asking if you can all come back on Monday night." Everyone went, "Oh, yeah. No problem."

I don't think his hand ever really came all the way back after that. The first few shows he did with the Garcia Band, it was kind of embarrassing. He couldn't play the notes. He was simplifying every solo way way down to the bare bones. Where there had been ten notes, there would be two.

justin kreutzmann: I talked to Jerry when we played Utah in February '95. I was with my girlfriend and we were at a sound check

and I heard this, "JUSTIN!" And I was like, "What?" I looked around and it was booming through the PA. The Dead had this new headphone system where they could talk to each other on stage but they had the speakers on. Jerry was talking to me from the stage but he was talking into his mike and he was like, "How did you let that Quentin Tarantino guy get ahead of you? He reminds me of a used car salesman." Booming over everything. Everybody was looking at me and I was just totally abashed. Jerry hated *Pulp Fiction*. I did, too. I thought it was a piece of shit. I couldn't get behind that movie at all.

dr. randy baker: As we got into the spring of 1995, I was acutely concerned about his health and I told him straight out that I didn't think he would be on the planet for very much longer if he didn't make radical changes in his lifestyle. One of the difficult things about working with Jerry was that he wanted to please me. I would say, "You need to do this" and he'd say, "Oh, yes. Sure. No problem," and then he wouldn't do it.

It was sort of my dream job. I wanted nothing more than to keep Jerry alive. It was also one of the most difficult jobs in the world. It was a supreme challenge. I would go to Dead shows and instead of enjoying the music, I would be thinking, "How can I get through to Jerry?" I would be worrying about his blood sugar. It became clear that it was essential for Jerry to stop eating sweets and to stop smoking and I felt that it was impossible for him to control those urges while he was using heroin.

harry popick: It was a strain seeing Jerry look the way he did. There were times when I'd be doing the monitors over by him and I'd just look away and close my eyes and say, "Oh, my God." I was waiting for him to fall to his knees. He could finish playing the first set, go back into his room there, and start snoring. He would conk right out. The fans knew. It troubled us all deeply. Everyone was shaking their head like, "My God. My God, what are we going to do? What's happening here?"

bob barsotti: He was just shriveling in front of our eyes. You could see it. He aged so much in the last few years and I kept going to these guys and they all kept saying, "We're doing the best we can." Maybe if Bill Graham had been here, he could have talked to him. Over the phone, I talked to David Crosby. I said, "You know, David, now is a

really good time for Jerry's friends to try to get close to him 'cause he's in trouble." He went, "Oh, yeah?" I went, "Yeah. He's in really bad shape. He really needs his friends to say something to him because the people that are around him are too tied up in the whole deal and it's hard for them to really articulate to him and have him listen."

David said something to me that really helped me get through my time. He said, "I went through all that too and every one of my friends came and talked to me. Then they came and yelled at me. Then they came and hit me over the head. Then they came and dragged me away to fucking institutes and you know what? I didn't listen to anyone until I was ready to listen to them. He won't, either. It has to be his decision. He has to come to that realization and I don't really want to talk to him before that because it's too sad. But, boy, I sure would love to be there when he comes out because I would love to help him."

Bill Graham was actually at one of Crosby's interventions. They got Crosby into the place for treatment and then he tied sheets together and escaped out the window.

vince dibiase: The last five years of his life, he didn't really hang out with anybody. He didn't like being bothered or going out. He was very reclusive. But he was being bothered by people, one in particular, and he did not even want to answer the phone but he would have to. He would have to return certain calls because some people were relentless with him. "Hello, hello, hello, hello. Are you there? Are you there?" "Yeah, I'm fucking here!" It was interfering with his train of thought. It was interfering with *Harrington Street*. It was the first time he'd tried writing in his life. It was something new for him and he started getting off on it. He'd found a groove. He had to do it by hand because the computer keyboard was much too linear for him. Just to get his password in took forever. He'd take pains typing it out with one finger and then he'd realize it had to be in capital letters.

One day, he sat me down and he stuck a big paintbrush in my hand and said, "Hold that." As he was sketching my hand, he started talking about when he was a kid. He and Tiff would play with fire and they'd set fires in the hills. He said that one day they got into throwing rocks and breaking windows. He was about five. Tiff might have been eight or so. He said, "Yeah, we broke a whole bunch of windows." I figured he meant three or four windows. He said, "We were standing there for at

least half an hour breaking windows." "How many windows did you break?" "Sixty or seventy windows." I said, "You're kidding me. Was it an old warehouse?" He said, "It turned out to be the back of a police station." The cops finally came out, picked both guys up, threw them over their shoulder, and took them home. Kicking and biting and screaming.

john perry barlow: The last interaction I had with Jerry was interesting. I was teaching Weir how to Rollerblade. We were staying at the Four Seasons Hotel in New York. Having gone through the great neofascist marble hallways of the New York Four Seasons on roller blades, Weir and I went through the lobby and came out the door and Jerry Garcia was standing there in the sunlight.

It was the first time I'd seen him in the sunlight in I don't know how long. He was totally white. White as death itself. He was like a Fellini vision or something out of Ingmar Bergman. This incandescent paleness. I don't think this is a retrospective overlay because it really was apparent at the time. The frailty and the whiteness of him. He looked up at us and he snorted and he said, "If you guys get killed out there, I'm not going to your funeral." I said, "I don't know. I've been to funerals with you where we were there for less." He said, "But I won't go to yours." And I said, "Jerry, I'll go to yours." He said, "Fine. Do that." Off we went to the park where we had a truly psychedelic kind of experience.

vince dibiase: Before the spring tour in '95, Jerry was in bad shape. The morning he went on spring tour, his blood sugar level was five hundred.

gloria dibiase: We were talking to his doctors. We were talking to band members about Jerry's deteriorating health. Jerry didn't like us talking behind his back. Like a child, he didn't want us to tell on him.

vince dibiase: He considered people alarmists if they talked about his health to others. The thing was that I didn't want to walk into that house and find him sprawled out on the bathroom floor dead. I'd rather have been out on the street with my family without a job and have him alive and recovering than have him dead. Once they were out on the road, I told Randy. I said, "Randy, does anybody know?" He said, "No." I said, "Don't you think you better tell somebody because I'm not a

doctor." Randy FedExed to Jerry and I don't know what the response was. They continued with the tour and Jerry seemed to get better while he was on the road but he still wasn't doing well.

eileen law: The kids at the shows would say, "Yeah, I got a feeling he's slipping again." It was scary to me because there would be that small percentage at the shows who I was sure would say, "He does it. So it must be cool." And we were starting to have some ODs out there on the road. Jerry would come into the office and because I knew things weren't good, instead of going up to him, I would almost run to my room. I read this wonderful article where in 1969 this one kid had yelled up to Jerry, "Hey, Garcia! Get your ass in gear!" I almost wish someone had yelled it in the last three years.

vince dibiase: Jerry suddenly began making life very hard for me. He would give me impossible tasks to do at the computer. He was pressuring me a lot. My feeling is that he was being pressured to get rid of us. Before the spring tour, he got rid of Yen-Wei, who was his lifeline. Yen-Wei had revived him those two times back in '92 and '94. But Jerry was getting really intense, real snappish. His blood sugar level was running wild. He said to me once, "You know, you make a fucking lot of money. You make a lot of money for a pretty good job. You got a great job. What do you do?" I said to myself, "This is not him speaking." He was paraphrasing what someone else said to him. I knew that. Because he never talked to me that way, ever.

gloria dibiase: We loved Jerry. We worked for him around the clock. We were on call. Whenever he needed us, he'd call us up at all different times of the day and night. If we weren't there in the house, we'd rush right over to see him. We dedicated ourselves to him. We were with Jerry almost full-time. We stayed at his house from early in the morning until late in the evening until he told us, "Okay, you can go home." Two or three days a week, we'd sleep at the house because he wanted us to stay there. He didn't want us to go home. He liked having us there.

vince dibiase: We watched him go downhill. You know it when you see somebody every day. He aged so rapidly. He got grayer. He was

not remembering. His face looked terrible. He was stooping more. He was tired more. He was really frustrated and so he was eating a lot more junk food and fatty food. He was smoking a lot. He was doing everything to excess. Extremely excessive.

gloria dibiase: We started with him with Manasha taking care of Keelin. Taking care of the Palm Avenue house, odd jobs, errands, personal stuff for Jerry, the art business, and then we were doing everything for him in his home after Barbara left. He would tell us that he loved us and he appreciated all that we did for him and thank us. When I wasn't there to take care of Jerry because I had to go to New York to visit my family, my daughters would go up to his house and do what I did. Cook his food, make his juice, his salad, his grains, clean up the house, shop for his clothing, and do his laundry.

Vince and I were fired on Cinco de Mayo, '95. I was devastated because I loved Jerry very much and it hurt. I felt like I was his mother. He was like my son. My family life was suffering because I was putting a lot of time and attention into Jerry's life. So when we were fired, I cried and cried. We went to his lawyer's office. We were sitting there and he told us we were fired and then he handed us a piece of paper to sign. We would get severance pay, we didn't know how much, if we didn't talk about anything. If we never wrote a book and we handed over everything we had relating to Jerry.

vince dibiase: No interviews. No talking about Jerry. Return every picture, every tape, every anything you have of Jerry's, and it was not a nondisclosure agreement. It was a confidentiality statement they wanted from us. It was not as though we had signed anything like that going in. This was taking our freedom of speech away.

gloria dibiase: I tore mine up and threw it on his desk.

43

dr. randy baker: One of the problems in working with Jerry during this time was that I would come see him with the latest set of blood tests I had done and the tests would look awful. His blood sugar was really high and his cholesterol was high. He had all sorts of things out of balance and the average person who had those labs would be feeling awful. But Jerry would insist to me time and time again that he felt perfectly fine. I think he did feel fine. But I think it was because of his use of heroin. It numbed him and made him not in touch with his body.

One of the things that motivated him to finally address his health was that he started to have some tingling and numbness in his fingers that was interfering with his ability to play the guitar. I think that was directly related to his diabetes. His body was finally speaking to him in a language that he understood. "If you don't improve your health, you're not going to be able to play." In the spring of '95, other people and I finally got through to Jerry. He really got the message then. It was decided that after the Grateful Dead's summer tour, he would do an intensive program to get off drugs and stop smoking and clean up his diet.

sue stephens: Jerry would complain about having to play these big places where the kids were getting busted and he said that he didn't want to go out there and be a shill for the cops. It upset him. He would have preferred that they didn't have to go and play these same places over and over again. He did voice his concern that it had no dignity for him anymore. These places like Nassau Coliseum that were famous for busting people. Garcia would say, "God, you guys. Why do we have to go back there again? Are we broke?"

When he came back from a tour, he'd still be walking around with his shoulders up in that stance. "Waiting for the next thing to hit him," as he would put it. In that sense, he would have to medicate himself. He

was working. He was trapped in the routine of going from the gig to the hotel and it was not great. When he was up on the stage playing, he was safe. But he always did say that he wanted to work. He'd say, "I need to work."

bob barsotti: Everything was not cool in Grateful Dead land and I spent quite a bit of time talking to their manager about how tough it was going to be out on the road this summer. Things were going to be different in your parking lots this year than they were last year. Radically different. It was a cumulative effect of their success and the fact that there was so much money in the scene outside their gigs.

Because the segment of society who came to see them was pretty broad, you had a lot of people and made a lot of money. It was also vacation time. You go on vacation, you take a thousand dollars with you to spend. That's what people do when they're on vacation. These people were taking their vacations around these gigs. They were spending all of their disposable income in the parking lots. It became this economy and there was so much money involved. It was real easy to exist out there on nothing and it was real easy to take advantage of people and through that door came these masses of our society.

Part of the reason that the parking lot scene got so big was that the Dead worked often enough that in between shows, the hard-core Deadheads could survive until the next gig. The other thing was that the Dead would play three or four gigs in one town and then take a couple of days off and then do three or four gigs in another town. So it was real easy to follow them.

I'd talk to all these dreadlocked kids out in the parking lot and most of them had grown up in suburbia. Their parents were never home and they'd been neglected their whole lives and there was nothing to their suburban lives. They wanted to eschew all materialism and go on the road with their brothers and sisters and stay high all the time and fuck whenever they wanted and not worry about AIDS because Jah would provide. Over the years, I spent a lot of time in the parking lot. But in the last few years, it got to where I couldn't go out there anymore. It was such a low-life kind of scene that it made me too sad to be out there.

robert greenfield: In June 1995, those on their way into the Bob Dylan/Grateful Dead show in Highgate, Vermont, had to make their

way past unconscious fans sprawled in the dirt around tanks of nitrous gas. As Bob Dylan played before the Dead took the stage, ten thousand fans without tickets stormed the fences and tore them down, turning the concert into a "free event." Five Porta-Johns actually in use at the time were knocked over. Many people were injured. Many more were drunk. Inside the venue, even as the Grateful Dead played, hundreds of people who had gotten too high to hear any form of music but their own lay passed out in the dirt.

cassidy law: I hate labeling but on the summer tour, I definitely saw the difference between the people my age, which is twenty-five, and the younger ones, who just really didn't care about anyone or anything. They were not Deadheads. They just wanted to be there for the scene. They didn't care about going inside. They wanted a free ticket. Everybody that was high was trying to crash the gates to try to get in free.

bob barsotti: I saw it coming. So I did double fences everywhere we went. I spent ungodly sums of money on police and security.

gloria dibiase: It was a tour from hell. I called it the "hell-in-the-bucket tour." So many bad things were happening all over. The last three months were really bad.

bob barsotti: Jerry must have known about the scene outside the halls. He had to. He drove through it every night. But Jerry was a leader who refused to be a leader and that was a problem.

chesley millikin: Going out with the Grateful Dead wasn't a lot of fun to Jerry anymore. He admitted that to me and it was less so on this last tour, "the tour from hell" as they referred to it. I think that really disturbed him. He was a very mellow man. He was strictly pacifistic. So for any kind of unruliness like that to come out, I can see him saying, "Fuck it."

robert greenfield: In their thirtieth year on the road, the Dead ran into more problems on July 2 in Noblesville, Indiana, at Deer Creek Amphitheater at what was meant to be a benefit concert for the Rex Foundation. Before the first of two scheduled shows began, a threat

was made on Jerry's life. Security guards were moved from the perimeter of the venue to protect the stage. This left a large section of fence unguarded. In order to make it easier to protect Jerry, the house lights also remained on during the Dead's second set. This enabled one and all to clearly witness the unscheduled mayhem which then occurred.

vince dibiase: We heard about the threat on Jerry's life. Supposedly, two guys were packing guns. The call came into the police department in Deer Creek. One guy called up and said, "Look, I can't live with this anymore. I know that these two guys are coming to the show with guns and they're looking for Jerry and they're going to shoot him." The cops took it as a real threat. They did the gig with all the lights on. The front row was all undercover agents with their tie-dyes and bulletproof vests on.

sat santokh singh khalsa: Many years earlier, Jerry told me that he felt like people wanted to kill him because he didn't deserve to be doing what he was doing. He said he felt he was playing for his life and he said he felt that way for many years afterwards.

vince dibiase: Jerry used to like to play games like people were chasing him or going to kill him. He had to play really good or else. He'd play games like that in his head. He liked to be scared. Because nobody could scare him in his whole circle. But he was really scared that night.

cassidy law: Deer Creek has this parklike setting all around so it was really appealing for everyone to come and hang out. When we drove up there that night, we knew. We went, "Oh, boy. Fourth of July weekend." People were definitely drinking and they had that really rowdy feeling about them. We were starting the show and all of a sudden, I looked over and there they were. Masses of them. Just masses of them rushing the doors and they broke through. They were tearing the gates off in the back. It was frightening. I was in this little tiny trailer right in the middle of it all and I went, "Okay, I'm gonna have faith here." Everyone was going, "Lock down! Lock down! Don't leave."

The band could actually see what was going on from the stage. They could see the dogs that the police around the facility used for security being let loose on people. You could hear the dogs barking and the whole

thing was pretty scary. The kids who had broken in kept it up and kept it up. They kept fighting with the police. People were hurt because all of a sudden, they were crammed in front of the stage. We had to cancel the next show on the tour. We knew it had come to a point where something had to be said. We'd done lots of leaflets that we'd handed out before saying, "Hey, don't tread on us anymore." In this one, we just really pinpointed it at them by saying, "This has gotta stop." It went out a couple of days later.

robert greenfield: Signed by Billy Kreutzmann, Jerry Garcia, Phil Lesh, Mickey Hart, Bobby Weir, and Vince Welnick, the letter sent out by the band read in part:

Don't you get it?

Over the past thirty years we've come up with the fewest possible rules to make the difficult act of bringing tons of people together work well. . . . We've never had to cancel a show before because of you.

Want to end the touring life of the Grateful Dead? Allow bottle-throwing gate crashers to keep on thinking they're cool anarchists instead of the creeps they are. . . .

. . . The spirit of the Grateful Dead is at stake and we'll do what we have to do to protect it. And when you hear somebody say, "Fuck you, we'll do what we want," remember something:

That applies to us too.

Three nights after Deer Creek, the Dead played at Riverport Amphitheater outside St. Louis. Grateful Dead fans without tickets trying to escape a rainstorm sought shelter on the second story of a pavilion at a nearby campground. When the structure collapsed, a hundred and fifty of them were injured, some critically. As the news media reported the story nationwide, St. Louis became yet another fire-scorched pit stop on the tour from hell. The Dead moved on to do the final shows of the tour in Chicago's Soldier Field, a concrete mausoleum far more suited for the Chicago Bears, the city's very own Monsters of the Midway.

cassidy law: We were in Soldier Field and I think that place holds about fifty or sixty thousand. We'd sold it out and it was packed. Besides the band playing, the light show definitely helped make it easier

to get into being at a stadium. But it was a concrete jail. After the show on the last night, I was in the van with Jerry and he was happy as could be. He was saying, "Hey, this is great. Let's keep going. Let's go for it." He knew it was the last show of the tour but he was saying what a great time he'd had at those two shows. We were watching the fireworks we did over the lake after the show and that just topped it for him. He was like, "All right. This is perfect." He was in a very good mood that night.

bob barsotti: We had a big Jerry Garcia Band tour scheduled for November '95. It was this perfectly routed tour of all the big buildings in the Midwest. It was going to be a huge tour and I did it early enough so I got all the right dates lined up. I kept telling all the promoters, "You've got to hold the date." They kept asking, "Is it confirmed?" "No. It's not confirmed but you've got to hold it." Finally, they were all saying, "Look, man, I moved hockey and basketball teams off these dates," and I leveled with them. "You saw Jerry on the last tour, right? After the summer tour, if he's in the shape to do it, we're going to have it and if not, we're not and I can't give you anything more than that." Every place said, "No problem. We'll wait." Because they all wanted Jerry, they held off everybody to hang on to those dates. Then as we got about halfway through the summer tour, Steve Parish said, "No, you got to cancel the dates. He can't do it." That was when Steve finally said we couldn't be taking him away anywhere.

robert greenfield: On January 19, 1995, Jerry Garcia lost control of the red BMW loaner he was driving while his own BMW was in the shop being serviced. After slamming several times into a retaining wall alongside the northbound lanes of Highway 101 between the affluent suburban towns of Mill Valley and Corte Madera in Marin County, the car spun around and finally came to a stop facing oncoming traffic. Although no one was injured and the accident itself received only minimal coverage in the press, it was not a good sign. Those who knew what was going on in Jerry Garcia's life could only wonder what would happen next.

cassidy law: The accident Jerry was in on Highway 101 really put a scare into everyone. He smashed his car into the divider. He was

very lucky. It had come to the point with him where so many little things kept happening that we got numb and irritated and kind of went, "Ah, man. What next?" Then all of a sudden you realize, "God, that's horrible. Is this how we feel about him now?" It had more to do with that we loved him so much that we didn't know what to do anymore.

Any Other Day

See here how everything
lead up to this day
and it's just like
any other day
that's ever been
Sun goin' up
and then the
sun it goin' down
Shine through my window and
my friends they come around.

—*Robert Hunter, "Black Peter"*

Such a long, long time to be gone
and a short time to be there.

—*Robert Hunter, "Box of Rain"*

44

dr. randy baker: I visited Jerry right after he got back from the summer tour before he went down to the Betty Ford Clinic. I made a house call to check in with him and give him support and encouragement. He looked very clear and he was very positive and he had a great attitude. He really wanted to do this. He was ready.

len dell'amico: Normally, Jerry was a guy who really hated to talk on the phone. The phone was just to set up dates. I called wanting to ask him when could we get together but he wanted to talk and we ended up talking for half an hour covering not work but emotional stuff. He told me that he'd really enjoyed working with me and that we were going to be working together again soon and how much fun we'd had. When the conversation was over, I said, "So when are we going to get together?" and he said, "Not soon. I'm going to Betty Ford." I was struck by that because he had never admitted that others could help him but I was fast on the rebound. "That's great," I said. "Go for it. There's so much we can do and so much in life to look forward to and you've got all these possibilities."

jon mcintire: Why would he check into Betty Ford? Let's say you had a straight line and that was reality. At a certain point with using drugs, you can't get high anymore. You are below the line of what it was like to just be alive with your old natural feelings. When you clean up, you can start getting high again. There was that reality of the chemical interaction in his body. And then there was the desire to grow and do better—salvation is one word for it—and then there was the desire to trip himself up, the lure of failure. All these things were going on. But if he was not honest with himself, if he was not really looking at what was happening, if he was hiding from his own interior pain and confusion,

then he was not going to be able to tell the truth about himself. He was not going to really know *why* he was going into Betty Ford. Because he just didn't know himself that well.

vince dibiase: One of our friends, a Deadhead, told us that their friends shared a room with him at Betty Ford and he kept on getting sick and they were feeding him phenobarbital, which from what I understand is not the drug of choice when someone's addicted to heroin. It doesn't mix with heroin. Randy, or whoever his doctor was, should have been forceful enough to stop him from going there. They knew how Jerry was—Jerry wasn't going to be locked up anywhere on his birthday. He wasn't going to let that happen. He was going to go out and party.

dr. randy baker: The Betty Ford Clinic itself was Deborah's suggestion. She had known people who had gone there and they were very impressed with the program. I really didn't see Jerry at Betty Ford and I advised against it. I proposed that he try to detoxify himself by using acupuncture, nutritional therapy, homeopathy, and brain wave training, which is a form of biofeedback. Then after detoxifying, he could have gone to Betty Ford for counseling. However, Jerry chose to go there directly after the tour. It is a good program and I supported his decision.

So he went down to Betty Ford, which is normally a four-week program. At the end of a couple weeks, he called Deborah with a request to leave. She asked me what I thought about him leaving and I agreed that it was appropriate. The reason that Jerry wanted to leave after two weeks had very little to do with the drug treatment program they have there. It had everything to do with the fact that now that Jerry was off heroin, he was really in touch with how bad his own physical health was. He was in a lot of difficult discomfort and he was unsatisfied with the medical treatment that he was receiving. He was having aches and pains and just feeling bad and they sent him to the local emergency room and the doctors there gave him prescription drugs that he was wary of. He was actually concerned for his life so he had to get out of there.

carolyn "mountain girl" garcia: I heard Jerry had been in Betty Ford and we were elated. We thought this was wonderful news. It was a very hopeful moment. "Oh, he's at Betty Ford. Great. Maybe he's really going to take this thing by the horns now. At Betty

Ford, he's got a chance of winning it." Then we heard he'd bailed out of there and I was going, "Oh, heck." It was good of him to try. It really was. But it was too late. His time to go do that was years previous. He waited until he was out of energy.

chesley millikin: He was not a disciplined man and Betty Ford is the ultimate in discipline. I spoke to Deborah and she and Parish were going down to see him and he did not like it and he didn't like the food. It was too hot and humid for him down there and he wanted out. By the time that came about, he was clean. He had been there for two weeks.

dr. randy baker: Steve Parish and Deborah went to get him and I saw him that very night. Once more, I did a house call. I came up and checked him over. Emotionally, he was in a very good space and he had a lot of good things to say about the program and the people that he'd met there. He had done a lot of emotional work and he seemed to be basically happy in general with that aspect of the treatment. But he was not feeling very well physically. Unfortunately, this happened at a bad time for me in that I was scheduled to get married the following weekend and go off on my honeymoon. I said to Jerry, "I want to delay my honeymoon so I can stay and help take care of you and work on your health." In true character, Jerry insisted, "No no no, don't postpone your honeymoon on account of me. I'll be fine."

gloria dibiase: When he came home from the Betty Ford Clinic, a friend of ours saw him in Whole Foods in Mill Valley on Sunday morning. He went straight over to the juice counter. I used to make him fresh carrot juice, fresh apple juice, fresh lemonade with maple syrup rather than regular sugar. So there he was at Whole Foods buying juice. Right next to the juice counter was the bakery counter. My friend said Jerry was very spacey and confused and that's a symptom of low blood sugar. He was buying baklava and all other kinds of sugared desert treats. My friend said, "Oh, I'm feeling a little spacey and confused myself. So welcome to the club." He said, "Yeah but I don't want to be in that club."

dr. randy baker: I set Jerry up with one of the finest physicians in the entire country who works in San Rafael so he could get good

holistic medical care during the time that I was away. I was using nutritional supplements, herbs, and homeopathy on Jerry. I could have given him some medicine for the pain but the problem was that we didn't want to use narcotics, and many of the other pain medicines might tear up his intestines or stomach.

chesley millikin: As soon as he got out of there, he went straight to one of his connections or so-called friends and did it. I can see that because I think that he could say, "I've got it whipped now but I'll do it anyway."

dr. randy baker: My understanding is that during the next weekend, Jerry did do a little bit of heroin. He used it not because he was jones-ing in the traditional sense but because he was in so much physical pain that he was trying to self-medicate. He was trying to heal his pain. But he wasn't comfortable with that. He definitely did not want to go back to his addiction. That was why he wanted to go into another treatment program to make sure that he didn't relapse.

sue stephens: He spent a good hour and a half in this office with me the day before he checked into Serenity Knolls. In his own words, he was in the frame of mind that he was "definitely taking a big bite out of this apple this time." He had come out of the Betty Ford place because he had gotten as much out of there as he felt he could. He had been between the two places for almost a week but he said that he still felt a little shaky and his willpower wasn't up to par yet. He wasn't strong enough to be out on his own. So that was why he felt that he needed to go back into some place close.

dr. randy baker: What Deborah told me was that during that weekend, Jerry said to her, "My body's shot." I think his body had been shot for a while. He just hadn't been in touch with it because of his addiction.

sue stephens: He looked thinner and a little pale but he wasn't dragging his feet by any means. He was in real good spirits but he did say that he could tell how his body had aged because I guess that was something you didn't notice when you were medicated. It was really nice

322

sitting here visiting with him. I had this new Deadbase book that had just come out and he was sitting here leafing through it and coming up with comments like, "Oh, I remember this gig and this and this happened." He was reminiscing. A couple days before then, he'd called me to get people's phone numbers. He asked me for Hunter's number, he asked me for the number up at the new studio because I don't think he'd ever been there yet, and for John Cutler because he was handling the studio, and for Steve Parish's home number. Not that he didn't have it. But he seemed to be busy. He may have been calling people to say goodbye. More or less in a parallel-reality way.

justin kreutzmann: I don't think Jerry felt he was done. Not from what I've heard talking to people who were hanging out with him the day before he checked into Serenity Knolls. He didn't strike me as that kind of guy. If he didn't hear it when he went into the coma the first time or when he got saved the second time, I don't see why he'd have been hearing it then. Someone I know talked to Jerry about four days before and he spent an hour and a half on the phone just laughing. Jerry wasn't ever one of those kind of guys who would say, "I'm going to die tomorrow." He wasn't a doom-and-gloom kind of person.

len dell'amico: There's no question in my mind that he called certain people or had long personal face-to-faces with people for the express purpose of saying things that needed to be said. That's not easy. But it's not uncommon.

alan trist: I was lucky enough to run into Jerry at the Ice Nine Publishing office. Just he and I one-on-one. He was waiting for a Rex Foundation meeting that was going to go on upstairs and we had an hour together. In retrospect, I feel that he was doing the rounds. He really talked to me and I could hardly get a word in edgewise. I got this feeling that he knew what was going on. He was also trying to make connection with Bob Hunter, who had a phone call from him that same day. What he talked to me about was his book. He told me the whole story of *Harrington Street*. I had brought with me the page proofs of Paul Foster's book that Hulogosi was publishing. I said, "You want to see some of this?" He said, "No, I haven't got time for that now." And it wasn't a put-down on Paul. And I said, "What are you doing, Jerry?" He said,

"I'm writing a book." And I said, "What's it about?" And then he launched into this forty-five-minute rave about it. He told me the whole story. It occurs, he said, between the ages of five and eight years old. That is the frame.

Jerry certainly mentioned to me that the fact that he didn't grow up with a father in his immediate family made him who he was. He definitely pointed to that influence, or noninfluence, as being significant as to how he viewed himself. His grandfather was the male figure substitute in some way but he was not really present and he had this face that was disfigured by cancer. These are heavy images and deep.

While he was talking to me in that hour about *Harrington Street,* I had a strong feeling that there was something about Jerry that was different. He always did this thing with his hands when he talked but he was like *mudra*-ing to me, really close up and intense. When I look back at it, and it's so clear to me even now, the expression in his eyes and the animation in his face and the enthusiasm of his voice, my feeling is that he was trying to get out something before he died, that he knew he didn't have long. He didn't have long and he *had* to do this. There was no sense of regret that he was about to die or of guilt for having created the conditions for his own death. Not at all. It was just, "I've got to take care of business now and get this stuff out."

That was who he was. He was just the same as when we'd sit at Kepler's and he would be playing the guitar and looking at me and I'd be reading and talking and he would keep playing away, never stopping, just smiling. He was the same person when I saw him last as he was then.

sue stephens: Jerry told me he was going to spend twenty-one days at Serenity Knolls. He was going to do the whole thing. He said that he had picked that place out because it was an old Boy Scout camp that they used to crash at in the old days. It was some place that was familiar to him. When he left here that day, he stopped and gave me the biggest bear hug. If you ever got to hug Jerry, it was the best. It was like hugging Santa Claus. That was just how it must feel. He gave me one of those big bear hugs and told me to take good care of myself.

owsley stanley: The guy had had a diabetic collapse and obvious heart problems. The fact that he was allowed to check in alone into a place like that one without anyone getting his medical records or doing

a complete examination, including a cardiogram, I find that very difficult to understand. It just doesn't seem right. Everyone in their own mind is immortal, I guess.

justin kreutzmann: Apparently he drove himself up there and he checked in and he was only there for a couple hours. They said he was making some really awful breathing sounds but he always talked in his sleep and he had a voracious snore that could, no pun intended, wake up the dead. They have these rooms called the sick rooms where you first check in just to make sure you're mellow. It's not a medical facility so it's not really set up for emergencies. They said he was talking in his sleep and making some horrible breathing sounds. At about one in the morning, he came out and went into the bathroom. The people who were watching him said, "You need anything?" and he said, "No." He went back in and they didn't hear anything so they figured he was fine. They found him a couple hours later and he was cuddling an apple like it was a baby with a smile on his face. By then, he'd been dead for a few hours.

dr. randy baker: The cause of death was coronary artery disease, which was greatly worsened by his diabetes. I think that the two things that killed him the most were cigarettes and sugar. Heroin played a role indirectly in that while using heroin I believe he really couldn't get a handle on controlling the urge to smoke and eat sweets.

justin kreutzmann: I've seen the autopsy report and he had like eighty-five percent blockage in three of the major arteries and then finally when you check the very last page, they said there were slight traces of heroin in his system. To me, it was the kind of dose you take just so you won't get sick. He didn't die of an overdose.

sandy rothman: I read very carefully the reports from the staff members there and they are not a medical facility and the staff is not medically trained. I don't think he heard loud snoring—I think he heard the sound of the apnea. I'm not saying the apnea killed Jerry but it may have been the immediate cause of breathing cessation.

dr. randy baker: Jerry did have some degree of apnea, which once more was strongly related to his weight. When his weight was high,

he had more episodes of apnea. When his weight came down, the apnea got better. He died of cardiac arrest. Some people will have warning time. Some will have chest pains for years before they have a heart attack. Others will not.

The most likely way for Jerry to die would have been from something sudden. I think he might have been able to rally and recuperate from anything that was lingering, in part because of the number of people who would pray for him when he was ill. Another thing I want to make clear is that Jerry really was doing his very best to get healthy. He wanted to stay on this planet for many more years. He had a lot of plans and projects and he was finally doing what he thought he needed to do to get healthy.

In retrospect, you could think why didn't I or other people around him apply more pressure? Why didn't we coerce him into getting treatment at a sooner time? To me, that just went against everything the man stood for. What he valued most was freedom and the liberty to find his own way. I didn't feel it was my role to try to coerce him into a treatment program. I didn't think a treatment program was likely to work until he was ready to do it.

I wanted to repeat all the cardiac testing that summer. The plan was to first have him come off the drugs and then repeat all those tests before the Grateful Dead's fall tour. Would Jerry have passed those tests with that kind of blockage? Probably not. I might have recommended an angioplasty but it is of limited value in people with widespread blockage. I don't think he would have gone for it. I don't think he would have been a good candidate for open heart surgery and I don't think he would have put himself through that. With his severe lung disease and diabetes, I would not have thought that he would have had a very good chance of making it through that surgery.

Instead, we would have tried to put him on a program aimed at controlling his diabetes. Exercise and following a low-fat diet has been demonstrated to reverse coronary artery disease. Would he have ever been able to tour again? Not for a long time at least.

45

sue stephens: We used to get the news all the time that Jerry had died. Somebody would hear it on the radio somewhere and there would be a flurry of "Oh, God" calls. Once I picked up the phone and called Jerry's home and he answered. I sort of stammered and I said, "The reason I'm calling is because this news was on the radio." He said, "No. I'm sorry. Not yet. Don't want to disappoint anybody. But nah. Sorry." This happened so many times before the morning when it was true that even Dennis McNally thought it was a rumor from the previous tour. To me it was like, "Oh, here we go. It's just these silly rumors again." When I heard that the sheriff's department had confirmed it, that was when I knew.

vince dibiase: I called Dennis McNally. I said, "Dennis. What's up?" He said, "Just L.A. hype. Just L.A. hype." I said, "Are you sure? Has anyone talked to Jerry this morning?" He said, "Well, no." Gloria said to me, "Honey, call Jerry up. Call Jerry up." I called and I got his answering machine. "Jerry, if you need us, we'll come over...." We were going to go over there so we got in the car. We were getting lots of phone calls but we got in the car because we were in total denial. We got in our car and we started heading over. As I turned on the radio, it came on.

bob barsotti: When I got the call about Bill Graham, that was a shock. That was really unbelievable. Whereas the call about Jerry was, "Oh today's the day." It didn't make it any easier. But it made it a little different.

sue swanson: Mickey Hart said it best the day that Jerry died. I looked him in the eye and I said, "You all right? How you doing? You okay? I know this is going to be really hard for you, Mickey." He said,

"I don't have to wait for the call anymore." My mom died this year and it was one of those things where it was really a blessing. I knew that call was going to come and that call came and then this call came.

clifford "tiff" garcia: Jerry's death was tragic but not a shock. It was sad that events turned out the way they did but he could have died in some hotel on tour. Or from heat exhaustion because they always toured the East Coast at the hottest time of the year and it was always harder for Jerry because he was overweight and in bad condition.

cassidy law: So many of us were just happy that if it was going to happen this way, at least we didn't find him in a hotel room. At least it didn't happen in a plane or in his car.

sonny barger: The bad thing about when people die is it leaves everybody else all fucked up. They're gone and it's no more a problem to them. It's just sad for everybody that's left. There'll never be another Jerry Garcia.

john perry barlow: I'd just come back from New Zealand and I was in Salt Lake City. I was swimming in my mother's swimming pool and I was totally totally toasted from jet lag. I was floating around like a dead body and for some reason, I suddenly started thinking real strongly about Garcia and the Dead. In this completely mercenary way, I was thinking, "You're doing well enough now so that it would be sort of okay if the Grateful Dead went away. You would be all right financially." Then I thought, "Why would the Grateful Dead go away? Because Garcia would die." That was a whole 'nother issue.

I went over to the cliff and looked off into the abyss again for the kazillionth time and it was different this time. It felt different and I thought, "Never mind the Grateful Dead. Isn't it going to be a drag not to have those wonderful light conversations? The Inner Galactic Olympics of the Mind you used to have with this guy?" Then I thought, "On the other hand, when was the last time you had one of those? You haven't had that kind of conversation with him at any point in the last two years and you probably never will again." Because he was down in there this time.

rev. matthew fox: I heard about his death and I called Deborah that very day. Just to see if I could be of service to her.

john perry barlow: It was like something I said to Garcia at one point when he first started using the MIDI system. He did this guitar solo that was so much like Miles Davis, as Miles Davis wanted to be. It was unbelievable and I came up to him afterwards and I said, "Man, you could have been a great fucking trumpet player." He said, "I *am* a great fucking trumpet player." He could honor the music in himself. He saw that as being an independent entity that he was perfectly willing to accept and honor but all of the other large independent entities in him, he wasn't willing to accept and honor. Like the soul which camps out in the body.

For him, the body was just this thing that had been put on him like an electronic manacle. It was the thing in which he'd been exiled from all the sweetness and the light. For him, it was like being in prison. He always hated his body. It was the thing that he was locked inside and he treated it accordingly. Just like a prisoner, he put graffiti all over the walls. He broke the toilet. He literally set the mattress on fire. It may have been no way to live. But if it weren't, then there wouldn't be so many other people doing it that same way. The other side will have its way. If you're going to manifest a lot of light, you've got to pay the bill.

rev. matthew fox: I was upstairs at the Grateful Dead offices with Mickey Hart and other members of the band and it was very chaotic. People were talking about how we would do the funeral and where it would be held when news came that President Clinton and Vice President Gore had eulogized Jerry and everyone was very moved. The band started talking about how it had been when they'd visited the White House. Right then and there, they were already discussing whether or not this might be the end of the band. People were saying, "It's over" while others were wondering if they could carry on. They talked about Jerry's father drowning before his eyes when he was a boy and how that had been the absolute transformative experience in his life.

alan trist: I went to the office as people were collecting and there were film crews on the corners outside. Inside, there was a lot of hugging and the kind of humor that occurs when people have been in that place of expectancy. It was not black humor but it was close to that. A lot of

very funny things were said which were essentially tender loving reminiscences of Jerry.

rev. matthew fox: I supplied them with a list of churches and then band members went out and looked at them. St. Stephen's Episcopal Church in Tiburon was the one they felt good about right away in terms of the feeling and the acoustics and it was only then they realized that not only was "St. Stephen" the name of one of their early songs but that they had also either played or recorded there very early in their careers. So the synchronicity was amazing.

john perry barlow: In a way, he was already dead. That was what I was getting at back in Hepburn Heights when I told him I wanted him to actually be certifiable so that we could mourn him. Because he was as dead as anybody ever needed to get. But you also saw life. Garcia was alive. There was nobody who was more alive. Nobody.

rev. matthew fox: There was a wake the night before where the body was laid out in a funeral home. It was very small.

clifford "tiff" garcia: The wake was in a funeral parlor in San Anselmo on Miracle Mile. The casket was open and he looked good. He did look good. I can't say he died with a terrific smile on his face. But he looked good. The band was there and it was nice. Just immediate family and band members. A lot of people offered me condolences on my loss. It was their loss, too. It was a greater loss for them than it was to me. After the wake, there was a party at Phil's house. Phil didn't go to the wake but he had a party. I got to regroup with band members and all the people in their families. It was like a party time for me. Not in terms of having fun but like an activity. I had to be there. I had to go there. I had to go see Mountain Girl to talk to her. She wasn't invited to the funeral.

carolyn "mountain girl" garcia: I didn't go to the funeral but I went to the church where they had Jerry's body laid out and it was astonishing. He had a nice little smile on his face. There were no flowers. My feeling about it was that I had no privacy. God, there were so many people around. Flanking the coffin were the four elders of

the church. Steve Parish and the pallbearers were there and they all had suits on and I don't think I'd ever seen them in suits before. They were all looking really serious.

stacy kreutzmann: Before the funeral started, it was so eerie. Because for thirty years, we were always saying, "Is Jerry here yet? Is he ready to go?" So I kept looking over my shoulder. "Is the limo here yet? I think we're running late. Shouldn't it be starting now?" It felt like everyone was waiting for Jerry to get there. It was so eerie to realize that he was not coming to the show. This wasn't a gig. That was not what it was about. We were in church.

manasha matheson garcia: I would have liked to have said good-bye to Jerry at the funeral but we weren't permitted to attend. Jerry wasn't big on funerals. We went to Bill Graham's funeral together. He didn't like a big funeral. He said, "Don't do this for me." He asked me not to. And the idea of an open casket was not his idea. I called people in the office to try and stop this but it did no good.

rev. matthew fox: I myself am accustomed to seeing the body at a funeral and therefore I did not think very much about it. It seemed to provide people with a chance to say good-bye to him. There was a line of people who came up to do so before the service and then another line of people once it was over.

rock scully: At Pigpen's funeral, Garcia saw the open casket and he was like, "Don't let them do that to me." That was what they did to him, too. Oh, well. At that point, he didn't care anymore.

sage scully: I didn't like the open casket at all. It didn't seem to be him and it didn't seem to be something he would want. I've heard Annabelle say that was something he always said he didn't want.

sue swanson: They could have done a little better job with the lips. His lips were a little light. They could have put a little lipstick on them but I guess they didn't want to do that. His glasses were down on his nose. Steve Parish said that he'd seen him look a lot worse.

david graham: He looked really confused in the open casket. He just had this look on his face of perplexity. It was weird.

cassidy law: He looked so polished. I just wanted to go tousle the hair and move his glasses and it wasn't him. But at least he looked very peaceful. That was the main thing. He just looked peaceful.

stacy kreutzmann: I touched him in the casket. We couldn't help it. We all had to touch him. I wanted it to go on because when everyone started laughing and telling stories about him, it was like he was there for a moment. It was like, "Can we just hold this forever? Let's not lose it."

david grisman: He had his glasses on and he was dressed like he always was dressed with one of those black jackets on. I put one of my picks in his pocket.

sue swanson: He just looked dead. But he looked at peace. I didn't want to feel him all cold and dead but I patted his chest. I loved him.

gloria dibiase: I was raised Sicilian Catholic. I must see the dead body in order to say good-bye. I must put something in the casket. I put this beautiful smoky quartz crystal heart in the casket, I kissed him on the forehead, I touched his hand, and said, "Good-bye, Jerry."

sandy rothman: I put my hand on his heart and on his forehead and I touched his hands a lot and I just felt like I would as soon be where he was. I didn't want to die but I felt so emptied out. I actually went through a moment of slight hilarity where I thought he was going to sit up because it was Jerry's kind of humor to think that way. The thought went through my mind, "It's the first time I've ever seen him not participate in something." Actually, one of the times I touched his hand, his arm moved. Not by reflex. It just shifted by my touch.

gary gutierrez: When I walked up to Jerry to say good-bye, it was weird. It must be an illusion when you look at someone who you're used to seeing life in and then you see them so frozen but there was this

little blip of a moment, a trick of the eye, where it looked like he was almost going to say something. After the funeral, Mickey Hart came up to me and he said, "The weirdest thing, man, was when I went up to Jerry's coffin. I looked at him and it looked like he was almost going to speak. Like he was almost going to say something." I said, "I had exactly the same feeling."

bob barsotti: To be honest, he looked pretty happy. He wasn't there anymore. That was the thing. He wasn't there anymore and you went, "Okay, right. He's gone and there's his body and we can lay that to rest."

sage scully: The funeral was one irony after the next. The church had these big stained-glass windows on the side. I saw the new Grateful Dead *Hundred Year Hall* CD and it looked like the same windows on the front cover. Each one of the windows had actual figures in it that were almost Gothic looking. They were like medieval knights. I drank something that Ken Kesey gave me and everything was kind of a little smushed for me. It was like a wedding. That was what I thought.

david graham: The funny thing is that every time I talk about it, I say "the wedding." That's probably the best way really to describe it. It was very similar.

nicki scully: Fortunately for me, I ran into Kesey in the parking lot and he gave me something to drink. Was it orange juice? It was nectar. It was nectar befitting of the crossing. It was the most delicious psychedelic syrup I've ever sipped.

rev. matthew fox: When I was making preparations for my part of the funeral, I was very much aware that I would have Buddhists there as well as angry Christians as well as nonbelievers and so I talked about Otto Rank, who said that healing can take place through psychology in a one-to-one situation, through the work of the artist, and on a mass level through a prophet. I said that Jerry had confused the issue because he was an artist who had affected the masses like a prophet.

sue swanson: Sitting directly behind me was Bob Dylan. The first guy who got up was the priest and he was doing the rote stuff. It was nice but it was rote. Behind me was Bob Dylan and at one point, it was like a Dali painting. Things just kind of started to melt in front of my eyes and I thought to myself, "Are you thinking what I'm thinking, Mr. Dylan? That when you are lying there that these are the words they're going to be speaking about you?" I don't know whether he was thinking it or whether I was thinking it. But it certainly was apropos for him. I had to blink a couple times to focus again.

david grisman: I played at the funeral. I played at his wedding and at his funeral. Me and my guitarist, Enrique Coria. We played "Shalom Aleichem" and "Amazing Grace." Deborah asked me to play and that was tough. That was real tough. It was just a hard emotional thing to do. Not the playing itself but how to do the right thing.

rev. matthew fox: Deborah did organize the funeral service itself. We had certain people designated to speak and then we opened it up and let anyone get up there to talk. I think there was a feeling of general release. Steve Parish spoke. And then Hunter, who read a poem he had written at like three in the morning which was very moving.

clifford "tiff" garcia: They asked me if I wanted to speak and I said, "I don't know. I may or I may not." At the time, I really didn't feel like speaking. For one thing, I had to take a leak real bad and it was like, "Mm, how much longer is this going to take?" We were standing outside for a long time before it started and I was a little nervous so I didn't. After Hunter did his thing and Weir did his thing, I didn't want to get into it. It was just too late. If I would have said something right away, it would have been fine but I just thought, "M-yeah, it's enough."

gary gutierrez: Probably the highlight for me was Steve Parish. He stood up and his manner was strong voiced and direct and it was just a kind of unabashedly masculine way of saying good-bye. To see that coming from such a big guy with such a strong voice was very touching. Because he sort of spoke for the workingman. He said that Jerry really understood and knew the workingman and respected the workingman

and that was what had meant a lot to him. He'd felt well treated by him. When he was finished, there was a big ovation.

alan trist: I was particularly taken with Steve Parish's remarks. They were some of the most soulful things I've ever heard in my life. For somebody who had been so close to Jerry for so long, the eloquence of Steve's remarks was just superb. If there was ever a natural-born poet who emerged in response to the occasion, it was Steve Parish at that moment. And then of course there was Hunter. Hunter has got a hell of a voice and he got up there in the nave of this huge resounding place and he brought the muse down. He physically pulled down the muse with his hands and with his voice. It was a bardic performance that put me back a couple of thousand years to when that was commonplace in the courts of kings. He was totally right-on.

robert greenfield: Delivering "An Elegy for Jerry," which was widely disseminated after the funeral, Robert Hunter concluded by saying of his old friend and songwriting partner:

> *I feel your silent laughter*
> *at sentiments so bold*
> *that dare to step across the line*
> *to tell what must be told,*
> *so I'll just say I love you*
> *which I've never said before*
> *and let it go that old friend*
> *the rest you may ignore.*

david graham: When Steve Parish spoke, that was from the heart. That was beautiful and I thought what Hunter said was beautiful. I was the one who was bold enough to go talk after Hunter because nobody could stand up after his thing. I went up there and said, "This is the way I feel about it." Because everybody was pretending to be sharing in Jerry's spirit. My feeling is that the spirit within him just went into his kids who were sitting there. I didn't want them to be lost in the shuffle. The isolation that I was thrust into after my dad died was something that I knew they were going through.

rev. matthew fox: Jerry's daughter made the comment about his having been a shitty father. In the context of the funeral, everyone laughed.

bob barsotti: Some people gasped and some people laughed. If you knew her, you laughed and if you knew Jerry, you laughed. If you were Jerry's friend, you'd have laughed at that.

robert greenfield: Aside from Robert Hunter's elegy, perhaps the single most widely reported comment to come out of Jerry Garcia's funeral was made by his daughter, Annabelle. Of her late father, Annabelle Garcia said, "He may have been a genius but he was a shitty father." Most of those who were at the funeral that day understood the special relationship that had always existed between the two.

cassidy law: Annabelle and Jerry are very much alike. I remember them together at the Warfield in 1980. Annabelle was probably only about eleven years and she and Jerry were hanging out in those little hallways and the dynamic between those two was amazing. They just beamed together. It was like they didn't even have to say anything to each other. They just knew what was coming next in that real dry humor and wit they both had. Was he a shitty father to her? I don't think so as far as one-on-one treating her shitty. As far as losing contact or maybe just not being there when he could have and should have, yeah. He was starting to flunk out there. They had their times and then it just kept tapering off and he was going back into his sheltered world again. Which was too bad because I think that was really a huge part of his life that he was missing.

hal kant: Great father figure. Such a terrible father. He wasn't around enough when his kids were young. I don't know how familiar you are with psychoanalytical theory but the strongest figure, the one that everybody relates to, is the father of the father. To a patient, the analyst of his analyst is the most powerful figure imaginable. In the Grateful Dead family with Jerry, you were looking at someone even more powerful than the father of the father.

rev. matthew fox: Deborah spoke at the funeral and I don't think I've ever seen a widow be that strong. She spoke for a good ten or

twelve minutes and at one point, she said, "I forgive the band." I think she was talking about the way they had treated her back then and I believe she just needed to get some things said in order to let them know how she felt about it all now. My concern of course was for her. Because there can be such an up and down in such times.

clifford "tiff" garcia: She didn't acknowledge that Jerry had kids. She mentioned all these things about how Jerry loved her and how she loved him and this great warmth and then she didn't talk about his kids. She didn't acknowledge any of his previous wives. It was really one-sided.

sue swanson: What is the Shakespeare line? "Methinks the lady doth protest too much." Everybody was saying that. Deborah Koons Garcia did not give a eulogy. She gave a me-ology. That was all she talked about. "I was the love of Jerry's life." With his children sitting right there, it was hard. It was wrong.

gloria dibiase: We sat behind Ken Kesey and Sunshine and Barbara and Sara, who were sitting there holding hands. At one point, Deborah said, "Jerry said I was the love of his life." Barbara looked at Sara and said, "He said that to me!" And Sara said, "He said that to me!"

barbara meier: Actually, I said it in this Italian gangster's voice. "He said-a dat to me!" and Sara answered me back the exact same way.

manasha matheson garcia: I really loved him. I feel like what we had together was a very special romance and friendship. He'd buy me roses all the time and he was always very affectionate with me and told me how much he loved me all the time. The day he left, he told me he loved me. He was crying the day he left. He was in the chair just weeping and I wondered what was going on.

sandy rothman: I introduced myself to Deborah at the funeral but she was pretty dismissive because behind me at that particular mo-

ment, Dylan was paying his respects to Jerry and she was just really fixing on him. He was really trying to get out of there and she stopped him when he walked by. He had his head down. His eyes were really red and when she came to a little momentary pause in what she was saying, he looked at her with those incredible steely ice blue eyes and said, "He was there for me when nobody was." And he walked around her and split out of there as fast as he could.

nicki scully: That morning, I opened Normandi Ellis's *Awakening Osiris,* her translation of the Egyptian Book of the Dead, and I said, "Give me one for Jerry," and it fell open to "Becoming the Phoenix." Like the Tibetan Book of the Dead, these are instructions that are meant to be given to the corpse after passing. At the funeral, I walked up to the front and started reading:

I flew straight out of heaven, a mad bird full of secrets.... I destroy and create myself like the sun that rises burning from the east and dies burning in the west. To know the fire, I become the fire ... I wage a battle against darkness, against my own ignorance, my resistance to change, my sentimental love for my own folly. Perfection is a difficult task. I lose and find my way over and over again.... There is no end to the work left to do. That is harsh eternity. There is no end to becoming.... I am the fire that burns you, that burns in you. To live is to die a thousand deaths, but there is only one fire, one eternity.

owsley stanley: It didn't really hit me till I put on "Stella Blue." That really blew out the stops and I had a good cry. I gotta admit. I really loved the guy. He was a remarkable individual. He wasn't a godlike figure to me in any way but an infinitely curious, infinitely intelligent, infinitely creative brother and in lots of ways, an inspiration. But it's what happened. As the Pranksters used to say, "Nothing lasts."

yen-wei choong: In ancient China, you know which kind of patient is the most difficult to treat? The emperor. If you treat emperor, they get angry. They don't take the herbs, what can you do? If you push enough, Jerry get angry. Nobody dare to push. We try to but difficult

to make him healthy and also please him. Oh, very difficult to treat emperor.

john perry barlow: What he was really trying to do, and on a good night doing, was becoming utterly invisible along with the rest of the universe. Just being the song. Just being the music. Being a completely straight pipe. Sometimes, when he was on the natch, it was the same kind of deal in his life.

jorma kaukonen: As a recovering person myself, I'm really sorry I never got to talk with him about that. We never did, so I don't really know where he stood on his problem, whatever those problems were. At the same time, he always had a strange serenity about him. A self-awareness of his own life. Which is almost a contradiction with what was going on in his life, but he really did. There was something in there that worked for him. I don't know what it was.

gary gutierrez: David Gans was on this talk show on KQED radio the next morning and they were fielding calls from people about it and some guy called up raving about, "How can you raise such a bad example and glorify somebody that had such a terrible life?" In a very even tone of voice, David said, "Look, it's kind of beside the point. If you took all the paintings off the walls of the galleries and museums of the world and took all the sheet music off the stands of the orchestras of the world that were written or painted by a person who had a problem with drugs, you'd have a lot of blank walls and silent concert halls." Jerry had his problems but his music and his art were as much a part of him as the devils that beset him.

hal kant: I think there was a kinship in his approach to life with Byron and Shelley, who were guys who violated every convention of their time and that was what they got off on. But he wasn't malicious. They were horrible people, really horrible, and Jerry was a sweetheart. He absolutely was a unique human and I think that when he was not in a bad state, everybody wanted to bask in his presence.

peter rowan: There's not a night that goes by when I sing "Panama Red" that there isn't a spark of Jerry in that tune. Here was the

guy who gave me the sense of what it was to do it on the highest level you could do it. Just a totally professional musician going for it all the time. Part of his legacy will be how the people who played with him live up to his highest musical ideals. That's something I feel very strongly about. I'm not going to play a note of music that doesn't have what Garcia would have put behind it in his best way. He would be the guy to please.

justin kreutzmann: He was like somebody you'll never ever meet or anybody I'll ever meet again. There was no way to barometer what you saw going on in his life with what either he was actually thinking or anything you could gauge by somebody else's life. It was like he had his own little scale.

barbara meier: He was such a paradox on so many levels and one of the paradoxes was that he had this huge mind. He had this vast Buddha mind but he also had these limiting beliefs that created a very restricted identity. He had an incredible investment in being perceived as a nice guy. But he also had a tremendous need to be a bad boy and he somehow pulled it off. He got away with it and that was the outrage. He pulled it off but it was his undoing. Because he was a nice guy. He was "good old Jer." And he was a *very* bad boy. He could do all of it and he didn't need to choose between them because he had so much power. Keats called it "negative capability"—to be able to hold disparate ideas in your consciousness without the need to choose. He had that. He had that in his life! He had that and he lived it and it ultimately wreaked tremendous havoc and damage, not only for him but for many others who loved him.

john perry barlow: To understand Jerry, you've got to take a look at the real star-making machine. Charisma itself. You know what charisma is? What the original Scholastics and Thomas Aquinas would have called charisma is unwarranted grace. Unearned, undeserved, completely gratuitous grace. Every time we'd try to get Jerry to see that, he would protest by saying it had nothing whatsoever to do with him.

jon mcintire: I remember him telling me once, "When I was in Palo Alto way back then and I was teaching guitar, people would cluster

around me and I never understood why. But they would do it. So this kind of onus being on me, this focus being on me, that's been with me all of my life."

vince dibiase: You'd walk into a room with him and the whole room lit up. When my daughter started baby-sitting for him, she said, "I don't know what it is about Jerry. But when I walk into the room where he is sitting, all of a sudden I feel very calm and very peaceful." I said, "Well, honey, you're sitting there with a living Buddha. You're right there with this guy who's just emanating all this stuff."

sue swanson: I was just thankful that he was on his journey and I wished him well. All I kept thinking was, "The loudest music possible must be blasting him through the gates of heaven." That was what I felt from him. All the way, that was what I carried. He was just blasting through the gates of heaven with the loudest possible music playing.

justin kreutzmann: My dad's line to me was, "If Jerry can be free, I want to be free too." He doesn't miss the scene. He just misses the music.

sue swanson: The most profound thing for me was "Who am I now? What am I?" I'd always been on this team. I'd always known that if one of my kids got sick or if that I ever really needed anything or that if things were really fucked up, Garcia would take care of me. And he was not there anymore and I didn't feel that way about anyone else on the planet. It hit me on a lot of levels. On a lot of levels. Personal, professional, public, private. I mean, this was a big death.

john perry barlow: I was in Australia a few days before he died. I was doing an interview about all this electronic stuff that I do and the interviewer suddenly said, "So you know Jerry Garcia, right?" I said, "Yeah." He said, "What's it like knowing Jerry Garcia?" and it just threw me and I said, "I don't know what it would be like *not* to. The guy and his manifestations have been so thoroughly embedded in every aspect of my life for so long that I don't know what it would be like *not* to

know him." Now I'm finding out. I haven't even been able to accept the fact that he's gone. Part of the problem is that I thought about this so many times. I said, "It's coming" over and over and over again and every time I experienced it, I developed a little callus against it. The callus is so thick that now that he has finally actually died, I can't experience it because I've developed this incredibly thick defense against it. I want to strip it away but I have not yet shed one tear over Jerry Garcia. Not one.

robert greenfield: At a wake for Jerry held at Alton Baker Park in Eugene, Oregon, after the funeral, Carolyn "Mountain Girl" Garcia spoke before about a thousand people. She talked of taking her runes from a bag and finding the second rune, "Partnership," which says, " 'I am your beloved. You are my true companion. We meet in the circle at the rainbow's center, coming together in wholeness. That is the gift of freedom.' "

david graham: I thought the way that his death was covered in the media was for the first time perfectly right because they couldn't say a bad thing about him. That was cool. Nobody played up the heroin thing and nobody tried to take him down and it was powerfully done and it was a good tribute. The fact that he was recognized as being the one person within the rock 'n' roll thing who went beyond the sex and drugs of rock 'n' roll and actually said something very deep and spiritual in terms that might have been heavy-handed but were right-on.

rev. matthew fox: If you look at the last picture in *Harrington Street,* which was the last painting he did that Deborah found on his computer, I think you get a sense of his vision of the afterlife or perhaps even where he is now. That bright sun floating at the end of what looks to be the birth canal.

jon mcintire: I think we were in the kitchen of the Grateful Dead office in San Rafael and I was talking about suffering as a fuel for creativity. He got this furrowed brow while his eyes were flashing back and forth and he said, "I know that's the stereotype. I know that's what history teaches us. But I'd really like to know what can be created from joy." One of the most important parts of Jerry was that he wanted to

create joy. Why that didn't win out more often in him, I don't know. I do know that the more intelligent a person is, the more completely he can deceive himself. Jerry was one of the most intelligent people I have ever met. Consequently, his capacity to deceive himself was far far bigger than in most people.

wavy gravy: I wrote "A Haiku on the Day of Jerry's Demise." It goes like this, "The fat man rocks out/Hinges fall off heaven's door/ 'Come on in,' sez Bill."

bob barsotti: The Dead were really an American phenomenon. Could that have been developed in other places? Yeah, but it would have been like taking Wild Bill's Wild West Show to Japan. I think it was Annabelle who said, "My father was a great American." That really made a lot of sense to me. He really was a great American and he really loved America. Because as fucked up as it is, it allowed him to be who he was. That's what America is all about, man. That's what's so great about it.

david grisman: Kesey was crying like a baby at the end. He said some great things. For me, his comments were the most insightful and heartfelt.

robert greenfield: On the Internet sometime later, the always redoubtable Ken Kesey weighed in from Oregon with a "Message to Garcia." The message concluded in part with:

You could be a sharp-tongue popper-of-balloons shit-head when you were so inclined, you know. A real bastard. You were the sworn enemy of hot air and commercials, however righteous the cause or lucrative the product. Nobody ever heard you use that microphone as a pulpit. . . . And to the very end, Old Timer, you were true to that creed. . . .

I guess that's what I mean about a loud silence. . . .

It was the false notes you didn't play that kept the lead line so golden pure. It was the words you didn't sing. So this is what we are left with,

*Jerry: this golden silence. It rings on and on without any hint of let up . . .
on and on, And I expect it will still be ringing years from now.*

*Because you're still not playing false. Because you're still not singing
Things Go Better With Coke.*

<div align="right">

Ever your friend,
Keez.

</div>

46

celeste lear: I had this dream. I was on an airplane and I looked next to me and it was Jerry Garcia sitting right next to me on that airplane. I was like, "Woo, Jerry. You're Jerry Garcia!" He was like, "Yep, I'm Jerry." He said, "Yeah, I'm on my way to a show," and I was like, "Oh, that's so cool," and we started talking and I told him I played guitar too and he was like, "Oh, you should come play with us tonight." I was like, "No, no. I'm not good at all. I'd just mess you guys up," and he was like, "No, you should just come." Then like a flash we were on stage. All of a sudden, I was on stage with the Grateful Dead and I was like, "No, no. I can't do this." The crowd was cheering and they handed me a white guitar. This amazing white guitar. I was freaking out and I was like, "I can't do this," and Jerry said, "Just do it." I was shaking and all of a sudden they started playing and I started playing with them and it flowed. It flowed. In the dream, I remember even shredding Jerry and Jerry was like, "Damn," and then the guitar disappeared and they handed me a trombone. A trombone. I was like, "I've never played this before in my life. What are you doing?" Jerry said, "Just play it," and I played it and I played it good.

laird grant: Jerry never laughed at the Deadheads because he'd been a soulless wanderer out there on the dark highways himself. He knew what that was. He did feel that there should have been some other way for them to get off but again they were caught up in their own drug. The Dead.

michael walker: I did Summer Tour '94. Me and my friend, we hit every single show. Summer Tour '94, it was like go. It was like it was on and that was what we were doing. Some tickets we mail-ordered. Some we didn't 'cause I didn't know how to get a ticket for some show

in Deer Creek, Indiana. We'd drive the bus, go to a town, and we'd kick it there.

manasha matheson garcia: The world doesn't seem like the same place anymore without Jerry and without the Grateful Dead. On a real limited personal level, I experienced the beauty. Before I was with Jerry, when I was a fan in the audience, I'd walk to one section of the crowd and all of a sudden I'd feel this gracefulness come. This beauty. There would be beautiful women and men dancing and it was just amazing. I feel really blessed and honored to have participated in that.

alan trist: The Deadhead Diaspora was the way Ken Kesey put it. Because what the Grateful Dead experience was, apart from the music and Jerry as a figurehead and his liquid guitar lines and the band's driving force and the dancing, and all of that, was a meeting place, a celebration, a ceremony, a ritual, a chautauqua, a gathering. Something timeless and endless and eternal. The thing that human beings do when they're in their most holy place. What the Deadhead Diaspora means is that now they're going to do the same thing, only dispersed in smaller units. It's the going on and the gathering that is the important thing. And the constant statement that there is another way.

michael walker: I was shocked the morning Jerry died. I woke up to a knock on the door really really early. It was just a couple of hours after it happened and my friend's mom told me Jerry died. That was the worst way to be woken up. It was a cold foggy morning and then that news. Jerry was gone. What a way to start the day.

We drove to the Polo Field in Golden Gate Park and we hung out there for a while. Actually, everyone went to Haight Street first. We all gathered at Haight and people were drawing on the sidewalks and everything and cops were everywhere and it was like when the Dead go to a town and Deadheads are everywhere and there are cops. Then everyone walked into the park. Some people walked together and some people kind of did their own thing and walked different ways but we all made it to the park.

When I got there, there was a big circle and flowers and somewhat of a shrine but it was still early on. As the day progressed, they were sticking cameras in everyone's face who was trying to pay their respects. People

were smoking bowls and drinking whiskey. I stayed for a long time and I got interviewed. Just some lady talking. I didn't even know who she was. She came around with a camera, asked me my name, where I was from, and just basic questions. Lots of people were crying and the media was taking advantage of that. They were sticking cameras in people's faces who were crying. There was lots of different music and there was a drum circle jamming and people were singing "Won't Fade Away" for just the longest time to the drum circle. To just the beat. For a long time, people sat there saying that, just crying, and the drums kept going but I think people were trying to make it a good thing. Like pick it up by making the music and trying to keep it together.

People were writing little letters to Jerry and putting them in the shrine. I took off the necklace that I had worn like forever, forever, forever at all my shows and I took that off and I laid that across a little poem I wrote and put it in the shrine and that was it. It was a time for lament but I left there kind of bummed. But I'd paid my respects and I was really glad.

celeste lear: I went to a memorial at Griffith Park in L.A. and there were about a thousand people there. It was by the carousel up on the hill and people were holding candles. The whole hillside was lit up with candles and people singing and playing drums and guitar and there were people down by the altar. People were crying and I saw a lot of my friends there and everyone was like, "Can you believe it?" Like, "Oh my God, this is the end." That day, I played myself. Just in front of my amp. I played for Jerry and I was totally flowing. It was so good.

bob barsotti: Everyone was talking about the memorial. On one hand, it was Jerry the icon, the Grateful Dead, all that. On the other hand, the city was also coming from a public safety standpoint. If something didn't happen, they were afraid these kids were going to camp in Golden Gate Park and not leave for months. Phil Lesh and Cameron Sears and Dennis McNally and I started talking. Phil said, "I hope you realize that none of us will be there. None of us are going to go." I said, "You know what, Phil? That's not a prerequisite. You guys don't have to come."

In my mind, I was thinking that without them, why bother? But he was having a hard time with it being based on his participation and I

knew these guys. If it was all up to them and the whole pressure was on them, they wouldn't do it. I said, "If you want to just sanction it and not come, then I'll set up the music and we'll do something and it will be fine." He said, "Okay. Under those circumstances, I think it's a good idea." I was going on the premise that they were not going to be there so I got everything all set and then I got the call from Mickey Hart's guy, Howard. "Bob, I think Mickey wants to participate." I said, "Fantastic." Then I got the call from Cameron Sears, their manager. "I think they all want to come down."

I got there about midnight and nothing was working right but it didn't matter. We were all there. All the people who had been doing this for Jerry for all these years. Tom Howard and his crew started setting up the stage in the middle of the night. There was a gathering of a couple of hundred people over on the other side of the ball field who had been there for a couple of days and they saw what was going on. It was pitch-black. Three o'clock in the morning. Guys climbed up to the top of the scaffolding to get this big picture of Jerry we were using as a drop up there. When they unfurled it, the whole crowd applauded. "Yeah, Jerry!" People were taking flash pictures and the picture of Jerry was popping into light because there was no other light. All the work lights had broken. They'd set this thing up in the dark.

The next morning, people started to arrive slowly. Just before it actually started, the numbers doubled. I think over the course of the day, over a hundred thousand people came through there. Nobody stayed very long. They came, they paid their respects, they left. There was a constant crowd of somewhere around twenty or twenty-five thousand people but it was come and go. It was like a neighborhood memorial or a wake. I told the Dead, "You shouldn't perform. You should just come and talk. This is your chance to be there with your audience and put the whole thing to bed."

We had the Grateful Dead Chinese New Year's dragon, which only comes out of the warehouse on Chinese New Year at Dead shows and it came out and it did the circle behind the mourning procession. Then we got all the drummers together. I got Deborah down there and all the band was there, all their wives, and we all picked up a drum or a cowbell. We were with some of the best drummers in the Bay Area, Michael Shrieve and Armando Peraza and all the Cuban guys and all the Talking Drum guys from Africa. Mickey Hart had arranged for them all to be there.

They had their incredible drums with them and we did this procession led by Olatunji. Baba Olatunji led us through the crowd and the crowd parted to let us through.

We got up on the stage and then all the different band members and the family members spoke. Paul Kantner was there. He came up and read a poem. Wavy Gravy spoke. I got Barlow up on the stage. He was standing down in front and he said, "I don't want to be up there." I said, "No, you're going up there. Get up there." On stage, he said, "They asked me to come up and speak and I've only got one word and the word is 'love.'" And he turned and walked away. It was a pretty emotional moment. Then Annabelle thanked the crowd for putting her and her sisters through college and making it so she didn't have to work at the Dairy Queen.

We had a line the entire day going up to the altar. People could go and stand in the center spot right in front of the picture of Jerry. The thing that always drew me to this business was the human energy that happened when groups got together focused on one thing in this euphoric state. For years, when I would go up on the Grateful Dead stage and stand behind the drummers, I could feel this focused energy there. It was really strong.

This day in the park when I went to that same spot on the back of the stage behind Jerry's backdrop, there was nothing there. But when I went to the altar down in front, that was where it was. Every person who wanted to pay their respects to Jerry got to go stand in Jerry's spot and feel the energy that Jerry had felt for all those years. They would go up and face the altar and it was coming in from behind them. It was like being on the rail in front of Jerry. Getting your last chance to be on the rail. Only this time, the energy wasn't focused up over your head. It was focused right on you. They'd go up and stand there for a minute and it would just overcome them.

michael walker: I went back up to that one too of course and hung out. There was a microphone and they gave people a chance to go up and talk if they wanted to say anything. By turning around and seeing all the people out there gathered for one cause, you could like see what Jerry had seen whenever he played. There was a reason everyone was there. It was to go and pay their respects and show their love for Jerry.

47

robert greenfield: And so it was that after Jerome John Garcia died, both the Volkswagen and Levi Strauss corporations felt compelled to take out full-page ads to note his passing in the Jerry Garcia memorial issue of *Rolling Stone* magazine. Although Jerry himself had done a folksy little Levi's 501 radio ad back in the eighties, did the folks at Levi Strauss and Company really consider him a member of their corporate family? As for Volkswagen buses, the man never drove one.

Much like the snowstorm of media coverage after his death (including tabloid headlines like I HAD JERRY GARCIA'S LOVE CHILD and WE SOLD JERRY GARCIA DEADLY DRUG COCKTAIL at which he himself would have roared with laughter), the ads had far more to do with the legend Jerry had become than the person he had always been.

How else could it have been? In Jerry Garcia's life, the mythological underpinnings were there right from the start. Like one selected by the gods on high to be tested from birth, Jerry was first marked by his own brother. Off came half a digit from a hand Jerry would then use to make himself rich, famous, and powerful. From the grievous yet sacred wound, this guitar hero drew greater strength.

As a child, Jerry then watched his father drown before his eyes. Already marked, Jerry was now entirely cut loose from the strictures of ordinary family life. Hammered by an awful blow which might have permanently crippled someone made of weaker stuff, Jerry suffered and then persevered. In time, Jerry became not only a father to himself but to those who followed him because of the music he played. Seeing in him the transcendent power they did not recognize within themselves, they waited for Jerry to lead them. But he would not do so.

For in actual fact, their hero was crippled. A born leader, he did not want to lead. In truth, he did not even want to be a hero. Jerry was more at home in an entirely different incarnation. The trickster. The shape-

shifter who in the course of his long and tangled journey through the mortal plane assumes many physical forms. In his wake, such a being often leaves confusion. None who encountered Jerry understood him fully. Those who knew him best still admit this plainly. At any given moment in time, it was impossible to know what he was really thinking or precisely which earthly goals beyond the playing of his music he wanted to pursue.

Formed by the tragic events of a traumatic childhood or perhaps by the kind of brain chemistry possessed by only a very few in any generation (to which Jerry added lysergic acid, DMT, THC, cocaine, amphetamines, and opiates in copious amounts previously unavailable to any man), his agenda remained always and forever strictly his own. When Jerry passed from this life, those left behind could only try to fit all the pieces of the puzzle together while knowing always that the bigger picture remained somewhat harder to see.

About him, we can safely say the following: As a person, Jerry Garcia sentimentalized the women and children in his life. He loved to love them when he loved them but as soon as the rigors of day-to-day life with them became too tedious, Jerry was out of there and goin' down the road feelin' sad. To some, he seemed guiltless. Yet again and again, guilt drove him back the way he had already come. Like many artists plugged more directly into the collective unconscious from which we all gather our dreams, Jerry dramatically embodied the yin and yang of the human condition.

A woman who knew Jerry very well suggested that perhaps at the center of his own particular maze, there was nothing much at all. A vacuum where the heart center was meant to be. More likely, both existed there, nestled side by side as it would seem they never could. With apologies to Kris Kristofferson, Jerry was "a walking contradiction, partly truth and partly fiction." The hippie embodiment of good vibes, he was so cynical and sardonic a survivor of the beatnik era that he could refer to the years he spent lost on junk at Hepburn Heights as his "vacation." Wanting to be left alone, he attracted others to him like a magnet. By bringing people in close, Jerry also kept them at bay. Bright as the Leo sun that was his birth sign, he could be one very dark star indeed.

Like so much else about him, his drug use was extreme. "Is that the biggest line you can whack out, man? Is that the fattest joint you can roll?" Jerry would demand with a grin back in the days when he was still in control of what he was using rather than the other way round. Nearer the end of his life, he disappeared during one sound check only

to reemerge on stage forty-five minutes later looking dazed with a disposable plastic hotel shower cap on his head. Sad as it may have been to see him so confused, Jerry was only wearing what had become his standard gear for keeping his hair away from the flame as he lit the pipe and/or chased the dragon on the road.

Extreme behavior? Most certainly so. But then the man always wanted more of everything. No matter what was on the plate, an extra portion was his primary need. For someone with lesser appetites and less ambition, what he already had might have been more than enough. Most likely, that person would have been someone other than Jerry Garcia.

At the end, when his body was shot and the drugs on which he had depended to blot out the pain were no longer those of his own choosing, he may have had the last joke on everyone by driving off by himself to Serenity Knolls (can that name be an accident?), lying himself down to sleep, and passing gently from this earth with a smile on his face, grateful to be dead at last and in a place where no one again could ever ask him for something he was not really certain he was qualified to give.

Perhaps he was smiling when he died because like the true cool beatnik he had always been, Jerry went off in style without having to explain what it was he meant. The act was the statement, man. The meaning was in the mix. Unlike Hugh Selwyn Mauberly, Ezra Pound's fictional poet who was woefully out of step with his era, Jerry Garcia was in fact precisely "what the age demanded." For better and worse, he was perfectly made for these times. Satisfying this particular requirement brought him more fame than even he could have ever imagined possible. As always, in his life, that double-edged sword managed to cut deeply in all directions.

So many believed they knew what he wanted that even after his funeral, some went to the trouble of bringing into view his hand with the missing finger so it could be seen before he was cremated. Jerry's ashes were then scattered not once but twice. With the Grateful Dead having voted their full approval of a plan that came to Bobby Weir in a flash between waking and sleeping and with a film crew present to record the event, Weir and Jerry's widow scattered about half of Jerry's earthly remains in the Ganges River. Speaking for the rest of his immediate family, none of whom had been notified beforehand of this plan, Carolyn "Mountain Girl" Garcia noted that not only was India a country Jerry himself had never visited but the Ganges was also the most polluted river on the face of the earth.

The second time around, Heather, Annabelle, and Trixie Garcia, Sunshine Kesey, Bob Weir, Phil Lesh and his wife, Jill, and Steve Parish were all present as the last of Jerry's physical remains were scattered beneath the Golden Gate Bridge on the gleaming waters of the San Francisco Bay.

Concerning the screaming fight on the dock beforehand as to who would be permitted to go along on what was, after all was said and done, Jerry's last trip, the less said the better. So too for Jerry's grinning image on birthday cards that proclaim, "You're Having Another Birthday" on the outside and "Be Grateful" inside. Not to mention all the commercial exploitations of his likeness yet to come. Those twin scatterings notwithstanding, now that Jery is dust and ashes, he belongs once more (as he always did in life) to no one but himself.

As Richard Nixon, a President who would never have welcomed Jerry to the White House but instead gave Elvis the FBI badge he wanted so badly, used to say, "Let me make one thing perfectly clear." It was not LSD or the sixties that made Jerry Garcia who he was. Jerry was always Jerry. Seemingly, he came into this world not only fully formed but, as Bruce Springsteen once sang, "with the diamond hard look of a cobra." That never changed. In his beginning may have well been his end. Yet both were always cloaked in mystery, perhaps even to him as well.

For those who wonder what all the fuss is about, I'd suggest sitting down again with any good live version of "Dark Star." Anyone caring to note where the development of the electric guitar happened to be at a certain point in history could do no better than to listen to Jerry get out there on his instrument, pure and free as he could never truly be in life.

Thankfully, my job here is not to analyze, categorize, or summarize the man. To do so would only trivialize the life. Instead, I'd just like to join my voice with all the others who felt the need to send best wishes his way for safe passage on the long and stranger trip on which he may now be embarked. Good-bye, Jerry. Thanks for all the good stuff.

Acknowledgments

For providing me with unlimited shelter from the storm and a key to the back door, I would like to thank Nancy Taylor and Jerry Pompili. For coming up with the idea in the first place, my thanks to Paul Bresnick. For hanging in there always, my thanks to Erica Silverman. Thanks to Milton Hare and Marilyn Fletcher for delivering under pressure. For surviving this roller-coaster ride by allowing me the time to work overtime, I congratulate my family.

speakers

Author's Note: Every effort was made to contact all the major figures in Jerry Garcia's life. Those who do not speak in their own voice in this book declined either directly or indirectly to participate. I would like to offer my heartfelt thanks to all those who did find the time to do so. All interviews for this book were conducted by the author. Unless otherwise noted, the interviews were done in 1995.

peter albin —A founding member of Big Brother and the Holding Company, he now works in sales and advertising for an independent music distributor in Marin County.

ken babbs (1989)—A former Merry Prankster, he lives in Oregon, where he continues to engage in a variety of literary pursuits.

dr. randy baker —Jerry Garcia's personal physician, he practices holistic medicine in Soquel, California.

sonny barger —A longtime member of the Hell's Angels, he now runs a motorcycle repair shop in Oakland, California.

john perry barlow —Having written the lyrics for many of the Grateful Dead's best known songs, he is the co-founder of the Electronic Frontier Foundation and a lecturer/consultant on cyberspace.

bob barsotti (1988/1995)—The last house manager of Winterland, he is now a vice-president at Bill Graham Presents in San Francisco.

peter barsotti (1988)—Along with his younger brother, Bob, he produced countless Grateful Dead shows. He is now a vice-president at Bill Graham Presents in San Francisco.

jerilyn lee brandelius —She is the author of the *Grateful Dead Family Album*.

steve brown —Having spent five years working for Grateful Dead Records, he is now a film and video producer.

yen-wei choong —He operates the Yellow Emperor Healing Center in San Anselmo, California.

tom constanten —The first "sideman" to play piano for the Grateful Dead, he continues to perform and record today.

tom davis —One of the original writers on *Saturday Night Live* and half of the comedy team of Franken and Davis, he is currently writing a screenplay with Dan Aykroyd and hosting a show on the Science Fiction cable channel.

john "marmaduke" dawson —A founding member of the New Riders of the Purple Sage, he continues to perform with the band today.

len dell'amico —Currently writing his first feature film, he spent eleven years with Jerry Garcia directing and producing award-winning long-form videos, pay-per-view broadcasts, and network television for the Grateful Dead.

gloria dibiase —Married to Vince DiBiase, she was Keelin Garcia's nanny for the first five years of her life. She took care of Jerry Garcia on a daily basis for the last two and a half years of his life.

vince dibiase —From mid-1992 until the end of 1994, he ran Jerry Garcia's art business. He was also his personal manager.

rev. matthew fox —A theologian who has written extensively about the role of the church in the modern world, he married Jerry Garcia and presided at his funeral.

david freiberg —A founding member of the Quicksilver Messenger Service, he lives in Marin County.

carolyn "mountain girl" garcia —A former Merry Prankster, she spent twenty-eight years as Jerry Garcia's friend, wife, and companion. The mother of Sunshine Kesey and Annabelle and Trixie Garcia, she is an organic gardener, writer, painter, fiber artist, and avid environmentalist who lives on a farm in Oregon raising black sheep and jackasses.

clifford "tiff" garcia—Jerry's older brother, he works for Grateful Dead merchandising.

jerry garcia (1988)—He was the former lead guitar player for the Grateful Dead.

manasha matheson garcia—The mother of Jerry Garcia's youngest daughter, Keelin, she currently runs Say Grace Music, a music production company, and is working to establish a holistic medical center.

sara ruppenthal garcia—A former member of the Anonymous Artists of America, she is about to begin a postdoctoral fellowship in clinical health psychology. She lives in San Francisco and is the mother of Heather Garcia.

bill graham (1989)—The legendary rock promoter, he died in a helicopter crash in 1991.

david graham—The son of the late Bill Graham, he was Blues Traveller's first manager. Having recently published a book of his own poetry, he lives in Marin County.

laird grant—A lifelong friend of Jerry Garcia, he was the Grateful Dead's first roadie.

david grisman—He continues to write, perform, and record music on Acoustic Disc, his own label.

gary gutierrez—He continues to work as a director of television commercials, music videos, and visual effects for movies.

dexter johnson—A guitar maker, he runs Carmel Music, a shop specializing in vintage instruments in Carmel, California.

mickey hart (1988)—Formerly one of the drummers in the Grateful Dead, he continues to write, perform, and record his own music.

hal kant—For the past twenty-five years, he has been the general counsel and head of business affairs for the Grateful Dead.

jorma kaukonen—A founding member of the Jefferson Airplane and Hot Tuna, he continues to write, perform, and record acoustic blues.

ken kesey (1989)—The noted author who was also once the chief Merry Prankster, he continues to live in Oregon.

sat santokh singh khalsa —As Bert Kanegson, he was a manager of the Grateful Dead. A leader in the Sikh community, he is now CEO of Rainforest Products, a socially responsible company working to preserve the rain forest.

justin kreutzmann —The son of Bill Kreutzmann, the Grateful Dead's first drummer, he works as a video director.

stacy kreutzmann —Justin's older sister, she works as a print broker, video producer, and publisher in northern California.

cassidy law —The daughter of Eileen Law and namesake of the Weir-Barlow song, "Cassidy," she did tour ticketing for the Grateful Dead. She continues to work for the band handling public relations.

eileen law —The former voice of the Grateful Dead hotline, she acts as liaison between the Deadheads and the Grateful Dead.

celeste lear —A college student and aspiring professional musician, she is a Deadhead.

marshall leicester —He is a professor of English literature at the University of California, Santa Cruz.

richard loren —The former manager of the Grateful Dead, Old and In the Way, and the Merl Saunders-Jerry Garcia Band, he lives in San Francisco and is developing several independent film and video projects.

jon mcintire —The former manager of the Grateful Dead, he now lives in Los Angeles where he is involved in screenwriting, acting, producing, and directing.

donna godchaux mckay —Having rediscovered her Christian roots, the only woman ever to be part of the Grateful Dead continues to make music while living in Alabama.

barbara (brigid) meier —A poet, painter, and Buddhist, she lives in New Mexico where she has assembled a book of recollections about Jerry Garcia entitled *Gaspar's Parrot*.

chesley millikin —The former manager of the Grateful Dead and the first general manager of Epic Records in Europe, he now lives in northern California.

david nelson—A founding member of the New Riders of the Purple Sage, he continues to perform with his own group, the David Nelson Band.

harry popick—A longtime soundman for the Grateful Dead, he is now involved in recording and production in Marin County.

ron rakow—The former president of both Grateful Dead and Round Records, he is a self-described "visionary business cat who is now a mundane venture capitalist with a great ocean view."

sandy rothman—He continues to play bluegrass music while living in Berkeley, California.

peter rowan—He continues to write, perform, and record as a solo artist and the leader of his own band.

merl saunders—He continues to write, perform, and record with the Merl Saunders Band.

nicki scully—Sage's mother, she is an author and teacher of metaphysics, shamanism, and healing who lives in Oregon.

rock scully—The former manager of the Grateful Dead, he is the author of *Living with the Dead*.

sage scully—Rock's daughter, she lives and works in Bend, Oregon.

grace slick (1988)—She is the former lead singer of the Jefferson Airplane and the Jefferson Starship.

joe smith (1988)—A noted raconteur and author, he ran both Warner Brothers and Capitol Records.

owsley stanley (1989/1995)—Also known as Bear, he is the street chemist who first synthesized LSD in very pure form for mass consumption. He now lives in Australia.

sue stephens—For twenty-two years, she worked as Jerry Garcia's personal assistant, office manager, and chief financial officer. She is now the secretary for his estate.

sue swanson—Called "my oldest fan" by Jerry Garcia, she has spent most of her adult life living with and working for the Grateful Dead.

bill thompson (1988)—He is the former manager of the Jefferson Airplane and the Jefferson Starship.

pete townshend (1988)—He is the former lead guitarist of the Who.

alan trist—He is the director of Ice Nine, the Grateful Dead's music publishing company, and President of Hulogosi Communications, a co-operative book publishing company.

michael walker—A college student, he is a Deadhead.

wavy gravy—The self-proclaimed "psychedelic relic," he continues to do what he has always done while also running a camp for children in northern California in the summer.

bob weir (1988)—The former rhythm guitarist for the Grateful Dead, he continues to write, record, and perform his own music.

joshua white (1988/1995)—The creator and namesake of the Joshua Light Show, he now works as a television producer/director in New York City.

suzy wood—Formerly married to Marshall Leicester, she is a reentry student who recently graduated from the University of California, Santa Cruz, with a degree in anthropology.

elanna wyn-ellis—For the past twenty-four years, she has been John "Marmaduke" Dawson's companion.

index